THE ARTISTS OF THE ARA PACIS

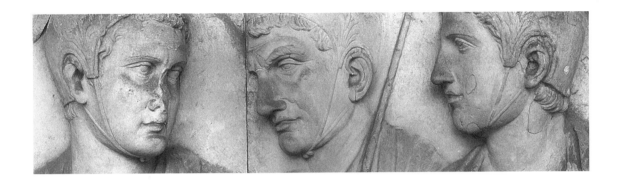

STUDIES IN THE HISTORY OF GREECE & ROME

P. J. Rhodes and Richard J. A. Talbert, editors

THE ARTISTS OF THE
ARA

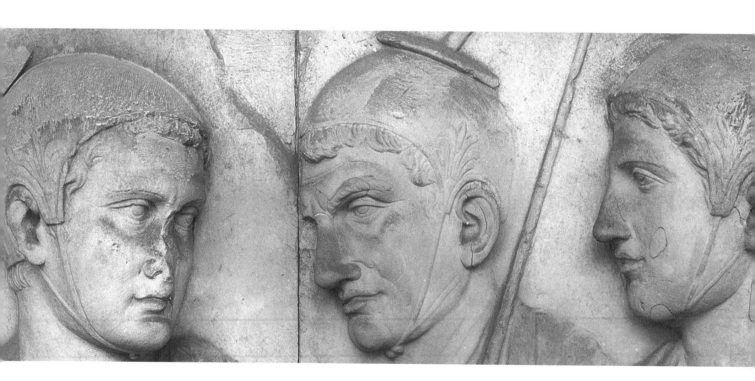

DIANE ATNALLY CONLIN

PACIS

THE PROCESS OF
HELLENIZATION IN
ROMAN RELIEF
SCULPTURE

THE UNIVERSITY OF NORTH CAROLINA PRESS

CHAPEL HILL AND LONDON

Designed by Richard Hendel

Set in Galliard and Trajan types

by Eric M. Brooks

Manufactured in the United States of America

The paper in this book meets the guidelines for permanence
and durability of the Committee on Production Guidelines for
Book Longevity of the Council on Library Resources.

Publication of this book was aided by a generous grant from
the Samuel H. Kress Foundation.

Library of Congress Cataloging-in-Publication Data
Conlin, Diane Atnally.
The artists of the Ara Pacis: the process of Hellenization in
Roman relief sculpture / by Diane Atnally Conlin.
p. cm. — (Studies in the history of Greece and Rome)
Includes bibliographical references and index.
ISBN 0-8078-2343-0 (cloth: alk. paper)
1. Ara Pacis (Rome, Italy) 2. Relief (Sculpture), Roman—
Italy—Rome. 3. Marble sculpture, Roman—Italy—Rome.
4. Friezes—Italy—Rome. 5. Sculpture, Hellenistic—
Influence. 6. Peace in art. 7. Human figure in art.
I. Title. II. Series.
NB133.C66 1997
733'.5'09376—dc20 96-41830
 CIP

01 00 99 98 97 5 4 3 2 1

FOR MICHAEL

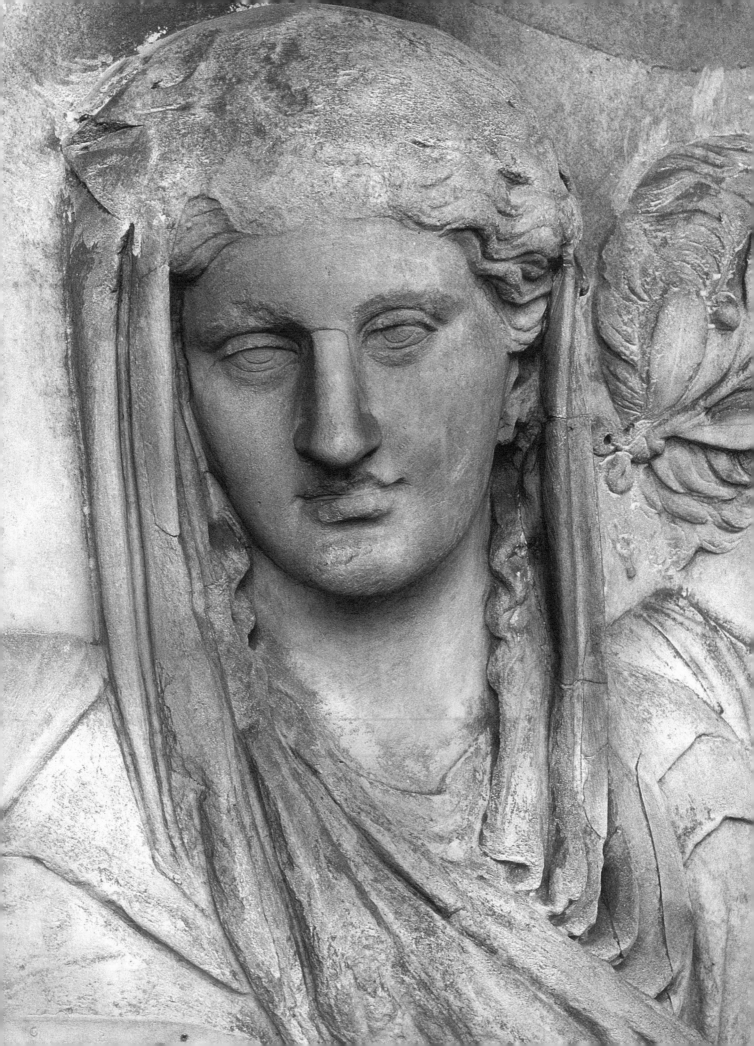

CONTENTS

PREFACE

The title of this book is somewhat misleading since this study does not examine in detail all of the sculpted decoration on the Ara Pacis Augustae. Rather, I have attempted here to identify the artistic preferences and learned traditions of the group or groups of artists who designed and sculpted the large processional friezes that adorn the exterior, long sides of the precinct walls of the Augustan altar. I have concentrated my examination on the large processions for two major reasons. The first was due to personal preference. As a student of Roman art, I have been most interested in stone reliefs carved and displayed in Rome that show scenes of Romans engaged in civic or religious activity— so-called Roman historical reliefs. My concern has been to understand how the designers and carvers working in Rome for Roman patrons created images that depicted their customers engaged in nonmythical activities. The second reason for limiting my study to only the large processions was more practical. The method I established to isolate and assess the details of carving on these large-scale reliefs was a slow process that required extensive on-site study. From the outset, both time limitations and the large quantity of data which I had anticipated my analyses would produce encouraged a narrower focus for my study of the Ara Pacis. Certainly, the firsthand, detail analyses used here can and should be applied not only to the remaining areas of sculpted relief on the Augustan altar but to other Roman reliefs carved both prior and subsequent to the late first century B.C.

This book is based in part upon a doctoral dissertation submitted in 1993 to the Interdepartmental Program in Classical Art and Archaeology at the University of Michigan, Ann Arbor. In 1988, the year I began in earnest my examination of the carving styles and techniques of the Ara processions, the study of Augustan art and its role within the larger context of the political, social, and religious structure of the Augustan age was already undergoing renewed interest. An English translation by A. Shapiro of P. Zanker's highly influential study of Augustan art and culture, *Augustus und die Macht der Bilder* (Munich, 1987), as well as a monumental collection of essays accompanying a comprehensive exhibition on the Augustan era in Berlin, *Kaiser Augustus und die verlorene Republik*, both were published in that year. Both studies contributed

enormously to the already massive quantity of studies devoted to Augustan art and the Ara Pacis in particular. Since then, the bibliography on Augustan art has increased with an explosion of intellectual curiosity that can only be matched by the output of studies in the first decades of this century. Keeping abreast of new publications on Augustan art, not to mention Augustan history and literature, has been a formidable task. While I have been able to review and synthesize a majority of the new books and articles, I have had less chance to digest fully and incorporate into this study the interpretations put forth in more recent major publications such as D. Castriota's *The Ara Pacis Augustae and the Imagery of Abundance in Later Greek and Early Roman Imperial Art* (Princeton, 1995), A. Kuttner's *Dynasty and Empire in the Age of Augustus: The Case of the Boscoreale Cups* (Berkeley, 1995), and K. Galinsky's *Augustan Culture: An Interpretive Introduction* (Princeton, 1996).

The reader will immediately take notice that many of the photographs in this book are new or rarely published shots of the Ara processions and other pieces of Roman relief sculpture. The majority of the new details were taken by myself. I must thank Dr. H. G. Oehler (now retired) and the staff at the Forschungsarchiv für antike Plastik in Cologne for their invaluable advice on photographing marble reliefs and for their assistance in providing additional photographic materials. Special thanks are owed to Ms. G. Fittschen-Badura for her generosity in providing me with a set of her excellent photographs of the Ara Pacis and her consent to publish many of them in this book. Yet, despite the enormous amount of photographic documentation accompanying the discussions in this study, I was not able to provide illustrations of every monument or piece referred to in the text. It was my decision to limit the illustrations basically to new photographs of the Ara Pacis rather than simply reprint figures of other pieces—photographs that are readily available in other publications. For photographs of sculpted pieces not illustrated in this book, especially for republican funerary reliefs, it is highly recommended that the reader have within his or her reach copies of V. Kockel's *Porträtreliefs Stadtrömischer Grabbauten* (Mainz, 1993) as well as D. Kleiner's *Roman Group Portraiture: The Funerary Reliefs of the Late Republic and Early Empire* (New York, 1977). Specific references to figures in these two works will be made frequently in the endnotes accompanying the text. For illustrations of the various types of sculptors' tools discussed in the text, refer to the excellent drawings and photographs in P. Rockwell, *The Art of Stoneworking* (Cambridge, 1993), in E. La Rocca, *Ara Pacis Augustae: in occasione del restauro del fronte orientale* (Rome, 1983), and in M. L. Bruto and C. Vannicola, "Strumenti e tecniche di lavorazione dei marmi antichi," *ArchCl* 42 (1990): 287–324.

My research year in Rome was generously supported by the Samuel H. Kress Foundation and the American Academy in Rome. I am indebted to the staff of the Academy in New York and in Rome, especially to President Adele Chatfield-Taylor, Professor Joseph Connors, and Assistant Director Pina Pasquantonio. Marina Lela secured the necessary permessi for my work and for her persistence and patience I am particularly grateful. The wonderful staff at the Academy library, in particular Antonietta Bucci, Tina Mirra, and Lucilla Marino, were exceptionally helpful. Special thanks must go to Professor Michael Putnam for his encouragement, friendship, and support. During my stay as a Fellow of the Academy, the following Fellows, Residents, and visitors offered their generous assistance: Russell T. Scott, Richard Talbert,

James Russell, Karl Galinsky, Niels Hannestad, Rebecca Ammerman, Bettina Bergmann, and Ann Kuttner. I am also grateful for stimulating conversations and advice from Amanda Claridge and Professor Carl Nylander. I am especially indebted to Peter Rockwell, Sheree Jaros, and Gianni Ponti for patiently listening to my unorthodox ideas and encouraging my mad search for tool marks on sculpture in various European museums. Mario Echevarria held the high ladder necessary for my close examination of the Ara reliefs, and for his steady hands and sympathetic ear, I am especially grateful.

Several individuals and institutions assisted and permitted me access to pieces and permission to publish photographs of sculptures in this work: Professor E. La Rocca (Comune di Roma), Dottoressa A. Mura Sommella (Musei Capitolini), Dottoressa M. Sapelli Ragni (Ministero per i Beni Culturali), Dottoressa M. L. Cafiero (Musei Capitolini), Professor C. Pietrangeli (Musei Vaticani), Conservateur en chef C. Metzger (Musée du Louvre), Dr. V. Brinkmann (Staatliche Antikensammlungen und Glyptotek, München), Dr. G. Hellenkemper Salies (Landschaftsverband Rheinland), Dr. K. Bemmann (Deutsches Archäologisches Institut Rom), Dr. R. Förtsch (Forschungsarchiv für antike Plastik, Archäologisches Institut, Universität zu Köln), the Archivo Fotografico of the Musei Capitolini, and the Fototeca Unione. Their generosity and kind assistance were especially appreciated.

There are numerous people to thank at the University of Michigan. I am especially indebted to my graduate advisor, Elaine K. Gazda, for her generous advice, salient criticisms, warm support, and friendship. Her ground-breaking work on the relationship between figural styles and sculptural techniques on republican funerary reliefs was the inspiration for this project. In addition, I owe great thanks to Professors Margaret C. Root, David Ross, Ilene Forsyth, and Sharon Herbert and Dr. John Humphrey as well as the staff of the Kelsey Museum of Archaeology, the Departments of Classical Studies, History, and the History of Art, and the Interdepartmental Program in Classical Art and Archaeology. I am especially grateful to Professor John G. Pedley for his encouragement, assistance, and constructive criticisms through the period of my doctoral research and the writing of this book. Great thanks also are owed to all my colleagues and students in Ann Arbor. I would like to thank especially my colleague and friend Anne E. Haeckl for reading much of the manuscript, for her assistance with the translations, and most especially for countless chat sessions over cappuccino about Roman art, archaeology, and life in general.

I have also had the great fortune to develop warm relationships with several of the faculty and students at the University of North Carolina at Chapel Hill. This project was begun as a paper for a graduate seminar on the Ara Pacis offered at Ann Arbor by Visiting Professor Gerhard Koeppel from UNC. It was Professor Koeppel who first proposed that I explore the topic of style and technique on the Ara processions. I am extremely grateful for his insightful suggestions, invaluable experience, and especially for his constant friendship over the years. I must also thank Professor Richard Talbert and the staff of the University of North Carolina Press, in particular Lewis Bateman, Mary Laur, and my editors, Ron Maner and Brian MacDonald, for their encouragement, experience, and patience. I am very grateful to the readers of the manuscript for their insightful comments and suggestions. Any mistakes, inconsistencies, or unconvincing arguments the reader finds are my responsibility alone. During my undergraduate

years at the State University of New York at Stony Brook, I was extremely fortunate to have supportive, caring, and enthusiastic professors in the Department of History. I owe a great deal of thanks to both Professor P. Ålin and to Professor J. Rosenthal. My continuing interest in medieval Europe and Anglo-Norman England stands as testimony to Professor Rosenthal's influence upon my scholarship.

Finally, I must express my immeasurable gratitude to my family: to my father, Professor Richard Atnally, who has wholeheartedly supported his daughter in her roles as both scholar and mother; to my mother, Mary Atnally, who not only edited a great part of this manuscript but who has been an extraordinary role model and always a best friend; to my young son, Kevin, who patiently (most of the time) allowed me to work at home while giving me countless reasons to laugh and smile and the confidence to know I made the correct life decisions; and to my newborn daughter, Julia, who gave me numerous kicks of encouragement and whose impending birth helped to hurry along the final writing of the manuscript. Last but forever first, I thank my greatest supporter and closest friend, my husband Michael Conlin, whose efforts and encouragement were essential not only to the completion of this book but to the success of my entire academic career and life.

LIST OF FIGURES

To assist the reader in locating particular figures, the majority of the illustrations of figures in the processions and on other reliefs are identified by both their placement number (e.g., S16) and their most common identification (e.g., Augustus). Identifications that are somewhat dubious or controversial are in quotations (e.g., "Rex Sacrorum").

In addition to the photographs that show details of the Ara Pacis, which have been grouped together and are listed below, illustrations providing an overall view of the monument and noting its location appear in the Introduction.

All photographs are by the author unless otherwise noted. The following abbreviations are used: FB = photographs are courtesy of Gisela Fittschen-Badura; INR = photographs are courtesy of the photo archives at the Deutsches Archaeologisches Institut in Rome; Köln = photographs are courtesy of the Forschungsarchiv für antike Plastik, Köln.

THE ARTISTS OF THE ARA PACIS

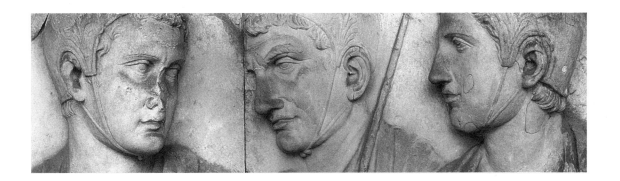

INTRODUCTION

This is a book about a group of artists whose names and biographies were never recorded, despite the fact they carved the long processional friezes on what was arguably one of the central monuments of Augustus's reign—the Ara Pacis Augustae. Although they were not mentioned in any ancient treatise or in any surviving inscription, nevertheless these now anonymous sculptors left for us tangible clues to their identity on the stone itself. The traces of tooling, the carving of details, and the various compositional formulas on the North and South friezes have the potential to reveal the technical and aesthetic traditions in which these artists were trained, the foreign methods that influenced their production, and the actual processes of design and execution.

Yet, while much past scholarship has been devoted to the iconography and to the identification of figures in the four mythological panels, the scroll frieze, and the processional decoration, few have examined the evidence left on the marble by the artists themselves. The lack of attention paid to the carving of the processions perhaps should not be surprising. Systematic technical analyses of tool marks and details of form are slow, often tedious processes requiring both months of on-site study as well as intimate knowledge of Roman stone-carving methods and tool mark identification. While techniques can be documented by macrophotography, the traces of ancient tooling can neither be observed nor studied from a considerable distance or from photographs. For the past two decades, systematic and meaningful technical analyses of Roman sculpture generally have been out of fashion, despite the immeasurable amount of information such studies provide. Perhaps the results of this detailed analysis of one of the seemingly most thoroughly examined Roman monuments will encourage others to reexamine the validity and profitability of detailed technical study.

For many who study Roman art, the processions on the Ara Pacis represent the paragon of Augustan neoclassicism in relief sculpture. This stylistic assessment has led, in turn, to the assumption that the reliefs were designed and carved by Greek master sculptors. However, the following examination of the technical and stylistic signatures left by the original Augustan relief carvers demonstrates instead that the authorship of the large processions was far more

complex than is normally assumed. In contrast to the generally accepted identification of Greek master sculptors, an analysis of the evidence reveals that most of these carvers were members of urban Roman workshops that practiced and taught their apprentices traditional methods of Italian relief production. It also illustrates that, in the late first century B.C., Italian-trained relief sculptors were facing new challenges. Marble, such as the Carrara marble slabs from which the processions were carved, was a relatively unfamiliar yet increasingly popular stone. In addition to the demands of patrons and the vicissitudes of popular taste, the adaptability and creativity of these Italian-trained sculptors encouraged them to incorporate and modify particular sculptural techniques practiced by Greek-trained carvers, who were more familiar with the carving properties and tool receptivity of marble. What we witness in the sculpting details of the Ara processions is a gradual conflation of indigenous and Hellenic sculptural traditions that was taking place in most urban relief-carving workshops during the first century B.C. The conscious Hellenization of Italian sculptural practices affected not only the production of officially commissioned, publicly displayed monuments such as the Ara Pacis. The adoption of Greek relief-sculpting practices also permanently altered the carving methods practiced by artists sculpting funerary reliefs for the growing clientele of Roman freedmen. The artists of the Ara processions were not working in isolation. They were influenced by the persistence of technical conservatism, while at the same time they contributed to the increasing experimentation and eclecticism that characterized the artistic milieu in Rome during the late first century B.C.

In the search for the artistic identities of these Augustan relief sculptors, several interrelated issues are examined. For example, what were the steps that have led the majority of scholars to believe the processions were the work of Greek masters, and what part did the identification and reconstruction of the altar as a whole play in the evolution of this theory? A historiographical survey of nineteenth- and twentieth-century literature on Augustan art and on the Ara Pacis in particular demonstrates the powerful effect of the political ideologies and national prejudices of European scholars writing during and after World War II upon modern assessments of the quality, originality, and authorship of the North and South friezes. Second, what do we in fact know about relief production in late republican and Augustan Rome and the influences from patrons' requirements upon actual design and execution? Extensive comparative study of ancient and postancient sculpting operations, workshop organization, and project management reveals the complexities involved in sculpting large-scale reliefs, the critical role of apprenticeship, the dynamics of interchange between craftsmen, and the connections between sculptural and architectural commissions.

The third issue concerns the postancient history of the large sculpted friezes on the Ara Pacis. Specifically, what physically happened to the panels and fragments of the processions after their original execution and final dedication in 9 B.C., and again after they were unearthed in the sixteenth and twentieth centuries? A comprehensive review of the post-Augustan tooling in addition to seventeenth-, eighteenth-, and twentieth-century archival records and restoration notes demonstrates that the North and South friezes were repeatedly recarved and reworked. The phases of post-Augustan restoration are peeled away layer by layer to isolate and interpret the original tooling and stylistic details. Finally, how do the carving and the

design of the two large processions on the Augustan altar fit into the more general picture of relief sculptural activity in Rome during the late first century B.C.? By comparing the original details on the processions with the anatomical forms, drapery rendering, and tool marks preserved on a number of earlier and contemporary funerary and nonfunerary reliefs with Roman content, it is clear that the artists of the Ara Pacis, having inherited much of the same traditional Italian sculpting methods, were communicating on some level with other relief sculptors in Rome.

HISTORICAL BACKGROUND

Divis orte bonis, optime Romulae
Custos gentis, abes iam nimium diu;
Maturum reditum pollicitus patrum
Sancto concilio redi.

Sprung from the Gods, first guardian of the race
of Romulus, already your absence is too long:
since you promised the sacred council
of the Senate an early return, return.

—Quintus Horatius Flaccus, *Odes* 4.5.1–4[1]

In the summer of 13 B.C., Augustus Caesar had been absent from Rome for three years. Provincial uprisings and local administrative concerns in the West had kept the first emperor of Rome occupied and away from the capital. Finally, in the consulship of Tiberius Nero and P. Quinctilius Varus (13 B.C.), Augustus returned to Rome, never to leave Italy on campaign again.[2] As the lines of the poet Horace suggest, the city and its citizens required Augustus's presence. Soon after, the emperor's chief general and the second most powerful man in Rome, Marcus Vipsanius Agrippa, returned to the capital after having completed successful military campaigns in the East.[3] The double *adventus* of Augustus and Agrippa was cause for thankful celebration. Upon hearing of the emperor's return, the Senate convened and voted Augustus several honors, one of which is specifically mentioned in the account of Dio—an altar in the Senate chamber itself. The emperor, however, refused this altar along with the other unspecified honors offered by the Senate.[4]

Yet, despite Augustus's customary reluctance to receive exceptional commendations, the emperor did accept a senatorial decree for an outdoor altar complex to be built on the Via Flaminia in the area of the Campus Martius—the Altar of Augustan Peace.[5] The altar was consecrated by a *senatus consultum* on 4 July 13 B.C. and finally dedicated three and a half years later on 30 January 9 B.C.[6] There were two festivals associated with the structure. The *constitutio*, or the official ceremony in conjunction with the senatorial decree for the altar, celebrated the return of Augustus in 13 B.C. while the *dedicatio* on Livia's birthday (30 January) in 9 B.C. commemorated the completion of the monument.[7]

The Ara Pacis consists of two major components: the altar proper, which rests on a high, U-shaped base approached by four marble steps on the west face; and a precinct wall that surrounds the altar, forming a nearly square, unroofed enclosure.[8] Both the altar base and the precinct walls, in turn, sit atop a high podium. The precinct or *saeptum* could be entered on the east and west ends through large rectangular doorways. The eastern portal originally opened onto the Via Flaminia, the major road into Rome from the north, while the western opening, which was the main entrance to the enclosure, faced the Campus Martius. Since the ground level of the Campus Martius in the Augustan period was significantly lower than the level of the Via Flaminia, nine large marble steps were required to ascend the podium.[9] Immediately west of the altar was a large sundial, constructed at the same time that the Ara Pacis was completed. It consisted of a bronze grid and the signs of the zodiac set into pavement, and had an Egyptian obelisk as its *gnomon*. In 1976, E. Buchner argued that the Horologium or Solarium Augusti described in Pliny (*NH* 36) was connected with the Ara Pacis. Buchner's hypothesis suggests that the altar/horologium complex must have required foresight and extensive planning.[10]

Both the altar and the precinct walls of the Ara Pacis Augustae are decorated with relief sculpture. The exterior side of the altar proper and its supporting base bear a series of relatively small-scale processional friezes. The inner surfaces of the projecting wings that abut the altar table on its north and south sides are likewise carved with processional scenes. Unfortunately, most of the friezes from the altar proper are extremely fragmentary. The two best preserved friezes are located on the exterior and interior of the northern projection in the modern reconstruction.

The reliefs that adorn the precinct walls are better preserved and far more extensive. The *saeptum* consists of solid blocks of Carrara marble. Both the interior and exterior faces of these blocks are carved with relief and are divided into two horizontal zones of decoration.[11] On the interior side, all four walls bear the same repeating design. In the lower horizontal field are raised vertical strips, which probably imitate wooden planks or slats. Above the vertical slats, a decorative band that shows garlands of fruits and leaves suspended from filleted bucrania or cows' skulls separates the upper zone. Between the bucrania and above the garland swags float images of sacrificial bowls or *paterae*. Simple square pilasters in low relief decorate each of the four interior corners.

The exterior of the *saeptum* is correspondingly divided into two horizontal relief zones. The lower register, which is consistent on all four walls, is carved in an elaborate, spiraling floral and candelabra design. The upper zone of the walls bears figural reliefs of two distinctly differing compositional formats. Four square panels, depicting mythological and allegorical subjects in self-contained compositions, flank either side of the east and west portals. Along the north and south faces, a series of sculpted slabs forms two continuous friezes, which depict approximately life-size figures participating in a processional ceremony. Elaborately carved pilasters in relief stand at each of the four exterior corners, mirroring the simpler pilasters on

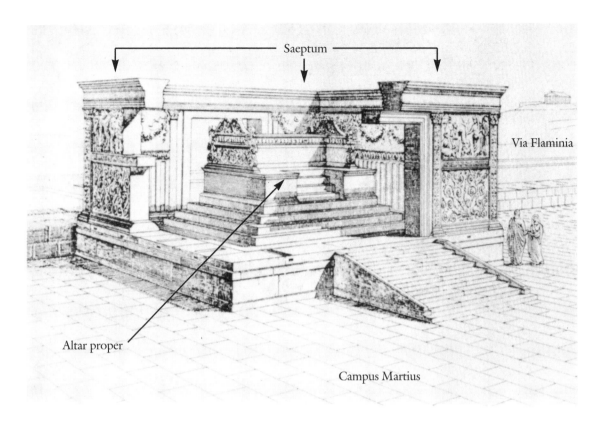

Saeptum

Via Flaminia

Altar proper

Campus Martius

Reconstruction of the Ara Pacis Augustae. After G. Moretti.

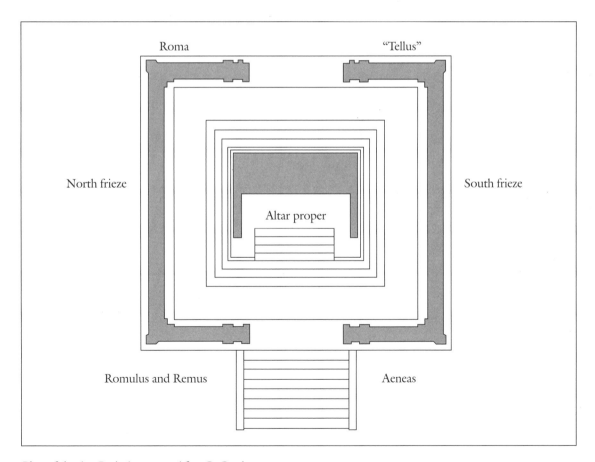

Roma

"Tellus"

North frieze

South frieze

Altar proper

Romulus and Remus

Aeneas

Plan of the Ara Pacis Augustae. After G. Gatti.

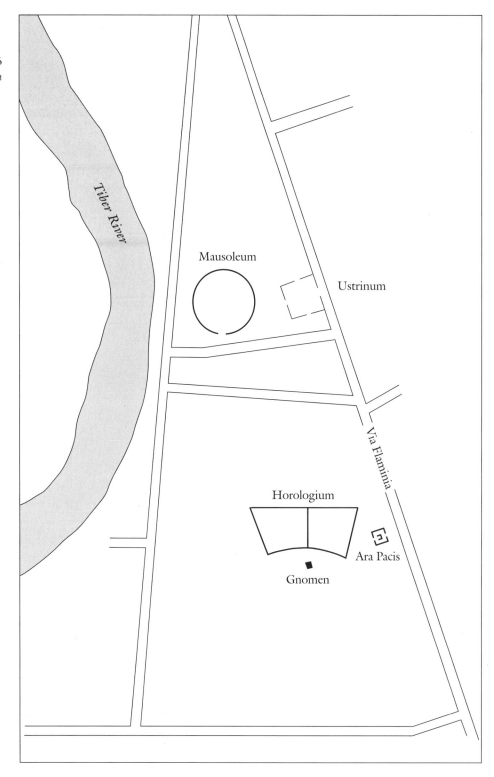

Plan of the northern Campus Martius during the Augustan period. After M. Boatwright.

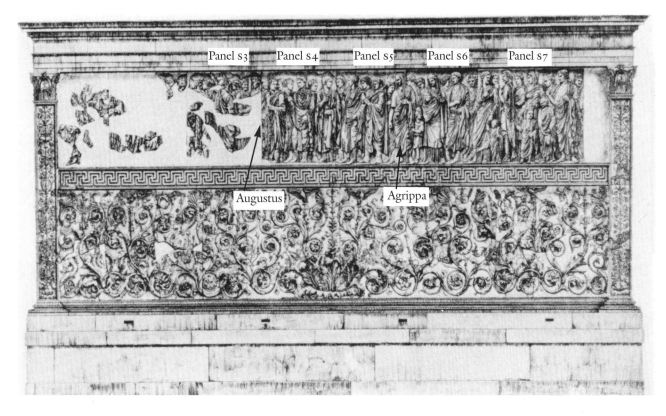

South frieze of the Ara Pacis Augustae. After G. Moretti.

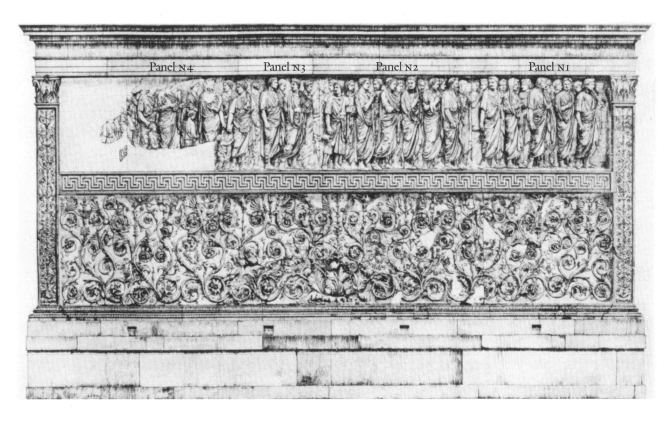

North frieze of the Ara Pacis Augustae. After G. Moretti.

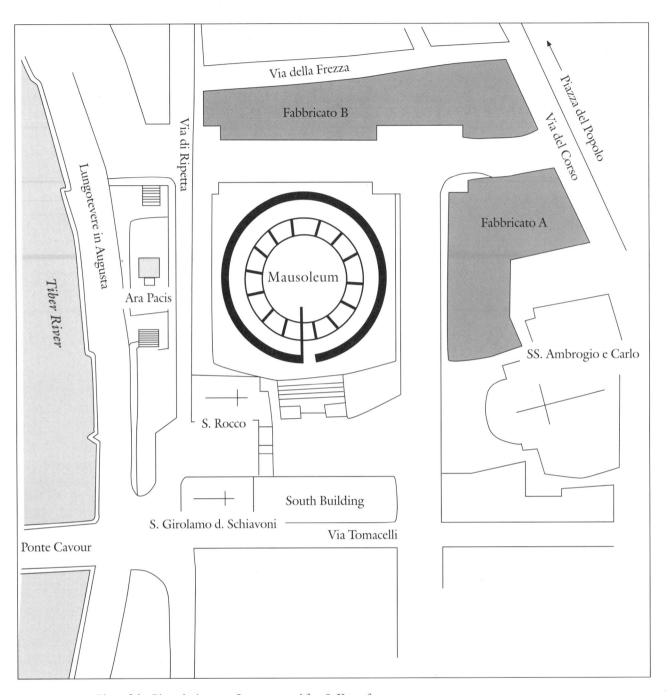

Plan of the Piazzale Augusto Imperatore. After S. Kostof.

the interior. The decorative and figural reliefs on the Ara Pacis survive in varying states of preservation. Some large sections are missing, while additional fragments, whose original location has not yet been determined, remain in storage.

SUMMARY OF SCHOLARSHIP

In 1879, F. Von Duhn first suggested that various sculptural fragments that were at that time dispersed among several European museums belonged to the Ara Pacis Augustae

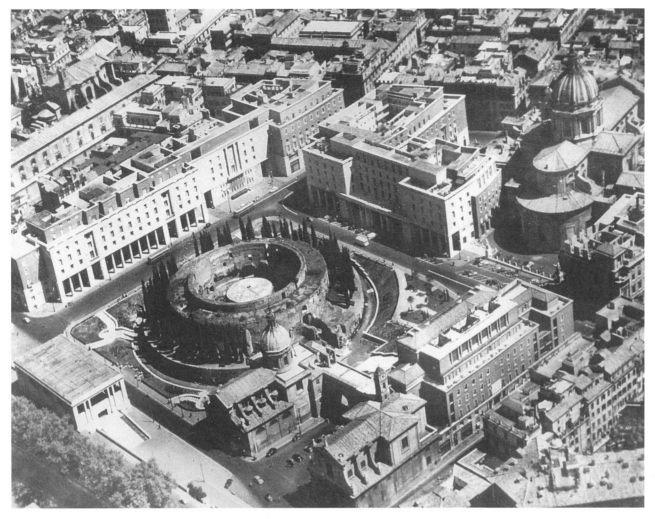

Aerial view of the Piazzale Augusto Imperatore. The Ara Pacis is located within the rectangular structure at the bottom left-hand corner. Fototeca Unione 4371.

recorded in the texts and on coins.[12] Although many sections of relief carving from the precinct walls had come to light by the mid-sixteenth century, a comprehensive understanding and hypothetical reconstruction of the structure and its decoration were not attempted until E. Petersen published his two-volume study in 1902.[13] Preliminary excavations in 1903 by Petersen and A. Pasqui, and a more extensive archaeological campaign in 1937–38 by G. Moretti and G. Gatti, revealed the ground plan, additional fragments, and the remains of the altar proper in situ. Soon after, the fragmentary sections of the Ara Pacis were collected and reerected along a different axis of orientation on the eastern bank of the Tiber River, located some distance from the original site and enclosed within a glass and steel structure.[14]

The Ara Pacis Augustae has been the subject of intensive study and lively debate for the past century.[15] Scholars have theorized about whether the architectural model for the structure was the archaic wooden *templum* prototype as described in Tacitus[16] or was instead a Hellenic altar form, such as the Pisistratid Altar of the Twelve Gods or the Altar of Pity in Athens.[17] The relief sculpture, however, has generated the majority of the published studies on the Ara Pacis. The stylistic and compositional precedents and iconographic symbolism of the exterior deco-

rative floral frieze and the interior garland reliefs have been repeatedly examined.[18] Numerous suggestions have been offered for the identification and significance of the mythological/allegorical panels, especially for the "Tellus" panel on the east.[19] For generations, scholars have proposed identifications for the figures and events represented on both the exterior processional friezes and the smaller sacrificial processions on the altar proper.[20] Working under the assumption that most of the figures on the North and South friezes represent actual historical figures, scholars have studied the presumed portrait heads and prosopography in an effort to determine the identity of each individual in the scenes.

The Ara Pacis processions lend themselves readily to such studies. The modern reconstruction and widely available photographic documentation have made the North and South friezes, as well as the four mythological panels, some of the most accessible works of Roman relief sculpture. In addition, the fact that the sculptural decoration of other major Augustan monuments known from texts and coin types has not survived (Augustus's arches in the Forum Romanum) or survives only in fragmentary condition (the Forum of Augustus, the Temple of Apollo Palatinus) has focused attention upon the Ara Pacis and its historical processions as keys to understanding the visual messages of Augustan relief art. Yet, while many have studied the processional friezes as a tactile record of Augustan ceremony, policy, and genealogy, very few have examined these reliefs as works of art in terms of style, composition, and artistic hands. Although the processional friezes are two of the most important examples of Augustan relief sculpture, there has never been a comprehensive formal analysis in conjunction with an examination of the carving techniques of the Ara processions. Moreover, the effects of post-Augustan recarving and restoration upon the original appearance of the reliefs have likewise received minimal attention.[21] It is due in part to the lack of stylistic and technical analyses that the Greek master theory has never been seriously questioned.

1 THE GREEK MASTER THEORY

In 1983, coinciding with the completion of an important cleaning and restoration of the eastern side of the *saeptum*, a study of the Ara Pacis identified the author of the Augustan altar as an anonymous neo-Attic Greek master.[1] This was not unusual. In most modern studies of the Ara Pacis, the artist responsible for the processions and the entire monument is confidently described, often without explanation, as an anonymous Greek master. How did this Greek master theory originate, and how has it been transmitted and modified over time to become codified into accepted fact? It is enlightening to place most modern assessments of the artistic value and authorship of the processions in a historiographic context, and this chapter will trace decisive steps in the sequence of theories. A chronological survey of the more relevant and influential interpretations helps to explain how this Hellenocentric bias developed in the literature on Augustan art and the Ara Pacis.

One interesting aspect to emerge from a historiographic analysis of the Greek master theory is the profound impact exerted upon the course of scholarship on the Ara Pacis by political events of the twentieth century. The vicissitudes of the Greek master theory will be shown to be intimately connected with the conscious and unconscious nationalistic sympathies of Italian, German, French, English, and American scholars in the pre– and post–World War II eras. It is not my purpose here to offer a comprehensive prolegomenon to the study of Augustan art or to comment at length upon present estimations of the validity of past approaches and conclusions. Certainly the fundamentals of many of the studies from the nineteenth century to the present day continue to be relevant and worthwhile. The aim of this chapter rather is to review the contemporary political and intellectual conditions that influenced earlier scholars' work so as to clarify the reasons why the Greek master theory was first proposed and how this assumption has been handled by successive generations of scholars.

THE ORIGINS

Throughout the history of the literature on the Ara Pacis, the figural sculpture on the Augustan altar has more often been compared stylistically with

monuments of classical Greece and, to a lesser extent, the Hellenistic artistic centers of Perga-mon and Alexandria, than to those of contemporary Rome. One of the earliest published observations concerning the similarity of the Ara processions to classical Greek sculpture was made in 1820 by E. Visconti in a Vatican museum catalog.[2] Visconti described and illustrated by line drawing a figural relief that he identified as Roman and dated to the pre-Hadrianic era. At that time, the relief was not associated with a known Roman monument. It eventually would be recognized as the first panel of the North frieze. In a footnote to the catalog entry, Visconti briefly discussed the similarity of the drapery folds on the Roman relief to the volu-metric drapery on the procession of maidens on the Parthenon frieze. Although Visconti's observation per se did not figure significantly in subsequent scholarship, he was the first to make a connection between the Ara Pacis reliefs and a classical Greek monument.

Arguments for a relationship between the Augustan altar and Greek monuments gained strength after Von Duhn's identification of the Augustan reliefs in the late nineteenth century.[3] However, the focus of interest shifted from Visconti's comparison of features on the reliefs themselves to the problem of how the marble slabs were originally positioned on the altar. Von Duhn suggested that the altar and its sculptural arrangement resembled the Great Altar of Zeus at Pergamon.[4] This idea was quickly accepted by the Viennese art historian F. Wickhoff: "An altar structure, richly decorated with sculpture like the Pergamene Altar, must surely have been created to glorify the emperor and to celebrate him as the Prince of Peace, a sculptural compliment to the Monumentum Anciranum."[5] Stylistically, Wickhoff saw the Ara reliefs as completely new, created to fulfill the unprecedented functional requirements of the officially commissioned imagery.[6] In the figural processions and the decorative vegetal reliefs, he recog-nized two characteristics peculiar to Augustan representation: a preoccupation with accurately rendering natural forms, and a fascination with the interplay between the different heights and masses of images as they recede from the foreground plane toward the relief ground. Accord-ing to Wickhoff, as well as his fellow Austrian, A. Riegl, Roman art underwent a positive, pro-gressive development from its earliest Hellenistic and Etruscan roots to a final expression in the late antique period.[7] Therefore, when Wickhoff characterized Augustan art in particular as Hellenized "imitative naturalism," he judged this retrospective mode inferior to native "illusionistic" sculptural traditions.[8] Nevertheless, despite Wickhoff's negative evaluation, his argument for the originality of the new Augustan rendering of surfaces and relief planes and their influence on later Flavian relief carving elevated the appreciation of the artistic value of the sculpture on the Ara Pacis.

More than a decade after Von Duhn's initial identification of the Ara reliefs, E. Petersen shifted the search for a Greek source for the Ara Pacis from Hellenistic Pergamon to fifth-century Athens. He rejected the Attalid model and instead insisted that the Ara's arrangement was based directly on the bipartite design of the Parthenon friezes. In two short articles pub-lished prior to his monumental monograph, *Ara Pacis Augustae*, Petersen argued that the North and South friezes had been placed on the Ara Pacis in imitation of the composition on the Parthenon. The intent was to show them as two parts of a single procession which was moving toward one end of the altar precinct.[9] His Parthenon theory was soon accepted by E. Courband: "If the sculptor of the Ara Pacis had an earlier Greek model in mind, it was not

the Great Altar of Pergamon, but the Parthenon."[10] Yet, despite the fact that Petersen and Courband now argued for the influence of the Phidian compositional scheme, they continued to call attention to the originality of the Augustan processions: "Augustan art is not, in fact, a simple imitation of Periclean,"[11] and "This figural composition recalls the Panathenaic frieze, which was simultaneously simple and erudite. But the procession on the Parthenon served as inspiration; it was not slavishly copied."[12] For both Petersen and Courband, the sculptors of the North and South friezes were inspired by their classical Greek forerunners but remained independent of them in both purpose and effect. Nevertheless, the associations between the composition and placement of the Ara processions and the Parthenon frieze made by these early scholars of the altar were the genesis of the Greek master hypothesis.

NATIONALISTIC AND
FASCIST INTERPRETATIONS

In the decades immediately following Petersen's hypothetical reconstruction in 1902 and the positive reevaluations of Roman art by Wickhoff and Riegl, most scholars commented on and continually stressed the originality of the Ara friezes. During this period, scholarship focused on the question of identifying national artistic qualities in order to discover what was indeed Roman about Roman art.[13] The Ara processions gradually moved to the forefront of discussions of the Romans as an artistically creative national or ethnic identity. Not surprisingly, in the attempt to discover and define artistic *Romanitas*, the emphasis on Greek precedents waned. For example, in her discussion of the sculpture of the Augustan age, E. Strong commented that the artists who created the Ara Pacis reliefs were "neither academics nor decadents," nor were they "servile imitators" but instead were "pioneers treading new paths which will take their successors nearly a hundred years fully to explore."[14] Strong likewise noted a novel spatial relationship between the figures and the relief ground, as well as a unique "psychological inter-relation" between the figural groups in the processional friezes.

Following upon both Wickhoff and Strong, J. Sieveking argued more emphatically that the Augustan sculptors had created a new representational format, heavily influenced by the characteristically Italic inclination to represent layers of spatial recession.[15] For Sieveking and many of his contemporaries, Augustan art and the Ara Pacis represented approaches to spatial depth that were wholly different from the art of the Greeks.[16] In this same study, Sieveking denounced comparisons of the Ara Pacis processions with the Panathenaic frieze on the Parthenon as misleading. He argued that the prevailing hypothesis that the Parthenon had served as the direct model for the Ara Pacis friezes was not only incorrect, but led to harmful, negative assessments of the artistic merit of Augustan sculpture.[17] Unlike Wickhoff, he understood the art of the Augustan age as the embodiment of the essential characteristics unique to Roman representation. For Sieveking, the art produced during the Augustan period was the greatest achievement of Roman sculptors.

In the mid-1930s, roughly a decade after Sieveking's trenchant study, the fragments of the Augustan altar were assembled and reerected in Rome. Initially it was unclear as to where the monument should be displayed. Early suggestions included a reconstruction of the Ara Pacis

across from the Column of Marcus Aurelius or atop the Capitoline Hill under a protective canopy overlooking the Augustan zone of the Forum Holitorium, including the Theater of Marcellus, the Porticus Octaviae, and the Temple of Apollo Sosianus.[18] These suggestions were discarded, however, when plans for excavating and restoring the Mausoleum of Augustus in the northern Campus Martius were undertaken in earnest. In 1930, the codirector of the excavations of the tomb, G. Q. Gigliogli, proposed the Mostra Augustea della Romanità, an enormous exhibition of photographs, plans, and models illustrating all facets of ancient Roman life that would coincide with the bimillennial of Augustus's birth.[19] It was clear from the exhibition's conception that the focus of the Mostra was to emphasize the political, social, and military connections between the ancient Roman Empire of Augustus and Mussolini's Italy. As S. Kostof has described, the Mostra Augustea "was not intended therefore as a scholarly exhibition but one of propaganda—a didactic display of the achievements of the Roman empire to bolster national pride in the past and inspire loyalty for the present custodians of this exalted tradition."[20] Not surprisingly, the reconstructed Ara Pacis and the Mausoleum were to play central roles in the bimillennial celebration.

After the design for the reconstructed Mausoleum of Augustus with its surrounding piazza structures was published in 1936, Mussolini himself personally directed the architect in charge of the project, V. Morpurgo, to include the Ara Pacis within the new piazza plan.[21] Originally, Morpurgo proposed to display the reliefs of the Ara Pacis in the central room of an underground gallery within the new loggia building on the southern border of the Piazzale Augusto Imperatore. However, in 1937, Mussolini thought this arrangement inadequate and insufficiently grandiose and ordered the Augustan altar to be reerected within an independent enclosure on the recently cleared space between the Tiber River and the Via di Ripetta. Finally, in 1938, the fragments of the Ara Pacis were hastily reconstructed within a pier and glass structure designed by Morpurgo in time for the Mostra Augustea.[22] Along the eastern side of the concrete podium of the Ara enclosure, Mussolini had inscribed the Latin text of Augustus's *Res Gestae*.[23] Augustus's list of achievements were mirrored by a prominent description of Mussolini's accomplishments, also in Latin, inscribed onto the facade of the new Fascist style building located just across the piazza known as Fabbricato B.[24]

Along with the *Res Gestae* and the recently refurbished Mausoleum of Augustus, the restored Ara Pacis was intended to connect Mussolini's dictatorial regime with the political glory and military power of Rome's imperial past. During an official visit to the newly restored imperial altar, the Duce strode confidently beneath the procession of togate Romans on the South frieze as the new Augustus of his new Italian empire (fig. 1). While the reerection of the Ara Pacis served the purposes of the propaganda program of the Italian Fascists, the reconstruction also had important consequences for the academic community. The modern display provided a physical structure for scholars to study instead of Petersen's questionable reconstruction of the Ara Pacis on paper. The restoration of the scattered pieces of the Augustan altar quickly prompted further study and, at least initially, elicited new positive assessments of its artistic value and originality.

During the years of Fascist control in Germany and Italy, several important studies of Augustan art and of the Ara Pacis in particular were published by German and Italian scholars.

Their exaggerated enthusiasm, even adoration, for Augustan art and the subsequent reactions by English- and French-speaking academics were to have profound effects upon the evolution of the Greek master theory. In 1937, in the wake of the nationalism of earlier twentieth-century scholarship, two studies continued to downplay the influence of classical Greek art upon the artists and patrons of Augustan Rome. First, in an article included within a volume celebrating the bimillennial anniversary of Augustus's birth, P. Marconi argued that the label "classicism," which often was used to describe Augustan art, was in fact "un errore storico e critico."[25] According to Marconi, although much of Augustan imagery drew upon classical forms, classical Greek art nevertheless constituted only one ingredient within an eclectic mix of artistic influences. Equally important to the creation of Augustan art were the Hellenistic currents that emanated from Magna Graecia and Etruria. Like Sieveking, Marconi also emphasized the vital role played by Etruscan and republican wall painting in the development of Augustan painted and sculpted forms. In his view, the artists of the relief sculpture on the Ara Pacis embraced many of these disparate influences and then recombined and reshaped them to satisfy the needs of the patrons. As a result, these sculptors produced a completely new artistic format and stylistic vocabulary for the celebration and justification of the new political establishment and of its values and its visions of Rome—past, present, and future. In Marconi's estimation, the Ara Pacis was not a paragon of neoclassicism but rather a creative outburst in the maturation of Augustan eclecticism.

More influential than Marconi's brief study, however, was G. Rodenwaldt's *Kunst um Augustus*, originally published that same year in a volume of *Die Antike*.[26] Rodenwaldt, who was the president of the German Archaeological Institute in Rome at the time, argued two central points concerning Augustan art and the compositional style and iconography of the Ara Pacis. The first of these resulted from his repeated comparisons of the relief decoration of the Augustan altar with the sculpture of the Parthenon. Although he recognized similarities between the two monuments in their general thematic content and circumstances of patronage, Rodenwaldt asserted that the creators of the Ara Pacis had not deliberately selected the Parthenon as their model.[27] For Rodenwaldt, the sculptures on the Parthenon and the Ara Pacis were different in both design and purpose. More important, the Ara Pacis was not artistically inferior to the Athenian monument, but rather stood as its equal with respect to sculptural arrangement, originality, and aesthetic value. The visual power of the processions on the Ara Pacis lay in the fact that the friezes represented a solemn event in a historically accurate manner with Augustus shown not as a master among slaves but as the "Führer von Freien."[28] Rodenwaldt contrasted what he saw as a realistic and dignified expression of an ideal sociopolitical principle in the Ara processions with the ahistorical Panathenaic procession and its unrealized utopian dream of the Athenian democratic city-state. This idealization of Augustus was characteristic of much discussion in contemporary German academic circles. Concurrently in the field of Roman history, many extolled the virtues of the *princeps*, heralding Augustus as the perfect ruler of the ideal state. In the works of W. Weber and W. Schurr, Augustus again was referred to as the "Führer" who saved his country from the destructive forces of internal strife and external attack in language comparable to the current political slogans of the Nazi Party.[29]

In addition to his more emphatic argument for the originality and artistic worth of Augustan art, Rodenwaldt further discussed the connections between the sociopolitical ideals of Augustus and Fascist ideological principles. In *Kunst um Augustus*, Rodenwaldt's stated purpose was to examine not only the stylistic and thematic characteristics of Augustan imagery but also to discover what value it held for contemporary political and nonpolitical institutions and artistic expression. Thus, he asked, "What can the art of the age of Augustus still mean to the present day and, specifically, to the present day of Germany?"[30] In fact, he began his study of Augustan art with a reference to contemporary sociological and anthropological arguments for a kinship between Germans and Italians, both of whom were understood as culturally and spiritually distant from the inhabitants of the eastern Greek Mediterranean. Particularly crucial to the work of Rodenwaldt and many of his fellow German scholars was the presumed link between the Third Reich and ancient Rome, not only in terms of political institutions and architectural landscapes but also with regard to ethnic heritage. For example, on the comparison of facial features in ancient Roman and modern German portraiture, Rodenwaldt declared that "these appearances remind us that the Romans were our kindred and are related to us by a long historical tradition."[31] The postwar reaction to these undertones of Nazi sympathy and propaganda in *Kunst um Augustus* would result in a rejection of earlier positive assessments of the artistic creativity and originality of the reliefs on the altar.[32] It also would lead to a reworking of the "Greek master" hypothesis for the identities of the anonymous artists of the Ara Pacis.

The second conclusion in *Kunst um Augustus* concerning the Ara reliefs focused on the identity of the creator of the Augustan altar and, as such, was the first attempt to address the question of authorship. Rodenwaldt was the first to suggest that the artist of the Ara Pacis was a Greek master who had found new inspiration and employment on Italian soil. However, for Rodenwaldt, this foreign artist had been overwhelmed by Roman aesthetic sensibilities and controlled by the requirements of the commission to such a great degree that, in fact, he had little if any input upon the design, the style, and the messages of the sculpted marble reliefs.[33] It was the patron, Augustus, who ultimately designed the altar and who stood as the creative force behind most Augustan imagery and architectural forms. In this rigid, "top down" model of artistic patronage, the artist merely fulfilled the contractual requirements and submitted to the stylistic preferences and propaganda motives of the patron-creator. Thus, the ethnic heritage or nationality of the artist was inconsequential to the final appearance of the sculpture.

In 1938, perhaps in response to the discussion of authorship by Rodenwaldt, two Italian scholars published studies that specifically addressed the figural style, composition, and artists of the sculpted reliefs.[34] Like Marconi, they recognized the eclectic character of Augustan imagery. In the decoration of the Ara Pacis, both D. Mustelli and M. Pallottino argued for a fusion of both Attic and Asiatic figural and compositional styles with the indigenous artistic traditions of Italy. Based on examinations of drapery treatment and overall composition, both scholars concluded that a least four separate sculptors had created the North and South friezes.[35] By seeing the Ara processions as the products of differently trained artists working alongside one another on a major commission, their examinations might have generated fur-

ther interest in the study of the sculptural workshops and the survival and transmission of different artistic traditions in the early Augustan period. Unfortunately, due to the contemporary political climate and the relative inaccessibility of the actual marble panels during the war, neither Mustelli's nor Pallottino's work received much international attention. The majority of scholars were content to continue identifying the events and persons depicted in the processions and the four mythological and allegorical panels of the Ara Pacis.

THE PHILHELLENIC REACTION

After the conclusion of the Second World War and the defeat of Hitler and Mussolini, the evaluation of Augustan art entered a new phase. European and American academics consciously abandoned the positive view of Augustan art and embarked on a path of unfavorable criticism that had an important impact on the study of the artists of the Ara processions. Certainly this change was in large part a reaction against the overt connection in many prominent German and Italian studies between the Augustan age and the recent Fascist regimes with their terrifying, once seemingly unstoppable armies. Never in the history of the scholarship on Augustan art had contemporary political and ideological conditions so profoundly affected the attitudes of the academic community as they did during these postwar decades. Archaeologists and art historians were not alone. After the end of the war and the subsequent reestablishment of the distribution channels for books to and from Britain and the European continent, R. Syme's *The Roman Revolution* emerged triumphantly from relative obscurity and found an audience only too eager to reevaluate all earlier estimations of Augustus's personality, his motives, and the sociopolitical climate of Rome in the late first century B.C.[36]

In order to appreciate the postwar rejection of the positive interpretations of Augustus's regime and Augustan art, it is important to recall the deliberate associations between Augustan Rome and Fascist Italy that had been continually encouraged and emphasized by Mussolini and his supporters. After the Fascist Italian Empire had been officially proclaimed in 1936, both politicians as well as Italian scholars enthusiastically drew numerous parallels between Augustus and the Duce. "The argument that the Duce of Fascism was the new Augustus had thus been clinched."[37] Favorable comparisons between the political stability, economic security, agricultural prosperity, and military power of the age of Augustus and Mussolini's vision for his new Roman Empire were frequently published by both academics and political ministers.[38] Meanwhile, at the entrance to the Mostra Augustea della Romanità were displayed Mussolini's own words: "Fellow Italians, the glory of the past will be superseded only by the glory of what is to come."[39] In May 1938, the Duce took great pride in presenting the Augustan exhibition as well as many of the recently excavated sites of ancient Rome to his ally Hitler during the latter's official visit to the capital city.[40] Numerous European newspaper articles and photographs captured images of the two Fascist leaders admiring the remains of imperial Rome. One specific stop on Hitler's tour was the Museo Nazionale Romano, where the director of the museum, G. Moretti, and the Italian archaeologist Bianchi Bandinelli described the imagery of the Ara Pacis processions, which had yet to be reerected in the Piazzale Augusto Imperatore.[41] In scholarly publications and Fascist propaganda pamphlets as well as in the

public media, Mussolini, as the third founder of the Roman Empire, was directly linked with Augustus, Augustan monuments, and Augustan imagery.

During the postwar revolution in historical and archaeological thought, one of the first and most influential scholars to challenge Rodenwaldt's *Kunst um Augustus* and the positive evaluation of Augustus was the French art historian J. Charbonneaux. Published in 1948, Charbonneaux's *L'art au siècle d'Auguste* presented a generally critical assessment of the character of the princeps and the political imagery of the Augustan age.[42] In the introductory chapter, he made clear on which side he stood in the Tacitean debate about the sincerity of Augustus and the constitutionality of the Principate. For Charbonneaux, Augustus was an ingenious strategist who used proclamations for a restored republic as a political ruse to disguise his own monarchical ambitions. He described the settlement of Octavian in 27 and the later reception of perpetual *tribunicia potestas* by Augustus in 23 as theatrical gestures designed to gratify the populus and stultify the Senate. "This attempt to reconcile democratic institutions with rule by one man, an attempt inevitably doomed to failure, reveals the artifice inherent in the Augustan restoration. The age of Augustus carries the mark of this stratagem."[43]

The Augustus of *L'art au siècle d'Auguste* was essentially a tyrant, and like many tyrants, he recognized the enormous propagandistic potential of images for communicating political and social ideologies and celebrating personal power.[44] Drawn to the art of classical Greece and postclassical neo-Atticism because of his personal preference for "elegance and clarity," Augustus imposed his own artistic tastes and agenda upon an impotent and compliant artistic community.[45] Ironically, Charbonneaux was in agreement with Rodenwaldt's view of Augustus as the creative force behind Augustan imagery. Yet, in sharp contrast to Rodenwaldt as well as to Sieveking, he saw Augustan art as an artificial, academic imitation of classical Greek models. In his view, imperial allegories (Pax, Concordia, Justitia) and Roman mythological figures (Aeneas, Romulus) were merely pale, lifeless versions of Greek draped types. Historical reliefs fared a bit better in Charbonneaux's assessment since they were animated by realism. However, as political records, Charbonneaux felt that they were neither disposed nor intended to elicit aesthetic appreciation. In *L'art*, the most important aspect of Augustan art was the codification of imperial iconographic formulas bequeathed to postancient artistic programs from the Byzantine courts to Napoleonic France. "In sum, the artistic product of the Augustan age matters less for its own merits than for the ideas it put into circulation."[46]

From this ensemble of uninspired, imitative imagery, Charbonneaux singled out the Ara Pacis as the most original monument of the period.[47] Based on an examination of all the figural reliefs on the altar, he identified two noteworthy Augustan innovations. The first was the appropriation of Greek allegorical figures and deities for service in the imperial propaganda program alongside native Italian mythological references and landscape vignettes. Charbonneaux recognized this phenomenon both on the sculpted cuirass of the Augustus Prima Porta as well as in the four individual panels on the east and west facades of the *saeptum* of the Ara. The second and more important invention was the representation in the processions of an actual historical event with persons, some identifiable, arranged in interconnected, intimate compositional units. According to Charbonneaux, the Ara processions presented Roman society as a hierarchical but harmonious collection of religious and social groups.[48] He compared

this Augustan compositional scheme and, by inference Roman societal structure, unfavorably with the artistic celebration of the individualized, albeit idealized, male citizen in the sculpture of democratic Periklean Athens.

Yet, despite these acknowledged novelties, Charbonneaux saw the sculpture on the Ara Pacis as heavily dependent upon the precedents of classical Greek art. In his discussion of the processional friezes, he resurrected Petersen's suggestion that the arrangement of the Ara reliefs had been based on the Panathenaic frieze on the Parthenon. However, Charbonneaux pressed the analogy even further. The Parthenon frieze was not only the basis for the physical placement of the processions on the Ara Pacis but was, more importantly, the model for their style and ideological content: "The double procession depicted on the North and South walls evokes an illustrious precedent—the Panathenaic frieze—and there is no doubt that the author of the Roman composition had it in mind when he designed this figural procession. Here, as on the Parthenon, the entire populace offers homage to the god. But if the idea and intention are identical, the Rome of Augustus is compared with the Athens of Perikles without direct imitation: it wished to contemplate the faithful reflection of its own vision in a marble mirror."[49]

More critical to the discussion of workshop traditions and the place of the Ara processions in the history of Roman art were Charbonneaux's aesthetic judgments and their relation to the identity, and indeed the ethnicity, of the anonymous artist: "Who was the creator of the sculptural decoration of the Ara Pacis? We do not know. But everything points to a Greek: the intelligence with which the idea of ruler is treated, the quality of the design, the variety of poses and drapery forms, and, finally, the tenor of the relief are all firmly anchored in the Hellenic tradition. We can even specify that he was a neo-Attic artist who was grounded in the classical tradition of the fifth century."[50]

Thus, for Charbonneaux, only an artist with "Greek training" would have had the necessary technical competence to sculpt reliefs that were of such high quality and as "inarguably successful" as the Ara slabs.[51] In our attempt to understand the contemporary circumstances surrounding Charbonneaux's judgments, it is important to recall that in the same year that he made these confident declarations about the ethnicity of the Augustan artists, he also published his monumental study of Greek classical art.[52] It would not be unreasonable to suppose that Charbonneaux's estimation of the quality of Roman art was based on its resemblance or adherence to the standards of Greek classical sculpture. His use of this subjective, Hellenocentric aesthetic evaluation as an essential criterion for identifying artistic nationality or ethnicity in Roman art, however, had unfortunate repercussions. Charbonneaux's negative bias against the quality of Roman art and its artists recalls J. Winckelmann's controversial but influential theory of postclassical artistic decline and decay in *Geschichte der Kunst des Alterthums*.[53] Moreover, Charbonneaux's conviction that high artistic quality in Augustan art was synonymous with Greek workmanship was subsequently shared by other students of the Ara sculpture.

One of the more vocal proponents for the primacy of Greek workmanship in Roman art was the English art historian, J. Toynbee. As early as 1934, three years prior to *Kunst um Augustus*, Toynbee challenged the nationalistic interpretations of Wickhoff and Sieveking. Heavily influenced by P. Gardner's *New Chapters in Greek Art* of 1926, Toynbee published her own work, *The Hadrianic School*, with its self-explanatory subtitle, "A Chapter in the History of

Greek Art." In the introduction, she argued that the art of the classical world followed a continuous evolutionary path of development. In her scheme, Roman art was neither separate from nor inferior to Greek art but was instead the culmination of Greek artistic expression. Toynbee emphasized that the majority of artists identified in Roman texts and in inscriptions bore Greek names and, occasionally, ethnics.[54] Mindful that some might condemn this evolutionary theory as an anti-Roman revival of Winckelmann's viewpoint, she was careful not to devalue openly the aesthetics of Roman imperial art: "There can be no question of judging Imperial art by 'classical' Greek or Hellenistic standards. It is, like all great arts, expressive of the spirit of its own age, and in that spirit alone can it be understood."[55]

One of Toynbee's primary objectives was to refute the notion of distinct indigenous traits in Roman art as described in the late nineteenth century by Wickhoff. She argued that each of Wickhoff's Italic archetypes—realistic portraiture, "illusionism" of spatial depth, and "continuous" narration—had their true precedents in Greek, especially Hellenistic, art. By eliminating Wickhoff's formal analyses as a means of isolating nationalistic characteristics, Toynbee persuaded herself and many others to regard the literary and epigraphical record as the only concrete evidence for the identity of Roman craftsmen. *The Hadrianic School* concluded that every aesthetic and technical element of imperial art, especially high-quality imperial art, was fundamentally Greek. Of course, Toynbee and others sympathetic to this evolutionary model were occasionally willing to admit that certain less "Greek looking" pieces likely were the products of non-Greek, usually Italian, residents in Rome.[56] These works, however, were inevitably inferior in quality and characterized by crude and inept rendering. According to Toynbee, if the content of imperial art was Roman, then its more successful artistic expression was Greek: "We have seen that there is nothing in style and technique of 'Roman' art (so-called) itself which we can really describe as being distinctly Roman, as yielding, that is to say, *internal* evidence whereby we can detect the Roman hand."[57]

It was with this theoretical baggage that Toynbee embarked on her examination of the sculpture on the Ara Pacis. In "The Ara Pacis Reconsidered," published in 1953, Toynbee identified the Ara processions as the "most original and most Roman parts of the altar."[58] Like Charbonneaux, she also argued for a relationship between the so-called high quality of the reliefs and the identity and ethnicity of the ancient sculptor: "the plan and designing of all the sculpted decoration of the altar as a whole must have been the work of one mind, of a single master—a Greek master endowed with a deep understanding of Rome and Italy. Greeks the artists of the altar must surely have been. There was no tradition of marble carving in Italy before the systematic exploitation of the Carrara (Luna) quarries under Augustus; and we know of no national school of Roman sculptors in marble in early Augustan days capable of producing, unaided, work of the standard."[59]

The belief that Italian sculptors had neither the experience nor the skill required to produce the Ara processions soon was supported by L. Budde in *Ara Pacis Augustae*: "There was no Italian tradition of marble carving to produce the Ara Pacis and the distance from indigenous Republican art was too great, which makes us appreciate the great height of this achievement."[60] A decade later, E. Simon perpetuated the Greek master theory in her publication, *Ara Pacis Augustae*.[61] Simon's comprehensive and concise work soon became one of the most com-

monly cited references in the study of the Ara Pacis. Consequently, the identification of the Ara sculptors as Greeks soon was generally accepted as fact. The Greek master theory was also adopted by R. Bianchi Bandinelli in his monumental and highly influential work, *Rome: The Center of Power*:

> In this monument, then, we see that such things as the general conception of an altar inside a precinct, the thematic blending of myth and history (as on the so-called Altar of Ahenobarbus), and the indifference to any structural or logical relationship between the component parts, all clearly suggest Roman taste, linked to the Italic tradition. Yet when we come to examine the artistic form in which this conception is embodied, we are forced to conclude that the artists responsible for its adoption and execution were Greeks. Whether they were also able to make use of local sculptors we do not know; in any case, it makes no essential difference.[62]

Another acknowledgment by A. Bonanno in 1975 reflects the pervasive popularity of the Greek master theory in recent scholarship on the friezes: "The classical character of the frieze and clarity of style are certainly due to the design and execution of Greek sculptors. . . . It is in fact on a fifth century Athenian monument that this processional frieze is modeled, the Panathenaic procession of the Parthenon."[63]

Given the general acceptance of the idea that Greeks carved the Ara, specialized studies continue to debate precisely which Greek models were used for the composition and figural style of the sculpture of the Ara Pacis. In 1975, E. Borbein reiterated the Parthenon model hypothesis originally proposed by Petersen and enthusiastically supported by Charbonneaux: "We now turn in more detail to the large frieze, which, in spite of its Roman theme and although a historical person stands in the center of the scene, is connected in a very special sense with Greek art. The frieze quotes not just any Greek monument, but a specific one, the frieze of the Parthenon on the Athenian Acropolis."[64] However, in addition to influence from the Phidian composition on the Athenian temple, Borbein introduced additional Greek altar types as further evidence for a reliance upon Hellenic architecture and style. His candidates ranged from the Altar of the Twelve Gods in the Athenian Agora, which was rebuilt in the late fifth century B.C., to a late second-century B.C. rectangular altar building found on the island of Cos.[65] D. Kleiner added even more possibilities to Borbein's list, arguing that family groups depicted on late fourth-century B.C. Athenian funerary stelai served as models for the Ara processions.[66] As these two studies illustrate, the reputed Greek models for the Ara Pacis quickly multiplied and became ever more remote both temporally and geographically from the Augustan capital. The unfortunate result was that the sculpted decoration as well as the sculptors of the marble altar became increasingly isolated from their original historical and artistic context.

THE ETRUSCO-ITALIC HERITAGE

The postwar primacy of philhellenic interpretations of the design of the Ara Pacis did not, however, totally eclipse interest in its Italic heritage. A few postwar studies offered alternative ideas about the artistic influences at work in the friezes. G. Kaschnitz von Weinberg, one of the

most astute and sensitive observers of Roman sculpture, was not concerned with challenging Charbonneaux and Toynbee or with shoring up a more positive appreciation of the aesthetic merit of Roman imagery. Rather, he wanted to find the most objective means possible to advance understanding of the regional characteristics of Roman representation in three-dimensional media. His approach was a narrowly focused one, temporarily setting the textual evidence aside to concentrate purely on the monuments themselves for clues to the artistic traditions of the creators. For Kaschnitz, the fundamental aspect of any piece of art, architecture, or archaeological artifact was its inherent structure (*Struktur*) of both form and space. The essence of this structure could not be altered by the fluctuating assessments of quality and aesthetic value symptomatic of much Roman art-historical debate. For this reason, he believed that, instead of formal stylistic analyses, an examination of the underlying framework of a monument and its relationships to the exterior surface and the surrounding void was the key to penetrating the indigenous, inner qualities of Etruscan and Italic, and consequently Roman, artistic tendencies. By understanding the inherent structure of Roman art, it was possible to appreciate its heritage as well as its contributions to the history of later European artistic and architectural expression.[67]

At several points in his career, Kaschnitz published interpretations of the Ara reliefs in which he recognized specific Augustan innovations. Especially noteworthy was the representation of figures in space (*Raumdarstellung*). While others such as Strong and Sieveking had remarked before upon the unique spatial relationships depicted in the friezes, no one had described its more complex qualities with the insightful sophistication found in Kaschnitz's descriptions. According to him, the tectonic character of classical Greek sculpture that maintained as distinct entities the figures and the relief ground, and which was epitomized by the Panathenaic procession, was absent in the Augustan friezes. The spatial relationships on the Ara processions betrayed a very different sensibility. They were rendered by a modulation of projecting and receding surfaces that merged with the background plane in such a way as to include the relief ground as an intrinsic spatial layer in the overall composition: "In contrast to this attitude [in Greek reliefs], the reliefs on the Ara Pacis show a whole new approach. When we examine any particular section of the processional frieze, then we notice immediately that the tectonic character of the structure, which was always painstakingly maintained in Greek art, completely disappears. All of a sudden the relief ground merges into the representation. The figures both emerge from the background and sink back into it again in a way that could never happen in Greek reliefs."[68]

Throughout his studies of Etruscan and Roman sculpture, Kaschnitz regarded this depiction of spatial layers as distinctly Roman, or more accurately, central Italian. He argued that these indigenous artistic traditions, characteristic of Italic representation since prehistoric times, were the most important creative forces for the sculptors of the Ara friezes. In Augustan art, the Italic tension between static and dynamic structural form (with static or stereometric construction the more dominant approach at this time) lay beneath an often disconnected surface layer. On yet another level, certain neo-Attic preferences for tectonic organization and figural style were introduced to this native dualistic heritage. The result was a new, distinctly Augustan approach to carving figures in space as embodied in the processional friezes of the

altar. Unlike Rodenwaldt, Kaschnitz believed that both the patrons' demands and the artists' will contributed to the creation of the Ara Pacis. However, while native artistic preferences (Kaschnitz's modified version of Riegl's *Kunstwollen*) were adapted during this period to suit the tastes of the client and the purposes of the commission, they were never permanently altered or abandoned. Stereometric structure continued to exist beneath the surface veneer of reinterpreted Greek figural styles.

In addition to the Italic ancestry of the structural qualities and rendering of space in Augustan sculpture, Kaschnitz recognized an affinity between late Etruscan tomb painting and the figural arrangement in the marble processional reliefs on the Ara Pacis.[69] Kaschnitz was not alone in noting the apparent influence of the compositional devices and thematic content in the painted scenes of Etruscan tombs on the design of the North and South friezes. In 1977, B. Felletti-Maj reiterated a suggestion first proposed by M. Pallottino more than two decades before.[70] She pointed out the similarities between the Augustan processions and the painted procession of magistrates and other togate figures in Etruscan painting, especially the Tomba del Tifone frieze in Tarquinia dated circa 200–150 B.C.[71] Like Pallottino and Mustelli, she recognized that the eclecticism of Augustan imagery resulted from the combined influences of Pergamene, mainland Greek, and South Italian artistic traditions in addition to indigenous central and northern Italian sculptural approaches. According to Felletti-Maj, even if the artists were Greek by name and training, they were confronted by numerous Etrusco-Italic works of art, in particular paintings, which decorated temples and other structures in Augustan Rome. These artists drew inspiration from these native images and, as a result, their own aesthetics and compositional formulas were changed.

In 1985, additional comparisons with painting were drawn by G. Koeppel, who argued that while Greek classical models inspired the designers of the Ara friezes, the more immediate influences came from neighboring Etruria: "Classical models are part of the answer, to be sure, but more recent and geographically as well as thematically closer models can be adduced to which I believe these artists first turned: Etruscan painted funerary processions."[72] Koeppel compared the Ara friezes to the fascinating painted processions from the Tomba Bruschi in Tarquinia (175–150 B.C.), a similarity first noticed by Pallottino in 1937 and later mentioned by M. Torelli and R. Bianchi Bandinelli in 1976.[73] Like Felletti-Maj, Koeppel also pointed out the connections with the Tomba del Tifone: "The Tifone painting may be seen as evidence in support of the theory that the artistic tradition of the funerary procession in late Republican times was first and foremost a pictorial one, from which sculptors took ideas with greater or lesser degrees of success. And it is in this tradition of the painted funerary procession that we do suddenly find antecedents of equal quality to the sculpted processions of the Ara Pacis."[74]

In addition to Etruscan wall painting, Koeppel discussed the compositional affinities between the Ara processions and a fragment of a travertine relief dated circa 100 B.C. which was found in the area of the Forum Boarium and shows togate figures, including lictors and a youth, in procession.[75] This intriguing republican relief, probably from a funerary context, was not the only sculpted stone precursor to the North and South friezes.[76] In fact, recently P. Holliday has suggested comparisons between earlier Etrusco-Italian stone relief carving and the processional composition of Ara reliefs. In 1990, he argued convincingly that the iconography

and compositional formats of scenes depicting processions of magistrates in Etruscan funerary art, especially on sculpted stone sarcophagi, were part of an internal, Italian development that was not dependent on Greek sources.[77] According to these studies, it is possible to trace a continuing use of locally developed, compositional formats for multifigured procession scenes from late Etruscan sculpted and painted representations to the Augustan reliefs on the Ara Pacis.

SUMMARY

These more recent examinations of the processions illustrate that an interest in the impact of indigenous artistic tendencies and aesthetic sensibilities upon Augustan artists has resurfaced with renewed zeal. However, this shift in focus from the philhellenic arguments for Greek models to the search for Etrusco-Italic influences has not found wide acceptance. The tenacious grip of the Greek master theory continues to dominate not only more specialized studies of Augustan imagery but, more importantly, many discussions in popular Roman art handbooks.[78] Perhaps recent trends focused on appreciating the traditional conservatism and transitional nature of the institutions, actions, and literature of the Augustan Principate will prompt Roman art historians and archaeologists to reevaluate the eclectic imagery of this most crucial and experimental period of Roman art.[79] Certainly the works of Kaschnitz, Felletti-Maj, and Koeppel have fostered my own interest in identifying indigenous traits in Augustan art and recognizing aspects of artistic continuity from the Republic to the early imperial periods. It was in this historiographic context of recent intellectual queries concerning the native Etrusco-Italic heritage of the reliefs of Ara Pacis that I originally embarked on my own examination of the artists of the altar. Admittedly, my own bias is rooted deeper in the ideas of indigenous Italic approaches to structure, spatial relationships, and emphasis on boundaries and surfaces as expressed by Kaschnitz rather than the Hellenocentric view of artists in Rome represented by Toynbee.

From the start of my investigation into the artistic identities of the Ara carvers, I recognized numerous problems with the Greek master theory. Two central issues stood out. First, the proponents of the Hellenocentric theory had never taken fully into account the series of restorations of the Ara friezes that occurred from the late antique period to the twentieth century. In many instances, these later reworkings have literally changed the face of the processions. Post-Augustan restorations had misled many into believing the smooth, crisp surface treatment of many areas of the marble panels was due to Augustan neo-Attic rendering rather than to eighteenth-century acid washes and neoclassical recarving. The original Augustan surfaces of many figures, including the figure of Augustus, were left relatively untouched by later restorers, and yet, this evidence had been ignored. Clearly the history of the altar and the effects of postancient restorers upon the present appearance of the reliefs must be considered in any attempt to identify the artistic traditions of the sculptors who originally designed and carved the marble processions.

The second problem centers around our knowledge of ancient sculptural apprenticeship and Roman workshop organization. Without a doubt, Toynbee was correct when she

acknowledged the importance of epigraphical and literary evidence for Greek artists in Rome. Yet, this evidence is limited. The names of only a few artists working in Italy during the first century B.C. were recorded by ancient writers, and only a fraction of the sculpture produced in Rome was signed. The majority of artists took no personal credit for their work and remained anonymous craftsmen. Is it correct to assume that they too had Greek names? And, if so, why did they not sign their pieces, including the Ara processions? More important, in my opinion, is the question of whether or not a Greek signature on a statue, for instance, betrays the artistic training and traditions of that particular artist? I question whether the two can be so confidently equated with one another. It remains unclear whether an artist was able to maintain his own distinct cultural and artistic traditions after he emigrated, willingly or not, to the capital city. Furthermore, how closely did an artist with a Greek name, who was a second- or third-generation inhabitant of Rome, follow Hellenic artistic traditions of the past? Was he in no way influenced by the techniques and stylistic sensibilities of native Italian stone carvers? With characteristic insight, O. Brendel remarked that "there is a limit beyond which it does not seem practical to call the work of artists with Greek names Greek art. The paintings of El Greco are beyond this limit; so is the Ara Pacis."[80] The limitations of literary references and signatures are clear. In order to assess what I believe is a complex intermingling of Hellenic and Etrusco-Italic influences upon the artists of the Ara processions, we must turn to the monument itself. By understanding the original and the restored carving as well as the practical circumstances of sculptural production in Rome during the first century B.C., we can finally place the reliefs as well as the sculptors of the Ara Pacis in their proper historical context and ultimately assess the validity of the Greek master theory.

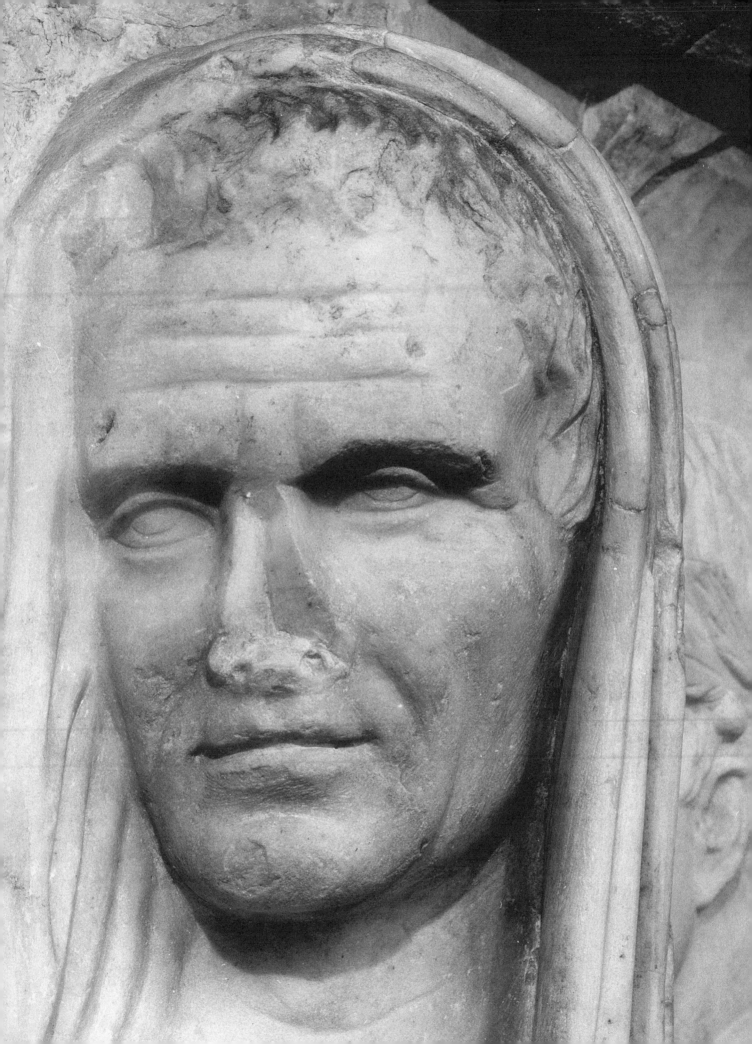

2 ARTISTS, PATRONS, AND ROMAN RELIEF PRODUCTION

If you become a stone cutter you will be nothing more than a workman, doing hard physical labor. . . . You will be obscure, earning a small wage, a man of low esteem, classed as worthless by public opinion, neither courted by friends, feared by enemies, but just a common workman, a craftsmen, a face in the crowd.

—Lucian of Samosata[1]

The Greek master theory, as discussed in the previous chapter, centers around the issue of one master sculptor. Yet, the practicalities of producing large stone monuments in the ancient world, as well as the evidence available from comparable ancient and postancient sculptural projects, strongly suggest that the large processional friezes on the Ara Pacis were not carved by one man. While a single individual may have been responsible for designing the compositions and perhaps overseeing the work, most of the actual tooling of the Carrara marble slabs likely was carried out by one or more sculptural workshops. It follows that an examination of ancient workshops and their production methods is critical for understanding the execution of the friezes on the Augustan altar. In order to better comprehend the various artistic traditions inherited by the carvers of the North and South friezes, we must review also the processes by which techniques and aesthetic preferences were transmitted from one generation of craftsmen to the next. This chapter focuses on several issues central to the study of premodern workshops hired for large-scale commissions: the size and personnel of ancient workshops, apprenticeship training, the mobility of craftsmen, and the role of the patron in determining the execution of the project. Included within this discussion of the evidence from the Roman era are specific references to the findings of several inquiries into workshop operations and large-scale commissions for cultures, regions, and periods other than late first-century B.C. Rome. Finally, I construct a model for the composition and production methods of a hypothetical sculptural workshop operating in Rome during the late Republic and early Augustan periods.

As is the case with many of the craftsmen who produced the monuments of ancient Rome, the artists of the reliefs on the Ara Pacis have neither names nor biographies. Despite the importance of their creation, which was singled

out as worthy of mention by Augustus himself in the *Res Gestae*, the artists were never identified in any surviving textual reference. Early imperial authors such as Pliny and Pausanias frequently cited the names and offered brief accounts of earlier sculptors like Pheidias or Polykleitos as well as more obscure Greek artists.[2] And yet the creators of the sculpted panels depicting uniquely Roman ceremonial processions with celebrated Roman participants went unmentioned by both contemporary and later Roman writers. Ancient texts offer no clues as to where the sculptors of the Augustan altar came from, what traditions they were trained in, and how their work was organized and executed.

This absence of textual information is not atypical for the Roman world. Ancient writers rarely discuss the creation of contemporary sculpted monuments in Rome or mention specific sculptors by name. Furthermore, unlike the Greek signatures on many freestanding portrait or ideal statues[3] or the intriguing sculptors' and masons' marks which survive not only on the Achaemenid Apadana friezes at Persepolis[4] but also on the sculpted decoration of the Romanesque Cluny III in Burgundy,[5] Roman "historical" reliefs such as the processional friezes on the Ara Pacis traditionally were not signed or marked by the artists who carved them.[6] Yet, despite the anonymity of these Augustan sculptors, we can piece together information about their training and their methods from two separate but complementary methods of inquiry. The first approach involves systematically observing and documenting individual anatomical and drapery forms, surface textures, and tool marks on the marble itself.[7] As previously discussed, the compositions of the processional friezes on the Ara Pacis have already received substantial attention. However the smaller, subtler details of form and the carving techniques also must be analyzed in order to gain a more precise understanding of the artistic traditions of the sculptors at work. By comparing the carving details preserved on the Ara reliefs from one figure to another and then with the details on other sculpted reliefs from Rome, we can better understand how different techniques for carving stone and various aesthetic preferences for rendering form were transmitted and modified from the republican to the early Augustan periods.

The second avenue of investigation that concerns us in the present chapter involves evaluating the conclusions and comparing the methods from studies of other ancient and post-ancient artists and artistic workshops. Although the workshop operations of other cultures in different geographical regions and time periods are by no means directly comparable with the conditions faced by workshops in late first-century B.C. Rome, a review of recent examinations into Persian, Greek, and medieval European stone-carving traditions and craft organization may provide insight into the more general features of such a conservative trade. However, despite the fact that from the sixth century B.C. to the twelfth century A.D. there was relatively little technological development in the traditional processes of carving a block of stone, certainly there are no historical connections between the sculptors at Persepolis, the stonemasons of medieval France, and the relief carvers in late first-century B.C. Rome. I present the findings from studies of anonymous artists responsible for large-scale relief projects only in an effort to expose alternative methods for investigating premodern sculptural production and to generate further dialogue among classical, Near Eastern and medieval sculptural specialists. For the purposes of this study, two groups of anonymous carvers are especially interesting: the ethnically diverse body of relief sculptors who carved the Apadana processions at Persepolis in the late

sixth century B.C. and the itinerant figural and architectural relief carvers of churches and cathedrals in Anglo-Norman England and Romanesque France. In addition to these more chronologically and geographically distant groups, results will be presented from several examinations of Greek sculptural and architectural projects as well as from recent investigations into imperial Roman marble quarrying and carving operations.

In addition to these comparative studies, this chapter presents selected types of epigraphical evidence previously unmined for information concerning the mechanics of official commissions and the operations and the personnel of Roman craft production. Despite the notoriously thin nature of the textual evidence, the information provided by occupational funerary epitaphs and early imperial *senatus consulta* may shed further light upon the questions of who carved early Roman stone reliefs and how projects such as the Ara Pacis were handled from inception to completion. Of course, the conclusions we draw from a comparative study of related methods as well as from the inscriptions have their limitations. The carvers of the Ara processions were working under specific conditions according to the requirements of a particular commission. The mechanics behind any sculptural project should be studied on an individual basis. This said, however, I hope that a review of the epigraphical evidence and a comparison of relevant methodologies will invigorate the study of Roman relief production, which long has been stymied by the relative silence of our primary sources.

THE ANONYMOUS ARTIST AND
THE SCULPTURAL WORKSHOP

Often when faced with the problem of artistic anonymity, scholars have seen the individual artist as working within a larger unit frequently labeled the workshop.[8] For both the archaeologist and the art historian, the term "workshop" can be used to describe various circumstances.[9] Occasionally workshop may refer to an actual structure or definable site of activity associated with a monument or building project, or with a district or street in an ancient city.[10] More often than not, however, the term refers to the workers themselves, the craftsmen. For our purposes, a sculptural workshop is a group of craftsmen who possess varying degrees of sculpting skill and who work under the direction of one or more senior, experienced sculptors. These senior artists, who are often referred to as the "master sculptors," not only direct the activities of the junior carvers but participate as well in the sculpting as supervisory members of the creative unit.[11] Such working conditions have been proposed for many ancient sculptural projects, including the Mausoleum at Halikarnassos. For this dynastic Hellenistic structure, Bryaxis, Scopas, Praxiteles, Leochares, and possibly Timotheos, the master sculptors, each "designed the decoration for one side . . . and then carved some of it himself and supervised the carving of the rest by his own team, ensuring that the whole side for which he was responsible was up to standard."[12] On the Apadana processions at Persepolis, it has been argued that different master carvers, who led separate teams of workmen, were responsible for different rows of figures. According to Roaf's analysis, the senior sculptors carved the most important sections of the body while their workmen were assigned less significant areas of the same figures.[13]

The size of the typical stone-carving workshop in the ancient world was relatively small, anywhere from two to twelve artists including the master or masters.[14] For the workshop of the sculptures on the Temple of Zeus at Olympia, Pausanias was told there had been two master sculptors, to which Ashmole plausibly added ten assistants.[15] For the Parthenon frieze, a team of roughly ten carvers including the master has been hypothesized, while three or four men including the senior sculptor Hektoridas carved the pedimental sculptures for the Temple of Asklepios at Epidauros.[16] Each compositional unit of the frieze on the Column of Trajan appears to have been produced by at least four separate workmen.[17] Perhaps four carvers would have been able to work simultaneously in the cramped two-room sculptural studio excavated north of the Odeion at Aphrodisias.[18] The size of any given sculptural workshop in the ancient world depended upon the type and medium of the pieces that group produced as well as the constancy and urgency of market demands. In addition, the number of personnel, including masters, might fluctuate due to temporary collaborations on large-scale commissions.

APPRENTICESHIP AND THE STRENGTH OF TRADITION

Ancient sculptors acquired, developed, and taught the skills of their craft through the master-apprentice relationship. Often this training was passed down from one generation of men to the next within the same family. Plato stated that sons of skilled Greek craftsmen learned their trade from their fathers and archaeological data suggest that Athenian pottery workshops usually were based upon the extended family.[19] Analysis of the signed statue bases produced by bronze sculpture workshops on Rhodes from the fourth century B.C. to the early first century A.D. reveals that the craft of bronze casting remained a family business. On Rhodes a Tyrian family established a sculptural workshop, and signatures from this group attest to one sculptor, Menodotos, son of Artemidoros, having collaborated on separate occasions with his father, his uncle, and his cousin. Certainly youths and adult craftsmen from outside the family as well as foreigners were brought into workshops, but the Rhodian evidence makes clear that the extended family unit was at the heart of sculptural workshop organization.[20]

That the craft of sculpting typically remained a family business in the ancient world is not surprising since the natural inclinations toward or talent for the art was often inherited.[21] Early and frequent exposure to both materials and tools would also have helped to foster the young carver. Furthermore, because the skill was economically valuable and some investment was required for studio space, tools, and materials, it was only natural that an attempt would be made to train the next generation and thereby ensure the survival of the family-based operation. Greek sculptors' and vase painters' use of patronymic signatures illustrates such successive generational apprenticeship patterns and indicates the importance of artists' family connections as advertisements of their credentials.[22] Whereas textual and epigraphical evidence for the existence of Greek sculptural dynasties is substantial, written evidence for the apprenticeship system during the Roman imperial period is less copious. Still, Lucian told how he himself was to learn sculpting under the guidance and in the workshop of his maternal uncle, and

Greek sculptors in Athens used patronymics when signing portrait statues of provincial rulers and Roman politicians during the first century B.C.[23]

Because artisans occupied a wider variety of legal and social status levels in the capital city, the circumstances of the master-pupil relationship in Rome were somewhat different. Surviving references to occupations in late republican and early imperial funerary inscriptions suggest that most craftsmen identified in these epitaphs were not working in large domestic household settings but rather in individual shops that catered to public demand in Rome and other cities. Most of these artisans were freedmen or *libertini* who passed both their job title and the necessary skills to their offspring and to their own freedmen.[24] It is probable that in order to supplement their own progeny, a sculptural workshop's master craftsman or comasters (*collibertini*) purchased slaves, preferably as youths, whom they could then train to carve for the family- or multifamily-based unit. As slaves these young apprentices were both legally and literally brought into the patron freedman's *familia*. Eventually many of these slave apprentices were freed in adulthood by the master artisans, with some choosing to remain as contributing members with their original workshop.[25] The epigraphical evidence for the apprenticeship patterns of freeborn stone carvers is less informative since they are not well represented in the preserved funerary inscriptions. Freeborn artisans might appear in an inscribed list of names set up by one or more members of a *collegium* declaring the offices or the types of dedications made by the participating craftsmen, a form that offers little information regarding training or workshop organization.[26] Nevertheless, it seems likely that the family-orientated master-pupil system was also the norm for the artistic training of freeborn sculptors of uncertain or nonservile origin in late republican and Augustan Rome and Italy.

Apprentices in any craft began their careers by learning the most rudimentary skills, gradually acquiring over time the experience and training for more advanced, complicated procedures. Scenes of vase painters', sculptors', and bronze casters' workshops on Greek painted pots show individuals working at separate stations, some performing simpler operations while others concentrate on the trickier tasks, often with young assistants at hand. Plato in fact had suggested that a young craftsman learn the complete spectrum of techniques as part of his artistic training.[27] This method of training, which we will refer to as the pyramid structure of apprenticeship, is clearly illustrated in a scene depicting five members of a sculptor's workshop preserved at the left side of a long relief fragment from Ephesus presently on display in the Istanbul Archaeological Museum.[28] At the far left of the workshop scene sits a small, clean-shaven male dressed in a short tunic sketching on a rectangular panel with a pointed instrument (fig. 2a). The next figure, represented in larger scale, is an older, bearded male, also clad in a short tunic, who sits upon a high stool (fig. 2b). The bearded sculptor, whom Mendel identified as the workshop master, is shown ready to strike his chisel with a hammer at the drapery folds of an under life-size statue of a togate male. Behind the master sculptor is another clean-shaven youth wearing a tunic gird at the waist, who uses a pumice rock to polish an object that has been placed on a table (fig. 2c). Mendel had identified this object as a protome with a lion's paw. A large bowl beneath the table may have served as a basin for the water used when polishing stone with abrasives.[29] The final group in the scene consists of a second sculptor and his assistant (fig. 2d). The beardless, tunic-clad sculptor is shown chiseling the

drapery at the shoulder of a portrait bust supported on a low table. To his left a small, young assistant stands by holding another tool, possibly a drill bow. The entire scene, carved in low relief and with only short, rapid strokes of a chisel, testifies to a division of labor within a sculptor's workshop in the Roman era based primarily upon age. On the Ephesus relief fragment, younger males serve as assistants or perform less-skilled tasks, such as polishing, while the older members carve the statues. Only one male is shown bearded, suggesting a more mature and probably more experienced master sculptor actively engaged in the production of the shop. The relief scene also suggests that both figural as well as ornamental pieces could be produced simultaneously by the same group of carvers.

The pyramid system of apprenticeship has been proposed also for the artists who decorated the walls of Roman houses and other structures. In Roman wall painting ateliers, the apprentice began as a wall plasterer, then proceeded to paint the less ambitious backdrops and decorative ornamentation (*pictor parietarius*), finally to graduate to the more sophisticated and valued skill of figure painting (*pictor imaginarius*).[30] For every art or craft during any historical period, a certain number of pupils would advance through these stages of skilled workmanship, some to become master craftsmen themselves. Just as important, however, is that many other artists would remain at a particular level in the pyramid process and specialize in a specific and vital skill.[31]

The training acquired from a master-pupil relationship tended to be conservative. A sculptor taught his young student to carve by the same methods which he himself had been instructed. In the sculptor's workshop, an apprentice learned by watching[32] and by carving, since the young artist could only learn how to sculpt stone by actually sculpting stone.[33] In this atmosphere, there was little time or opportunity for experimentation or innovation on the part of the apprentice. Once traditional tool-handling skills and aesthetic preferences were learned, they were not easily abandoned. Instead, they served as the foundation blocks of a stone carver's style.[34] When novelty happened it might come about from direct or indirect contact with competing groups of sculptors working along different lines or exposure to the sculptures they created.

There is substantial evidence from several periods to show that different groups of carvers worked together, often side by side, on the same project, which was typically a large official commission. The inscribed building accounts for the Erectheion in Athens show that six small groups of carvers worked independently on each of the six Ionic columns on the east facade.[35] For the Parthenon, the Mausoleum at Halikarnassos, and the Achaemenid monuments at Pasargadae and Persepolis, to name just a few specific examples, different carving workshops were assigned to nearby or even adjacent areas of the monument under the direction of separate masters. The Epidauran building committee actually appears to have preferred to contract different stone carvers for separate parts of the Temple of Asklepios.[36] For the Romanesque period, close examination of the architecture and sculptural decoration of the twelfth-century cathedrals of St. Maurice and St. André-le-Bas has shown that two separate stone carving workshops worked together on each building and continued to exchange design ideas and technical methods as the project progressed.[37] Likewise, at least three distinct workshops simultaneously carved the decoration for the collegiate church of Saint-Caprais at Agen, dated

from the late eleventh to the early twelfth century.[38] During both the ancient and postantique period, such multiple contracting was without doubt more practical in terms of efficiency and timely scheduling. Competitive interaction between artisans likely influenced to some degree the working methods and perhaps the aesthetic sensibilities of one or all of the workshops in question. Whatever the dynamics of artistic transmission were between competing groups, it is probable that at times the traditions of one group or another dominated the stylistic and technical exchange.

Adaptation of a sculptor's learned methods might also occur with the introduction of an adult artist trained outside the workshop's tradition who had a degree of influence on his co-workers' execution. It is clear from signatures on bases that sculptural workshops on Rhodes were not kinship-exclusive.[39] There are examples of foreign adult artists who emigrated from mainland Greece, Asia Minor, and Syria to enter the Rhodian family-based atelier in order to collaborate on specific pieces. Occasionally these men remained members of that particular workshop unit. For the republican period, we have ample textual testimony that sculptors and other artisans previously trained and working in the Greek East were brought to Italy as adult captives during the third and second centuries B.C. after Roman expansion in the Mediterranean.[40] Early in Augustus's reign, Mark Antony's sculptor, C. Avianus Evander, was sent as a prisoner of war from Alexandria to Rome following the victory at Actium in 31 B.C. Soon after his forced emigration to the capital, the emperor ordered Evander to restore the head of Timotheos's Artemis for the new Temple of Apollo on the Palatine.[41] However, while the sources provide evidence for the appearance of adult sculptors from the Greek East in Rome and Italy, they do not tell us whether these foreign carvers were absorbed as contributing members by the preexisting stone-carving communities in Rome and at the Carrara quarries. Perhaps some foreign-trained slave artisans, after attaining freedmen status, were able to establish their own sculptural workshops both in Rome and abroad under the auspices and for the benefit of their Roman patrons.[42] Other foreign artisans may have voluntarily joined or, if slaves, may have been purchased by native, family-based sculptural workshops, as was the case on Rhodes.

Other no less important factors to influence any reinterpretation of the artists' ingrained traditional sculpting methods were the tastes of the patron as manifested in the requirements of the commission itself.[43] New or unusual materials, subjects, compositional formats, or scale might force the stone carver to adapt his learned techniques and approaches to rendering form. However, any adaptation of an artist's traditional execution, whether deliberate or subconscious, tended to be conservative and limited. In a discussion of the active role of the designers at Persepolis, Root notes that "in the area of *style* there *may be* significant points at which ingrained patterns of early training in specific media and representational modes and ingrained region-specific aesthetic sensibilities of individual carvers do in fact show through the overlays of master planning."[44] Such a situation may also be argued for the processions on the Ara Pacis. Furthermore, although it is possible that radical change could occur as the result of the talents and influence of one uniquely gifted individual, this scenario, inherited from the Renaissance model of the artist as genius, probably occurred far less frequently in the ancient world than is sometimes projected.[45] It is important to note that what often appears as stylis-

tically or technically new often may have taken several generations of slow, occasionally hap-hazard development whose vestiges easily can be overlooked.[46] Taking into consideration all these factors for change (the degree of adaptation to suit the job or the influence of outside artists and competing groups), often we can still detect the basic carving traditions within which the majority of the sculptors were trained as apprentices, provided that enough original sculpting survives in a relatively good state of preservation.

ARTISTIC TRANSMISSION AND
THE MOBILITY OF THE SCULPTOR

An important factor in determining both the means and the extent of the transmission of techniques and aesthetic preferences within the master-pupil system is the degree of mobility afforded to any sculptor. For instance, could a sculptor, once trained, work for two or more workshops on separate projects or even on the same commission? Evidence from the Greek world suggests that at times there may have been a certain degree of fluidity. Vase painters in sixth-century Athens would work for more than one potter and were not exclusively bound by contractual obligation to any one workshop or artist.[47] Signatures reveal that Hellenistic Rhodian bronze casters often formed temporary partnerships for the production of specific pieces.[48] On the great processions on the Apadana at Persepolis, Roaf has suggested that some of the carvers worked for separate master sculptors who were responsible for different areas of the composition.[49] In the Roman period, many craftsmen were either slaves or freedmen, and it is unclear whether their social and legal status restricted their mobility and their ability to work for more than one group. To some extent the obligations associated with manumission and patron-freedman relationships (bonds of *obsequium*, *officium*, and *operae*) must have prevented artisans from abandoning their workshop group. However, for sculptors who were slaves, there remained the possibility of being bought and sold or lent out by the freedmen masters or managers of one sculptural *officina* to another. Evidence for the movement of an artisan between workshops in the Augustan period comes from the Vigna Codini Columbarium II on the Via Latina in Rome. An epitaph from the funerary tablet of a sculptor named Agrypnus tells how this slave sculptor was transferred from the household of Augustus's advisor, Maecenas, to the staff of the emperor's wife, Livia, where he was responsible for imperial statues (*in statutis*) and where he ultimately became an imperial freedman.[50]

In addition to exchanges of workshop personnel, the degree to which sculptors or entire workshops would travel between cities or provinces in order to support their livelihood or seek profit during the early imperial era remains uncertain. The Greek evidence is at times contradictory. Many signed statues and bases as well as literary testimony suggest that some artists, especially those that specialized in sculpting freestanding pieces, often traveled to cities or centers where there was work to be found. Powerful and wealthy *poleis* like fifth-century Athens, influential sanctuaries such as Delphi, Olympia, Delos, and Epidauros,[51] and the seats of Hellenistic kings and foreign despots[52] attracted sculptors and a myriad of skilled tradesmen from throughout the Greek world. A recent study of the signed statue bases from Attica during the archaic period suggests that ethnically diverse workshops dominated by Ionian sculp-

tors produced funerary and votive sculpture for Athenian patrons.[53] For the Roman era, there are instances of sculptors from Gaul traveling to North Africa, Germany, and Britain for specific commissions.[54] For the Augustan period, a group of local limestone carvers trained by Italian craftsmen traveled throughout southern Gaul executing large mausolea and their sculptural decoration for the Gallo-Roman aristocracy.[55] Earlier in the sixth century B.C., the celebrated Etruscan sculptor, Vulca, emigrated to Rome from Veii to execute a number of important commissions for Tarquinius Priscus, including the cult image for the temple of Jupiter on the Capitoline.[56]

Yet, in contrast to these references to travel, the epigraphical evidence for Rhodian workshops argues for a more stable, settled life in a permanent studio setting as the rule in areas where demand for statuary was relatively high.[57] There is likewise a case for the existence of "sculptural industries" or permanent workshops supplying the constant and growing demand for funerary stelai in fourth-century Athens or for decorative statuary on Delos in the second and first century B.C.[58] To be sure, by the first century B.C., a growing and presumably profitable market for statuary and relief sculpture must have been firmly established in the capital city of Rome. The conflicting nature of the written and physical evidence can be understood best as proof of the complexity of the situation. When the *senatus consultum* was issued for the Ara Pacis in 13 B.C., there must have been in Rome both celebrated and obscure sculpting *peregrini* and more permanent workshop establishments from which to select for the contract. The degree of contact, if any, between these two types of sculptors may have contributed to an exchange of artistic traditions between the artisans who ultimately designed and carved the Augustan altar.

Although the specifics of sculptors' movements between different workshops remain obscure, it is clear that oftentimes carvers who were familiar with a particular type of stone would travel with that material to the job site. For instance, at Delphi it appears that Parian masons may have worked the Parian marble on the Athenian treasury building,[59] while in the third and fourth centuries B.C., Athenians were hired specifically to accompany and work their local Pentelic marble at the sanctuary of Asklepios at Epidauros.[60] The Epidauran patrons also contracted a family of masons from Argos to supply and carve the desired black Argive stone for the sanctuary.[61] This is not to say that the origin of a stone necessarily betrays the nationality of its carvers, but it was without doubt advantageous during both the Greek and Roman eras to hire craftsmen who were already familiar with the properties and behavior of the specific kind of stone chosen for a building or monument.[62] For the circular Temple of Hercules Victor located on the bank of Tiber River in Rome, and dated from the mid-second to late first century B.C., Athenian carvers were brought over from Greece to sculpt the original Corinthian capitals of Greek Pentelic marble.[63] During the urbanization of provincial centers in the early imperial period, Roman stone carvers familiar with Carrara marble accompanied the Italian stone when it was exported for projects in Mauretania, Crete, and especially in the Augustan and Julio-Claudian colonies in southern Gaul.[64] Although the evidence is disputed, it has been suggested that carvers emigrated from Asia Minor to both Rome and North Africa in order to carve pedimental statues and architectural ornamentation.[65] Stylistic comparisons suggest also that in the second and early third centuries A.D., native stone-carving workshops

traveled with the Anatolian marble that was exported to Palestine for building projects at Caesarea, Askalon, and Scythopolis.[66]

SCULPTOR AND STONEMASON

In the ancient and medieval world, frequently blocks of stone for statuary and architectural members were roughed out at the quarry site. Sculpted pieces found in the red granite quarries at Aswan show how large-scale statuary was partially or completely carved in the quarries of Egypt. Neo-Hittite carvers specializing in stone stelai half-completed these reliefs at a quarry workshop site, while the Assyrian sculptors of the immense *lamassu* nearly finished these beasts in the quarry before transporting the limestone colossi to the palatial sites at Nineveh.[67] From the classical world, the more celebrated examples of statuary carved at the quarry site itself include the partially carved colossus found lying in the Apollonas quarry and the archaic kouros discovered in the Phlerio quarry on Naxos.[68] Semifinished column bases, tables, altars, and reliefs found in the Fossa cava and Fanti scritti quarries at Luna illustrate that this practice continued into the late republican and early imperial periods.[69]

Partial or complete finishing in the quarry was not restricted to the carving of fine white marble. A completely finished statue of pavonazzetto marble representing the draped torso of a Dacian prisoner destined for the Forum of Trajan has been found abandoned in a Phrygian marble quarry.[70] Furthermore, from the mid-second to the end of the third centuries A.D., Asiatic columnar sarcophagi were carved to a finished or near-finished state by a sculptural workshop located within the Docimium quarries in Asia Minor. Workshops based in the Proconnesian quarries produced roughed out Corinthian capitals and near-finished garland sarcophagi, which were then transported from the quarry to the port for shipment to various overseas markets.[71]

The carving of architectural members and sculpture at the quarry site was done not only to reduce the weight, and thereby save in the cost of transport, but also it was done because stone, especially marble, is much softer and more easily shaped when first separated from the quarry bed.[72] In many instances it is likely that a sculptor from the workshop was present, if not actually responsible, for the selection and removal of the stone block from the quarry itself. Passages from a late antique source illustrate how sculptors often went to the quarry themselves in order to locate suitable marble veins for their commissions.[73] Intimate knowledge and experience with the quarry beds were advantageous since the appearance, the geology, and therefore the sculpting behavior of even the same type of marble can differ depending on from where in the quarry it was extracted.[74] This is particularly true for Carrara marble, since this quarry range produces stones that exhibit a wide range of colorations, granular sizes, and structural textures.[75]

It is quite possible that many sculptors, especially those anonymous artisans who created Roman architectural and funerary reliefs, also worked at some point in their careers as or alongside stonemasons. This was certainly the case for relief carvers of other periods. At Persepolis, many of the same symbols that may identify individual carvers or sculptural workshops have been found on both the processional reliefs and on architectural blocks. In the Treasury tablets

from this same site, sculptors were listed as a subgroup within the more encompassing category of stone workers and were paid the same monthly wages.[76] In the fourth-century B.C. building accounts from Epidauros we learn that one sculptor named Sannion was responsible for both the sculpted frieze and the lintel moldings on the Temple of Asklepios.[77] Later, in the second century A.D., the imperial quarries at Docimium in Phrygia were home to both quarrymen and sculptors who perhaps were under the same administrative control. These Phrygian craftsmen worked alongside one another in extracting, roughing out, and carving various types of architectural elements and marble sculpture, including sarcophagi, funerary stelai, and freestanding statuary.[78]

The collaborative relationships and workshop allegiances that existed between sculptors and stonemasons did not end with the collapse of the centralized control of Rome's imperial quarry system. Recently published fabric accounts dated to the fourteenth century that record the expenditures for the construction of Exeter Cathedral attest to the survival of this phenomenon long after the antique period. For this project, a sculptor named William of Monacute carved both the architectural ornament and the figural grotesques. While the Exeter accounts listed payments for other groups of artisans explicitly by specialties such as glaziers, plasterers, and painters, sculptors remained undifferentiated within the larger group of stonemason labor.[79] Furthermore, careful analysis of the mason's marks and hands on Cluny III illustrates that the same group of stonemasons who cut the ashlar blocks for the walls of the Romanesque churches of Burgundy also carved the figural reliefs of the tympana for these same structures. One specific example was the case of a carver working at Vézelay who cut and squared a significant number of ashlar blocks, carved the masonry details for the nave arcades, and sculpted the roundels at the central portal.[80]

Since neither masons' marks nor detailed building accounts survive for the Augustan period, the precise nature of the relationship between relief carver and stonemason is uncertain. It appears, however, that in both inscriptions and texts the term *marmorarius* was applied to relief sculptors and stonemasons alike, implying that the Romans drew no sharp distinction between the two activities.[81] Thus, any craftsman who worked with marble, whether sculpting relief figures, carving architectural ornament, or squaring blocks, was called a *marmorarius*.[82] Although there is no evidence for formal associations specifically created by and for figural relief sculptors such as there were for wood carvers in fifteenth-century Germany, we do have ample evidence for *collegia* or formal occupational associations of *marmorarii*, especially from the Carrara quarries in northern Italy. Inscribed blocks offer the names of officials in a *collegium* of slave stonemasons at Carrara incorporated in the early Tiberian period at about the same time the operation of the Carrara quarries had been taken away from the *colonia* of Luna by the imperial administration.[83] Likewise we know that a *collegium* of marble carvers (*marmorari[i] conviv[a]e*) set up a funerary monument for a fellow worker who died at the age of seventeen.[84] It is reasonable to suppose that a certain number of relief sculptors working with Carrara marble in Rome were members of a *collegium* of *marmorarii* and had spent some of their apprenticeship working in shops located at or near the quarries of Luna. In this case, the relief carver and the stonemason, if they were not in fact the same man, may have worked in the same *officina* and received similar training.

The use of a particular material such as Carrara marble for a relief or monument was often the decision of the patron. Because the type of stone chosen frequently was a factor in determining who was contracted to carve it, material selection and other specifications in ancient commissions are keys to understanding how Roman monuments like the Ara Pacis were begun, created, and completed. One essential consideration in the creative process is the role of the patron. How were the workshops chosen and who chose them? To what degree, if any, did the patron and/or his agents control the activities of the sculptors? Furthermore, precisely which actions of the artists were directed by the specifications of the commission? Once again, we know precious little about the contracting system in Augustan Rome. It is possible, however, to deduce some information based on the contracts for large public monuments from other periods. Of primary concern for us are the mechanisms and the reasoning behind workshop selection. Fortunately, inscriptions have preserved the details of contracts for large projects constructed in the Greek East during the classical and Hellenistic eras. Particularly useful are the Epidauran building accounts since they provide valuable data regarding the people as well as the steps involved in the hiring process. Because relief and decorative sculptors were at least closely allied with architectural stonemasons, a general comparison with the architectural contracting procedure at Epidauros and other sites seems reasonable and worthwhile.

At Epidauros, a large public project such as the Temple of Asklepios had to be sanctioned by a decree from the highest governing council, in this case probably the council of the *artynoi*. The actual implementation of the decree was carried out by two separate committees. The finance board, which consisted of secular officials drawn primarily from the local aristocracy, authorized payments. On the other hand, the second committee, referred to by Burford as the building commission, included influential master craftsmen, material suppliers, and others who had demonstrated talent for management and who were knowledgeable in the practicalities of stone building construction. In addition to the committees, a priest or group of priests of the sanctuary, serving as intermediaries between the finance board and the building commission, was responsible for the management of expenses and payments. While an architect served as technical advisor, according to Burford, it was nevertheless the building commission, not the architect, that was ultimately responsible "both for the design of the building and for the organization of its construction."[85] The building commission received the bids from the artisans and the suppliers.[86] While some artisans were hired directly by the committee, as was also the case for much of the construction in fifth-century Athens, other jobs were farmed out to subcontractors who were responsible for supplying the necessary materials and labor. Thus, from the initial proposal put forth by the patrons to the final dedication of the completed structure, there were many decisions made by several different committees and individuals. The Temple of Asklepios, like most large-scale projects, truly was a group effort.[87]

The textual evidence also suggests a competition was held between workshops bidding for the contract. Plutarch remarked that "when cities invite bids for temples or colossi, they scrutinize the artists who compete with each other for the contract and bring them estimates and

models."[88] Cost must have been one crucial criterion for the selection of a particular offer, but other factors also may have influenced the choice of a workshop, including experience, competence, and previous successful or unsuccessful contractual relationships. As noted already, certain materials were carved by sculptors and masons familiar with the stone's structural properties and idiosyncrasies. Such specific material selection would have reduced significantly the pool of available labor and given advantage to particular carver groups. On the other hand, a material might be selected to deliberately provide employment for a specific workshop or region, especially if related stone suppliers, workshop owners, or their patrons were consulting members of the building commission.

The actual contract awarded to the selected artisans could be extremely specific, with a high degree of control enforced by the patrons. For example, the specifications issued by the patrons in an inscribed contract for an early second-century B.C. Temple of Zeus Basileus located outside the small Greek town of Lebadeia in Boeotia required that the mason "make the undersurfaces of all the stones . . . not less than two feet from the next joint with a close-toothed, sharp chisel."[89] In this case, the patrons who were designated in the inscription as the "Building Commission" determined minute criteria such as spacing dimensions, tool selection and techniques, and material selection. Apparently the contractor for the temple at Lebadeia was under constant supervision by both the architect and the patron: "the insertion of dowels, clamps, and axe-shaped ties, the weights of these things and all the lead casting the contractor (shall) personally (submit) to the building commission. He must not set anything permanently without our sanction."[90] Most surviving contracts were not as specific, but many include requirements for particular materials, working methods, scheduling, payment and inspection.[91] Obviously the more specific the requirements for a large-scale project, the less likely there would be serious planning errors or scheduling mishaps, provided that those hired paid close attention to all such details.

In addition to material and method specifications, the requirements of the contract and the preferences of the patron could have a profound impact on the design of the monument. While it does not seem surprising that customers should have been personally involved with the appearance of their portraits or the decoration of their domiciles,[92] it is less clear whether patrons imposed their own design ideas for the sculpted decoration on complex large-scale public monuments. Certainly most patrons of major commissions must have made clear what subjects they wished the artists to carve. However, we have to ask to what extent did the instructions of the contract, whether written or verbal, determine how the monument would ultimately look in terms of technique, composition, and figural style?

For the Achaemenid reliefs at Persepolis, Darius and his advisors probably dictated the tone of the messages of power, control, and empire that the processions and other images convey. It has been suggested that the Persian nobility was directly involved in creating the figural canon associated with the "court style" characteristic of certain Achaemenid relief sculpture and seal imagery.[93] Regarding the Apadana friezes, Roaf envisioned a group of designers creating a precise plan for individual figures as well as for the entire composition. He argued that it was these designers who created the Persepolitan style and that they did so following the instructions of their patron, Darius.[94] Precisely how specific these royal directions were is not

made clear. Yet, in general, specialists in Achaemenid art are prone to understand the patron as a commanding, highly influential force in the creation of sculptural design and figural style.[95]

From the details of postantique construction projects we find further instances of the role of the patron as designer. For the late eleventh-century bishop's chapel at Hereford, England, the chronicler William of Malmesbury recorded that the patron, Robert of Lorraine, drew up the design for the structure himself, copying much of it from his knowledge of the plan of the basilica at Aachen. However, the master mason either was given or simply took the freedom to introduce elements from his native Anglo-Saxon architectural vocabulary into the patron's Germanic design. In this case, the basics of the design were the responsibility of the patron, Robert, but the details were left to the devices of the master mason and his craftsmen.[96] Unlike Roaf's hypothesis which assumed that the carvers had no influence on the Persian designer's rigidly specific plan, Gem's view of Anglo-Norman construction instead argues for an inter-active, creative relationship between the patron-designer and the stonemason. A similar relationship between client and artist occurs with the design of the chevet of Saint-Denis, for which the major design changes were decided by the patron, Abbot Suger, while the less significant details and alterations were the responsibility of different masters, subcontractors, and visiting consultants.[97]

Assessments of the influence of the patron upon sculptural design and figural style in the Greek world vary. The few surviving building contracts argue for direct involvement concerning specific decorative features. For example, the inscribed accounts from Epidauros state that the building commission, acting on behalf of the patrons, provided *paradeigmata* or models to the contracted craftsmen for elements such as the plasterwork, the metalwork, painted decoration, and particular architectural moldings.[98] Burford suggested that the architect, as technical advisor and perhaps a member of the committee, supplied drawings or models for some features and proportional schemes.[99] In a brief discussion of the building of the Parthenon, on the other hand, Bundgaard had argued that no detailed drawing was required: "However paradoxical it may sound to modern ears, detail drawings from which to *build* these incredibly consummate edifices were unnecessary. . . . I consider there are good grounds for believing that the Greeks made no use whatever of such a natural accessory as a fully detailed drawing is to us, but acquired the mastery of the architectural forms solely by virtue of a sure tradition built up through many generations."[100] The epigraphical testimony from Epidauros and Lebadeia contrasts significantly with the traditional view of the Greek craftsman, especially the sculptor, as an independent artist whose creative spirit worked essentially without the intrusive restrictions imposed by patrons' contracts. In the scholarship on the sculpted decoration for the Parthenon, the creative role of designer is assigned to Pheidias, the master sculptor, while his patron and ally in the Athenian building committee, Perikles, is argued to have had only nominal and informal influence.[101] Between the extremes of precise instruction and minimal interference stands the hypothesis that a committee of Eleans, patrons of the sixth-century Temple of Zeus at Olympia, gave orders for the material and the subject matter of the pediments and metopes but left composition and design to the sculptors.[102]

For the sculpted images created during the reign of Augustus, scholars typically have assumed that the emperor played an active and decisive role. Recently, in reference to classi-

cized portrait types in particular, Zanker remarked that "the original must have been designed with Augustus's approval, or even at his own instance [*sic*]. It is equally obvious that the chosen sculptor, like a kind of court artist, was working from a set of prerequisites dictating style and overall conception."[103] Yet, portraiture is by its very nature personal. The involvement of the emperor is both understandable and expected. The questions for us are how precise were Augustus's instructions for large-scale public monuments and what role, if any, did the emperor play in the design and execution of the processional friezes on the Ara Pacis? Augustus himself tells us in the *Res Gestae* that the altar was consecrated by a *senatus consultum*. Unlike his forum and the other structures which Augustus took personal credit in the *Res Gestae* for financing and constructing, the Ara Pacis was listed as a product of senatorial patronage undertaken by a formal senatorial decree. Due to the iconography celebrating Augustan political and ideological themes, it is highly improbable that the Senate was the sole patron of the altar acting independently from the influence of the *princeps* and his advisors. Nevertheless, an examination of the procedural traditions associated with *senatus consulta* may shed light on how the commission was carried out and how directly involved were the initiators of the project with the design.

Although many *senatus consulta* were recorded and often survive (though unfortunately not in the case of the Ara Pacis), very little is known about the actual part played by the Senate or some senatorial committee in seeing that a statue or other honorary monument was started and completed. Are we to envision a system of senatorial committees overseeing the design, contracting, and construction in a manner similar to the Epidauran building commission? The analogy is tempting but does not take into account the fact that the Roman Senate was notoriously reluctant to delegate responsibilities for even the most mundane duties to standing subcommittees.[104] For specific projects where close supervision was demanded, however, there are instances where temporary commissions were established to control the work. For example, senatorial committees were created in order to manage critical issues concerning finance and extortion during the first century A.D. For public works and services, administrative functions were assigned to specially designated officers drawn from the Senate, such as the *curatores aquarum* mentioned by Frontinus for the *senatus consultum* of 12/11 B.C.[105] During the latter part of Augustus's reign two senatorial *curatores aedium sacrarum et operum locorumque publicorum* were established, and *senatus consulta* named such Julio-Claudian senatorial committees as the *curatores locorum publicorum iudicandorum*.[106]

In addition to specific committees and *curatores*, the chief magistrates of the Senate, the consuls, appear to have had responsibility for carrying out certain business sanctioned by senatorial decrees. In 9 and 8 B.C., it was not a committee but the consuls themselves who were put in charge of administering particular public works in Rome by order of a *senatus consultum*.[107] Later, when the *praefectus urbi*, L. Volusius Saturninus died in 56, it was the consuls who were responsible for seeing that statues were made and properly displayed.[108] Based on the evidence for standard senatorial procedural practices, we might imagine that when the *senatus consultum* for the Ara Pacis was issued in 13 B.C., either a committee of *curatores* similar to the late Augustan *curatores aedium sacrarum* or the consuls of that year, Tiberius Nero and Quinctilius Varus, or perhaps both, were designated to contract the carvers, supervise the con-

struction, and see to the timely completion of the altar. Furthermore, the senatorial *curatores* or the consuls probably delegated certain responsibilities to specialized subcontractors who were experienced with the practical problems associated with marble quarrying, transport, and stone-carving workshop availability. It is possible that the patron-client relationships of the various persons involved in the commission played some role in the Senate's selection of committee members and subcontractors. For the Ara Pacis, these connections, if they existed, remain unknown.

While ancient texts and inscriptions provide some insight into the types of senatorial personnel involved at the initial stages of a commission, in general the sources have said little about the actions or responsibilities of the *curatores* or consuls regarding the actual design, figural style, or other specifications of a monument. Most often we learn that the decree required a particular type of material, especially when that material was valuable or symbolically charged. For the honors posthumously awarded to Germanicus, Tacitus reported that the senate decreed that a statue of the imperial prince made from ivory was to head the processions at the circus games and that a huge golden *clipeus* or medallion portrait of Germanicus was to be placed among the portrait busts of the great orators.[109] Recently, however, there have been discovered fragments of two bronze tablets from Spain (the Tabula Siarensis), which contain several *senatus consulta* describing in more detail the posthumous honors voted for Germanicus after his untimely death in 19 A.D.[110] In particular, they include directives for three commemorative arches to be erected in Rome, on the Rhine, and in Asia Minor.

For the arch in Rome, the *senatus consultum* is extremely specific about the location in the capital city (*in circo Flaminio* near the statues dedicated by C. Norbanus Flaccus to Divus Augustus and the Domus Augusta), the material (marble), and the precise wording of the lengthy dedicatory inscription. With regard to the sculptural decoration of the arch, the decree specifies the locations on the arch for statues of members of the Julio-Claudian imperial household, including a central triumphal quadriga with the figure of the victorious Germanicus flanked by statues of his parents, his wife, his siblings, and his sons and daughters. As illustrated by this decree, the most pressing concerns of the Senate as patron of the Arch of Germanicus *in circo Flaminio* were the subject matter and the location of the sculpted decoration. There is no directive for selecting the statue types or the sculptors. Apparently these elements were not officially declared in the wording of a senatorial decree, which may indicate that such details were not decided by the Senate, but rather by a senatorial subcommittee, the designer, or the master sculptor. This may have been the situation with the decoration on the Ara Pacis. Because of the complex semiotic relationships between the varying types of relief imagery on the *saeptum* and altar proper, the design of the Ara Pacis must have required planning on the part of some senatorial officials or designer(s) or both.[111] Yet the selection of the figural and compositional styles as well as the sculptors hired for the project may have been of secondary importance in the minds of the patrons.

This review of selected workshop studies as well as the epigraphical evidence offers a more accurate picture of how relief-carving workshops operated in Rome when the Ara Pacis was commissioned in 13 B.C. The average workshop would have consisted of a relatively small number of sculptors, including both experienced carvers and apprentices, who were related to one another by kinship ties or the bonds of manumission. Probably one or more of these carvers belonged to a *collegium* or professional association of *marmorarii*. At least one or more of the experienced carvers probably were trained at the quarry producing the stone most frequently and competently worked by his sculptural group. For workshops that sculpted Carrara marble, these apprenticeships took place at the quarries near the prosperous colony and port city of Luna located on the Adriatic coast of northern Italy. At the quarry workshops, the apprentice would have become familiar with the idiosyncratic characteristics of the various types of Carrara marble while he worked alongside stonemasons. During his years of artistic training, which tended to be conservative and based on the traditions of his master-mentor sculptor, the young carver would have learned the full range of carving stages and techniques. Toward the end of his apprenticeship, the artist may have chosen to specialize in one type or area of figural sculpting and perfected his skills and his style for that specialization. Eventually, he may have gone on to become the master sculptor of his own workshop unit.

After his sculptural studio became a part of the workshop community that catered to the demands of the Roman art market, the relief carver and his workshop may have had opportunity to compete for imperial or senatorial commissions. A subcommittee, which probably consisted of builders, marble suppliers, and other qualified persons responsible for the more practical duties, would have drawn up the specifications of the commission, reviewed the competing bids, and possibly studied small-scale models or other tangible demonstrations of a workshop's competence. These subcommittee contractors in turn would have answered to a senatorial committee, established temporarily for the duration of the project, or to the appropriate consuls or other imperial agents. At some point a design for the reliefs may have been created, although neither the details of any preliminary model nor the identity of its author(s) is revealed through our epigraphical or methods studies.

After having been hired for a large-scale project like the Ara Pacis, the relief workshop most likely worked alongside other groups of sculptors, some or all of whom also may have had previous experience carving Carrara marble. It is possible that foreign-trained artisans also were brought in from outside the local workshop system by either the craftsmen or the contractors to contribute to the project. During the execution of the monument, the participating sculptors would have had opportunity to exchange their ideas for compositions and details of form, their carving techniques, and their aesthetic preferences. The sculptural traditions and stylistic tendencies of some of the artists or workshops involved in the project may have been more influential than others.

This flexible model for the operations of a sculptural relief workshop in Rome during the

late first century B.C. illustrates the potential and the limitations of textual and comparative methodological research. To understand further which artistic traditions and influences were at work during the design and execution of the North and South friezes, we must look at the Ara Pacis itself. The information we have drawn from studies of other workshops and from funerary inscriptions and official decrees will become more valuable and useful when viewed in conjunction with a description of the post-Augustan history of the processional friezes and with a detailed examination of the original carving preserved on the marble panels and fragments of the Ara reliefs.

3 THE POST-AUGUSTAN HISTORY OF THE PROCESSIONAL FRIEZES

Prior to its legendary foundations in the eighth century B.C. up to the present day, Rome has been continually inhabited and, at one time or another, most of its ancient structures have been refurbished or repaired. Like many monuments in the capital city, the Ara Pacis Augustae and the reliefs that originally adorned its precinct walls were altered after their dedication in 9 B.C. Several separate restorations have changed, to varying degrees, the late first-century B.C. processions. However, most modern discussions of the figural styles and artistic models of the North and South friezes do not take into account these post-Augustan modifications, despite the fact that the majority of these later reworkings are well documented by texts, drawings, and marks on the marble itself. This chapter examines the post-Augustan restorations that have most transformed the original carving and details of anatomical and drapery forms on the processional reliefs. Such a review is especially crucial when evaluating the artistic traditions and technical preferences of the original artists, since it is only by acknowledging these later layers of recarving that we can determine the Augustan sculpting techniques and properly assess the original appearance of the friezes. The results from the following study of the post-Augustan restoration activity also serve to underscore the importance of understanding the ramifications of the complete history of a monument, especially a structure so frequently studied and cited as the Ara Pacis.

HISTORY OF THE DISCOVERIES

In the last decades of the thirteenth century, the English cardinal Hugh of Evesham established building foundations in the area of the ancient Campus Martius partly atop the remains of the Ara Pacis Augustae.[1] This medieval structure, which served as the palatial residence of the cardinals of San Lorenzo in Lucina, underwent several restorations and renovations in the course of its history.[2] During one of these restorations in 1568, blocks from the North and South friezes of the Ara Pacis were unearthed. In the following year, these blocks, along with other sections of the floral frieze and the mythological panels from the Augustan altar, were purchased by Cardinal Andrea Ricci da Mon-

tepulciano for the soon-to-be grand duke of Tuscany, Cosimo I. In a letter dated 11 February 1569 to Bartolomeo Concini, then secretary to Cosimo, Cardinal Ricci informed his benefactor that between fifteen and eighteen "Greek marbles" had been found during palatial renovations. The Roman cardinal described some of the pieces as panels having "on one side figures from triumph scenes that in time have become somewhat broken, and on the other side festoons."[3] Having purchased the much prized ancient reliefs, Ricci had the slabs sawed lengthwise, separating the figural sides from the festooned sides and making the reliefs lighter and easier to transport to Florence.[4]

Despite the fact that the processional reliefs were prepared for transport, they remained in Rome.[5] Panels 5, 6 (fig. 3), and 7 (fig. 4) from the South frieze and Panels 2 (figs. 5, 6) and 3 (fig. 7) from the North frieze were stored in the Villa Medici, built by Cardinal Ricci, on the Pincian Hill. Meanwhile, Panels 1 (fig. 8) and 4 (fig. 9) from the North frieze remained on the grounds of the Palazzo Fiano. Finally in 1780, the five processional panels at the Villa Medici were sent to Florence for eventual display in the Uffizi. A short time later in 1788, Pius VI acquired Panel 1 from the North frieze for the museum collection at the Vatican, where it was displayed in the Belvedere cortile.[6] In the early nineteenth century, the last panel at the Palazzo Fiano, Panel 4 from the North frieze, was transported to the Villa Aldobrandini, the residence of the French governor of Rome, General Miollis. Soon after, the panel was acquired by the Marchese Campana, who eventually sold part of his collection, which included the Ara relief, to the Musée de Louvre in Paris.[7]

While seven panels from the main processional friezes had been unearthed by chance in the mid-sixteenth century, additional fragments remained beneath the Palazzo Fiano. Following the hypothetical reconstructions of the altar proposed by Petersen and the assemblage of the various fragments in the Museo Nazionale Romano, A. Pasqui began new explorations under the palazzo in 1903.[8] Pasqui not only discovered numerous fragments of decorative relief, but also fragments of lictors, a fragmentary section that includes the upper torso and portrait of Augustus and the three figures to Augustus's right (figs. 10, 11), and a portion of the torso of a youth now located at the eastern end of the North frieze (fig. 12). In addition, he discovered and photographed the relatively intact fourth panel of the South frieze, but left the marble slab in place since he feared that its extraction would undermine the foundations of the palazzo.[9] Thus, Panel 4 (noted henceforth as S4)[10] remained in situ until the more extensive campaigns of 1937–38, when an ingenious hydraulic engineering system allowed the slab to be safely removed. During these excavations, additional fragments from the lictor section of the South frieze were uncovered as well as more figural fragments assigned to the North frieze in the Fascist-period reconstruction.[11] Although the majority of the fragments and panels of the North and South friezes were incorporated into the 1938 reconstruction (with the exception of the Louvre panel), a number of figural sections including fragments of laureate heads, drapery, and footwear remain in storage in the Museo Nazionale Romano. Of the 607 decorative and figural marble fragments unearthed during the 1903 and 1937–38 excavations, it is estimated that 311 of these fragments can be attributed to the Ara Pacis based on stylistic and technical characteristics. Included among these are portions of seven *calceii*-clad feet and six laureate heads.[12]

HISTORY OF THE
RECARVINGS, RESTORATIONS,
AND RECONSTRUCTIONS

47
*History
of the
Processional
Friezes*

Both before and after they had been accidentally discovered during the Renaissance, the panels from the North and South friezes were repeatedly recarved and reconstructed. Yet, despite the fact that specific information regarding several restorations was published in the nineteenth century by Von Duhn and Petersen, the effects of post-Augustan reworkings upon the original appearance of the Ara processions have never been sufficiently assessed. While certain restorations are relatively obvious (additions of heads, drapery, etc.), other recarvings are much more subtle, and consequently less immediately recognizable, especially when studying the reliefs from photographs. In order to isolate the original, Augustan details of form and technique, it is essential to understand these later restorations as fully as possible. The following discussion offers detailed descriptions of the various phases of restoration in chronological order. This information is based on testimony preserved in the archival documentation, data published by Italian restoration specialists, personal discussions with marble-carving authority and sculptor P. Rockwell and other knowledgeable scholars, as well as my own firsthand examination of the reliefs themselves. The combined results reveal not only the specific effects of several documented restorations but also offer new information regarding recarving that was not recorded in texts or other archival sources. The evidence reveals that much of the original Augustan surface has been removed or otherwise altered on several panels of the two large friezes.

A Late Antique Restoration?

In the study of Roman sculpture, it is generally acknowledged that many freestanding and relief portraits, especially portraits of Roman emperors, were recarved during the late third and early fourth centuries A.D. In 1993, as part of my doctoral thesis, I suggested that the figures in the large processions on the Ara Pacis also had been recarved during the late antique period.[13] The impetus for my hypothesis was the existence of incised irises and pupils on the eyes of many of the original heads in the North and South friezes. These irises and pupils had been noted earlier by A. Bonanno, who offered the idea that they were the result of a Hadrianic restoration coinciding with the raising of the level of the Campus Martius and the construction of a protective parapet wall enclosing the Ara precinct.[14] Yet, both the style and technique of the irises and pupils do not conform to the typical Hadrianic rendering of eyes. Moreover, there is as yet no comparative evidence to substantiate the notion that Hadrianic sculptors engaged in reworking earlier imperial relief heads. Since the incising of irises and pupils was not a technique employed by carvers sculpting stone reliefs in Rome during the first century B.C., I had postulated an undocumented recarving in the Tetrarchic period that involved eye detailing with chisels as well as rasping for the purpose of aesthetically updating the Augustan heads. Recently, N. Hannestad also has argued, albeit more emphatically, for an extensive late antique restoration.[15] However, after long consideration and comparative analyses of stone pieces sculpted in Rome and in the Greek East prior to and contemporary with the

Augustan altar, I have begun to question the extent of the late antique reworking of the Ara friezes.

The issue of a later recarving in the Tetrarchic period revolves around three types of tool marks left on the marble, which hitherto have been considered non-Augustan: scratches from rasps, parallel incisions from scrapers, and chisel incision around the area of the eyes. These marks will be discussed one at a time, beginning with rasping. To be sure most, but certainly not all, of the surfaces of the figures on the Ara processions are covered with scratch marks of varying degrees of depth left by rasps. Scratches from rasping survive on the faces and necks (fig. 13), on arms and hands (figs. 14, 15), and on drapery, veils, and laurel wreath leaves (figs. 16–18). Several scholars have noted with curiosity the preponderance of rasping on the surface of the Ara reliefs, including Petersen who suggested that the rasp work was intentionally left for the better adhesion of paint.[16] Hannestad has argued that the rasping was the work of late antique restorers attempting to repair the effects of weathering and erosion to the marble surface.[17] He compared the rasp work on the Ara panels to the rasping left on the certainly recarved Hadrianic roundels reused as *spolia* on the Arch of Constantine.[18] On close inspection, however, the actual application of the rasp to the stone on the Hadrianic reliefs was quite different from that on the Ara processions. On the Hadrianic pieces, the rasp was dragged across the surfaces of both the figures and the back plane with a horizontal motion, leaving a fairly regular series of parallel scratches on the stone.[19] In contrast, the rasp was applied to the Ara panels with a more circular motion in a variety of directions, most often following the swelling and receding contours of the flesh and drapery. Only in one isolated area of Panel N4 do scratches from rasp work survive on the back plane. All other surfaces of the relief ground on both processional friezes show no sign of rasping.[20]

It seems reasonable to suggest that in order to argue a later, post-Augustan rasping of the Ara processions, it should be established that there are no comparable precedents for rasped surfaces on stone reliefs carved by first century B.C. sculptors in Rome. Should such precedents exist, then there may be an alternative explanation for the rasping of the Augustan reliefs. In fact, several pieces predate the Ara friezes from Rome that have been left rasped. The rasping of flesh surfaces occurs on many republican heads from marble funerary reliefs in Rome which otherwise bear no signs of having been restored. For example, the surfaces of the cheeks and neck were left rasped on a female head from a funerary relief carved, liked the Ara processions, from Carrara marble and dated to the early 30s B.C.[21] Also rasped are the flesh surfaces of a portrait head of an elderly woman, dated circa 50–30 B.C.,[22] a male head dated circa 30 B.C.,[23] as well as a male and a female head from another funerary relief dated to the late 30s B.C.[24] Noticeable rasp marks were also left on the surfaces of the faces on the marble four-figure "Sepolcro del Frontispizio" relief, likewise dated to the late 30s B.C.,[25] and on the flesh surfaces of a three-figure funerary relief, dated to the 30s B.C.[26] In all of these examples, the rasp work is confined to the flesh surfaces of the heads. Yet there is a republican precedent for extensive rasping on both flesh and drapery surfaces—the full-length relief portraits of a man and woman from the Via Statilia dated to circa 50 B.C.[27] Just as on the Ara figures, the sculptor of the Via Statilia relief applied the rasp to the faces, necks, hands, and drapery with fluid motions that follow the curving modulations of the flesh and cloth. He then left these

surfaces rasped with no further smoothing in a manner similar to the treatment of the Ara heads. The tooling on the Via Statilia relief illustrates that sculptors working in republican Rome were experimenting with rasped surface textures before the commission of the Augustan altar.

Yet, despite the examples cited here, rasping was not a common final surface finish for the majority of early republican reliefs. What then might have influenced these republican carvers to rasp the surface rather than follow the more traditional roughly chiseled approach? In her detailed analysis of the figural style and carving techniques on the Via Statilia relief, E. Gazda had concluded that the piece was the work of a locally trained Italian sculptor heavily influenced by Greek Hellenistic figure types and carving methods.[28] Gazda noted specific Greek features such as the figures' full-length poses, their garments, and the use of the drill. However, the majority of characteristics pointed to local craftsmanship, including the linear organization of the facial features, the disregard for an internal facial bone structure, the flat, geometric quality of the drapery folds and the unnatural anatomy of the underlying bodies. In Gazda's opinion, the Via Statilia relief served as an informative representative of several late republican funerary reliefs, which were "evidently designed and carved by Roman craftsmen," but nevertheless, "clearly show that technical procedures from the Greek tradition were experimented with."[29] Although it was not mentioned in Gazda's analysis, rasping the final surface may have been one of these technical experiments. Leaving the surface covered with scratches from rasps had become an increasingly common tendency of carvers in the Greek East during the course of the Hellenistic period.[30] By the Julio-Claudian period, the flesh and drapery surfaces of many full-length marble portrait statues carved and displayed by Greeks were left heavily rasped.[31] Thus, rasping was used as a finished surface texture long before the late antique period. It may be possible to infer from the evidence that when Italian carvers began to explore new materials, such as the marble-like limestone from which the Via Statilia relief had been carved or Carrara marble from which many late republican funerary reliefs as well as the Ara processions had been carved, they consciously experimented with Greek techniques for finishing these more compact stones. In the case of the Ara processions, the rasped surfaces may indicate the actual participation of Greek-trained craftsmen. The fact that rasping was a technique employed by certain carvers working with marble and marble-like stones in Rome prior to the sculpting of the Ara processions challenges the hypothesis that it could only have been the work of late antique restorers. The rasp scratches on the Ara figures in fact may be original, illustrating an increased Hellenization of local Italian relief carving procedures in Rome during the first century B.C.

The second type of tool mark left on the processions also argued to be the result of a late antique restoration is the parallel incisions creating by dragging a small-toothed scraper across the marble.[32] The marks left by scrapers are relatively easy to differentiate from standard rasp work. Instead of the intersecting, shallow scratches left by the back-and-forth application of the rasp, the scraper produced more deeply incised lines that consistently run parallel to each other across the stone. Marks from a scraper are found at different areas of the figures in the Ara processions. They are preserved along the jawline of Antonia Minor (s36) (fig. 19),[33] along the left cheek of s17 (fig. 20), at the left temple of Agrippa (fig. 21), and in isolated areas of the

drapery (fig. 22). The most obvious use of the scraper appears on the priestly caps of the two flamines on Panel s4, where it was dragged in a downward motion from the back to front following the curving contour of the cap (figs. 23, 24). Like the rasp, the scraper was used as a finishing tool to give a particular texture to the stone, rather than to remove any appreciable quantity of marble. On the Ara processions, marks from the small-toothed scraper are found on the figures and not on the back plane.

As was the case with rasping, the limited scraper work on the Ara friezes has been argued to be the work of late antique recarvers.[34] Yet, the use of scrapers before the early Augustan period is well attested. In the fifth century B.C., a Greek carver applied a scraper to create the wavy incisions on the beard of the older fallen warrior from the pedimental group of the Temple of Zeus at Olympia (fig. 25). Scrapers were often used on the background and nonfigural surfaces of funerary reliefs from Attica carved during the fifth and fourth centuries B.C., such as on a stele in Munich depicting a vessel (fig. 26). During the course of the Hellenistic era in the Greek East, scraper marks appear more frequently. Occasionally scrapers were applied to the figures themselves, such as on the Alexander sarcophagus from Sidon.[35] In Rome during the first century B.C., funerary relief carvers adopted this Greek tool in order to give texture to the hair of particular female portrait heads. For example, the scraper was used to create the hair incision for a female figure on a three-figure funerary relief dated circa 40–30 B.C.,[36] on a female head carved from Carrara marble dated to the 30s B.C.,[37] and on the women from a full-length three-figure marble funerary relief perhaps sculpted contemporaneously with the Ara processions.[38] Evidence for the dragging of a scraper along a curving contour in order to create a textured surface design very similar to that on the caps of the Ara flamines also appears on the hair of the elderly man and woman on the marble, three-figure "Santecroce" funerary relief dated circa 20 B.C. (fig. 27).[39] On these republican and early Augustan marble funerary reliefs, the scraper marks are confined to the area of the hair. The use of a scraper on the flesh and drapery surfaces of the Ara Pacis appears to have no first century B.C. precedents. Further study of the scraper techniques preserved on additional late Hellenistic reliefs carved in Greece and Asia Minor might provide evidence for a change in application by carvers in Rome due to Hellenic influences. On the other hand, the incisions from scrapers may be the work of post-Augustan, possibly late antique, restorers. It should be noted, however, that on reliefs recarved in the third and fourth centuries A.D., the scraper was typically applied to the back plane and far less often on the figures themselves. On the Hadrianic roundels, the recarved surfaces of the figures were rasped and generally not scraped. At this point, the date for the parallel incisions made by small-toothed scrapers on the Ara friezes must remain uncertain. Yet, the pre-Augustan use of the scraper in Rome by relief sculptors working in marble certainly indicates that this particular type of tool would have been available to the carvers of the Ara processions.

Unlike the use of the rasp and the scraper, there are no known precedents for the rendering of the irises and pupils on the eyes of the figures in the Augustan processional friezes. While many Etruscan terra-cotta and stone portrait heads bear incised irises and pupils similar in style and technique to the treatment of the Ara heads,[40] incising of the eyeball does not appear to have been a technique used by stone relief carvers in Rome prior to the second century A.D. Of the thirty-six preserved heads on the South frieze, twenty-five have received some

degree of eyeball incision or drilling. On the North frieze, two of the eight original heads have carved eyeball detailing. The chiseling and occasional drilling of the irises and pupils on the eyes of the Ara figures does not occur in any consistent pattern across the friezes. The majority of eyes bear only the incised, shallow outlines of irises, such as s30 (fig. 28), Agrippa (s28) (fig. 29), Livia (s32) (fig. 30), s29 (fig. 31), s17 (fig. 32), the "Rex Sacrorum" (s 26) (fig. 33), and three of the four flamines (s24, s23, and s22) (figs. 34–36). Others have extremely small semicircular incisions appearing just below the upper eyelid that were meant to represent either the iris or the pupil, such as flamen s20 (fig. 37) and Drusus Minor (s39) (fig. 38). Occasionally, the carver incised both an iris and a pupil, rather than an iris alone. On the western side of the procession, the deeply set right eye of Augustus (s16), which abruptly abuts the back plane, has been given both an incised iris and a pupil (fig. 39).[41] The foreground left eye, however, is too damaged for us to determine whether it also bore an added iris and pupil. This incised iris and pupil-eye design is also found on the heads of certain two-figure groupings on the eastern half of the South frieze. For example, the outline of the pupil was incised within the outline curve of the iris on both the left or foreground eye of s45 (fig. 40) and the eye of the background figures of an elderly man, s44 (fig. 41). This treatment also occurs on the eyes of figures s41 and s40 (figs. 42, 43). In both instances, there is a pattern to the recarving that involves a foreground or middle-plane figure facing westward and the background figure in front of it in the procession.[42] Not all of the carving of the eyes involved chisels. Rather than incision, figures s46 and s15 bear small, shallow circular depressions on one or both eyeballs, which may indicate the use of a narrow-bit drill for suggesting pupils (figs. 44, 45). On the North frieze, the eyes of the small girl have larger pupil depressions that more likely were created with a drill (fig. 46). Yet, although most figures bear some type of eyeball carving, the eyes of other equally prominent foreground figures show no traces of irises or pupils, such as those of "Tiberius" (s34) and Antonia Minor (s36) (figs. 47, 48).

In addition to the incision and drilling of irises and pupils directly into the eyeball, there are other tool marks found at the area of the eyes that are uncommon for typical late republican portraiture rendering. Several figures in the eastern half of the South frieze bear distinct drilled holes at the inner tear ducts, including Antonia Minor (s36) (fig. 48), Ahenobarbus (s45) (fig. 40), Livia (s32—right eye only) (fig. 30), "Tiberius" (s34—left eye only) (fig. 47), and the background females s37 (fig. 49) and s44 (fig. 41). Such deep, obvious drilled holes are rarely found on republican funerary reliefs. As Hannestad had suggested, the drilling of holes at the tear ducts was a technique employed by late antique sculptors for both original and recarved pieces.[43] Yet drilling of holes for tear ducts at the inner corners of the eyes was practiced also by carvers prior to the late third century A.D. Drilled tear ducts that are remarkably similar to those on the Ara heads are found on the eyes of a Victory that had decorated the spandrel of the Parthian Arch of Augustus,[44] on the figures on the Flavian Cancelleria reliefs,[45] on the marble head of Usia Prima on the Rabirii relief, recut perhaps in the Flavian or Trajanic period,[46] and on the figures on the marble Mattei relief dated Hadrianic to Antonine.[47] Therefore it cannot be said with certainty that the drilled tear ducts were a result of a late antique restoration. They may be due perhaps to an earlier undocumented restoration of the Ara processions.[48]

Another unusual treatment for late republican figural reliefs found on the Ara processions is the incision of individual eyebrow hairs. It also occurs predominantly on the western half of the South procession, as for example on D. Ahenobarbus (s45) (fig. 40), s44 (fig. 41), s41 (fig. 42). s40 (fig. 43), and Drusus Minor (s39) (fig. 38). The incising of the eyebrow hairs then abruptly stops at figure s37, where it is replaced by rendering the eyebrow as a sharply modeled ridge occasionally accentuated with incision along the lower contour, as on Antonia Minor (s36) and "Tiberius" (s34). The ridge treatment for eyebrows continues up to and including the figure of Agrippa (s28). For figures s27 and the "Rex Sacrorum" (s26), the incising of individual brow hairs resumes. With the easternmost flamen (s24), a new type of eyebrow carving appears, which involved scoring a more three-dimensional raised ridge with vertical incisions as if to combine the ridge and incision techniques of the aforementioned heads. The scored-ridge technique occurs on the flamines s24 (fig. 34), s23 (fig. 35), and s22 (fig. 36) as well as the background male s21 (fig. 50). Finally, at figure s20, the westernmost flamen, the carving of the eyebrows returns to a ridgelike form that is noticeably smoother than the eyebrow carving on the eastern part of the procession. This "softer" ridge type continues westward for the remainder of the processional figures, including the figure of Augustus. For both the ridge type and the scored-ridge type of eyebrow rendering, we have numerous republican precedents.[49] The incising of individual hairs occurs far less often.[50]

To summarize the evidence for an ancient recarving of the Ara processions, there does appear to have been a post-Augustan incising of the eyeballs, eyebrow hairs, and possibly the drilling of the tear ducts of many of the figures in the North and South friezes. Far less certain is whether the marks from rasps and scrapers are original or post-Augustan, since there are republican precedents for the use of both these tools. Those responsible for the eye area incision do not appear to have intended to alter the identity of any of the persons in the processions. Rather, the recarving, which was both haphazard and limited, seems to have been performed for the purpose of updating the style of the eyes to at least second century A.D. tastes. The argument that an undocumented late antique restoration removed most of the original Augustan surface is, in my opinion, unfounded. Much of the original tooling and details of individual forms survived relatively unaltered, particularly on those sections and fragments unearthed in the early twentieth century.[51]

The Renaissance

Although seven of the panels from the North and South friezes were known in the Renaissance, only Panel N1 bears restorations dated stylistically to the *seicento*.[52] All of the foreground heads, several background heads, and portions of hands, drapery, and feet of the togate male figures on the first panel of the North frieze were carved and attached during this period. Unfortunately, very little information was recorded concerning the details of this restoration. The artists, the precise dates of the restoration, and the patron(s) who commissioned the project are unknown. Unlike the other panels discovered in 1568, no prerestoration drawings were made of Panel N1, which might have provided information about the condition of the relief prior to the Renaissance reworking. The earliest illustration is a line drawing accom-

panying Visconti's Vatican catalog entry published in 1820.[53] The drawing shows the panel with its restored heads, and although Visconti recognized the restoration work, he neither explained nor dated the postantique heads.[54] The Renaissance work appears to have involved chiefly the addition of pieces that were presumably missing or severely damaged. Fortunately, the added marble restorations are immediately recognizable by their clear joining seams and different marble coloration. There appears to have been no attempt to restore the original drapery and background surfaces, which are at present damaged and substantially weathered.[55] On many areas, the marble is pockmarked due to corrosion to such a degree that tool marks and carving details have been obliterated (fig. 51).

The Neoclassical Period

With regard to the figural style and carving technique of the Ara processions, the most important alterations occurred during the neoclassical period. In the late eighteenth century, the five panels (N2, N3, S5, S6, S7) that had been discovered in 1568 and stored at the Villa Medici in Rome were sent to Florence for their eventual display in the Uffizi Gallery. In preparation for their display, the curators hired the Roman sculptor, Francesco Carradori, to restore the five marble slabs. However, in contrast to the anonymous, undocumented restorations of the late antique and Renaissance periods, two sets of detailed records help us identify Carradori's restorations. One of these is Carradori's treatise on sculpting published in 1802, which includes a description of his procedures for restoring ancient sculptures.[56] Although Carradori's book does not discuss the restoration of any specific ancient pieces, the results of the restoration methods he described and practiced can be identified on the five panels of the Ara Pacis processions. More important than his sculpting treatise, however, are Carradori's notes concerning his restoration in 1784 of the Ara reliefs, which were preserved in the archives of the Uffizi and published by Von Duhn in 1881.[57] Although neither the sculpting treatise nor the notes are as specific as one might wish, this written documentation along with the physical traces of his work on the reliefs themselves provide a good idea of Carradori's extensive restoration project.

In order to evaluate the character and extent of Carradori's work, it is necessary to assess the condition of the panels prior to his restoration. This is made possible by sketches of the reliefs drawn in the sixteenth and seventeenth centuries while the sculpted panels were displayed at the Villa Medici. The most detailed illustrations are the drawings by an anonymous artist in the Codex Ursianus at the Vatican (c. 1600) (figs. 52–57), the Dal Pozzo-Albani collection in Windsor Castle (c. 1620–57) (figs. 58–60), and two engravings by Bartoli published in 1693 (figs. 61, 62).[58] Of the three, the most informative illustrations are the Vatican drawings, since the artists of the Dal Pozzo-Albani collection and the engraver Bartoli added imaginative details.[59] The Vatican illustrations attest to the damaged condition of the frieze panels before Carradori began his project. While Panels S5, S6, and S7 appear relatively well preserved except for the lower portions of the feet of the figures, all of the foreground heads and other high relief pieces are missing from Panels N2 and N3.[60]

In addition to the evidence of pre-eighteenth-century drawings, Carradori himself briefly

remarked on the condition of the panels prior to his restoration. According to his notes in the archives of the Uffizi, the Ara reliefs were "in uno stato assai deplorabile."[61] Carradori noticed that the panels not only showed wear from time and weather, but also had been sawed into pieces in order to accommodate their display in the Medici gardens. An early twentieth-century photograph of the panels in storage at the Museo Nazionale Romano shows this sawing of the friezes along the contours of particular figures (fig. 63). Furthermore, the reliefs suffered fairly extensive surface damage from the blows of stones thrown at the panels at some point in their history.[62]

Carradori's restoration involved three basic steps. First and most obvious to the modern viewer is the replacement of missing pieces of stone. As noted previously, the neoclassical, foreground heads on Panels N2 and N3 are his work (fig. 64), as are two heads on the South frieze (fig. 65). Less apparent is the fact that Carradori also replaced with his own marble additions missing or damaged portions of hair, drapery, feet, background and facial features on all five panels. That Carradori recut the original broken parts and removed original stone is attested by the nature of the joins after the removal of his additions. For example, modern restorers have removed Carradori's noses on figures s32 and s28 (identified by most as Livia and Agrippa, respectively). Their present appearance illustrates how Carradori cut back and leveled clean the original remains of the figure's nose for the eighteenth-century attachment (figs. 66, 67). In this instance, it is clear that Carradori removed original marble during his restoration.

The final two stages of Carradori's restoration are more subtle and concern surface treatment and texture—two crucial areas for interpreting the artistic traditions of the original carvers. The most efficient method of determining the extent of Carradori's surface restoration procedures is to compare the technical details on the panels he restored (especially Panels s5, s6, s7) with the techniques preserved on Panel s4 and the fragments that were not discovered until the early twentieth century. In addition, Carradori's work on the restored panels of the North and South friezes can be compared with the tool marks and surface treatments on Panels N1 and N4 (not restored by Carradori) for further technical discrepancies.

Because much of the surface was worn or damaged, the restorer recut original surfaces to "clean up" the overall damaged appearance and either removed or smoothed rough areas of original marble. There are significant marks from a wide-toothed claw chisel on several areas of the drapery of figures s45 and s46 (figs. 68–70). They appear to have been made on top of the finished surfaces of the folds and have been identified as the work of Carradori.[63] In addition to actually recarving the stone with sculpting tools, Carradori applied an acidic solution, perhaps to the entire marble surface, in order to remove unwanted debris and make uniform the color and texture transitions from original sections to his own additions.[64] The surface of the rightmost figure on panel s7 (figure s46) clearly shows the corrosive effects of the acid-bath wash (fig. 71). An excellent way to measure the amount of marble removed by Carradori's acid washing is to compare the tooling preserved on the caps of the four flamines. The rounded curve of the caps worn by two flamines on Panel s4, which were not restored by Carradori (s20 and s22), show clear traces of the scraper as it was dragged across the surface (figs. 23, 24). The surface of the caps worn by the two flamines (s23 and s24) on Panel s5, which Carradori

restored, have no traces of this tooling. Instead, the surfaces have been removed with acid and, in some areas, lightly rasped by the eighteenth century restorer (figs. 72–74).

These two methods, recutting and acid bathing, are chiefly responsible for the smooth crispness of the carving on the reliefs, especially noticeable for the imperial family group on the South frieze. Essential to a full appreciation of Carradori's restoration is the acknowledgment that the eighteenth-century restorer, working in the neoclassical artistic milieu of his time, was commissioned to reconstruct and recarve damaged ancient reliefs in order to make them more aesthetically acceptable to contemporary viewers. Many scholars, especially those proponents of the Greek master theory, have remarked upon the delicate, crisp carving of the Ara processions. Yet, it may just be possible that the five panels which were restored by Carradori display such neoclassical features as smooth finish and sharp outlines because the reliefs were extensively reworked during the eighteenth-century neoclassical period. The present appearance of the processional friezes, especially the eastern half of the South frieze, very likely is not truly representative of its original Augustan condition.

The Louvre Panel

While the majority of the panels of the Ara Pacis processions unearthed in the sixteenth century had undergone at least two restorations by the late eighteenth century, the panel that was eventually to become part of the Louvre collection underwent further restorative projects.[65] The first postantique restoration of Panel N4 took place in the early nineteenth century, during the Napoleonic occupation of Rome. Following the relocation of the panel from the grounds of the Palazzo Fiano to the Roman residence of General Miollis, governor of Rome, the damaged relief was provided with plaster additions by the sculptor, Annibale Malatesta. A drawing from the Dal Pozzo-Albani collection illustrates Malatesta's work (fig. 60).[66] However, since these plaster additions were not permanently attached, and since Malatesta did not recarve original surfaces, his restorations of the Louvre panel were easily detached, with no adverse effects upon the Augustan relief.

Sometime after 1835, while the panel was the property of the Marchese Campana, more radical changes were made. Malatesta's addition of a female head and outstretched arm on figure N36 were removed and in their place was attached with wax a marble portrait of Antoninus Pius.[67] As a result, the entire content and date of the relief changed. In the catalog of the Museo Campana, Panel N4 is described as a sacrificial scene with Antoninus Pius and Faustina from some unidentified large-scale second-century A.D. monument.[68] Once again, however, the anonymous Campana restorers left most of the original surface undisturbed. It was not until Petersen recognized the relief as belonging to the Ara Pacis that the restored portrait of Antoninus was removed. Despite these two restorations in the nineteenth century, the present condition of the Louvre panel preserves a generally accurate record of the original Augustan relief and the possible subsequent post-Augustan ancient recarving.

The Fascist Period

Following Petersen's identification of the fragments of the Ara Pacis and the new discoveries resulting from the campaigns of Pasqui and Moretti, the entire Augustan altar was hastily reconstructed in 1938. Recently published correspondence and notes from the committee established by Mussolini to direct the project reveal an urgency to erect the Ara Pacis in time for the grand Fascist celebration of the bimillennium of Augustus's birth (fig. 1).[69] The rushed schedule of the project forced the reconstructing team to join as many panels and fragments as possible (generally according to Petersen's scheme), in order to create the impression of a complete and coherent monument. The joins made during the Fascist period, which were often disguised by plaster when original edges did not match, have led to confused areas in the present composition of the North and South friezes.[70] Fortunately, however, the Fascist-period reconstruction did not involve any actual recarving of the reliefs themselves. Consequently, the 1930s phase had no effect upon the original details or sculptural technique.

Summary

The majority of the processional panels have undergone several phases of restoration and recarving, which have altered to varying degrees their original Augustan appearance. The area of the eyes on the figures from the North and South friezes, including panels and fragments discovered in the twentieth century, may have been incised and occasionally drilled during an undocumented ancient reworking that occurred either in the second century A.D. and/or the late antique period. Five panels (s5, s6, s7, N2, N3) underwent more extensive restoration in 1794 by the neoclassical sculptor, F. Carradori. The eighteenth-century work involved (1) the attachment in marble of missing portions of anatomy, drapery, and implements, (2) a recarving of original surfaces, both for the new attachments and to reduce the visible effects of damage from weather and deliberate mutilation, and (3) the application of an acidic solution, which resulted in a smooth surface finish and the probable loss of most Augustan and late antique tool marks. The restorations carried out in the Renaissance, the mid-nineteenth century, and the Fascist period had little effect on details of rendering and technique, although these restorations have resulted in problems concerning the composition of the friezes.

For the purposes of identifying and analyzing original Augustan carving, the most informative parts of the processional friezes are those which have undergone the least amount of post-Augustan restoration—Panels s3 and s4, the fragments discovered in the early twentieth century, and the Louvre panel. The panels restored by Carradori and Panel N1, however, occasionally do preserve evidence for the original contours of details and the overall structure of anatomical and drapery sections. It is these traces of original tooling and the details of form to which we must now turn in order to assess the artistic traditions of the Augustan carvers of the North and South friezes.

4 THE AUGUSTAN ARTISTS OF THE PROCESSIONAL FRIEZES

As discussed earlier, both contemporary and later classical texts are silent regarding the artists who sculpted the large processional friezes on the Ara Pacis. Ancient writers such as Pliny and Vitruvius, who otherwise filled their treatises with minute and often seemingly mundane details, showed no interest in recording the identities of any creators of Roman public relief sculpture. There are few clues in the ancient written record other than the one Latin signature on a Trajanic relief in the Louvre and the chance epigraphical reference to a *marmorarius*.[1] For those who investigate the mechanics of artistic production and the personalities behind the creation of such a unique and influential body of material as Roman historical reliefs, the monuments alone stand as testimony to the efforts of their creators. With respect to the processional friezes on the Ara Pacis in particular, a search for the hands of the Augustan artists is further complicated by the series of post-Augustan restorations that have obscured and even obliterated the work of the original anonymous sculptors. To be sure, it is unlikely we will ever recover their biographies or even their names. However, their training, their aesthetic preferences, and their techniques—what we can call their *artistic identity*—are detectable. It is possible to draw a clearer picture of those now anonymous craftsmen hired sometime after 4 July 13 B.C. to execute one of the most remarkable structures surviving from Augustan Rome because portions of the processional friezes were not restored by Carradori or by other postancient reworkers. The keys vital to identifying the artistic heritage of the Augustan carvers are original tool marks and details of form, and in many areas these marks have survived.[2] No less important than the evidence itself, however, is our level of sensitivity to and appreciation for the physical clues left on the Carrara marble slabs some two millennia ago.

STYLE AND SCULPTURAL TECHNIQUE: INTERDEPENDENT ELEMENTS OF ROMAN RELIEF PRODUCTION

Figural style, the formal characteristics of the final product, and technique, the physical activity of rendering these characteristics on a block of stone, are

integral aspects of the sculpting process. Technique in the broadest sense of the term is the crucial, determining link between the artist's conceptualization of how a figure *should appear* and how the finished product *actually appears*. Throughout the active process of creating, the artist continually decides which tools to use and how to apply those tools. He does so at a deliberate, conscious level but, more often, at a trained, subconscious level. If the final product he creates resembles one or more art-historical style categories (for example, "Greek archaic" or "Augustan neoclassicizing"), this stylistic identification is due not only to the artist's design or to his selection of various iconographic elements, but it is also due to how individual details were physically hewed out by his hands. The interdependent relationship between tool use and final form is crucial to understanding the sculptural tradition of the artist behind the creation.

Unfortunately, however, in many studies of Roman sculpture, style and technique too often are treated as separate, unrelated phenomena. Frequently discussions of sculpting techniques and tool use, relegated to a separate subheading or appendix, read as documentary exercises or filler addenda to broader chapters on stylistic analysis.[3] Yet traces of tooling warrant more serious scrutiny. For relief sculptures, especially those produced in Rome during the republican and imperial periods, the often numerous marks left on the stone by the carvers as they struck, scraped, or bored with various types of chisels, rasps, drills, and other instruments are the "technical signatures" of these otherwise anonymous creators. The study of sculptural technique should focus on the relationship between individual forms and how they were carved by which tools in what sequence rather than simply describing without explanation or analysis a collection of random marks on the stone. It is important to recall that technical preferences learned during apprenticeship training are by nature conservative and highly resistant to change.[4] As P. Rockwell noted: "It is important to dwell on this continuity of technical tradition because the stylistic study of art and architectural history tends to erect barriers that do not necessarily exist in technology. Traditional carving methods are only modified, not completely overthrown, with stylistic change. In the lifetime of one carver there may be a great change visually, but his methods may remain similar."[5] No matter the superficial compositional and iconographic characteristics of a sculpture, the tools and tool applications that were used for carving that piece betray the conceptualization of form and the technical heritage of its creators. In other words, the tool-handling skills and aesthetic faculties of the craftsmen lie beneath the stylistic veneer of the imagery. Stone carvers trained in the sculpting methods of different traditions will not produce a figure in the same manner, even if they have both selected identical figural styles for that image. Thus, the way a style is rendered is as important as the choice of that style, and careful analyses of the techniques and details of forms have the potential to reveal to us the artistic identity of the carvers.

As noted in the previous chapter, the large processions on the Ara Pacis are characterized by layers of tool marks from different chronological phases ranging from original Augustan sculpting to relatively modern recarving and restoration. Consequently, in order to understand the interdependent relationship between form and technique, the first task is to isolate as clearly as possible the sections that are the least recarved and thus preserve the majority of original, first-century B.C. sculpting. In order to accomplish this, I have followed a two-stage procedure: first, identify post-Augustan tool marks based on comparative analysis and infor-

mation provided by archive drawings and restoration notebooks[6] and, second, recognize and document tool marks that are either similar to or in some cases identical with tool marks found on *unrestored* figural reliefs carved from stone during the first-century B.C. in Rome.[7] The traces of tooling on the Ara processions that compare closely to marks on unrestored contemporary Roman reliefs can be considered original Augustan work. Marks that relate neither to a known post-Augustan restoration nor to first-century B.C. figural carving may be either traces of an unknown later restoration or evidence of carving innovations introduced by the Augustan sculptors. In light of the apparent novelty of the overall design of the Ara Pacis Augustae and its incorporation within the Horologium complex and the larger urban landscape of the northern Campus Martius, perhaps we might expect a few technical experiments on the part of the sculptors. On the other hand, tool use that is atypical for pieces carved during the first century B.C. in Rome may also point to the introduction of techniques and/or craftsmen from outside the urban republican tradition. For this reason, the carving preferences of artists working in the Greek East during the late republican and early Augustan periods must be considered. In fact, it will be shown that there is evidence on the Ara processions for experimental innovations and adaptations that suggest an increasing Hellenization of the sculpting practices of the urban relief-carving workshops that operated in Rome during the later decades of the first century B.C.

GREEK AND ITALIAN FIGURAL RELIEF-CARVING CHARACTERISTICS

In order to appreciate the extent to which the Augustan sculptors of the Ara Pacis both relied on established local Etrusco-Italian carving traditions and simultaneously experimented with contemporary Greek techniques, it is necessary to review briefly the major differences between the traditions of Greek relief sculpting and the tendencies of stone carvers working in Rome in the second and first centuries B.C. prior to the voting of the Augustan altar. I present these discrepancies between Hellenic and Italian stone carving with great trepidation due to the obvious danger of oversimplifying the situation and thereby misleading the reader. The problems with differentiating between these two sculpting traditions include the facts (1) that our present knowledge of ancient tooling is at best rudimentary,[8] (2) that we have yet to explore fully the sculptural techniques used by carvers working in the Greek East after the classical period, and (3) that, during the period in question, not all artists in the Greek East nor in Italy carved in the same manner. The lacunae in our information for Hellenistic relief sculpting in particular must profoundly affect any attempt to summarize the methods of sculptural production in the classical world. Taking all these difficulties into consideration, we ought to avoid neat summaries of ancient carving practices, especially since such summaries by their nature involve grouping all sculptors into rigid, artificial categories. Artists are and were certainly more flexible individuals, adapting and creating according to, or in some cases independent of, contemporary historical, social, and economic circumstances.

Nevertheless, by careful study of sufficient numbers of comparative pieces, several scholars have been able to isolate various technical and aesthetic tendencies displayed by most sculptors

during particular chronological phases and in limited geographical regions. These preferences can be understood as the basic (but not necessarily the all-inclusive) characteristics of distinct sculptural "schools" or traditions. For example, some attention has been paid to carving practices in Greek relief sculpture for the earlier archaic and the classical periods in and around the region of Athens. Albeit somewhat simplistically, the basic stages of Athenian Greek relief carving have been most comprehensively discussed by Sheila Adam in her work, *The Technique of Greek Sculpture in the Archaic and Classical Periods.*[9] According to Adam, some of the most important characteristics for Athenian sculpting practices for figural reliefs during the classical period are (1) an approach to carving figures whereby the outline of the figure is established first and then the background removed to isolate the three-dimensional block of stone that will eventually become the figure,[10] (2) the extensive use of the drill for outlining and separating the figure from the back plane,[11] for carving the intricate hollows and furrows of elaborate drapery folds, and for sculpting the deeper details of the face (nostrils, eyelid creases, lip crease, ears),[12] (3) the use of various types of chisels to model the forms, and (4) the removal of all tool marks from the surfaces of the figure (especially the surfaces of human skin) and occasionally the background by meticulous smoothing with fine chiseling and a variety of abrasives such as emery or pumice. "The surface the Greeks wanted was free from all extraneous marks. Ideally, every tool mark should be removed. Claw and flat in turn removed the marks of previous tools even while they added to the modeling, and we shall see how rasps removed the marks of the flat and abrasives smoothed away all sign of the rasps."[13] Adam also noted that the gradual decrease in attention paid by Greek sculptors to the complete removal of marks left by the chisel and rasp typically are seen as indicative of a decline in the high standards of Greek sculpture that took place during the course of the fourth century B.C.[14] In fact, a prejudice which runs throughout Adam's study and many other discussions of Greek sculpture and technique is that polished or smoothed surfaces are exquisite and beautiful while unpolished surfaces on classical Greek reliefs on which one can discern the marks of a chisel or rasp must have been the result of accidental oversight or deliberate unfinish.[15] Thus roughly tooled surfaces are interpreted in most studies of classical Greek stone sculpture as aesthetically unpleasant and are not representative of the finish intended by skilled Hellenic sculptors.

During the course of the Hellenistic period on mainland Greece, a gradual change occurred in the finishing of drapery and background surfaces on stone statuary. Rather than smoothing the drapery folds and relief ground with abrasives, sculptors often left the surfaces lightly rasped.[16] However, for the most part, flesh surfaces continued to be smoothed. Traces of rasping left unsmoothed by further abrasion also occur on reliefs from Asia Minor. On a funerary relief for a certain Euripedes from Smyrna dated first century B.C./first century A.D., scratches from rasping were left on the back plane while the figures were completely smoothed.[17] Earlier examples of tooled background surfaces are the sculpted coffers from the Belevi Tomb (300–250 B.C.) in the Izmir Museum.[18] Instead of rasp work, the Hellenistic carver has left light traces of the claw chisel on the background while completely smoothing all surfaces of the figures. Yet, despite this increase in rasp or tooth chisel marks on surfaces, an aesthetic preference for smoothed surfaces continued to flourish in southern Anatolia in the Augustan period. On both the Zoilos frieze[19] from Aphrodisias (dated c. 30 B.C.) and on the large relief frag-

ment from the cenotaph of Gaius Caesar from Limyra (dated soon after A.D. 4) displayed in the Antalya Museum,[20] almost all the surfaces of both the background and the figures have been smoothed with abrasives. Although admittedly much more detailed study needs to be done on the sculpting techniques of Greek relief carvers working in the East during the late Hellenistic and Augustan periods, it appears that during these phases there were at least two approaches toward surface finishing. While many stone relief sculptors (especially those working in Greece proper and in northern Anatolia) preferred to leave rasp or tooth chisel marks on the surfaces of drapery or on back planes, carvers working in Caria and Lycia tended to maintain the traditional classical preference for smoothed, markless surfaces.

The identification and analyses of the characteristics of relief carving in Rome during the middle and late Republic have been more complicated tasks.[21] Reasons include the fact that far less material has survived, and that a wide variety of influences shaped the development of Italian stone carving. The often underestimated persistence of the strong Etruscan tradition of sculpting in both stone and in terra cotta was combined with Hellenistic Greek ideas and techniques imported to Italian soil through both trade and, perhaps more importantly, through the immigration of craftsmen. Both artistic currents may have altered native Italian, specifically Latium, aesthetic and technical sensibilities. Another more immediate problem associated with the study of local Italian sculpting preferences is the fact that the very existence of an indigenous and vital tradition of creatively shaping stone in Italy following the Etruscan domination of the seventh and sixth centuries B.C. is not universally accepted by scholars. Despite the relative wealth of available evidence, the only detailed study of sculptural styles and their relationship with carving techniques used for second- and first-century Roman reliefs is E. Gazda's work on republican funerary sculpture.[22] In her work, Gazda has examined closely the influences of Etruscan and Greek Hellenistic carving practices on what she has identified as the "vernacular" tradition of Roman portraiture. In her discussion of the early first-century travertine funerary relief of the Blaesius family, Gazda notes the following carving traits, which she defines as typical of this local, indigenous tradition: (1) all surfaces of the figure and the background have a rough texture created by either the claw chisel (typical for backgrounds) or flat or bull-nosed (rounded) chisel (typical for figures) with no further smoothing, (2) very little use of the drill or rasp, (3) an emphasis on ovoid masses in portraying heads with little interest in representing underlying skeletal structures, (4) distorted anatomical proportions, and (5) a preference for abbreviating both anatomical and especially drapery forms to basic, geometrically abstract shapes with an emphasis on flat, angular planes and linear surface designs.[23] Even a cursory comparison of Hellenic and Etrusco-Italian sculpting practices reveals that the approach of the local stone sculptor working in republican Rome to carving a figure in relief was from the outset extremely different from that of the relief sculptor working in the Greek East.

In addition to the basic characteristics discussed by Gazda, P. Rockwell has astutely recognized another technical feature apparently unique to stone figural reliefs carved in Rome. Rockwell has observed that the Italian carver established the most basic contours of the figure with the point or chisel and then proceeded to work the figure first, from the foreground plane to the background plane—that is, from front to back rather than following the Greek approach

of establishing the entire solid mass of the figure before sculpting the details within the mass.[24] "The [Roman] carver's reference plane was always the front plane of the stone."[25] The Italian relief sculptor either removed the superfluous background stone as the figure was being sculpted toward the relief ground or, more often, left it to be removed toward the end of carving and, in the process of carving the figure, may have used this stone to rest or steady his hands or tools. One effect of this Roman carving approach was that the figure was not initially outlined with the drill and separated from the back plane as was the case in classical Greek sculpting. Thus we find that many figures on late republican and early Augustan funerary reliefs merge directly into the background plane. The tooling on the stone itself reveals that the Roman funerary relief carver was working back into the stone in a series of successive layers.[26]

The importance of Gazda's and Rockwell's observations cannot be underestimated. This method of "layer sculpting" and surface texturing may be directly associated with observations concerning figural style made by G. Kaschnitz von Weinberg. Kaschnitz argued that the Roman sculptor paid most attention to the surfaces of figures rather than to approximating the organic relationship between the flesh and an underlying supportive structure. Specifically, in reference to portraiture during the Augustan period, he notes: "With Augustus, Greek structure, as achieved by Roman conceptualizations of form, is completely taken over and Italicized. In this transformation, which concerns the surface and the relationship of volumes, the inner tectonic forms are conserved although changed so to speak into a fossilized condition. The true Italian approach to creating forms is concerned only with the development of boundaries. It cannot and indeed it does not intend to form a solid structure of substance."[27] For heads carved by locally trained Italian sculptors, the facial features lie on the surface of the three-dimensional volume of the head rather than being incorporated as a coherent, interactive part of the overall skeletal and muscular structure. As Gazda had noted: "The Roman mason simplified the structure of the head, reducing the complexities of the interrelationship of the separate parts by treating them as individual areas adjacent to but not interlocked with one another. For conveying the superficial design of the head he depended upon quick shifts in the direction of planes and upon incisions in the surface."[28]

Thus, Gazda, Rockwell, and Kaschnitz, through separate avenues, have described the two complementary sides of the interdependent relationship between technique and style in Roman sculpture. Consequently, we can discuss the native approach to figural relief stone carving in republican and early imperial Rome as based on a conceptualization and subsequent translation of forms by concentrating on exterior surfaces and the carving of those surfaces as a series of receding layers from the front plane to the back plane. If features appear to lie disjointed on the surface of a figure carved by an Italian-trained sculptor, this is due in great part to the fact that even before his sculpting tools struck the stone, the Italian carver did not conceive of the figure as a three-dimensional form with a substantial underlying supportive structure separated from the back plane. Rather, the various parts of a sculpted figure were seen as resting on the exterior boundaries of receding relief planes. The stone beneath these surfaces merely occupied the void between the layers of features.[29] The continuing vitality of "layer carving" as the aesthetic and technical tendency of local Italian sculptural traditions will be-

come more evident when we turn to the analysis of tool marks and the details of form on the processional friezes of the Ara Pacis.

TECHNIQUE AND STONE

In addition to how the sculptor approached the stone with various carving tools, one of the more important factors for understanding any sculptural tradition, including Greek and Italian sculpting practices, was the type of stone selected by the patron or artist for the work. Different types of stone require different tools and different uses of those tools. As Rockwell pointed out in *The Art of Stoneworking*, "the working properties of a stone are a combination of definable physical characteristics with 'feel.'"[30] The type of stone worked by the carver will influence the way he learns to carve. While some stones, such as marble, can receive a high degree of intricate detail, others with a less compact grain structure and/or lower tensile strength are inherently unsuitable for elaborate detailing. For much the same reason, certain types of stone react well to smoothing with rasps or abrasives while others, because of their physical characteristics, simply do not warrant the effort. As Rockwell noted: "The nature of stone, its receptivity to abrasives as smoothing agents, is what defines its polishability rather than the skill of the workmen."[31]

In the third millennium B.C., sculptors on the Cycladic islands exploited local marble for figurines and statuettes and discovered the polishability of marble with locally found abrasives. As early as the late seventh century B.C., Greeks on the mainland and along the coast of Asia Minor also found marble to be a suitable and available material for stone sculpture. They soon became familiar with the varieties of statuary marble, their physical qualities, and tool receptivity. New tools (such as the tooth chisel) were invented by Greek artists to sculpt this relatively hard but visually pleasing and durable stone.[32] Numerous reliefs and freestanding pieces attest to the fact that intricate detailing and polishing were highly developed techniques in Athens by the latter half of the sixth century B.C. As the carving of the great friezes from the Altar of Zeus at Pergamon illustrate, relief sculptors working in the Hellenized capitals of Asia Minor during the Hellenistic period were masters at shaping and manipulating marble with a sophisticated variety of tools and tooling techniques.

The stone supply in Italy was an entirely different matter. Although there is now substantial evidence for the discovery and use of the white marble from the Carrara quarries around the ancient town of Luna as early as the sixth century B.C., such employment remained on a relatively small scale.[33] Marble essentially was unfamiliar to most local stone workers and they had little or no experience with its working characteristics. Even up to the middle of the republican period, when marble was used for a piece or a construction such as the round Temple of Hercules Victor near the Tiber River, not only was the marble imported from Greece, but so were the Greek stonemasons to carve it.[34] The absence of locally carved marble statuary and architectural ornament in Italy before the late Republic, however, does not necessitate a lack of a local stone-carving industry. The Italian tradition of stone carving developed not from working polishable marble, but from sculpting the more porous, brittle stones native to the Italian peninsula: the volcanic rocks of tufa and nenfro as well as travertine and limestone. Since these

local stones do not readily accept intricate detailing or polishing due to their geophysical characteristics, the Italian carvers could not drill intricate hollows or apply abrasives. In fact, the stones they most frequently worked actually discouraged them from adopting these tools and techniques. Thus, the physical characteristics and availability of stones such as tufa and travertine were crucial factors in determining both Etruscan and especially Italian stone-carving methods. Unlike their Greek sculpting counterparts, who relied on and mastered the drill, the rasp, and abrasives, the Italian carvers preferred the chisel (both flat and rounded) as their primary shaping and finishing tool. This preference no doubt developed because the chisel was the most efficient tool for carving details on locally available stones. During the Etruscan and early republican periods in Rome and in Etruria, local sculptors used various types of chisels to both carve forms and produce final surface textures. Very often the marks caused by applying the chisel at an oblique angle across the surface were left with no further smoothing on both the drapery and anatomical areas of figural statuary. For this reason, several Etruscan and the majority of republican stone pieces bear a more rough, tooled-surface finish in comparison to smoothed Greek marble statuary. For those more familiar with the smoothed and polished surfaces of Greek sculpture, these rough textures may appear clumsy and unfinished. However, these *are* the final surfaces of finished pieces as they were intended by the artists. Further smoothing down of the surface was not practical and probably not desired: "The marks that tools leave on the surface of the stone can be thought of as having decorative value in themselves."[35] It was the nature of the stones along with an interest in emphasizing surfaces that helped foster in the Italian carver an aesthetic preference for roughly tooled textures.

THE AUGUSTAN CARVING ON THE ARA PROCESSIONS

For the purposes of isolating and describing original Augustan carving, the traces of tooling that survive on the processional friezes can be divided into two categories: marks on panels that were restored by F. Carradori in the late eighteenth century, and marks on sections that were unearthed during the first half of the twentieth century as well as those on the relatively less restored Louvre panel (Panel N4) from the North frieze.[36]

Sections Restored by Carradori

The evidence on the more restored sections will be discussed first. Unfortunately, on the panels restored by Carradori in the late eighteenth century (S5, S6, S7, N2, N3), very little of the Augustan chiseled surface survives unaltered. There are, however, some notable exceptions. These marks are distinctly dissimilar from Carradori's work but compare closely to tooling techniques preserved on numerous unrestored late republican figural reliefs.[37] On the restored sections of the Ara processions, they appear most often in areas located near or around the feet and hands, at the contours of torsos and heads, and in the hair of some figures. The survival of these original tool marks is probably due to the fact that they occur in "hidden" places on the relief, easily overlooked by even as extensive a project as Carradori's restoration.[38] For instance,

narrow channels left by a chisel used by the Augustan carver to shape and finish forms have survived on the lower side of Antonia Minor's right hand (s36) (fig. 75) and along the lower edge of the raised right hand of L. Domitius Ahenobarbus (s45) (fig. 76). However, overall there are relatively few vestiges of chiseled-surface finishes on the figures in the restored panels. Carradori's smoothing and recarving removed most of the traces of original tooling, particularly on the more heavily restored drapery areas.

Perhaps the most informative marks of original Augustan carving are preserved not on the actual figures themselves, but on the surfaces of the background. Wide, short, rounded chisel strokes are found frequently around the areas of the feet and on the bottom sections of the back plane and may serve as illustration of the "layer carving" approach of the Augustan sculptor. In these areas, the depth of the back relief ground is not flat and uniform but rather has a concave channeled texture curving outward at the contours of the figures.[39] The sculptor has chiseled out the back plane after finishing the legs and feet, allowing the back surface to merge with the feet of the figures. The background was not smoothed and the feet of the figures were not separated from the relief ground by a drilled channel. This chiseling technique can be found, for example, between the feet of Agrippa and the attendant in front of him (s28) (figs. 77, 78) as well as on the back plane between the feet of figures N14 and N13 (fig. 79) and figures N34 and N33 (fig. 80), and in front of figure N31 (fig. 81). Also in these areas, we can see that the lower-relief background legs, shod feet, and, in the case of figure N34, the drapery folds were shaped and roughly finished with the chisel alone.

Another important type of tool mark found on the background surface of the restored Ara panels is the shallow, U-shaped channel found along the contour of the upper sections of many of the figures. These easily identifiable concave depressions were created by applying a relatively wide rounded chisel at an oblique angle to the marble surface of the back plane. Referred to in this study as *contour chiseling*, this distinct technique most probably was one of the last steps performed by the sculptor of the upper portion of the figure (as opposed to the background carver) as he removed the superfluous background stone along the edge of the figure in the "layer sculpting" process. Despite the fact that Carradori's restoration removed much of the original surface treatment on the seven panels in question, there are significant traces of original contour chiseling around the heads of figures s33 (fig. 82), s37 (fig. 83), s24 (fig. 74), Livia (s32) (fig. 84), and the "Rex Sacrorum" (s26) (fig. 85). These traces of contour chiseling around the heads of both foreground and background figures are critical for understanding the technical heritage of the Ara sculptors. Chiseling a wide, concave channel along the contour of a figure was not part of the repertoire of carving methods practiced by Hellenic relief sculptors working in the Greek East. Instead, Greek stone carvers of reliefs in all periods consistently preferred either to drill a narrow channel along the contour line or abut the figure directly to the background with no additional delineation.[40] Creating a wide chiseled channel along the contour, however, was particularly characteristic for Italian stone carvers sculpting funerary reliefs in Rome during the late first century B.C. For example, a wide, chiseled channel follows the contour of a female head on a marble, four-figure funerary relief ("Sepolcro del Frontispizio") dated to the late 30s B.C. (figs. 86, 87)[41] as well as the contour of the right shoulder of the older male figure on the Rabirius relief dated to the early Augustan period (fig. 88).[42]

Pronounced contour chiseling encircles the head of the boy on the Servilii relief in the Vatican dated to the late 30s B.C.,[43] while less noticeable traces occur along the contours of the three surviving adult male heads on a funerary relief in Copenhagen dated to the 20s B.C.[44] The contours of all four figures on the marble Vettii relief, also dated to the 20s B.C., are characterized by varying widths of chiseled channels.[45] Like the chiseling on the Ara panels, the contour chiseling on the earlier republican reliefs is restricted to the areas around the skull and along the lines of the shoulders, often creating a "halo" effect around the head of the figure. It appears to have been part of the urban Italian process of sculpting a portrait head in relief in stone.[46] The vestiges of contour chiseling on the Ara processions strongly suggest that one or more carvers of the Augustan friezes had been trained in the Italian approach to carving heads of figures in relief.

However, not all of the heads on the restored sections of the Ara processions appear to have chiseled channels preserved around their contours. The difficulty in determining the original carving of these nonchanneled contours rests on the degree of Carradori's eighteenth-century smoothing of the surface. It is possible that Carradori smoothed some areas more than others, which in turn resulted in the preservation of contour chiseling marks along some figures and the obliteration of these marks along others. On the other hand, it is equally possible that particular figures were not originally chiseled along their contours and, if this was the case, then we may have one indication of the influence of Hellenic carving practices in the execution of the Ara processions. The heads of figures s44 and s41, both background figures in profile, adjoin the plane of the relief ground with no contour chiseling or excess marble apparent (figs. 89, 90). They appear in silhouette in a manner similar to profile portraits on coins with thin incised lines along their contours separating their heads from the back plane. From a technical point of view, this contour incision with the edge of a chisel appears to be a modification of the Greek practice of outlining the figure with a drilled channel. The resulting effect of isolating the figure is similar. What is distinctly different from the Greek manner of carving relief figures in profile, however, is the fact that the heads of s44 and s41 are significantly more plastic than their lower-relief necks and upper torsos. A similar discrepancy between the head and the torso occurs for the frontally viewed head of figure s30, whose facial features project outward in higher relief than her neck and upper body (fig. 91).

This phenomenon whereby the head of a figure is carved with more volume than its body is especially common for many republican funerary reliefs carved in Rome. One of the earliest known funerary reliefs, the four-figure travertine relief from the Esquiline dated circa 80 B.C., displays this juxtaposition of higher-relief, more three-dimensional heads sculpted atop much flatter, lower-relief necks and torsos.[47] It is apparent also for the carving of the figures on the "Sepolcro del Frontispizio" relief dated to the late 30s B.C.[48] (fig. 92), the figures on the "Santecroce" relief in the Vatican dated circa 20 B.C.[49] (fig. 93), and the male figure on a later three-figure marble relief dated by Kockel to the mid to late Augustan period[50] (fig. 94). Perhaps the most extreme example of this "volumetric head/flat relief body" approach is found on the marble relief in Copenhagen dated to the 20s B.C.[51] This particular treatment of figures in republican reliefs probably developed from an interest in visually accentuating the heads since the portrait heads function as the identifiers of the deceased and their families portrayed in the

reliefs. Unlike the heads on the Ara processions, however, many of the heads on funerary reliefs have been given an even greater sense of fullness and three-dimensionality by hollowing out the area around the portraits, rather than only by carving the head in higher relief against an even back plane. The effect is quite comparable between the portraits on republican funerary reliefs and the heads on the Ara processions, but the technique is somewhat different. The Augustan carvers wished to maintain a relatively level back plane around the areas of the heads—a characteristic preference of Greek-trained sculptors. Yet, at the same time, they desired to accentuate several of the background heads and did so by carving them with more volume and in higher relief. This duality of interests (the Greek preference for a level back plane and the Italian tendency to emphasize the heads) resulted in a novel approach that certainly adds to the sense of modulating planes and variations in relief height. The rendering of these background heads and upper torsos specifically illustrates a conflation of influences from both the Hellenic and Italian stone-carving traditions.

In addition to contour chiseling, the sculptors of the processions occasionally used the rounded chisel to create the corrugated surface texture that survives on several areas of the background plane. The most pronounced occurrences on the restored panels are in front of the face of Drusus (fig. 95) and the area between the heads of figures N37 and N36 on the Louvre panel (fig. 96). Interestingly, the use of the chisel to create the alternating furrow/ridge surface texture of the background plane was neither universal nor consistent on the Ara processions. While some carvers left a rougher, corrugated surface afforded by the rounded chisel, others followed Greek procedure and smoothed the surface with abrasives, as in front of S34 (fig. 97).[52] The preference for a textured background surface is certainly characteristic of figural relief carving in Rome in the second and early first centuries B.C. Funerary reliefs from this period show that sculptors used heavy blows of either the point and/or the claw chisel to create a very rough, "pocked" surface, which contrasts well with the relatively smoother, chiseled finish of the figures in relief.[53] Around the third quarter of the first century B.C., it appears that a change was occurring. Point marks virtually disappeared as a finished surface treatment for funerary reliefs,[54] and the claw chisel was used in a different manner. Instead of striking the stone at right angles with the teeth of the claw, the claw chisel was held at an oblique angle to the stone and struck to effectively "scrape away" the excess stone, leaving pronounced, parallel channels for a final background texture.[55] This use of the claw chisel provided an even stronger background pattern to contrast with the surface finish of the figure in relief.

The sculptors of the Ara processions employed the same oblique angle but changed the tool to the broader, rounded chisel, thereby lessening the earlier pattern effect of the background texture and reducing the contrast between the surfaces of the figures and the background. This different tool and consequent change of tool mark had the visual effect of enhancing the illusion of spatial recession for which the Ara processions are so frequently noted. The figures, especially those in the intermediate planes, more easily blend into the background. Whether this reduction of surface texture is also evidence of the influence of Greek carving practices or was instead an innovation on the part of the late first century B.C. carvers is uncertain.[56] Yet, the fact that substantial areas of the background plane on the Ara processions were actually smoothed with abrasives does suggest that traditional Greek techniques,

perhaps introduced by immigrant Greek sculptors, influenced the finishing of the relief ground.[57] If these Greek sculpting practices were being adapted to the established repertoire, it suggests an interest in technical experimentation within an otherwise conservative Italian sculptural tradition.

Original Augustan carving may also be preserved on the hair of many of the restored figures.[58] Although Carradori's reworking involved the smoothing of many surfaces by means of acid washing, many of the hair locks, especially those located nearest the back plane, appear to retain their original form. Numerous stone reliefs carved in Rome during the late first century B.C. illustrate that there was a specific, consistent manner by which hair locks were shaped with the chisel alone. For young and middle-aged male figures, the locks tend to be short and wide, with an overall C-shaped or "comma" contour. The center of these locks rises upward while the edges recede back at an angle to create a curved, wedge-shaped form. Locks closer to the face, while often thinner and longer, retain the curved shape and occasionally received shallow incised lines along the length of the lock in an effort to indicate individual hair strands. Both the hair above the forehead on the right male figure from a fragment of a travertine funerary relief in Rome dated circa 50 B.C.[59] and the locks on the older male (third from left) on a four-figure marble relief ("Sepolcro del Frontispizio"), also from Rome and dated to the mid to late 30s B.C., illustrate this "comma" lock design (figs. 98, 99).[60] This type of hair lock design, although abstract and relatively inorganic, could be carved with speed and efficiency with a few skilled strokes of the chisel. Such late republican "comma" locks are found in the hair treatment of most of the male heads on the restored procession panels on the Ara Pacis. Yet, unlike male portraits on funerary reliefs, the majority of males in the North and South processions wear laurel wreaths, caps, or veils, and the design of the hair locks often depends upon their location in relation to the head gear. On the laureate male figure s45 (L. Domitius Ahenobarbus), for example, the curved locks above the forehead and at the left temple were incised with interior strand detailing, while the shorter "comma" locks below the wreath at the back of the neck were arranged in two rows of simpler double-strand forms that lose their interior detailing as they approach the back plane (figs. 100–102). The design of the hair locks on figure s24 changes depending upon their location in relation to the priestly cap; locks above the forehead are more narrow and S-shaped (fig. 103), whereas those that emerge from beneath the cap at the back of the neck show the simpler "comma" design (fig. 104). In some cases the abstract "comma" shape was given to locks above the forehead, such as in the case of figure s26 ("Rex Sacrorum"), where thick, volumetric C-shaped curls appear from beneath his veil (figs. 105, 106), and on the background togate, laureate male s27 (figs. 107–9). An even more schematicized rendering of the "comma" lock design occurs in the hair of several background male figures, including figures s33 (figs. 82, 110, 111), N30 (figs. 112, 113), N32 (figs. 114–16), and N37 (fig. 96). In these cases, the curved locks, which are similar to each other in proportion and generally curl in one direction, are arranged in a pattern of stacked rows that wrap around the skull.

For the hairstyles of the two surviving elderly males on the South frieze, Agrippa (s28) and s44, there is some continuation from the type of hair rendering found on certain funerary reliefs dated 50–30 B.C. During the mid-first century B.C., there appears to have been a change

in the rendering of hair for elderly males. The pronounced, strongly delineated receding hairline that characterizes much republican male portraiture was being abandoned gradually in favor of a hairline, which although it still recedes above the temple, is less abrupt and contains more three-dimensional, individually carved hair strands.[61] This "softer version" of the republican hairstyle is worn by both Agrippa and the more balding s44. Despite the fact that the hair above the forehead on Agrippa has been damaged, a close observation allows one to discern the remnants of the "comma" shaped locks (fig. 117). Nearer to his right temple, the locks become longer and thinner—another characteristic of the carving of hair for portraits of older males on several mid-first-century B.C. funerary reliefs (fig. 21).[62] Figure s44 also bears the longer curling locks near and below his right temple (fig. 118), while the hair protruding from beneath the wreath is a more slender version of the standard "comma" lock (fig. 119).

In general, the sculpting of male hair on the Ara processions appears to have developed from the more caplike rendering of hair with its smaller, less three-dimensional locks that characterizes early to mid-republican male hairstyles on stone funerary reliefs carved in Rome. Although the hair locks on the Ara males were carved in higher relief, follow a more orderly arrangement, and display more variation than those on earlier funerary reliefs, the tendency toward quickly chiseling individual, abstract curved locks is the same. The drill never was used for sculpting hair on either the earlier republican reliefs or on the Ara heads.[63] The forms of the locks, while they may vary, remain relatively comparable between the Ara heads and late republican funerary portraits. The carving technique is identical.

As on the male heads on the restored panels of the South frieze, the basic hair lock forms that were originally sculpted in the late first century B.C. are preserved also on the female heads in the Ara processions. However, instead of the C-shaped or comma type of hair lock that typified male hair, the predominant shape for a female hair lock was the S-shaped strand. Thick, rounded, serpentine locks, swept back from either side of a central part above the forehead, characterize most of the hair rendering on the female figures in the South procession. Like the carving of the male hair locks, the female locks were carved with the chisel alone. S-shaped locks of varying widths frame the face from the forehead to above the ears of the veiled female figures s32 (Livia) (figs. 120–22)[64] and s41 (Antonia Maior) (figs. 123, 124). More slender curving strands carved in lower relief adorn the forehead of the veiled background women s37 (fig. 125) as well as the forehead and left temple area of the background figure s40 (figs. 126, 127). Two long flowing strands, carved in high relief relative to the face, also appear like fillets from beneath the laurel wreath of s40.[65] Figure s36 (Antonia Minor), the only foreground adult female on the South frieze not *capite velato*, wears the most elaborate, detailed hairstyle in the procession. Voluminous curving locks frame her face (fig. 19) while a braided bun emerges from beneath her laurel wreath. Like the male figures in the procession, the locks above her wreath are far more two-dimensional and follow a stylized repetitive hooked-shape pattern (fig. 128). On close examination, we can see that the hair locks around the face have been lightly incised with the edge of a chisel to indicate smaller hair strands (fig. 129). The triangular divisions of the braided bun also were carved with the chisel alone. The final adult female figure on the South frieze is figure s30 who has been identified as an eastern barbarian queen (fig. 130).[66] Unlike the Roman women, her hairstyle, obscured for the most part by her

diadem and laurel wreath, more closely resembles the shorter "comma" locks worn by males than the elegant, curving strands of the females. Only the small hooked curl that appears next to her right eye (fig. 28) and the earring in her left ear lobe (fig. 131) indicate a female gender for this background figure.

The carving of the hair of the women in the South frieze stands at the latter end of a gradual shift away from earlier republican rendering. On the earliest surviving funerary reliefs from Rome, female hair, no matter what the hairstyle, consisted of long, uniformly shaped, wavy locks indicated only by shallow incision onto what was otherwise a solid mass representing the hair. This technique appears, for example, on the travertine Blaesius relief dated circa 100–50 B.C. and on the marble relief of Stagia Ammia and P. Vaterius also dated to the mid-first century B.C.[67] During the third quarter of the first century B.C., female hair rendering becomes more three dimensional with rounder curving locks and interior strand detailing. This is particularly true for hair closest to the face—as, for example, on the female figures from the marble relief of the so-called Sepolcro del Frontispizio (fig. 132) and the marble relief of the Furii.[68] The carving of hair on the female heads in the Ara processions takes this interest in volume and detailing a step further. On the Ara, most of the female locks are sculpted as individual forms while smaller strands within these major locks are suggested by lines and furrows carefully incised to varying depths. The resulting design not only exploits the effects of highlight and shadow but also places increased emphasis in the contrasts of textures between the flat planes of the face and the curving, modulating lines of the hair. However, despite this development in appearance of the finished form, the tool used to achieve this style remained consistent. In the early first century B.C., stone carvers applied flat and rounded chisels to sketch quickly only the most basic indications of hair strands. At the time the Ara processions were carved, the sculptors of the female heads were able to manipulate the stone with flat and rounded chisels in a more sophisticated fashion. Yet, while the Augustan artists appear to have discovered, or were introduced to, marble's inherent capacity to withstand intricate chiseling of more three-dimensional forms, they continued to avoid the drill, even for hollowing out the deepest channels between the serpentine locks. These furrows, like the rest of the hair, were chiseled. Although the final Augustan surface finish of the female hair locks remains uncertain due to Carradori's smoothing, the original carving of the S-shaped hair strands on the women in the processional friezes, especially on s36 (Antonia Minor), demonstrates confidence, patience, and skill in applying the chisel to marble. It also indicates a greater familiarity with the sculpting properties of marble and therefore may be the work of a carver or carvers trained at a workshop with better access to marble supplies.

While the rendering of individual hair locks for adult figures generally conformed to two basic types (C-shaped for males, S-shaped for females), the carving of hair worn by the children in the processions shows more variation in forms. Unfortunately, on the restored panels of the North and South friezes, much of the children's hair has been severely damaged or weathered. For example, on figure s43, a foreground figure of a young girl often identified as Domitia, daughter of L. Domitius Ahenobarbus, most of the surface of the hair has been removed. A few scant traces of chiseled curving locks appear from beneath the poorly preserved braid that wraps around her forehead (fig. 133). Although the surfaces on the head of

figure S38, a foreground boy frequently identified as the young Germanicus, son of Drusus Minor and Antonia Minor, also were worn down, better-preserved traces of chiseled C-shaped locks similar to the adult male type do survive (fig. 134). In both these cases, it appears that the young Romans received hair lock designs similar to the adult types.[69] Although the appearance of children in Augustan representation is typically considered a result of Augustus's personal and official promotion of traditional Roman family values and the importance of procreation among the upper class, children do occasionally appear in funerary reliefs dated prior to the consecration of the Augustan altar. However, representations of children on earlier Roman reliefs tended to be limited to background heads (either a floating portrait bust type or appearing from behind the shoulders of the adults) rather than the more prominent, full-figure, foreground images on the Ara processions. A comparison between earlier republican children's hair rendering and that on the Ara friezes shows a change in form but a continuation in technique. Despite the poor state of preservation, the hair of the two girls on the limestone Vettii relief, recently dated to circa 40 B.C., illustrates the typical flat caplike treatment.[70] Traces of chiseled locks survive on the severely worn surface of these heads. On the later "Santecroce" relief in the Vatican, dated around 20 B.C., the flat curving locks of the male child in the center of the composition likewise were sculpted with the chisel alone.[71] The hair on the Roman children in the Ara processions, while more volumetric with more individualized strands, essentially was carved by the same chiseling technique. The absence of drill work once again is characteristic of both republican representations and the carving of the friezes on the Ara Pacis.

For the child clutching the toga of Agrippa (S31), recently identified as a foreign hostage,[72] there is a significant change in the rendering of hair. Unlike the more flat, modified adult versions on the Roman children, the barbarian child wears thick curling locks that fall down upon his face on either side of a central part. Particularly interesting are the tubular-shaped locks that appear from beneath his headgear at the back of the neck. While the hair of the Roman children seems to have been carved with the chisel alone, this more volumetric treatment was produced with both the chisel and the drill. The chisel was used to shape the curl forms, after which the carver applied a narrow bit drill to outline and undercut some of the contours of the larger locks and to highlight with drilled depressions the centers of at least seven circular curls (figs. 135, 136). The same combination of a chisel and drill was also applied to the hair of the second barbarian child on the North frieze (N35) (figs. 137, 138). In this case, long serpentine locks shaped only with the edge of a chisel hug the contour of the skull as they fall down from a central braided part. At the neck, a deeply chiseled incision marks the point where the locks angle sharply forward to end in a row of circular curls enhanced with uniformly sized drilled holes. On both of these barbarian children, the chisel was the primary tool for shaping while the drill was used sparingly for the decorative purpose of creating distinct shadows. The tentative application of the drill suggests that the carver was experimenting with a relatively unfamiliar tool, possibly in an effort to differentiate the hairstyles of these non-Roman children from the young members of the imperial household. Since the drill was never used for carving hair on reliefs produced in Rome during the republican period, perhaps we might speculate that, at a deliberate and conscious level, the carvers of the Ara Pacis considered this limited drill work particularly appropriate for enhancing the foreign or exotic character of these children's

hair renderings.[73] The drilling of the barbarian children's hair on the Ara Pacis might serve as evidence for the possibility that particular techniques and surface finishes, whether familiar (rough chiseling) or imported (drilled holes), could contain meaningful associations for both the ancient sculptor and his contemporary audience.

Despite the fact that many of the hands of the figures in the restored panels of the processions were heavily reconstructed by Carradori, enough instances of original hand carving and design survive to assess the technique and design of these features. In this case, the hands of figures on the panels restored by Carradori can be discussed along with those found on sections not reworked by the late eighteenth-century sculptor. The majority of hands on the Ara processions consist of an unnaturalistically rendered, solid, boneless mass of the hand proper with little or no indication of the knuckle bones or of the muscles. The fingers merely merge out from this swollen form and often wrap around drapery folds, laurel branches, or other implements with little indication of the separate joints of the fingers, as for example on the left hand of s36 (fig. 75). Frequently these boneless fingers are too long (e.g., the right hand of s41, fig. 139) and unnaturalistically curve upward at the location of what should be the second joint. They often bear fingernails that are basically squarish, semicircular depressions at the fingertips, as on the left hand of flamen s20 (fig. 140). The fingers themselves are separated from one another by shallow incisions or drilled channels. For example, note the abbreviated design of the left hand of s46 (fig. 141). Here the flat rectangular forms of the fingers are separated from each another by chiseled incisions and from the awkwardly placed thumb by a drilled furrow. The fingers end abruptly with squared-off tips while the attenuated thumb displays the characteristic swelling at the second joint and the depressed, square fingernail.

Many of the original hands display a particular type of design; the first two fingers are larger and rise up from the hands either at a bent angle or in an outward extension while the two smaller fingers are rendered as flatter cylinders and in lower relief (fig. 15). This design is the common convention for the sculpting of hands found on the majority of funerary reliefs carved in Rome during the first century B.C. and appears to have been inherited from Etruscan hand design formulas.[74] Compare, for example, the rendering of hands and fingers on the Ara processions with the hand arrangements consisting of prominent pointer and middle fingers coupled with shorter, more squared ring fingers and little fingers on the Blaesii relief,[75] on the male figure on the Stagia Ammia relief,[76] on the Aelius relief,[77] and on the later Furii relief.[78] Also note the similarities between the rendering of the half draped hand of s41 (Antonia Maior) (fig. 142) and the similarly draped left hand of the woman on the Via Statilia relief.[79] Although the arrangement of the individual fingers is different, both hands display jointless digits and a hand that swells to a rounded form at the center, then tapers awkwardly back into the relief. When the hand is depicted as completely covered by cloth, it is suggested by routinely carving a rounded, boneless, distorted mass, as, for example, for the right hand of s32 (Livia) (fig. 143), the left hand of n40, and the right hand of the female figure on a three-figure funerary relief in the Palazzo Mattei (20–10 B.C.).[80] The unnaturalistic, elongated designs of boneless hands on the Ara processions can be directly related to Etrusco-Italian traditions of depicting hands on earlier republican funerary reliefs.

Sections Not Restored by Carradori

While the post-Augustan restorations, particularly those by Carradori, removed a significant portion of the original Augustan surface on Panels S5, S6, S7, N1, N2, and N3, the fragments and the two panels from the South frieze (S3 and S4), which were not discovered until the early twentieth century, retain substantially more original carving. It is, in fact, on the panels showing the emperor, his attendants, and the lictors that the clearest evidence of original tooling survives. On the major surfaces of these sections, four types of tool marks survive: rasping, scraping, drilling, and rounded chiseling. As discussed in the previous chapter, the marks from rasps and scrapers may be original first-century B.C. tooling, which betrays the influence and adoption of Greek sculpting techniques. These marks also may have resulted from a post-Augustan restoration of the friezes conducted at some point before the reliefs were buried beneath the Campus Martius.[81] At the present, a case can be made for either conclusion. Further study of Greek Hellenistic as well as republican and imperial Roman sculptural techniques may clarify the origin of these marks. On the other hand, it is far more certain that the traces of drill work and surface chiseling are original tooling. The carving techniques preserved on a substantial quantity of unrestored republican pieces carved in Rome prior to and contemporary with the Ara processions compare exactly with the drilling and the rough chiseling on Panels S3 and S4 and the various fragments. The original carving on these sections of the friezes indicates that the rounded chisel, the primary instrument for republican stone relief sculptors, was in fact the most important tool for both shaping and finishing the flesh, hair, and drapery of the figures on the Ara processions. Having inherited the sculptural traditions of their republican predecessors, the carvers of the procession friezes on the Ara Pacis were likewise efficient, skilled masters of shaping stone with a chisel. Furthermore, as was the case with artists working in Rome during the second and first centuries B.C., the artists of the Ara Pacis occasionally experimented with Greek techniques for finishing the surfaces of a material recently introduced to urban Roman sculptural workshops—white Carrara marble quarried from the hills near the northern Italian town of Luna.

Marks from rounded chisels are found on various areas of the portions of the South frieze unearthed during excavations in the first half of the twentieth century. Numerous sections of drapery, especially at areas around the shoulders and on the upper torsos of the figures, show that both the folds and the furrows were originally shaped and finished with the chisel alone. Clear traces of chiseling are found on the drapery at the shoulders of lictor S13 (fig. 144), along the right arm of S13 (fig. 145), at the left shoulder of lictor S14 (fig. 146), and at the upper torso area of figure S12 (fig. 147). The upper drapery folds and furrows of the attendant standing in front of Augustus (S15) have been carved with the rounded chisel alone (figs. 148), as has the drapery covering the left arm of the attendant to Augustus's left (S17) (figs. 149–51). Also carved primarily with the chisel are the folds at the left shoulder of flamen S20 (fig. 152). The upper drapery of Augustus himself was shaped and finished with only a rounded chisel. Prominent chisel strokes survive along the cloth at his left shoulder (fig. 153) and his right shoulder, on the folds of the veil that falls behind his face on the back plane (figs. 154), and along his extended left arm (fig. 155). In all these instances, the drapery was rendered as series of flat

creases with sharp edges. Rather than voluminous, flowing folds, the chisel created abrupt transitions between the furrows and creases, as if the costumes were made from rigid cardboard rather than pliable cloth.[82] This chiseling method on the figures in Panels s3 and s4 and in the fragments differs significantly from drapery treatment typical for relief figures carved in the Hellenistic East.

As noted earlier, working within Greek traditions of sculpting, marble carvers in Greece and Asia Minor usually took full advantage of marble's receptivity to the drill for hollowing elaborate drapery channels and to rasps and abrasives for softening the edges of the marble folds in order to achieve the effect of smooth, draped fabric.[83] The tendency to carve drapery folds with only a chisel and leave the folds roughly chiseled with no further smoothing is highly characteristic of sculpting techniques practiced by Italian stone relief carvers working in Rome during the first century B.C. For example, the exact same manner of carving drapery as it appears on these unrestored areas of the South frieze also occurs for the drapery of the figures on the Via Statilia relief (fig. 156),[84] and on the four-figure "Sepolcro del Frontispizio" relief.[85] In fact, even a rapid survey of the rendering of drapery on stone funerary reliefs carved in Rome during the first century B.C. reveals that Italian sculptors consistently used the rounded chisel to shape and finish drapery folds.[86] The remarkable similarities between the chiseling of the drapery folds on Panels s3 and s4 of the South frieze and the sculpting of drapery on stone funerary reliefs carved in Rome during the first century B.C. illustrate the continuity of republican relief-carving techniques and aesthetic preferences into the early Augustan period. It also reveals communication and perhaps cooperation between sculptors of private commissions and artists of official public projects in late first-century B.C. Rome. It may even suggest that in the case of the western half of the South frieze, carvers of private funerary reliefs actively participated in the execution of this particular imperial project.

In the rendering of drapery, the Augustan sculptors of the Ara friezes occasionally used the drill, but in a manner entirely different from Greek use. Instead of exploiting the unique capability of the drill to hollow out complicated areas of negative space, the original carvers of the Ara processions used a narrow drill bit simply to outline the edges of the more major drapery folds (figs. 157–59). Often it appears that the drill was applied after the fold and furrow had been carved with the chisel in an effort to enhance the play of light and shadow across the surface. The drilling of the drapery is linear and two-dimensional, especially on the unrestored Panels 3 and 4 of the South frieze.[87] The minimal use of the drill on the drapery in these panels may indicate that the sculptors were unaccustomed to using the tool and were experimenting with the process of drilling stone. Yet the carvers of the Ara Pacis were not the first artists in Rome to explore the decorative possibilities afforded by drilling. Tentative and limited drapery drill work had been practiced earlier in the first century B.C. by sculptors of full-length stone funerary reliefs, such as on the Via Statilia relief,[88] and the marble Eurysaces relief from the Porta Maggiore.[89] The drill was a tool borrowed from the Greek sculptural tradition, and its introduction into the Italian repertoire for carving figural reliefs is certainly an indication of the increased Hellenization of local carving traditions during the late Republic. What is interesting, however, is that Italian carvers either did not immediately recognize or deliberately ignored the capacity of the drill to shape more complicated furrows and intricate hollows in

marble. Instead, they preferred to exploit its ability to create decorative patterns that complimented their own traditional aesthetic preferences for linear design and texturized surfaces. Furthermore, the way that the drill and the rounded chisel were used for the rendering of drapery on these sections of the Ara Pacis, as well as on numerous late republican and early Augustan funerary reliefs, is evidence that these Italian carvers were sculpting marble with techniques traditionally used to carve the coarser, more brittle stones native to the Italian peninsula.[90] They are, in effect, carving marble as if it were travertine or tufa. During the last half of the first century B.C., sculptors of marble funerary reliefs and nonfunerary reliefs such as the Ara processions frequently left the marble roughly chiseled—this despite marble's capacity to withstand deep drilling and smoothing with abrasives. In the carving of the drapery of the figures in the unrestored sections of the South frieze, we are witness to a critical stage in the development of Roman relief production—the experimentation and gradual adoption of Greek sculpting practices as well as a technical transition from carving tufa and travertine to sculpting Carrara marble. The clues to this dynamic process lie visible on the stone itself.

In addition to the tooling of the drapery, marks from chisels on flesh surfaces, hair locks, and the *fasces* carried by the lictors offer the most striking evidence that some of the carvers of the Ara processions were trained in the same Italian sculptural traditions as their republican predecessors. While the degree of detail and overall shape of the locks of hair vary among figures, all the hair on the figures in Panels s3 and s4 and on the fragments follows the same basic pattern and was carved exclusively with the edge of a chisel. As on the eastern half of the South frieze and the few original heads on the North frieze, the predominant form for males is the C-shaped lock of hair carved in a wedge design in which the center of the lock is in highest relief with the edges tapering back. This type of hooked, wedge-shaped lock appears on most of the heads in Panels 3 and 4 and the fragments, including the side and back locks on s17 (fig. 160), the forelocks of s15 (fig. 161), and all of the hair on s21 (fig. 162), s18, and s19 (fig. 163). On the two flamines s22 and s20 on Panel s4, C-shaped, wedge locks appear beneath their caps at the back and above their foreheads while more slender strands curve near their temples (figs. 23, 24, 164, 165).[91] Even the hair of Augustus, while composed of more individualized, larger curving locks, was carved with only the edge of a chisel (figs. 39, 166, 167). The most apparent use of the chisel for carving wedgelike locks occurs at the hair of the lictors in the South procession. Note the extremely abstract pattern of curving wedge-shaped locks on lictor s14 (fig. 168), and at the back of the heads of s13 (fig. 169) and s12 (figs. 170, 171). Lictor s11 bears some of the best-preserved examples of this chiseled lock form (figs. 172, 173). The fragmentary heads of lictors s9 and s8 also display the wedge locks above their foreheads and atop and at the back of their skulls (figs. 174–77). The damaged head of figure s10, who may not be a lictor, shows the combination of wedge forms above the forehead and more slender curving locks beside the temple area (fig. 178). By consistently repeating the solid, abstract wedge-shaped form, the Ara sculptors created a stylized, plastic geometric hair pattern that compares closely to the standard first-century B.C. Roman approach to carving hair locks on male figures.[92] This extremely efficient method of chiseling three-dimensional lock forms causes the hair to appear overall as an inorganic, caplike mass sitting, sometimes rather awkwardly, atop the skull.

The carving of the *fasces* on Panel s3 and the fragments now to the left of this panel also demonstrates the precise, skilled chiseling technique employed by the Ara carvers. Although the low-relief *fasces*, or the tied bundle of rods, carried by the lictors in the South and North friezes have few close comparisons in large-scale stone reliefs dated to the first century B.C.,[93] in general, representations of lictors bearing the *fasces* or carrying staffs were venerable, conventional scenes in Etruscan and republican relief art.[94] And like the archaic nature of the scene itself, the carving technique used for the *fasces* was also traditional. The rods (*virgae*) were separated from one another by pronounced, V-shaped channels created by two, angled passes with the edge of a flat chisel. This technique is evident for the *fasces* in front of s10 (fig. 179), in front of figure s5 (fig. 180), and between figures s4 and s3 (fig. 181). The use of the chisel to create the V-shaped channels separating the rods also is apparent for the *fasces* carried by lictor s14 (fig. 182), lictor s11 (figs. 183, 184), and lictors N1 and N3 on Panel N1 of the North frieze (figs. 185, 186). Although a drill could have created, perhaps more expediently, the furrows between the rods, it was not used. In addition to the channels, the thongs binding the rods as well as the rods themselves were chiseled without further finishing. Precisely the same manner of sculpting the *fasces* with a chisel is preserved on two late republican funerary reliefs—the *fasces* at the right edge of the travertine Servilii relief dated to the 30s B.C.,[95] and the ceremonial bundle of rods on the later marble Licinii relief dated to the Augustan period.[96] On the only other large-scale marble relief depicting lictors carrying *fasces* that dates to the first century B.C., the "Lictor relief" in the Vatican, the carving of the channels, rods, and thongs is identical to that on the Ara processions.[97]

Perhaps the most revealing evidence for the continuity in carving techniques and the transitional nature of early Augustan figural relief sculpting on the Ara processions are the tool marks left on many of the flesh surfaces of the figures in Panels s3 and s4 of the South frieze. Once again, the surface texture was left finished with the rougher, concave channeling created by a rounded chisel. The most extensive and interesting example of this chiseled-surface texture on anatomical areas survives on the figure of Augustus. Long chisel strokes shaped the curve of the face (especially noticeable at the jaw line) while shorter strokes carved the flesh on the forehead and neck (figs. 167, 187). This use of the chisel is exactly comparable with the tooling left on the flesh surfaces of numerous republican figural reliefs, such as on the marble Rupilius relief dated circa 50 B.C.,[98] on a marble three-figure funerary relief dated to the 30s B.C.,[99] and on the marble three-figure funerary relief of the Clodii dated to the 20s B.C.[100] Long, relatively wide rounded chisel strokes almost identical to those on Augustus's left cheek and jaw are preserved also on the travertine, two-figure Visellii relief, also dated to the 20s B.C.[101] Rough chiseling along the surfaces of the face and neck is apparent especially on the heads on the marble three-figure Mattei relief dated to the Augustan period (figs. 188, 189)[102] and the marble Antestii relief, also Augustan in date.[103] The carvers of Augustus's portrait not only selected the same tool used by republican relief portrait sculptors, but used that tool in precisely the same manner to create an identical surface texture. In addition to the surfaces of the face and neck of the *princeps*, long, concave chisel strokes survive on Augustus's fragmentary extended right forearm (fig. 190), along the lower face and neck of lictor s11 (fig. 191), and the neck of lictor s12 (fig. 192).

Yet while the flesh surfaces of Augustus and two lictors were left chiseled and those of many other figures on Panels s3 and s4 were left rasped, the faces of a few figures at the western end of the South procession appear to have been smoothed, possibly with abrasives. Most of the facial surfaces of figure s3 (fig. 181), figure s10 (figs. 174, 175, 178), s12 (figs. 169, 170), figures s18 and s19 (fig. 193), flamen s20 (fig. 164), and the background figure N32 (fig. 114) bear no traces of tooling. The smoothing was confined to those flesh surfaces nearest the facial features. Such removal of marks by smoothing is entirely consistent with Greek sculpting methods and may be further indication of a specific technique carried over and subsequently adapted from the Greek tradition. However, like so many of the techniques preserved on the Ara processions, this Hellenizing tendency to smooth down tool marks along the frontmost areas of the faces had begun earlier in the first century B.C.[104] Several marble funerary reliefs from Rome illustrate that urban relief carvers already had explored the effects of smoothing the flesh surfaces nearest the eyes, nose, and mouth. Evidence for limited facial smoothing is preserved on the portrait heads on the Santecroce relief, on the Furii relief, and on the relief of Anteros and Myrsine. The emergence of smoothing as a surface finish for reliefs carved in republican Rome suggests that local Italian carvers were influenced by Hellenic aesthetic preferences for flesh textures. Limited surface smoothing also indicates that some sculptors, including those carving the Ara processions, were testing marble's receptivity to abrasives. The appearance of this technique on private reliefs carved in Rome prior to the Ara processions suggests that the Augustan sculptors of the North and South friezes were following a preexisting trend practiced by certain urban workshops rather than independently introducing a technical innovation for finishing Roman figural reliefs.

Despite the frequently deceptive layers of post-Augustan recarving and restoration, a sufficient amount of original, first-century B.C. tooling has survived on both the North and South friezes to shed light upon the artistic identity of the anonymous Augustan artists. The traces of background texturizing, contour chiseling as well as the chiseling of the flesh, hair, drapery, and *fasces* on Panels s3 and s4 indicate that many of the Ara carvers had been trained in workshops that taught traditional Italian approaches to carving stone reliefs. Other marks, including those from rasps, scrapers, smoothing agents, and drills, may point to influence from Greek carving practices, perhaps introduced by Greek-trained artisans. However, the limited almost cautious use of the drill in the rendering of much of the drapery suggests experimentation with this Greek tool rather than skilled confidence and familiarity with the working properties of marble. As shown by the comparisons with numerous funerary reliefs carved in Rome during the first century B.C., the gradual adoption of Greek techniques for carving marble reliefs did not begin with the commission of the Ara Pacis. The Hellenization of Italian sculptural techniques had begun decades prior to the execution of the reliefs on the Augustan altar. The original techniques and details of form preserved on the Ara processions serve to illustrate that the conflation of Italian and Greek sculpting methods continued to exist as a vital artistic current from the late republican to the Augustan period. The traces of tooling and the rendering of specific details also are evidence for the persistence of the native Italian approach to relief carving, despite the ever increasing Hellenization of methods and materials. Just as it is possible to argue for the transitional nature of many of the political actions, social

reforms, and religious revivals promoted by Augustus, one might consider the processions on the Ara Pacis as conspicuous artistic links between republican modes of representation and later imperial relief sculpting.[105]

STYLE SELECTION, DESIGN, AND THE DIVISION OF LABOR

The details of the carving that survive on the North and South friezes suggest a general consistency in execution. The chisel was the primary tool for shaping both major and minor forms. Variations in tool use were limited to the finishing of surfaces and include rasping, scraping, rough chiseling, and smoothing with abrasives. Yet, while the carving techniques and tool applications remained relatively constant for the Ara processions, the styles chosen for facial types, drapery, figural compositions, gestures, and other details of form vary from one area to another within the friezes. This disparity between variations in the styles chosen and the overall consistency in technique may be the result of separate responsibilities, concerns, and training of the designer(s) and the carvers of the marble panels respectively.

The most important differences in the selection of particular figural styles relate to the heads of the procession participants. The heads on the South frieze offer the clearest evidence for a pattern of selecting facial types. There were three distinct approaches toward representing heads and facial features on this frieze. The first occurs on Panels s6 and s7 for the adult heads of the "imperial family" group. It is characterized by simple, generic facial features on an overall structureless, oval-shaped head. On these heads, the features are placed on the surface, rather than integrated into the structure of the spheroid mass of the head, with little attention paid to rules of anatomical symmetry or to how facial features relate to one another and to an underlying muscular and skeletal framework. For this reason, the features are treated more as surface details than as a coherent translation of anatomical reality. Typical features include flat, broad foreheads, puffed, fleshy cheeks, prominent, rounded chins, and asymmetrical arched or almond shaped eyes. This approach begins at the background figure (s29) on Panel s6 standing to the east of Agrippa and continues up to and including the rightmost head of figure s46 on Panel s7.[106] The figures that most typify this generic, structureless design are the foreground figures of Livia (s32) (fig. 194), "Tiberius" (s34) (fig. 195), Antonia Minor (s36) (fig. 19), Drusus Minor (s39) (fig. 196), and Ahenobarbus (s45) (fig. 197). The generic approach was also used for the majority of the background heads located between s29 and s46, including the heads of figures s29 and s30 (fig. 198), figure s33 (fig. 82), the particularly bloated face of figure s37 (fig. 83), figure s40 (fig. 127), Antonia Maior (s41) (fig. 90), and figure s46 (fig. 199). In addition to the facial styles of these background heads, it is also interesting to note that they consistently fall into one of two categories—those depicted in strict profile (s40 and s29) and those shown in a distorted version of a three-quarter view (s30, s40, and s46).[107] The three-quarter view is especially noteworthy, since it also occurs on Panel s3 (for figure s15) and on Panel N1 (for figure N9) of the North frieze.[108] It consists of an awkward combination of frontally viewed facial features, an unusually extended cheek and jaw, and an incorrectly viewed profile ear. The repetitiveness of this unnatural view suggests a standardized method

used by the Ara carvers to represent the frontal three-quarter view. Thus, all of the faces on the young adults within the imperial family group in Panels s7 and s6 were depicted as static and expressionless, with little variation to suggest individuality. Many have described these heads as classicized or neoclassical. However, a more accurate term would be "generalized" or generic, since many of the characteristics associated by scholars with the term "classicizing," such as the smooth surface and the crisp lines and contours, are in fact the result of the reworking by the eighteenth-century, neoclassical sculptor Carradori.[109] The style of the generalized heads, in fact, was without doubt an attempt to imitate Athenian classicism. The final result, however, illustrates instead a thin veneer of appropriated classicized facial features, often distorted and arranged asymmetrically, lying on the surface of a characteristically Italian, structureless, ovoid mass of the skull.

The second approach to depicting facial forms in stone is illustrated by the heads of the figures in Panels s3, s4, and s5 (and the fragments to the left of Panel s3), including the figures of Augustus, his lictors, and the four flamines.[110] Unlike the generalized heads in the imperial family group and in contrast to their rounded, almost boneless faces, the heads within the official priestly group are for the most part individualized and expressive. Here the carvers have at least attempted to render both the structure of the underlying skull as well as the separate facial muscle groups. Although variations occur, the major characteristics shared by these heads include (1) prominent foreheads divided by a chiseled, horizontal crease into a flatter upper section and a swollen, plastic lower brow (which was itself often vertically divided in half by a shallow, vertical furrow or furrows above the nose bridge), (2) incised contours of particular facial features and muscle groups (nasolabial folds, nostril wings, etc.), (3) deep-set eye sockets with sharply delineated, slightly raised ridges for eyebrows, and (4) protruding, rounded chins and small mouths. All the heads exhibit a compact, overall square shape which is common for many portrait heads on first-century B.C. Roman reliefs.[111] The combination of a protruding, contracted brow overhanging deep-set eyes gives many of the faces an intense, almost fierce expression. Note, for example, the use of this expressive design scheme for the faces of the flamines s24, s23, and s22 (fig. 72), figure s21 (fig. 162), flamen s20 (fig. 164), figures s19 and s18 (fig. 193), figure s17 (fig. 20), figure s15 (fig. 200), figure s13 (fig. 182), lictors s12 and s11 (fig. 170), and fragmentary figures s10, s9, and s8 (figs. 174, 175). This expressive facial type with its swollen brows and flesh creases, although somewhat out of context considering the solemn, calm nature of the processional scene, is distinctly reminiscent of facial designs on much Hellenistic portraiture carved both within and outside of Italy.[112] Numerous late republican relief portrait heads also display this expressive facial rendering.[113] Even the portrait of Augustus, often compared with the more classicized, freestanding portraits of Augustus from Prima Porta and the Via Labicana,[114] conforms in many ways to this facial type. For instance, the overall contour of Augustus's head appears rectangular and solidly compact, although less blocklike than those of the lictors and the figures on either side of him (fig. 39). His forehead is clearly divided by a strong horizontal depression into a lower swollen section, with two strong vertical incisions above the nose bridge, and an upper flat section (fig. 167). The eyes are extremely deep-set and the undulating, chiseled surface of the left cheek is separated from the plastically modeled area of the mouth by a subtly incised nasolabial fold (fig.

201). In addition, the chin tapers to a rounded shape, and the hair, like that of all the figures on this half of the South frieze, is divided into clearly defined curved, triangular segments.

In comparing the details and structure of the two facial types—the generalized type and the expressive type—one might conclude that the artist(s) who carved the expressive heads of the official priestly group were better trained or at least displayed more interest in rendering the various internal and external structures of the head and the organic, interdependent relationships among flesh and bone.[115] On the other hand, the generalized type used for the imperial family group might be understood best as a rudimentary attempt to adapt the facial style of Athenian expressionless idealism to the faces of Romans in a distinctly Roman religious and civic figural scene in marble. The faces of the imperial family group on the South frieze of the Ara Pacis are certainly some of the earliest surviving examples in Augustan relief sculpture of a more generalized, or as some might say "classicized," portrait style. However, as the surviving sections of the Ara processions illustrate, the generalized facial type represents only one option within the larger, eclectic repertoire of styles that were available to and adopted by first-century B.C. patrons and artists.

The third method of rendering the face and head of the adult figures on the South frieze was a noticeably softened, less exaggerated version of the republican realism found on both funerary reliefs and freestanding portraits carved in Rome from the third to the first century B.C.[116] The realistic portrait type as it appears on the South frieze is characterized by an emphasis on facial swellings and deep creases around the eyes, forehead, and jaw. Figure s28, widely accepted as a likeness of Augustus's general and close friend Agrippa, is a sensitive, skillful depiction of an aged man (fig. 202).[117] The broad expanse of his high forehead is striated by horizontal creases (fig. 117) and the heaviness of his fleshy face accentuated by modeled swelling and undulating folds. The deep-set eyes, with their incised crow's feet at the corners, enhance the expression of pensive introspection (fig. 29). The realism and individuality achieved in this portrait stand out all the more since Agrippa is followed by the expressionless faces of the "imperial family" figures to his right. The same juxtaposition of realistic and generalized heads occurs at the far right of the South frieze, where a realistic, individualized portrait of an elderly, hunched man (s44) was placed between generalized heads of female and male foreground figures and behind the figure of a young girl (fig. 118).[118] Similar to the figure of Agrippa, the head of figure s44 displays the wrinkles and sagging folds of age, particularly above the nasolabial furrow and along the line of the jaw, and the deep-set eye sockets (figs. 41, 203).

Unlike the first two facial styles, the faces carved in the realistic manner display a substantially more sophisticated understanding of the interconnections of muscle, flesh, and bone, the accurate, smooth transitions between the various facial features and surface planes, and natural symmetry and correctness of view than either the generalized or the expressive types. If one concludes based on the tool mark evidence that the processions were executed by one or more groups of carvers similarly trained with respect to technique, then it appears from the rendering of the different facial types that either (1) these carvers were, as a group, best trained in this softened version of realistic portrait rendering or that (2) those in the workshop most skilled in carving accurately naturalistic faces (portrait specialists) were assigned to the figures that were designated by the designer as realistic portrait heads. In either case, the technical and

the stylistic evidence suggests that sculptors trained in Hellenized late republican realism, as opposed to Greek classicism, were the more skilled, experienced stone sculptors within the workshop that carved the Roman ceremonial scene depicted on the South frieze.[119]

The combination of two or three distinct facial styles within a single scene or relief frame was practiced decades prior to the execution of the Ara processions. The most obvious examples of this combination are the frequent pairings of realistically rendered male portraits alongside generalized female heads, as for instance on the Stagia Ammia relief,[120] on the so-called Eurysaces relief,[121] and on the Via Statilia relief.[122] The juxtaposition of all three separate approaches to facial design in one composition occurs on a four-figure relief dated to circa 50 B.C., where one finds a male with expressive features, two relatively generic female heads, and a realistic portrait of an elderly male.[123] On the Ara processions, the reasons behind the selection of these particular facial types for certain figures in the scene are unclear. Perhaps the designer chose the generic approach for both male and female members of the imperial family in an effort to make these figures appear more as a unified, related group rather than as distinct, individual personalities. Perhaps the figures in the western half of the South frieze all received the same expressive facial style to emphasize their elevated religious and civic positions within the context of the *supplicatio* ceremony and distinguish them from the imperial family group. Until a more comprehensive study is carried out on the use, frequency, and mixtures of facial styles in late republican and early imperial sculpted reliefs, such suggestions must remain pure conjecture.

Variations in style, however, were not restricted to the facial types. The existence of different compositional and drapery styles within the processions on the Ara Pacis was recognized as early as 1938, when M. Pallottino published the most comprehensive stylistic analysis to date of the Ara friezes in a mere ten pages entitled "L'Ara Pacis e i suoi problemi artistici."[124] Limiting his examination to drapery treatment and the overall composition of the figures, and making no reference to the portrait heads, Pallottino concluded that the two processional friezes were carved by four distinct master sculptors.[125] For the South frieze, he suggested that the physical break between the fourth and fifth panels coincided with a boundary between two distinct styles. On the left-hand side, which includes the figures of Augustus, the lictors, and two flamines (s22 and s20), Pallottino recognized as characteristic of one style a preponderance of a decorative, linear treatment of the drapery folds with little sense of plasticity. He also pointed out the extremely low relief of the background figures in this half of the frieze, which, with many figures seen from different views, adds to a crowded but successful sense of spatial illusionism. He ascribed this more schematic, linear style with its emphasis on spatial recession to an indigenous tradition and referred to the sculptor as the "Flamens Master."[126] For the right half of the South frieze (Panels s5, s6, and s7), Pallottino observed that the drapery is less linear, the relief more plastic, and the projection of the figures from the ground more pronounced. He also noticed a greater variety of gesture. In general, he observed that these panels, which include two flamines (s24 and s23), the "Rex Sacrorum," and the imperial family, show less use of the line in a decorative manner, which in turn causes the drapery to appear more naturalistic. This right half he ascribed to the "Master of the Imperial Family," who Pallottino felt was versed in both Hellenic classicism and native, Roman illusionistic traditions.[127]

In his discussion of the right half of the North frieze, Pallottino commented upon the high relief of the foreground figures, the volumetric treatment of both body and drapery, the lack of linear patterning, and repetitiveness of gesture. This half he concluded was the work of the "Master of the Senate," who, he suggested, had been trained in the Greek Asiatic tradition and who had only superficially employed the new illusion achieved by the "Flamens Master." The left half of the North frieze, which he identified as the work of a fourth sculptor, the "Master of the Populus," he saw as characterized by a greater sense of illusionistic depth and a specific type of crumpled drapery.[128] Due to the fragmentary condition of this section, however, Pallottino could not identify a specific tradition within which the sculptor was trained.

Despite the fact that Pallottino was commenting upon reliefs which he must have known and recognized as heavily restored, he made no mention of the restorations. When one considers the important effects of the post-Augustan restorations as discussed in a previous chapter, the problem with Pallottino's four-master theory is at once apparent. His division of the North and South friezes into four distinct drapery styles was no doubt due in large part to the different types and degrees of restoration. What Pallottino saw as a more volumetric, three-dimensional treatment of the drapery worn by the imperial family group (Panels s5, s6, s7) and the "senators" (Panels N1, N2, N3) is due to the extensive additions to the damaged folds during Carradori's eighteenth-century restoration of these panels. In fact, the drapery folds in question appear all the more plastic when set alongside the two more fragmentary sections not restored by Carradori (the western portion of the South frieze and Panel N4 in the Louvre). Moreover, the variations or repetitions in the composition and the gestures of figures as well as the differences in relief height, all of which Pallottino used as criteria for isolating distinct artistic personalities, do not necessitate the presence of four different "master sculptors." Instead these patterns and fluctuations might be better understood as compositional devices or visual punctuations within the design of the two processional friezes.[129] Pallottino's theory of four master sculptors for the North and South friezes, although an earnest attempt to point out the eclectic nature of Augustan art and recognize the unique contributions of indigenous Roman sculptors, was nevertheless highly influenced not only by the substantial restorations made to the reliefs but also by what was then the commonly accepted identification of four separate social or political groups represented in the processional friezes (priests, imperial family, senators, and Roman people).

Taking the post-Augustan restorations into account and recognizing that major sections of the panels are missing, the criteria used by Pallottino to identify four "master sculptors" (namely drapery treatment and figure composition) instead might argue for the presence of two separate designers for the North and South friezes respectively. On the other hand, the two distinct compositions on each of the two processional friezes in fact may have been the work of only one designer who simply chose to select different styles for each of the friezes. The problem with identifying design responsibilities centers around the issues of (1) the limitations imposed on designers by the specifications of the commission, and (2) the existence and degree of detail in a preestablished sketch or model. The traditional approach to identifying "masters" for ancient sculpture would be to consider each of the two distinct compositional schemes as the work of two different artists.[130] If the traditional method for identifying

designers is followed, then one might propose the following situation. The first artist, desig-nated here as Designer A in accordance with traditional labeling, was responsible for the North frieze. Assuming that the designer was responsible for figural rendering, then one might sup-pose that Designer A was better trained in depicting the organic relationship between over-lying draped cloth and underlying anatomical forms. This use of drapery to reveal the sub-tleties of the bodies beneath the cloth is best expressed around the thighs and calves of the male figures at the front of the North procession as well as the uplifted forearms and hands of figures N36 and N40 on the Louvre panel (fig. 9). An understanding of the naturalistic relationship between drapery and underlying anatomy is particularly characteristic of figural sculpture carved in the Hellenic East and may indicate, although not necessitate, that this fictional Designer A was trained in or influenced by the Greek tradition of naturalistically representing the draped human form. At the same time, the creator of the North frieze appears to have been less interested in exploring variations in the gesture and posture of the figures within the groups. The predominant design element on the North frieze was the curved line, which was used extensively in the contours of major drapery folds and lent a degree of motion to an otherwise visually static composition (especially for the figures in Panels N1 and N2) (figs. 5, 6, and 8). Finally, Designer A generally limited his figural composition to the two most basic relief planes—the high foreground level and the much flatter relief of the background plane.

In contrast to the approach of Designer A, the designer of the South frieze, referred to here as Designer B, for the most part paid little attention to depicting a naturalistic, coherent rela-tionship between the draped cloth and the bodies of the figures in his panels. It is true that the drapery on the figures in the South frieze tends to obscure rather than reveal the position of the anatomy underneath. This is especially true in the lower portions of the figures in the "imperial family" group (Panels S5, S6, S7) (figs. 3, 4). Likewise, the proportions and postures of many of the figures, including the more important foreground figures, are awkward, dis-torted or simply incorrect. On the other hand, Designer B of the South frieze devised a wider variety of gestures and often indicated a third level of relief depth—both of which added to the sense of animation in this processional composition, despite the fact that the primary design element for Designer B was the more static, straight line (used both vertically and occasionally horizontally). The combination of an unnaturalistic depiction of the relationship between drapery and body and a general disregard for naturalistic proportions and visually correct views might lead one to believe that Designer B was trained in the indigenous traditions of Etrusco-Italic figural representation. At the same time, however, Designer B was clearly famil-iar with the methods of rendering spatial recession in Hellenistic art and Hellenized Etruscan painting and relief sculpture that already had influenced and been adopted by Roman artists.[131]

The scenario as described here follows the traditional method of assigning two designers to each of the two processions. However, the hypothetical identification of Designers A and B does not take into account several critical issues regarding precisely who was responsible for which features of both the design and the execution. Taken as a whole, the Ara Pacis was a rel-atively complicated monument containing several different types of compositional formats comprised of thematically interconnected relief representations. The altar's decoration as well as its position in relation to the Horologium, the Mausoleum, and the Ustrinum—in fact, the

entire architectural landscape of the northern Campus Martius—took forethought and deliberate planning. If one is to imagine two separate designers for the North and South friezes based on general compositional and stylistic incongruities, then it should follow that one must propose a separate designer for each of the more distinct types of relief composition on the altar. There would then be a designer for the four mythological panels, another for the scroll frieze, another for the interior garland and architectural decoration, and yet one more for the small-scale processions that adorn the altar proper. That would amount to six separate relief designers which, in logistical terms, seems rather impractical. The two-designer hypothesis does not allow for the possibility that one artist consciously created two distinct figural compositions for the two long exterior faces of the *saeptum*—a more static, repetitive scene that is more visually legible on the side facing visitors on the Via Flaminia entering Rome from the north, mirrored by a more dynamic, complicated grouping including portraits of both Augustus and Agrippa on the side that faced the traditional center of the capital city. As he approached and experienced the narrative program of structures constructed on the northern Campus Martius, a pedestrian in Augustan Rome first would have viewed the South procession. The more daring, complex interweave of figures merging into and out from layers of receding planes, especially apparent around the figure of Augustus himself, would have demanded more contemplation, participation, and time on the part of the viewer. The composition, as much as the portrait heads of identifiable Roman figures, might have motivated the Augustan audience to linger. This, in turn, would have provided greater opportunity to take in the architectural landscape laden with symbolism and narrative content that lay both nearby and off in the not too distant northwestern horizon. In contrast, the rhythmic staccato and predictable repetitiveness of the North frieze echoed and encouraged the movement of travelers entering Rome by its major northern conduit.[132] The idea that one designer recognized the significance of such compositional distinction in relation to the placement, viewing position, and content of the scenes is by no means provable, but it is certainly tempting to consider. The assignment of both processions to one designer also frees the Augustan artist from the misconception that his creative energies were somehow restricted to one fixed type of compositional arrangement. Certainly there is no evidence to suggest that patrons of Roman public reliefs were directly involved in determining the specifics of compositional design. They appear to have been concerned primarily with placement, material, and subject matter and left the selection of composition and figural styles in the hands of the artists.[133] In the case of the North and South friezes, it is arguable that one designer used this freedom to create two different types of compositions.

The traditional designation of two designers brings to the fore yet another problem in the study of Roman relief sculpture—the assumption that there were relatively detailed sketches or models drawn up by designers beforehand to guide closely the actual carvers of the stone. If we accept the notion that designers drew up detailed drawings prior to the carving of the reliefs, then we assume that the designers were the ones who determined the final appearance of most major details, including figural types, drapery rendering, and gestures of all the figures in a scene. The existence of such detailed sketches or pattern books for wall painters and mosaicists during the Hellenistic and Roman periods seems well attested. Papyri from Ptole-

maic Egypt discuss specific models or *paradeigmata* provided or approved by the patrons to which the painters and mosaicists were forced to adhere in their execution of the projects.[134] Yet painting a wall or laying a fresco is a different process than sculpting stone. Both the painter and mosaicist have more degree of control over both their media and the appearance of the final piece and could thereby follow closely a preestablished drawing. The sculptor, on the other hand, must constantly react and readjust his methods as well as the design depending upon the reaction of the stone to his carving. Different blocks of the same type stone have the potential to react differently to the sculptor's tools. Unforeseen faults or accidental blows must force the designer and the carver to adjust the composition accordingly. In his study of relief panels that adorn the interior walls of the passageway of the Arch of Titus in the Forum Romanum, M. Pfanner suggested that particular compositional problems were not only the result of, but served as evidence for, the lack of a detailed, predrawn working sketch.[135] Recently, P. Rockwell discussed the possibility that some Roman reliefs were designed during, not prior to, execution. According to Rockell's detailed analyses of technique and composition, the carvers of many Roman reliefs were provided with only a rough sketch of the designer's composition and were free to adapt details depending upon their traditional, learned preferences as well as upon the working characteristics of the selected stone slabs. In particular, his examination of the carving of the spiral frieze on the Column of Trajan revealed that the second-century A.D. sculptors were not working from a measured drawing or a comprehensive, preestablished design. Rather, often they were afforded the freedom to create and alter compositions as they went along.[136] The suggestions by both Pfanner and Rockwell that large relief-sculpting projects in Rome may have lacked detailed plans drawn up by a designer prior to the actual carving were based for the most part on particular problems, inconsistencies, and "mistakes" in the finished compositions. Accepting that such "mistakes" may indicate design during execution, we might wonder if there are similar problems with the compositions of the Ara processions that suggest the designer did not provide the carvers with a detailed, fixed model or drawing.

There are, in fact, numerous inconsistencies in the compositions of specific figures represented on both the North and South friezes.[137] On the North frieze, the feet of figure N2 do not line up correctly with the profile head, nor does the one profile foot with the head of N4. Figure N5, a background male whose upper body is turned eastward, appears to have only one profile foot pointed westward. There is also a problem with the alignment of the profile leg with the turned torso of N7. Figure N9, the only original head on the North frieze shown in an odd frontal view, was given only one leg, which awkwardly points westward. Figure N11 appears to have no feet at all. Similar problems with correct upper torso and head and foot alignment occur for figures N13 and N17. The placement of the feet of the foreground figure N20 would, in reality, cause this togate male to fall face forward. Figure N21 has no feet, while figure N23 has a frontal viewed torso with two incorrectly matched profile feet. Precisely who was meant to own the low-relief profile foot seen between the feet of N24 is unclear, but in any case it is not aligned correctly with either of the two heads of N25 and N26 placed above it in the composition. Figure N28 likewise displays a similar alignment problem between the torso and the legs. Figure N32, a background male depicted in a rather unsuccessful rear three-

quarter view, possesses two inaccurately aligned profile feet pointed in the opposite direction as the torso. Finally, figure N34, another background male shown in frontal view at the torso, has only one profile left foot which does not line up with his upper body.

The compositions of figures in the South frieze illustrate many of the same problems. The background head of s18 has no feet, while s19, whose upper body consists of a frontally positioned torso bearing a profile head facing eastward, has two incorrectly positioned profile feet pointed to the west. The torso and profile leg of s21 are not lined up correctly, nor are the torso and legs of s25. A confusing composition occurs at figure s27, whose torso is shown frontally while his profile head faces east. The incorrectly aligned left leg of s27 is viewed frontally but the back right foot, raised up on its toes, is shown awkwardly in strict profile pointed west. The feet of both s29 and s30 are aligned incorrectly. Furthermore, as was the case with figure N32 on the North frieze, figure s33 has a rear view torso, a profile head facing east, and two inaccurately placed profile feet pointing west. The placement of the legs of "Tiberius" (s34) in relation to his torso is incorrect to the point where this togate male appears to be on the verge of toppling backward. The profile foot of s35 lines up incorrectly with the torso, as do the profile feet of s44. Lastly, at the far eastern end of the South frieze, there appears perhaps the most bizarre compositional inconsistency on the Ara processions: figure s46 is shown with a male head wearing a male hairstyle which rests (out of proper alignment) atop a female, stola-draped lower body.

The compositional incongruities of the processional friezes on the Ara Pacis are important clues to determining the actual processes of designing and executing a large-scale relief in Rome during the late first century B.C. The majority of anatomically incorrect or impossible compositions occur for figures sculpted in the intermediate or back plane. It appears that there was no specific design model or drawing for the secondary figures of the Ara processions. Rockwell had noted a similar situation on the Column of Trajan frieze, whereby the carvers of the background appear to have not had a preliminary sketch to guide their work.[138] Yet this brings up another question: even if the carvers of the background figures were designing these figures as they carved, why did they consistently, and in some cases dramatically, incorrectly align the lower portion of the body with the upper torso and head? The answer to this enigma may lie in how work was allocated to individual carvers within the sculptural workshops.

In the past, students of Roman reliefs tended to assume that one or possibly two sculptors were responsible for each entire figure, carving it vertically from head to toe. However, the presumption that relief sculptors were assigned to sculpt entire figures in a multifigure composition such as the Ara processions, in fact, may not be accurate for all relief-carving projects. There is accumulating evidence for the division of labor within sculptural workshops that suggests a degree of flexibility in the execution depending on the circumstances of the market and of that particular commission. One of the most important and frequently employed methods for allocating work within a workshop during the Roman period involved specialization. M. Waelkens argued that during the first half of the second century A.D. there were workshops of stone sculptors in Phrygia, possibly based at the Docimium quarries, who specialized in carving architectural statuary for imperial commissions constructed in Rome.[139] M. Pfanner has recently discussed the appearance of Greek workshops based primarily in Athens that spe-

cialized in carving marble Corinthian capitals during the second and first centuries B.C. For Italian sculptors who specialized in carving the so-called Italic capitals such as those used at the Sanctuary of Fortuna at Palestrina, Pfanner proposed a division of responsibilities whereby the tufa blocks were carved in two stages. First, the crude tufa form was roughed out by assistants ("Hilfskräfte") at the quarry while the porous stone was still "soft," after which architectural ornament specialists carved the leaves and other more intricate details.[140] In *The Art of Stoneworking*, P. Rockwell demonstrated how the division of labor within most modern and premodern sculptural workshops involved breaking down the various activities into specialized tasks. For example, twentieth-century Italian marble sculptors at Carrara divide the labor for producing a figural statue among various specialists who are then responsible for particular areas of the figures, such as the hands, faces, feet, drapery, and final surface finishing. In describing how natural and efficient it is for the sculptural workshop to proceed in stages, thereby encouraging divisions of labor and consequently specialization, Rockwell argued that artistic specialization is not restricted to the practices of the modern sculpting studio but was in all likelihood characteristic of sculptural workshops in most periods, including the ancient Roman era.[141] Specialization is likely to occur particularly for large-scale, multifigure projects required to be finished within a limited amount of time. Specialization as a general workshop practice also tends to take place during a period when a great number of projects are commissioned in a limited geographical region, such as in first-century B.C. Rome and its environs.

For certain projects, specialization afforded expedient results without sacrificing quality of workmanship. On the Column of Trajan, Rockwell discovered that one group of sculptors was assigned the foreground figures, while another carved the imagery in the background. Yet, an important point made by Rockwell and reiterated here is that there is no fixed model for relief-carving specialization. Instead, every project must be considered individually, with its own set of patron requirements, time constraints, and economic limitations. Sculptural workshops were flexible, adapting to the specifics of each commission and altering their methods accordingly. For ancient projects carved by anonymous artists, the most important clues to this organization lie in the evidence for tooling, stylistic details, and compositional formats. The evidence on the Ara processions appears to point to the following stages of design and execution.

After the Senate voted Augustus an altar to commemorate his return from the western provinces in 13 B.C., certain persons, perhaps organized as a senatorial committee, were chosen to manage the project and hire the architects, artists, and stone carvers. Most likely in consultation with professional architects and sculptors serving as technical experts, the managers of the project formulated an overall design for the altar. Any specifications concerning the relief decoration as required by the patron, whether the patron was Augustus, members of his court, or the Senate, were given to the sculptural designer who also may have been the master sculptor of a participating workshop. A preliminary design was drawn up by a designer for the foreground figures of both processions in accordance with the selected *supplicatio* scene. This preliminary sketch determined the placement of particular foreground figures in the scene as well as their basic gestures and postures. There was no strict, preestablished design for the background figures. The workshop or workshops, which may or may not have included the designer as an actively contributing sculptor, set about dividing up the work according to the

typical and traditional stages of relief carving. The most experienced figural carvers who were masters at chiseling were given the first task—carving the foreground figures. Among this group of skilled sculptors, there likely was a further division between those that carved the drapery, limbs, and lower body and those responsible for the heads.[142] It is, in fact, possible that the draped torsos were carved before the portrait heads. Since the rendering of the drapery and the underlying anatomy differs significantly from the North to the South frieze, one might imagine separate drapery carvers designing much of the drapery during execution for these two processions. On the North frieze, the sculptors appear better acquainted with a more naturalistic rendering of draped torsos and may have included Greek-trained artists, while those responsible for the South frieze appear to have preferred the more schematic, anatomically distorted rendering of draped figures characteristic of the traditional Italian approach to figural carving. Thus, the differences in the rendering of the draped bodies on the North and South friezes may be due to the carvers and not the designer.

At the second stage, the background figures were carved. This might have been performed by the same sculptors or by a different group of sculptors, depending on the number and size of the workshops involved. The compositional discrepancies between the heads of background figures and their legs and feet strongly suggest that the carvers of the second stage also were subdivided into the carvers of heads and upper bodies and the carvers of legs and feet. For the majority of the background figures, there appears to have been some miscommunication between these two groups of carvers. The carvers of the legs and feet consistently did not line up the lower portions correctly with the upper shoulders and heads of the figures.[143] Finally, there were surface finishers who in most cases would have been apprentices or slave assistants, who were responsible for leveling the back plane and smoothing, rasping, or scraping much of the relief surface. This hypothetical reconstruction of the division of labor within the Ara workshops applies only to the execution of this particular commission. The Ara carvers may have specialized on certain areas or features on a temporary basis only for the duration of this project.[144] Due to the uncertainty of precisely when the actual sculpting began between 13 and 9 B.C., it is impossible to determine the number of carvers or workshops who participated in sculpting the processions.

SUMMARY

The tool applications and rendering of forms as preserved on the original areas of the two processions suggest that the majority of the sculptors of the Ara friezes were trained in local Italian methods of carving stone. The tool applications they used for carving Carrara marble, especially their handling of the rounded chisel and the drill, illustrate their unfamiliarity with marble. Their tentative, limited employment of rasps, scraper, and abrasives suggests their willingness to experiment with Greek techniques for finishing marble statuary. However, most were not trained as apprentices in Greek approaches to carving figural reliefs in stone. The marks on the Ara processions as well as on numerous republican funerary reliefs reveal that relief workshops operating in Rome during the latter half of the first century B.C. were in an age of transition. This transformation was characterized by the change from traditional, local

stones such as tufa and travertine to marble, by the increasing Hellenization of their carving methods, and by the challenging demands from a more conscientious clientele of both private and official patrons. The center of this evolving conflation of artistic currents was Rome and, in the late first century B.C., it was no doubt both a demanding and profitable place for a stone relief sculptor. Yet, despite the pressures to adapt to new materials and new subjects and to incorporate foreign artists and unfamiliar sculpting techniques, the Italian-trained carvers managed to continue to practice much of their traditional, learned methods and preserve those techniques for future study on what were certainly two of their most important commissions—the processions on the Ara Pacis.

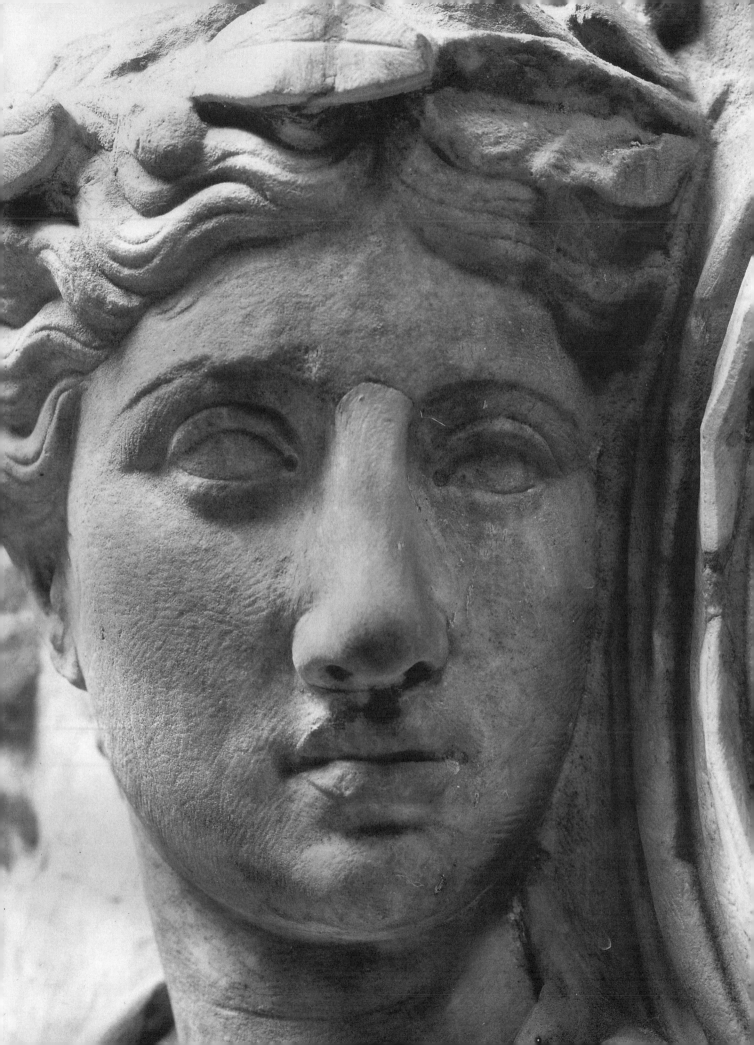

5 CONTEMPORARY FIGURAL RELIEF CARVING

In order to acknowledge and understand fully both the conservative tradition-alism and the occasional experimentation practiced by the designer and the carvers of the large processions on the Ara Pacis, it is necessary to examine in detail the sculptural techniques and the rendering of anatomy and drapery on figural reliefs carved either immediately prior to or contemporary with the early Augustan friezes. This chapter will focus on two examples from each of the following categories of figural reliefs carved during the late first century B.C.: (1) the large-scale, nonfunerary relief, (2) the standard funerary portrait relief, and (3) the small-scale processional frieze. Too often scholars study the North and South friezes in isolation, as if the artists of these historical reliefs worked in some sort of vacuum, completely independent of and immune to the various trends and tendencies practiced by other relief-sculpting workshops in Rome. By examining this selected group of related figural stone reliefs, I hope to demonstrate further that the carving of the processional friezes on the Ara Pacis was not completely novel. Rather the sculptors were following a long-standing and yet constantly changing local, Italian tradition of carving the human figure in relief.

LARGE-SCALE LATE REPUBLICAN NONFUNERARY RELIEFS

An important and yet rarely discussed example of an unrestored nonfuner-ary, processional relief from the late first century B.C. consists of a series of six fragments of fine-grained, white marble known as the "Lictor frieze" in the Vatican.[1] The six fragments preserve the heads and portions of two torsos of at least nine (perhaps ten) figures, four of which are lictors carrying the *fasces* in a manner similar to that of the lictor figures on panel s3 and the fragments from the South frieze of the Ara Pacis (fig. 204).[2] Fragment 1 of the Lictor frieze shows an almost heraldic composition of the heads of two male youths facing in opposite directions in a secondary plane behind a much shorter, extremely damaged foreground figure (figs. 205, 206).[3] Like many of the background heads on the South frieze, the two male heads (heads 1 and 3) on fragment 1 are

carved in relatively high relief. Head 1, which originally spanned two blocks of stone,[4] is shown in a three-quarter view facing to the viewer's left, while head 3 is seen in strict profile (fig. 207). Both faces are dominated by large, elongated eyes consisting of a flat-surfaced eyeball beneath heavy, squared-edge eyelids with only a ridge to represent the upper borders of the lower lid. The treatment of the eyebrow on both figures, which is indicated simply by a slightly raised ridge created by the intersection of two major facial planes, is exactly comparable with a type of eyebrow on several heads in the South frieze of the Ara Pacis (fig. 208)[5] as well as those on the majority of second- and first-century republican funerary reliefs (fig. 209).[6] The eyebrow design appears to have been a conventional form used by stone sculptors for faces on figural reliefs carved in the first century B.C. in Rome. In addition to the eyebrow form, heads 1 and 3 on the Lictor frieze and the faces of figures in the western portion of the South frieze share the following facial characteristics: (1) a forehead divided by an incised furrow into an upper flat expanse and a lower, bulging supraorbital zone, (2) facial folds and creases indicated by shallow incision with the edge of a chisel, (3) a small, full lip, mouth, and (4) a pronounced, rounded chin. The most remarkable area for stylistic comparison, however, is the treatment of the hair which, on heads 1 and 3 of the Lictor frieze, has been dramatically stylized into curved, triangular locks (the wedge-shaped type) which have the same shape and geometric interior modeling as the locks of hair on the lictor figures on the South frieze on the Ara Pacis as well as other secondary figures on both processional friezes of the Ara Pacis (figs. 115, 169, 172).

The next complete head (5) in the modern reconstruction of the frieze fragments is a generalized depiction of the face and neck of a youthful lictor carrying the *fasces* shown in strict profile view (figs. 210, 211). Head 5 shares most of the same facial features as heads 1 and 3 and, moreover, displays an exceptionally clear example of the wedge-shaped, stylized hairstyle found on this Vatican relief, on the lictor portion of the Ara processions, and on many first-century funerary reliefs.[7] Despite distinct and important differences among the renderings of particular features,[8] a remarkably close comparison can be made between the composition of head 5 and the background figure of a lictor on the South frieze of the Ara Pacis (s11) (figs. 183, 191), especially in the awkward arrangement of the *fasces* directly abutting the chins of both figures.[9] If a date of about 40–30 B.C. is accepted for the Lictor frieze,[10] then the arrangement of the lictors in the Vatican relief as shown on fragment 3 may have actually served as a compositional model for the lictor section of the South frieze on the Ara Pacis.

Similarities in compositional format are also found on fragment 6 (figs. 212–16). As was the case for fragment 1, fragment 6 shows two youths (however on fragment 6, they are specifically lictors) with the backs of their heads touching, facing in opposite directions. Variations of this arrangement on the Ara friezes occur at the groupings of figures s14 and s15 (fig. 217) and, particularly, at figures s18 and s19 (fig. 193). In the case of the better-preserved Ara reliefs, however, one of the two figures in the composition is shown in a middle plane between the background and foreground levels, and therefore the arrangement on the South frieze appears less awkward than the grouping on the Lictor frieze.

Although the surfaces of heads 8 and 9 on fragment 6 are substantially more damaged than the other heads on the Lictor frieze, the facial details of the idealized, youthful lictors appear much closer in both form and style to the facial designs on the South frieze. Head 8 (fig. 214),

that of a lictor facing to the viewer's left, shares the same compact, oval-shaped head with rounded cheeks as most of the male figures in the imperial family group on the Ara Pacis (figs. 195–97). At the same time, the subtlety of the skillfully modeled mouth resembles that same area on the portrait head of Augustus (fig. 201). Like many of the heads on the South frieze, the eyes of head 8 on the Lictor frieze have different shapes—in this case, an almond-shaped right eye and a much flatter, cylindrical left eye.[11] In addition to wearing the wedge-shaped hair lock form worn by the previously discussed figures in the Lictor frieze, head 8 displays a group of C-shaped locks at the back of the neck and plastically rendered side locks, both of which are found on the majority of male figures on the South frieze.[12]

Head 9, that of another youthful lictor facing to the viewer's right in three-quarter view (figs. 215, 216), is perhaps the figure on the Lictor frieze most comparable with the generalized facial type on the South frieze of the Ara Pacis. Not only are the eyes, with their pronounced upper lids and slightly modeled lower lids, extremely similar to many of the eyes in the imperial family group, but the puffy cheeks, the eyebrow ridge, strong chin, and the oval contour of the head all resemble the design formula of the generalized facial type that dominates on the right half of the South frieze. However, interestingly enough, the forehead of head 9 is not a plain, flat expanse as it is on the generalized type, but is rather a compartmentalized design consisting of a smooth upper brow divided from a bulging lower brow by an incised furrow that is characteristic of the expressive facial type on the left half of the South frieze. Finally, as with all the youths on the Lictor frieze, the hair of head 9 follows the wedge-shaped lock form, here used with a late republican-style "receding" hairline.

In addition to the basically generalized heads of male youths and lictors, the realistic portrait of head 7 on fragment 4 illustrates that, like the creators of the South frieze, the designer(s) of the Lictor frieze juxtaposed different facial types within the one compositional format (figs. 218–21). Furthermore, as is the case with the portraits of Agrippa (s44) and to some extent Augustus on the Ara Pacis, the realistic type on the Lictor frieze is handled with recognizably greater skill, experience, and understanding of sculpting anatomical form. This head of a balding, elderly man in profile view shares basic facial characteristics with the youths on the Lictor frieze (elongated eyes with heavy upper lids, a large ear, carefully modeled mouth, and stylized hair locks), but has been given character and identity by carefully modeled surface modulations, an individualized skull contour, and a more detailed treatment of the eye area with wrinkles, crow's feet, and plastic brow hairs. In attempting to suggest the underlying skeletal structure of the skull, the sculptor has taken full advantage of the effects of light and shadow playing on the stone surface whose texture ranges from smooth to roughly chiseled. Head 7, like the portraits of Agrippa and s44 carved about twenty-five years later, is a telling illustration of the new softening or "idealizing" of the realistic type for elderly male portraits in relief that occurs in Roman art during the transitional or experimental period of the last half of the first century B.C.[13]

Although little drapery survives on the Lictor fragments, enough remains for an informative comparison with the drapery on the Ara processions. Fragment 2 (fig. 205) and fragment 5 (fig. 221), as well as small sections of folds on fragments 3 and 6, reveal a flat, two-dimensional form with a minimum of volume and a preponderance of channel lines that clearly resembles

the schematic, linear drapery treatment on the South frieze.[14] One can compare, for example, the simple pattern of intersecting diagonal and vertical lines and the flat expanses of cloth on fragment 2 and on headless figure 6 on fragment 3 with similar drapery designs on figures S12 and S35 on the Ara procession. On both the Lictor relief and the South frieze, the intention was to create an impression of draped cloth by means of line and the play of light and shadow, while ignoring, disguising, or suggesting incorrectly the underlying anatomical forms and their naturalistic proportions.

In addition to their similar approaches to rendering anatomy and drapery as well as figural compositions on both the Lictor frieze and the Ara Pacis processions, the sculptors of the two friezes display remarkable similarities in the carvers' selection of tools and the specific ways in which they used those tools. As on the Ara processions, the predominant tool for carving figures in relief is the rounded chisel. Particularly clear traces of these chisel strokes occur on the flesh surfaces of the figures, where the tool marks not only consistently follow but, in fact, emphasize the contours of forms.[15] The edge of the chisel was also used for sculpting the individual rods and channels of the *fasces*, the folds and furrows of the drapery, and the stylized hair locks, all in the same expedient manner as occurs on the surviving Augustan sections of the North and South friezes.[16] Like the Ara reliefs, the drill was not used in the hair, and it was only occasionally and timidly used for emphasizing the initial hollow of a drapery channel. This sporadic, tentative use of the drill for rendering drapery is directly analogous to the experimental application of the drill for outlining major drapery folds on the Ara processions. In fact, the drilling on the Lictor frieze argues that locally trained workshops in Rome had already been testing the tool for carving drapery before the commission for the Augustan altar was issued and certainly supports the idea that the carvers of the Ara processions relied on earlier, local sculptural traditions. For smoothing flesh surfaces, the carvers of the Lictor frieze did use some sort of abrasive (but no rasping) to remove chisel marks from the highest relief areas of the faces of heads 8 and 9 on fragment 6. This method compares well with the smoothed, higher-relief portions of several heads on the South frieze and serves as another example of experimentation with Greek techniques for finishing stone surfaces prior to the carving of the Ara processions.[17]

Another example of a late republican, multifigured relief in approximately life-size scale that bears close comparison with the Ara processions is the so-called Via Druso relief in the Braccio Nuovo of the Palazzo Conservatori in Rome.[18] The relief consists of four fragments of Carrara marble, two of which preserve substantial portions of five male figures.[19] The first of these two fragments was discovered in 1937 during utility excavations in the area of the Piazza Numa Pompilio.[20] In that same year, the second block was unearthed on the Via Druso.[21] The relief appears to have originally adorned an exedra-shaped structure, perhaps a funerary monument of an upper-class magistrate or military general.[22] Block 1, which shows the upper portions of three male figures, has a concave, sculpted front face and a flat rear face with anathyrosis (fig. 222). The edge of the sculpted area on the front face ends in a curve that closely resembles the curved relief ground on the ends of the processional reliefs on the Ara Pacis. Figure 1 on block 1 is a seminude youth in frontal three-quarter view who rests a spear or staff over his left shoulder (fig. 223). He shares many traits with both the figures on the Lic-

tor frieze and on the South frieze, including a solid, oval head, ridge-type eyebrows, asymmetrical eyes, a full, small mouth, and a prominent chin. Despite the fact that his curly, tousled hairstyle is distinctly different from the flatter, caplike coiffures worn by the male figures on the Ara, the individual lock forms of the Via Druso youth conform to the same basic C-shaped, wedge type found on the Ara Pacis. Figure 1 also has the awkward composition that we have seen used for profile-view lictor figures carrying the *fasces* on both the Ara friezes and the Lictor fragments, in which the far cheek intersects unrealistically with the rising diagonal column of the staff.

The techniques used to carve figure 1 are almost identical to those used on the Ara processions. The majority of anatomical and drapery forms were shaped with a relatively narrow rounded chisel, which has left clear traces on the cheek, jaw, and neck. As on the Ara and the Lictor friezes, the chiseling on the Via Druso figure followed the surface contours of the various undulating planes of the head, torso, and drapery, and the edge of the chisel was used to delineate the individual parts of the eyes, mouth, and hair locks. There was no use of the drill on figure 1 (including the drapery furrows), nor were any of the surfaces smoothed with abrasives. As appears characteristic of figural reliefs carved in Rome during the first century B.C., the figure merges directly into the back plane with no drilled contour outline. Also found here and on the majority of republican funerary portrait reliefs is the typical, pocked-mark texture on the background surface left by the blows of a claw chisel.[23] The particular application of the claw chisel on the Via Druso reliefs, during which the carver struck the stone with the claw chisel and dragged it across the surface for a short distance before lifting it off to strike again, occurs on many reliefs carved in Rome around the middle to the late first century B.C., but not on the Ara processions.

The next foreground figure (figure 3) on block 1 of the Via Druso relief has been tentatively identified as the portrait of a late republican general, perhaps even of Mark Antony (fig. 224).[24] This figure of an older man, who stands frontally, wears a plumed helmet, and holds a spear vertically in his right hand, has been rendered in a portrait style that is markedly different from the expressionless, idealized head of the youth appearing alongside him. The deep-set eye, slanted brow, and furrowed forehead of figure 3 create an impression of emotional pathos similar to that found on certain Hellenistic portraits,[25] while the sagging muscles around his nose and mouth and the sunken hollows under his cheekbones reflect traits of Hellenized, realistic facial types carved in the republican period.[26] Unfortunately, not enough of his damaged face has survived for us to appreciate fully this combination of facial formulas that results in a kind of "expressive realism." Meanwhile, although the facial design of figure 3 is different in many ways from those on the Ara processions, the carving techniques remain very similar. Regrettably, the marble surface of figure 3 is substantially worn and, in consequence, many of the individual tool marks have not survived. Notable exceptions are the chisel marks on the individual strands of the arching plume, which resemble the chisel marks found on drapery folds on many first-century B.C. reliefs and on the western half of the South frieze. Traces of contour chiseling similar to those preserved around the heads of figures on the South frieze have survived along the contours of figure 3, especially along the edge of the helmet to the viewer's left.

The figure that stands in the background plane between the curly haired youth and the

older general on block 1 appears to be a stock type of soldier (figure 2) who shares features with certain background figures on the Ara processions. These include (1) a simple arrangement of facial features carved superficially onto the outermost surface of the solid, square mass of the head, (2) minimal modeling of musculature, and (3) an overall lack of an internal, supportive bone structure (fig. 225). As is the case for the male head of s46 in the imperial family group on the South frieze,[27] there is an attempt to show the soldier in three-quarter view, but the composition is distorted by both the flatness of the relief and the unnaturalistic extension of the contour of the right jaw. Although the surface of this background figure has been worn, enough remains to determine that he was likewise carved primarily with the chisel without subsequent rasp work or drilling.

The second block (2702) from the Via Druso monument preserves the upper torso and head of another curly-haired youth and the uplifted right arm and hand of a second male figure, along with what may be the remnants of a helmet (figs. 226, 227). The raised hand of figure 5 is comparable with hands on the Ara processions and on many late first-century reliefs in that the parts of the hand (here seen palm side forward) have been simplified into their most basic cylindrical forms.[28] It is not a naturalistic translation into stone of an actual human hand, but rather a stylized and abstract impression of a hand. The use of a drill to hollow out the channels between the fingers on figure 5 is also found on both the Ara friezes and contemporary funerary reliefs.[29] Finally, there are slight traces of contour chiseling around the outline of this arm and hand, especially noticeable at the thumb area.

Figure 4 on block 2 is a bust-length, nude male youth shown in a distorted three-quarter view (fig. 116). The right shoulder of this figure was incorrectly elongated, causing the torso to appear as if it were in an unnaturalistic full frontal view. This tendency to combine different views and distort anatomical proportions was typical of both late republican funerary reliefs and the processional friezes on the Ara Pacis.[30] With regard to the overall rendering of details and the actual carving of the torso and face, figure 4 is extremely similar to figure 1 on block 1, with the important exception that the sculptor of figure 4 used a distinctly different formula for the facial design. Instead of the expressionless, generic type used for figure 1, figure 4 bears a version of the Hellenized "expressive" type that occurs on many of the heads on the left half of the South frieze, characterized by a bulging lower forehead, contracted brow, and deep-set eyes.[31] As was the case for the South frieze and several late republican funerary reliefs, the designer of the Via Druso relief incorporated several different facial types within one figural scene, while at the same time, the stone carvers used the same standard chiseling techniques for all the figures regardless of type. Furthermore, the facial type that was carved most skillfully from the point of view of an understanding of the natural, organic structure of the human face was once again a type clearly derived from late republican realistic or veristic portraiture.

LATE REPUBLICAN/EARLY AUGUSTAN FUNERARY RELIEFS

The similarities in figural style, drapery rendering, and overall sculptural technique between numerous late republican and early Augustan funerary reliefs[32] and the processions on

the Ara Pacis suggest that there was communication between these artists. Although many illustrations of these analogous features have been commented on earlier, two specific reliefs will be examined in further detail. For example, dated on the basis of hairstyle to the decades immediately preceding the *dedicatio* of the Ara Pacis (30–13 B.C.), a three-figure, bust-length marble relief (the Mattei relief) displays many of the technical and design characteristics that were to be used for the figures in the North and South friezes.[33] The male bust to the far left of the block (fig. 94) bears an individualized portrait similar to the softened version of the realistic facial type used for Agrippa on the South frieze.[34] This male wears the flat, receding hairline commonly depicted on portraits of the third quarter of the first century and found on the roughly contemporary Lictor frieze (c. 40–30 B.C.). Next to him sharing the *dextrarum iunctio* gesture is a young woman (figs. 188, 228) wearing a *nodus* from which twisted sections of hair have been pulled back over the ears and tied in a bun similar to the one worn by Antonia Minor.[35] The third figure, a slightly older veiled woman (figs. 189, 229), wears a more complicated hairstyle in which large, wavy locks frame either side of the face in a manner resembling the framing coiffures of s32 (Livia) on the South frieze and the seated female figure in the Tellus panel (fig. 230). However, for understanding the transmission of sculptural traditions from one group or generation of carvers to the next within the workshops of Rome, neither the types of hairstyles nor the clothing[36] is as informative as are the details of the anatomy and drapery and the tools and techniques used to render these forms.

Like both the Ara processions and the other large-scale figural reliefs previously discussed, numerous traces of narrow, rounded chisel marks survive on the surfaces of these three faces as well as on their varying hairstyles and drapery folds. The carver(s) left these shallow channels as the final surface texture except at the points of highest relief on the central female figure. Here, as on several of the heads on the South frieze, the foremost portions of the face have been smoothed with abrasives. Such smoothing, we may recall, was not done on the Via Druso relief but did occur on fragments 4 and 6 on the Lictor frieze. Smoothing with abrasives was a Greek technique that gained popularity among marble relief carvers during the second half of the first century B.C.[37] Yet, unlike the standard Greek practice, the smoothing was confined to the areas of the face closest to the eyes, nose, and mouth. Like the previously discussed reliefs, the drill was used to accentuate the major drapery channels after they had been shaped with the chisel, to outline major folds, and to accentuate the crease between the lips. In the case of the rightmost female figure on this relief and s32 (Livia) on the South frieze, the drill also was used to separate the wavy side locks of hair from the overlying veil. Unlike the carving of the Ara figures, however, the drill was used, albeit sparingly, to create a crude channel between the figure and the back plane (especially noticeable along the right contour of the male figure's head). Emphasizing the outline of a figure and separating the figure from the background plane by drilled channels was, as we have seen, a common Greek tendency.[38] Nevertheless, despite this limited "experimentation" with drilled contouring, the majority of the contours of these three figures merge directly into the background plane with no drilling and retain substantial traces of the kind of contour chiseling technique later found on the Ara reliefs.

In addition to similarities in carving techniques, the anatomical and drapery details of this private memorial often compare well with the rendering of the figures on the South frieze of

the Ara Pacis. The oval heads of the women, with their flat foreheads and rounded chins, closely resemble those same features on the generalized facial types on the right half of the South frieze.[39] In particular, the almond-shaped eyes with thick upper lids and ridge-type eyebrows are almost identical in technique and form to the treatment of the eyes on the figures of Antonia Minor (s36) (fig. 48), Livia (s32), and s30, the so-called barbarian queen.[40] Meanwhile, the incised forehead furrows, deeper-set eyes, and well-understood bone structure of the portrait head of the man are similar in the same details to the softened version of the realistic type used for the portrait of Agrippa.[41] In addition, despite the fact that the man has a receding hairline, the individual locks of hair have been carved with the chisel into the same curved, wedge shape as the stylized locks worn by figures with full heads of hair on the left portion of the South frieze and in the background of the North frieze.[42] The most noteworthy comparisons, however, occur in the drapery treatment. The folds on all three figures in this funerary relief are composed of flat, narrow strips of roughly chiseled stone that have been outlined by chiseled, or even occasionally drilled, linear furrows. This is precisely the method of carving and rendering drapery found on the original sections of the left portion of the South frieze.[43] The awkward combination of this linear, two-dimensional drapery and the much higher relief, solidly three-dimensional heads likewise occurs on Panels s3 and s4 of the Augustan procession. Finally, several anatomical distortions on this relief, especially the narrow proportions of the torsos and the asymmetry of the man's shoulders as well as the oversimplified, rubbery forearms and fingers are all features that are characteristic of traditional approaches to depicting human form found in abundance on earlier and contemporary republican funerary reliefs and also on the Ara friezes.[44]

Another marble funerary relief depicting four figures (the "Sepolcro del Frontispizio" relief), dated to the 30s B.C.[45] and originally found on the Via Appia in Rome, shows an older couple with their hands clasped in the *dextrarum iunctio* gesture in the center of the composition with a young man to their left and a young woman wearing the *nodus* coiffure to their right (fig. 231). The relief is relatively well preserved except for some surface damage to the foreground portions of the faces and the loss of all four noses. Following the practices of most first-century B.C. funerary relief carvers, the sculptor has left the background surface roughly textured with pronounced marks of the claw chisel. Clear traces of contour chiseling with a rounded chisel survive around the edge of the head of the younger female figure (figs. 86, 87).[46] While most of the features on these four heads were clearly shaped with a chisel, there is evidence that other sculpting techniques were applied experimentally, in a manner similar to their use on the Ara reliefs. For instance, abrasives were used to smooth some of the highest relief areas of the face. The chiseling of the cheeks has been removed in places by a rasp, which in turn has left its characteristic scratches on the marble. These faint marks are one of the few instances of rasping on late first-century funerary relief sculpture.[47]

The four figures on this relief share with the figures on the processional friezes heavy lidded, almond-shaped eyes, abbreviated, chiseled locks of hair, and incised wrinkles, furrows, and creases. The female heads resemble the rounded volumes typical of the generalized type and have the ridged eyebrow form found frequently on the Ara friezes. The rendering of the elder woman's portrait is atypical among female heads of the early Augustan period, with its

dramatically swept-back hairstyle, concentrated expression, and masculine features. Neverthe-
less, the individual forms of the facial features, hair, and drapery closely resemble those on all
the previously discussed reliefs. This similarity lends support to the theory that, through the
study of the details of rendering and the specifics of technique, we may identify the relief carv-
ing tendencies of a chronological period.[48]

The two men on this funerary relief bear portraits carved in the softened realistic style
found on the Ara and have eyebrows that are more three-dimensional and naturalistic (figs. 36,
92, 232), similar to those of figure s23 (fig. 35) on the South frieze. All of the figures display
solid, massive heads artificially balanced atop much shallower necks and virtually two-dimen-
sional, draped torsos. The preferences for distorted perspectives, unnaturalistic proportions,
and simplified anatomical forms we have found characteristic of figural relief carving in this
period have been taken to an almost comical extreme. Finally, the heavily chiseled, slatlike
drapery folds and linear furrows are likewise an extreme illustration of the flat, decorative qual-
ity so characteristic of late republican drapery treatment.[49] This strong contrast between the
plastic rendering of the portrait heads and the abstract, flatter torsos is further evidence for the
suggestion that there were separate sculptors for different areas of this relief and that workshop
specialization was as much a phenomenon here as it was in the case of much figural relief pro-
duction in the late first century B.C.[50]

SMALL-SCALE PROCESSIONAL FRIEZES

In the final category of figural reliefs to compare to the North and South friezes of the Ara
Pacis are processional reliefs carved on a small scale (less than half life-size) that typically dec-
orated altars, statue bases, and architraves. The purpose of these comparisons is to determine
whether carvers trained in the local chiseling tradition sculpted all types of processional reliefs
produced during the late first century B.C., regardless of their scale or original mode of display.
A recognizable similarity in carving traditions would suggest that sculptural workshops in
Rome specialized on the basis of the type of scene to be carved and may indicate that the
carvers of scenes of Roman content, such as civic ceremonies and historical narratives, were
specifically assigned to locally trained craftsmen.

In the Braccio Nuovo of the Palazzo dei Conservatori are several fragments that originally
adorned the Temple of Apollo built by C. Sosius, a structure located next to the Theater of
Marcellus near the Forum Holitorium in Rome.[51] Sosius, who had vowed to rebuild the old
Temple of Apollo *in circo* after his own victory in Judaea in 34 B.C., completed the project
around 25 B.C., approximately a decade prior to the decree that led to the erection of the Ara
Pacis. The largest and best-known fragment of the Sosius frieze is a block of white marble
which shows part of a triumphal procession (figs. 233–35). The composition is rhythmic and
repetitious. The figures are arranged in a series of interconnected groups and are shown in a
variety of postures and views, some distorted with regard to proportions and perspective.[52]
Small-scale figures, usually dressed in garments with a minimum of drapery folds and placed
against a neutral, shallow background, displaying distortions of both figural proportions and
visual perspectives, are some of the hallmarks of what has been variously labeled as the native

Italic style, the plebeian style, or the popular style.[53] On the Sosius frieze, details have been handled in an abbreviated, yet highly efficient manner. Sections of hair, drapery folds, and musculature were simplified to their most basic forms while still remaining legible to the viewer. Bulbous facial features were delicately carved with a minimum of strokes onto solid, compact heads.

Yet, while the figural style of the Sosius frieze shares many characteristics with the larger-scale historical and funerary reliefs from the late first century (such as proportional and perspectival distortions, schematicized anatomical and drapery forms), the technical execution of this marble block is markedly different. Unlike the tooling on the Ara processions and on most late republican and early Augustan funerary reliefs, no chisel marks, including those made by contour chiseling, were left on the marble surface. Instead, the carvers finished all of the figures, animals, and equipment with a high polish and allowed no surface tooling to remain except for relatively deep channels made by a narrow-bit drill around the contours of the figures. Furthermore, the background has been smoothed with abrasives.[54] As noted in the previous chapter, both surface smoothing and drill outlining are typical of Greek figural carving in relief.[55] The evidence for the use of these techniques might suggest that some of the carvers were trained in the Hellenic tradition for finishing stone. However, in the case of the Sosius frieze, it is also possible that the polishing and drilling may have been consciously adopted for its suitability on small-scale, multifigure scenes in marble that were originally displayed high up on a temple architrave and therefore difficult to see clearly from the ground. The smoothing of the surface and the drilled outlining, in particular, may have helped to differentiate the various figures and groups in the procession.

Another section of the Sosius frieze may serve to illustrate further the notion that, in some instances, sculptural technique was determined more by the original display spot of a piece than by the traditions in which the carvers were trained. This smaller fragment shows two togate figures in procession, one of which appears to be a lictor carrying the *fasces* (fig. 236). On this piece, there are no polished surfaces and no drilled contours. Instead, all the surfaces were roughly chiseled, similar to those of the larger-scale reliefs previously examined. However, at the right edge of this fragment are marks characteristic of blows made by a point, a tool most often used during the earliest stages of carving for the purposes of removing large amounts of stone quickly. Such point marks were usually not meant to be seen and, on architectural blocks, are often indicative of anathyrosis. This small section, therefore, was very likely originally positioned at a corner or at some hidden edge of the architrave where the rough pointing would be either invisible or difficult to see. This positioning, in turn, may indicate that the chiseled surface of the figures was not the result of the carver's training but was instead a purposely rough surface on a part of the procession that would have been at least partly obscured by its original location. But whether the polish and drill techniques on the large fragment of the triumphal procession were the result of the training of the craftsmen or the position of the frieze or both, the carving techniques used for this small-scale relief are completely different from the techniques used to produce the large Ara processions and the other, related larger-scale figural reliefs.

Similar to the composition and scale of the Sosius procession are the small processional

scenes that originally adorned the sides of the rectangular altar table of the Ara Pacis and its two wings. Two larger portions and many smaller fragments of these marble friezes were not unearthed until the early twentieth century, and therefore may have not been subjected to any documented post-Augustan restoration.[56] The two larger and better-preserved sections of the processions will be discussed here. The first fragment, which decorated the interior face of the northern projecting wing shows an orderly procession moving from left to right, consisting of six draped female figures led by two togate men and followed by another togate attendant (figs. 237–39). These female figures, whose position within the procession appears to have been determined on the basis their height, are traditionally identified as the six Vestal virgins partaking in a sacrificial ceremony related to the *consecratio, dedicatio,* or some other ceremony connected to the altar complex.[57] The second, larger frieze (figs. 240–45), which decorated the exterior, northern side of the altar proper, shows a scene of sacrificial beasts being led from left to right by attendants in a composition very similar to the staccato arrangement of figures on the right half of the Sosius frieze.

The figures in both these pieces from the Ara Pacis display most of the characteristics of the figural type found on the Temple of Apollo Sosianus frieze. However, the Augustan carvers of the altar reliefs have rendered the male musculature more robustly and naturalistically and have given more detail and volume to the folds and furrows in the drapery worn by the female figures and their attendants. The rendering of the figures in a sense appears to be an example of the further Hellenization of the Italic style. These small friezes on the Ara Pacis are, in fact, referred to as Augustan survivals of the republican Italic style.[58] More important for our purposes than the figural style, however, are the techniques used to carve the small Ara processions. The longer, sacrificial scene was carved with the same interest in polished surfaces as the Sosius frieze. All of the figures, animals, implements, and background surfaces have been smoothed, leaving no marks of the chisel. Unlike the Sosius frieze, the contours of the figures on this small Ara procession were only occasionally emphasized by much shallower, narrower channels that may or may not have been created with a drill. The same is true of the "Vestal frieze," although in addition to polishing and the occasional outline, the drapery surfaces of the figures on this section have been noticeably rasped (figs. 246, 247). Extensive surface rasping of drapery is not characteristic of these types of small-scale processions in the first century B.C., but does occur on the Ara processions and on a few republican funerary reliefs.[59] It is characteristic of late Hellenistic Greek carving techniques.[60] Since these friezes, unlike the Sosius frieze, were not displayed at some inconvenient distance from the viewer, the polishing and experimentation with channel outlining on the *suovetaurilia* section may not have been determined by its original position but instead by the sculptural traditions within which the carvers were trained.[61] The similarities in both figural style and technique between the small Ara processions and the Sosius frieze suggest that, regardless of their original display, small-scale processions produced during the late first century often were finished, if not designed and carved, by artisans more familiar with Greek methods of relief sculpting.[62] Furthermore, the stark discrepancies between the carving of these small-scale marble friezes and the techniques used on the main processions of the Ara Pacis along with the other large-scale figural reliefs might offer evidence that there were separate stone-carving workshops that specialized

on the basis of the scale of a figural relief—Greek-trained artisans carving small-scale figural scenes working in workshops dominated by locally trained sculptors who also occasionally experimented with Greek techniques in carving the larger-scale reliefs. Specialization may not have been influenced in this case by the content of the scene or even by the figural style chosen by the designer, but by the actual scale of the relief commissioned. Additional study of the techniques and details of form preserved on small-scale, marble figural reliefs must be carried out before we can fully assess the practice of specialization within the sculptural community based on the scale of the commission.

CONCLUSION

The character of the technical signatures left by chisels, drills, and other tools along with the aesthetic preferences for anatomically unrealistic, structureless figures and abbreviated details of form demonstrates that we must abandon the Greek master theory. On the Ara processions, the tangible evidence for layer carving and surface design suggests instead that we should search for the artists of the friezes in the urban workshops of Rome. These shops trained their apprentices in traditional Italian methods of sculpting locally available stones such as tufa and travertine and, at the same time, experimented with Greek carving methods. Our detection of Italian approaches toward shaping and finishing figural stone reliefs as well as the tentative adoption of Greek methods indicates that the sculpting trends begun in Rome by relief carvers during the republican period continued to flourish in the earlier Augustan era. The combination of traditional Italian methods and Greek innovations on both funerary reliefs as well as imperial projects also suggests a level of interaction and artistic exchange among sculptors commissioned for public and private monuments decorated with reliefs. Augustan "court sculptors," if such a group indeed ever existed, may have executed pieces for patrons not directly connected with the imperial household. According to the evidence on the stone, the distinctions "private" and "public" may not have been so neatly defined for stone relief carvers. From the relief carvers' perspective, the latter half of the first century B.C. was a period of transition and experimentation with new demands and new materials.

As discussed in the first chapter, the Greek master theory, which has dominated much of the modern scholarship on the authorship of the Ara processions, resulted from negative assessments of the artistic creativity and flexibility of sculptors in Augustan Rome. The notion that only foreign, Greek-trained sculptors were capable of producing the North and South friezes was a viewpoint promoted by philhellenic art historians led by J. Charbonneaux and J. Toynbee in the decades immediately following the Allied victory in World War II. Specifically the philhellenes were rejecting the positive interpretations of Augustus's regime and the originality of Augustan imagery as argued in the 1930s and 1940s by such prominent German and Italian scholars as G. Roden-

waldt and M. Pallattino. Significant to this postwar rejection was the fact that the more favorable interpretations of Augustan art made by many German and Italian academics had been encouraged by contemporary Fascist nationalism and the supposed ethnic and spiritual connections between Hitler's Germany, Mussolini's Italy, and ancient, particularly Augustan, Rome. As the design of the Piazzale Augusto Imperatore so clearly illustrates, the Ara Pacis not only had been symbolically but also physically incorporated within the urban architectural landscape of Mussolini's Rome. The images on the Ara Pacis in particular symbolized victory, prosperity, and dominance in the age of Augustus and in that sense were used to help justify Mussolini's ambitious agenda for a revitalized Rome within a new Roman Empire. It was against this political backdrop that the philhellenes so vehemently reacted. However, pre– and post–World War II alternative intellectual currents, spearheaded by G. Kaschnitz von Weinberg, kept alive an interest in identifying the indigenous Italian qualities of Roman representation. Kaschnitz and his followers resurrected the possibility that in Augustan art one could detect specific structural and design characteristics that indicated the tenacity and vitality of indigenous, non-Greek approaches to sculpting figural images in stone.

In more recent years, interest in the process of sculpting and the mechanisms behind ancient commissions has begun to shift attention away from the more subjective assessments of authorship based solely upon iconography and general stylistic features. Examinations of the evidence for the operations of workshop production and the practicalities of designing and executing large-scale architectural and sculptural commissions in the ancient and medieval worlds may ultimately contribute to our understanding of the probable processes involved in creating the Augustan processions. The training of relief sculptors as or alongside stonemasons at the quarry, the conservatism inherent in apprenticeship, the mobility of sculptors, the transmission of artistic traditions over space and time, and the involvement of patrons and committees must all be taken into account in any serious attempt to comprehend the artistic identity of anonymous sculptors of ancient stone monuments.

No less important than our understanding of ancient artistic training and modes of workshop organization is our awareness of the often significant impact of postancient restorations upon the original appearance of any given piece. Many of the proponents of the Greek master theory either were unaware of or otherwise disregarded the profound effects of such restorations. Yet, post-Augustan recarvings, replacements, and acid washes have measurably altered the Augustan face of the large processional friezes. Specifically, F. Carradori's restoration during the late eighteenth-century Italian neoclassical movement invested much of the processions with a quality of classicism that disguises the original Augustan carving and finished appearance.

Fortunately, substantial sections of the processional friezes were not restored by Carradori. On these areas, original technical signatures, including contour chiseling, rough surface chiseling, wedge-shaped, chiseled hair locks, and tentative linear drill application indicate an adherence to local Italian methods for figural relief carving in stone. In addition, certain details of form and composition—variations in plasticity between heads and torsos, the designs of hands, distorted combinations of views, incorrect figural proportions, disregard for internal supportive structures—point to non-Greek conceptualization and subsequent design and exe-

cution. Yet at the same time, characteristics such as experimentation with traditional Hellenic techniques (the rasping and scraping of flesh and drapery surfaces, the occasional smoothing of the back plane, and the smoothing of specific areas of the face) illustrate the growing assimilation of Greek tendencies for sculpting figures in marble. Compositional problems on the North and South friezes, in conjunction with the evidence from comparative studies of Roman reliefs, indicated the creative role of a perceptive designer, the lack of detailed drawings for the background figures, and a division of labor within Roman stone-carving workshops based on specialization, including the workshops that carved the Ara processions.

Finally, comparative analyses of tooling and stylistic details on selected first-century B.C. funerary and nonfunerary figural stone reliefs with Roman content carved in Rome suggested that the sculpting of the Ara processions was not a *creatio ex nihilo*. The design of individual forms and of the anatomy and drapery on the Ara friezes are closely comparable with several earlier and contemporary figural reliefs. The emphasis in earlier republican relief sculpture on surface incision, geometricized structures, and simplified forms for anatomy as well as on a two-dimensional, linear treatment for drapery persists on the Ara processions, as do distortions in both figural proportions and perspectives. Likewise, the combination of various stylistic veneers for depicting human facial design, such as generalized, expressive, and realistic, occurs on reliefs produced prior to the Augustan altar. Rather than working in isolation, the artists of the Ara processions were a contributing group within a dynamic, evolving artistic environment—a milieu characterized by adherence to traditional Etrusco-Italian methods and the gradual adoption of Hellenic marble-carving techniques. One facet of the artistic ingenuity of the Ara processions is that the Augustan artists applied their inherited, traditional technical and stylistic formulas, which were familiar and legible to the contemporary, urban viewer. At the same time, they also experimented with Greek sculpting practices on a complex, multi-figured, composition in marble. Furthermore, the crowded compositions of the processions were executed on a relatively grand scale and showed the emperor, the imperial family, and the priestly colleges not as Greek demigods, Hellenistic heroes, or republican military victors, but as Roman citizens dressed in Roman garb participating in a conservative, solemnly pious Roman ceremony. A comparative study of stone reliefs produced in Rome during the late republican and early Augustan periods demonstrates that, in order to interpret the artistic identities and creative abilities of anonymous artists, we must assess the techniques and stylistic details of any monument within its original historical and artistic context.

This study of the artists of the Ara processions presents several unresolved issues that demand further study. One of the more important questions involves the responsibilities of the designers of Roman representation and the reasons, if any, for their selection of figural styles or materials. In Chapter 4, it was suggested that specific facial styles on the South frieze were adopted to differentiate visually and accentuate the separate groups in the processions. Compositional discrepancies between the static, repetitive arrangement of figures in the North frieze and the more illusionistic, interwoven groupings on the South frieze may have been chosen on the basis of the content of the scenes, the approach and viewing positions of the Augustan audience, and the original position of the Ara Pacis within the larger urban landscape of the northern Campus Martius. Recently, other studies of the juxtaposition of dis-

parate figural styles and compositional formats on late republican and Augustan monuments have pointed to the profitability of such exercises.[1] The notion that artistic styles might have been selected on the basis of particular associations or intended atmospheres recognized by contemporary patrons and audiences may be demonstrated by the decoration of another feature in an Augustan complex in Rome—the ramp connecting the House of Augustus to the Temple of Apollo Palatinus on the Palatine Hill. The walls of this inclined passageway, which led from the domicile of the *princeps* to the adjacent shrine of his patron deity, were painted in a modified version of the First or Masonry Style of Roman wall decoration.[2] While the rendering of painted masonry courses was probably understood as appropriate for the decor of entrances or passageways,[3] one might also suppose that the artist and the patron at the same time were attempting to create an atmosphere within the ramp that echoed and anticipated the venerable, old-fashioned character of the Tuscan-like temple and its archaistic terra-cotta revetments to which the ramp led. The painted walls of the ramp might have been intended by the designer to function as an artistic transition between the extravagant, relatively novel Third Style decoration of the private spaces of the domus and the older, archaic feel of the temple complex. Perhaps both functional and meaningful aesthetic considerations determined the selection of this simpler, more antiquated style of wall treatment. Similar contemporary aesthetic sensibilities and intended messages may also have played a part in the design and execution of the Ara processional friezes.

During the Augustan period, the use of particular styles to generate meaningful associations in the minds of the ancient audience was not restricted to painting and sculpture. The old-fashioned, conservative plan and superstructure of the Temple of Apollo perched on the Palatine, recognized as archaized by the contemporary architect Vitruvius, served as a visual connection to the Tuscan appearance of the venerable Temple of Jupiter on the nearby apex of the Capitoline Hill.[4] The Mausoleum of Augustus, with its Etruscan *tumulus*-like silhouette, may have likewise been adopted in order to remind contemporary pedestrians entering the city from the north of Rome's more distant, Etruscan heritage.[5] For the altar proper of the Ara Pacis itself, the designer chose not to use the more common rectangular format for altars. Instead, he selected a U-shaped design, influenced by Hellenic altar types, which may have invoked recollections of the then still visible series of archaic, sixth-century B.C. U-shaped altars at the ancient Latin sanctuary of Lavinium, a mere thirty kilometers south of Rome.[6] As for architectural projects, the eclectic combination of Italian, Greek, and Egyptianizing figural, drapery, and compositional styles on Augustan reliefs was not haphazard or without purpose. Further study of the patterns of style selection in relation to content, placement, and technical execution of sculpted and nonsculpted imagery may clarify further both the associations intended by Augustan designers and patrons as well as the adaptability of artists producing stylistically eclectic monuments in Rome, such as the Ara Pacis.

NOTES

ABBREVIATIONS

The abbreviations used in the notes and bibliography for periodical titles and monograph series are those recommended in the *American Journal of Archaeology* 95 (1991): 4–16.

Adam S. Adam, *The Technique of Greek Sculpture in the Archaic and Classical Periods* (*BSA*, suppl. vol. 3, London, 1966).

Ashmole B. Ashmole, *Architect and Sculptor in Classical Greece* (New York, 1972).

Bonanno, *Roman Relief Portraiture* A. Bonanno, *Roman Relief Portraiture to Septimius Severus* (*BAR* Suppl. Ser. 6, Oxford, 1976), 23–34.

Burford A. Burford, *Craftsmen in Greek and Roman Society* (London, 1972).

Classical Marble N. Herz and M. Waelkens, eds., *Classical Marble: Geochemistry, Technology and Trade* (NATO ASI series, Dordrecht, 1988).

Gazda, *ANRW* E. Gazda, "Etruscan Influence in the Funerary Reliefs of Late Republican Rome: A Study of Roman Vernacular Portraiture," *ANRW* 1.4 (1982): 855–70.

Gazda, "Style and Technique" E. Gazda, "Style and Technique in the Funerary Reliefs of Late Republican Rome" (Ph.D. diss., Harvard University, 1971).

Kleiner D. Kleiner, *Roman Group Portraiture: The Funerary Reliefs of the Late Republic and Early Empire* (New York, 1977).

Kockel V. Kockel, *Porträtreliefs Stadtrömischer Grabbauten* (Mainz, 1993).

Koeppel G. Koeppel, "Die historischen Reliefs der römischen Kaiserzeit V Ara Pacis Augustae, Teil 1," *BonnJbb* 187 (1987): 101–57.

La Rocca, *APA* E. La Rocca, *Ara Pacis Augustae: In occasione del restauro del fronte orientale* (Rome, 1983).

Petersen, *APA* E. Petersen, *Ara Pacis Augustae* (*Sonderschr. OAI*, vol. 2, Vienna, 1902).

Pfanner, *Titusbogen* M. Pfanner, *Der Titusbogen* (Mainz, 1983).

Pollitt J. J. Pollitt, *Art in the Hellenistic Age* (Cambridge, 1986).

Rose C. B. Rose, "'Princes' and Barbarians on the Ara Pacis," *AJA* 94 (1990): 453–67.

Stewart A. Stewart, *Greek Sculpture: An Exploration* (New Haven, 1990).

Torelli, *Typology and Structure* M. Torelli, *Typology and Structure of Roman Historical Reliefs* (Ann Arbor, 1982).

Toynbee, "Ara Pacis Reconsidered" J. M. C. Toynbee, "The Ara Pacis Reconsidered and Historical Art in Roman Italy," *ProcBritAcad* 39 (1953): 67–95.

Toynbee, "Some Notes" J. M. C. Toynbee, "Some Notes on Artists in the Roman World. II: Sculptors," *CollLatomus* 9 (1950): 49–65.

INTRODUCTION

1. *Horace: The Complete Odes and Epodes with the Centennial Hymn*, trans. W. G. Shepherd (New York, 1983), 179.

2. R. Syme, *The Roman Revolution* (Oxford, 1939; reprint, London, 1967), 392. For this study, reference will be made to the fifth reprinting throughout.

3. For testimonies to Agrippa's eastern campaigns, see Dio 54.24.4; Josephus, *AJ* 16.3.3. Also see Rose, 457 and n. 16, for a discussion of the problem of the date of Agrippa's *adventus*. Rose suggests a date sometime in late June 13 B.C. For testimonies concerning the travels of both Augustus and Agrippa, see H. Halfmann, *Itin-* era Principium: Geschichte und Typologie der Kaiserreisen im römischen Reich (Stuttgart, 1986), 157–66.

4. Dio 54.25.1.

5. Although not mentioned in Dio, essential information about the Ara Pacis and its attending sacrificial ceremonies is found in various calendars: Fasti Praenestini, *CIL* I² 232; Fasti Caeretani, *CIL* I² 212; Feriale Cumanum, *CIL* I² 229; Fasti Amiternini, *CIL* II² 244; Fasti Antiates, *CIL* II² 248. See A. Degrassi, *Fasti Anni Numani et Juliani* (Inscriptiones Italiae XIII.2, Rome, 1963), 117, 189, 279, 404, 476, and Koeppel, 102, n. 4. Additional references occur in the Acta Fratrum Arvalium,

CIL VI 2028b, lines 8–11 (30 January A.D. 38), *CIL* VI 32347a, lines 6–9, and in H. Broise, "Deux nouveaux fragments des Actes des frères arvales de l'année 38 après J.-Chr.," *MEFRA* 92 (1980): 224, lines 38–42 (4 July A.D. 38). For further discussion of the relationship between the Ara Pacis and the rites of the Arval Brethren, see J. Scheid, *Romulus et ses frères. Le Collège Arvale, un modèle du culte public dans la Rome des empereurs* (*BEFAR*, vol. 275, Rome, 1990), 64, 424–26, 435–39, 692, nn. 12 and 13. Ancient references to the Augustan altar are also found in Ovid's *Fasti* 1.709–22 and 3.879–82 and Augustus's *Res Gestae* 12. See Koeppel, 102, n. 4. In addition to the texts, representations of the altar along with legends identifying the structure as the Ara Pacis are preserved on a few Neronian and Domitianic coin types. For illustrations of these coins, see Petersen, *APA*, 194–96 and fig. 60; F. Studniczka, "Zur Ara Pacis," *AbhLeip* 27 (1909): pl. VI, fig. 1. Also see Koeppel, 102, n. 7, for a comprehensive bibliography for the Ara Pacis coin issues.

6. The Ara Pacis was not the first altar to be decreed by the Senate upon the successful return of Augustus from campaign. Six years earlier, in October of 19 B.C., the Senate voted that an altar of Fortuna Redux be built in front of the Temples of Honor and Virtus at the Porta Capena in Rome to commemorate Augustus's return from Syria. See *Res Gestae* 11. On the relationship between the Ara Pacis and the Altar of Fortuna Redux, see Torelli, *Typology and Structure*, 28–29. For the calendars with references to the Ara of Fortuna Redux, see Degrassi, *Fasti Anni Numani et Juliani*, 195, 199, 279.

7. Augustus himself reports in *Res Gestae* 12 that "the magistrates and priests and Vestal Virgins should perform annual sacrifice there"; *Res Gestae Divi Augusti*, trans. P. Brunt and J. M. Moore (Oxford, 1967), 25. For the problem of precisely at which festival Augustus is meant to be represented on the Ara Pacis, see most recently the summary of opinions in R. Billows, "The Religious Procession on the Ara Pacis Augustae: Augustus' Supplicatio in 13 B.C.," *JRA* 6 (1993): 80–92, esp. 80–84. For a discussion of the terms "constutio" and "dedicatio" as they relate to the Ara Pacis, see E. Welin, "Die beiden Festtage der Ara Pacis Augustae," *Dragma Martino P. Nilsson, Acta Inst. Regni Sueciae*, ser. 2, 1 (1939): 500–513.

8. The measurements of the altar precinct (11.625 by 10.655 meters) were first established during the 1903 campaign led by A. Pasqui and E. Petersen. See M. L. Cafiero and the Comune di Roma Assessorato alla Cultura, *Ara Pacis Augustae* (Rome, 1989), 27.

9. The level of the ground surrounding the Ara Pacis complex appears to have been raised during the second century A.D. For a discussion of Hadrianic building in this area of the northern Campus Martius, see M. Boatwright, *Hadrian and the City of Rome* (Princeton, 1987), 64–73.

10. E. Buchner, "Solarium Augusti und Ara Pacis," *RM* 83 (1976): 319–65; "Horologium Solarium Augusti," *RM* 87 (1980): 355–73; and *Die Sonnenuhr des Augustus* (Mainz, 1982). For problems concerning Buchner's theory, see M. Schütz, "Zur Sonnenuhr des Augustus auf dem Marsfeld. Eine Auseinandersetzung mit E. Buchners Rekonstruktion und seiner Deutung der Ausgrabungsergebnisse, aus der Sicht eines Physikers," *Gymnasium* 97 (1990): 432–57. In this article, Schütz argued that the inlaid bronze grid and the obelisk served as a meridian instrument rather than a true sundial and that Buchner's calculations were highly speculative. With respect to the Ara Pacis, Schütz not only questioned Buchner's theory that the shadow of the obelisk fell on the altar on Augustus's birthday but also doubted the interrelationship of the Ara Pacis to Buchner's Solarium Augusti. For further discussion of the Ara Pacis and the topography of the northern Campus Martius, see M. Torelli, "Topografia e Iconologia. Arco di Portogallo, Ara Pacis, Ara Providentiae, Templum Solis," *Ostraka* 1 (1992): 105–31.

11. A substantial portion of the marble between the two reliefs' sides was later removed in the sixteenth century. See Chapter 3 at n. 194.

12. F. Von Duhn, "Über einige Basreliefs und ein römisches Bauwerk der ersten Kaiserzeit," *Miscellenea Capitolina* (1879): 11–16.

13. Petersen, *APA*.

14. For a fuller discussion of the history of the discoveries and reconstructions, see Chapter 3.

15. For the basic bibliography on the Ara Pacis, see Koeppel, 152–56.

16. Tac., *Hist*. 4.53. See especially A. Pasqui, "Per lo studio dell'Ara Pacis Augustae. Le origine e il concetto architettonico del monumento," *StRom* 1 (1913): 283–304.

17. See E. Petersen, "Ara Pacis Augustae," *JOAI* 9 (1906): 309–13. H. Thompson, "The Altar of Pity in the Athenian Agora," *Hesperia* 21 (1952): 79–82. A. Borbein, "Die Ara Pacis Augustae. Geschichtliche Wirklichkeit und Programm," *JdI* 90 (1975): 242–66. Also see the discussion in D. Castriota, *The Ara Pacis Augustae and the Imagery of Abundance in Later Greek and Early Roman Imperial Art* (Princeton, 1995), 33–41.

18. Among the more important studies are T. Kraus, *Die Ranken der Ara Pacis. Ein Beitrag zur Entwicklungsgeschichte der augusteischen Ornamentik* (Berlin, 1953); H. P. L'Orange, "Ara Pacis Augustae. La zona floreale," *ActInstRomNorv* 1 (1962): 7–16; C. Börker, "Neuattisches und pergamenisches an den Ranken der Ara Pacis," *JdI* 88 (1973): 283–317; H. Büsing, "Ranke und Figur an der Ara Pacis Augustae," *AA* 2 (1977): 247–57; G. Sauron, "Les modèles funéraires classiques de l'art décoratif néo-attique au Ier siècle avant J.-C.," *MEFRA* 91 (1977): 183–236; G. Sauron, "Le message symbolique des rinceaux de l'Ara Pacis Augustae," *CRAI* (Janu-

ary–March 1982): 80–101; G. Sauron, "Le message esthétique des rinceaux de l'Ara Pacis Augustae," *RA* 8 (1988): 3–40. Also see most recently the discussion and bibliography in Castriota, *The Ara Pacis Augustae*.

19. Selected bibliography includes E. Strong, "Terra Mater or Italia?," *JRS* 27 (1937): 114–26; M. Schäfer, "Zum Tellusbild auf der Ara Pacis Augustae," *Gymnasium* 66 (1959): 288–301; S. Weinstock, "Pax and the Ara Pacis," *JRS* 50 (1960): 44–58; A. Booth, "Venus on the Ara Pacis," *Latomus* 25 (1966): 873–79; K. Galinsky, "Venus in a Relief on the Ara Pacis Augustae," *AJA* 70 (1976): 223–43; L. Berczelly, "Ilia and the Divine Twins: A Reconsideration of Two Relief Panels from the Ara Pacis Augustae," *ActaAArtHist* 5 (1985): 89–149; N. de Grummond, "Pax Augusta and the Horae on the Ara Pacis Augustae," *AJA* 94 (1990): 663–77; K. Galinsky, "Venus, Polysemy, and the Ara Pacis Augustae," *AJA* 96 (1992): 457–75; B. Spaeth, *The Roman Goddess Ceres* (Austin, Tex., 1996); B. Spaeth, "The Goddess Ceres in the Ara Pacis Augustae and the Carthage Relief," *AJA* 98 (1994): 65–100.

20. The bibliography on this subject is extensive. The more recent studies include Rose, 453–67; J. Pollini, "Ahenobarbi, Appulei and Some Others on the Ara Pacis," *AJA* 90 (1986): 453–60; R. Syme, "Neglected Children on the Ara Pacis," *AJA* 88 (1984): 583–89; R. R. Holloway, "Who's Who on the Ara Pacis," *Alessandria e il mondo Ellenistico-Romano, Studi et Materiali, Ist. Arch. Univ. Palermo* 6 (1984): 625–28; Torelli, *Typology and Structure*; Bonanno, *Roman Relief Portraiture*, 23–34; L. Fabbrini, "Il ritratto giovanile di Tiberio a la iconografia di Druso Maggiore," *BdA* 49 (1964): 304–26; Toynbee, "Ara Pacis Reconsidered," 67–95.

21. Unlike the processional friezes, the carving and restoration of the Tellus panel and the fragments from the Roma panel have recently been studied and documented in La Rocca, *APA*. However, the technical evidence was not examined in relation to the figural and compositional style of the panel. This study suggests that the artist responsible for the Tellus panel, and in fact the entire monument, is without question an anonymous Greek neo-Attic master (La Rocca, *APA*, 63).

CHAPTER 1

1. La Rocca, *APA*, 63: "Autori: Anonime maestranze greche neoattiche."

2. E. Q. Visconti and G. A. Guattani, *Il Museo Pio Clementino*, vol. 5 (Rome, 1820), 191–95.

3. F. Von Duhn, "Über einige Basreliefs und ein römisches Bauwerk der ersten Kaiserzeit," *Miscellenea Capitolina* (1879): 11–16. See Introduction at n. 12.

4. F. Von Duhn, "Sopra alcuni bassirilievi che ornavano un monumento pubblico Romano dell'Epoca di Augusto," *AICA* 53 (1881): 302–32. In this same article,

Von Duhn, comparing the processions with the Panathenaic frieze on the Parthenon, discussed the similar problems both designers faced in placing long processional friezes on a structure. However, Von Duhn did not suggest that the Parthenon frieze had served as a model for the Augustan designers.

5. "Es sollte ein Altarbau geschaffen werden, reich mit Bildwerk geschmückt, wie der zu Pergamon, und bestimmt, den Kaiser zu verherrlichen, ihn als Friedensfürsten zu feiern, eine plastische Ergänzung gleichsam das Monumentum Anciranum." F. Wickhoff and W. Ritter von Hartel, *Die Wiener Genesis* (Vienna, 1895), 20.

6. "The style, the concept of function, is entirely new" (Die Art, wie die Aufgabe gefasst wurde, is ganz neu). Wickhoff and Ritter von Hartel, *Die Wiener*, 20.

7. For a discussion of the views of Wickhoff and Riegl, see O. Brendel, *Prolegomena to the Study of Roman Art* (New Haven, 1979), 25–37.

8. Wickhoff and Ritter von Hartel, *Die Wiener*, 20. For a discussion of Wickhoff's label "illusionism," and the terminological confusion it has caused, see Brendel, *Prolegomena*, 25–36.

9. E. Petersen, "L'Ara Pacis Augustae," *RM* 9 (1894): 177–228, esp. 192, 197; and "Il fregio dell'Ara Pacis," *RM* 10 (1895): 144: "but the east frieze of the Parthenon, where the Augustan sculptor found the model for his bipartite procession, offers a closer comparison" (L'analogia più stringente però offre il fregio orientale del Parthenone, ove lo scultore augusteo trovò il modello della sua processione bipartita). See also Petersen, *APA*, 165–69.

10. E. Courband, *Le bas-relief romain à représentations historiques* (*BEFAR*, vol. 81, Paris, 1899), 84: "Si le sculpteur de l'Ara Pacis a songé à quelque modèle grec antérieur, ce n'est pas au grand autel de Pergame, c'est au Parthénon."

11. "L'arte Augustea non è affatto una semplice imitazione di quella Periclea." Petersen, "L'Ara Pacis Augustae," 145.

12. "C'est en effet l'admirable frise des Panathénées que rappelle cette disposition, simple et savante à la fois, des figures. Mais il s'en est inspiré, il n'a pas copié servilement." Courband, *Le bas-relief*, 84.

13. One important exception to this trend was the work of J. Strzygowski, who preferred to emphasize the Oriental influences upon Roman art in *Orient oder Rom: Beiträge zur Geschichte der spätantiken und frühchristlichen Kunst* (Leipzig, 1901). For a concise discussion of Strzygowski's viewpoint and its limited influence, see Brendel, *Prolegomena*, 41–47.

14. E. Strong, *Roman Sculpture from Augustus to Constantine* (New York, 1907), 56.

15. J. Sieveking, "Das römische Relief," in *Festschrift Paul Arndt* (Munich, 1925), 18: "a new relief style, with an emphasis on three-dimensionality that has no proto-

type in Greek art, came into play" (mit der Betonung der Räumlichkeit ein neuer Reliefstil zur Anwendung, der in der griechischen Kunst keine Vorläufer aufzuweisen hat). Sieveking later discusses the importance of wall painting and Etruscan funerary sculpture as forerunners for the compositional style of Augustan reliefs. For a reference to more recent discussions of the influence of wall painting upon the composition of the Ara Pacis, see Chapter 2.

16. For example, see C. Weickert, "Gladiotoren-Relief der Müncher Glyptotek," *MüJb* 2 (1925): 1–38. For a brief discussion of the arguments against this view, see the summary in the introduction of J. M. C. Toynbee, *The Hadrianic School: A Chapter in the History of Greek Art* (Cambridge, 1934), xiv–xviii.

17. Sieveking, "Das römische Relief," 14; also 18: "There are certainly those—first Petersen and, more recently, but to mind my even more incorrectly, Schober—who have wished to find some such [source in Greek sculpture], as for the Roman procession in the Panathenaic Frieze and for the panel reliefs in the Telephos Frieze" (Einen solchen hat man zwar, wie für die römische Prozession im Panathenäenzug, für die Kurzfriese im pergamenischen Telephosfries finden wollen, zuerst Petersen und ganz neuerdings wieder Schober, aber wie ich meine, mit noch viel weniger Recht).

18. C. Cecchelli, "L'Ara della Pace sul Campidoglio," *Capitolium* 1 (1925): 65–71. For an illustration of the Capitoline Hill proposal, see A. Cederna, *Mussolini urbanista: Lo sventramento di Roma negli anni del consenso* (Rome, 1981), fig. 6.

19. G. Gigliogli, "Il sepolcreto imperiale," *Capitolium* 6 (1930): 532–67. Gigliogli's suggestion was approved shortly thereafter by Mussolini in 1932.

20. S. Kostof, "The Emperor and the Duce: The Planning of the Piazzale Augusto Imperatore in Rome," in *Art and Architecture in the Service of Politics*, ed. H. Millon and L. Nochlin (Cambridge, Mass., 1978), 270–325.

21. For a detailed discussion of the planning of the Piazzale Augusto Imperatore, see ibid., esp. 289–309. According to Kostof, Mussolini was personally involved with the planning of this Fascist square, approving every stage of the design process and, on occasion, ordering changes to those plans. See ibid., 289.

22. For further discussion of the Fascist-period reconstruction, see Chapter 3.

23. A cast of the inscription from the pronaos of the Temple of Augustus at Ankara had been made during a visit to Turkey by an Italian mission in 1911 and brought back to Italy. See Kostof, "Emperor and Duce," 295. For the Mostra Augustea, this cast was installed within a reconstruction of the Ankara temple in a central exhibition hall of the Palazzo dell'Esposizioni on the Via Nazionale. For contemporary discussions of the Mostra

exhibition, see the reviews by the then vice-director of the British School in Rome, E. Strong, "The Augustan Exhibition in Rome and Its Historical Significance," *Nineteenth Century* 124 (1938): 169–77; and "Romanità throughout the Ages," *JRS* 29 (1939): 137–66. The enormous emphasis upon the Augustan age in the exhibition was succinctly described by Strong: "As all roads lead to Rome, so at the 'Mostra' all roads led to and from Augustus" (137), and "The wealth of material grouped round Augustus is easier to imagine than to describe" (146). For a slightly less enthusiastic review, see Ch. Picard, "L'exposition du bimillénaire de la naissance d'Auguste," *RA* 9 (1938): 335–37. For a more recent discussion of the Mostra, see A. M. L. Silverio, "La Mostra Augustea della Romanità," in *Dalla Mostra al Museo: Dalla Mostra Archeologica del 1911 al Museo della Civiltà Romana*, Marsilio editori (Venice, 1983), 77–90.

24. Kostof, "Emperor and Duce," 304–9.

25. P. Marconi, "L'Arte dell'età di Augusto," *Emporium* 513 (1937): 478.

26. G. Rodenwaldt, *Kunst um Augustus* (*Die Antike*, vol. 13, Berlin, 1937). For this study, reference will be made to the separately bound edition by Walter de Gruyter & Co. (Berlin, 1943).

27. "It has sometimes been suggested that the Master of the Ara Pacis wished to create a contemporary counterpart to the Parthenon and its sculpture. But not even the smallest detail suggests that he had any model in mind, either consciously or unconsciously" (Man hat mitunter gemeint, daß der Meister der Ara Pacis ein zeitgenössisches Gegenstück zum Parthenon und seinen Bildwerken habe schaffen wollen. Aber nicht das geringste Detail verrät uns, daß ihm bewußt oder unbewußt jenes Beispiel vorgeschwebt habe). Ibid., 34.

28. Ibid., 44.

29. See, for example, the discussions in W. Weber, *Princeps*, vol. 1, *Studien zur Geschichte des Augustus* (Stuttgart, 1936); W. Schurr, *Augustus* (Lübeck, 1934). See also K. Hönn, *Augustus im Wandel zweier Jahrtausende* (Leipzig, 1938).

30. "Was kann die Kunst der Zeit des Augustus noch der Gegenwart und insbesondere der deutschen Gegenwart bedeuten?" Rodenwaldt, *Kunst*, 6.

31. "Diese Erscheinungen erinnern uns daran, daß auch die Römer uns stammverwandt und durch eine lange geschichtliche Tradition mit uns verbunden sind." Ibid., 8.

32. Although Rodenwaldt was never a member of the Nazi Party, his writings indicate that he was certainly an enthusiastic supporter. He and his wife committed suicide in Berlin in April 1945. For a biography of Rodenwaldt, see A. Borbein, "Gerhart Rodenwaldt," *AA* (1987): 697–700.

33. Rodenwaldt, *Kunst*, 50.

34. D. Mustelli, "L'Arte Augustea," in *Augustus, Studi*

in occasione del bimillenario Augusteo (Rome, 1938), 307–38; M. Pallottino, "L'Ara Pacis e i suoi problemi artistici," *BdA* 32 (1938): 162–72.

35. Pallottino, "L'Ara Pacis," 168–72. For a discussion of their four-master theories and the problems with their methods, see Chapter 4.

36. Syme's *Roman Revolution* was published shortly after the official declaration of war in 1939. Although it was quickly reviewed, rather unfavorably, by A. D. Momigliano in *JRS* 30 (1940): 75–80, the influence of Syme's *Roman Revolution* was not felt until the 1950s. For more recent discussion of Momigliano's attitudes toward the scholarship of Syme, see "Introduction to R. Syme, The Roman Revolution," in *A. D. Momigliano: Studies on Modern Scholarship*, ed. G. W. Bowersock and T. J. Cornell (Berkeley, 1994), 72–79. For discussions of Syme's impact, see the essays in *Between Republic and Empire: Interpretations of Augustus and His Principate*, ed. K. A. Raaflaub and M. Toher (Berkeley, 1990), esp. the chapters by H. Galsterer ("A Man, a Book, and a Method: Sir Ronald *Syme's Roman Revolution* after Fifty Years," 1–20) and Z. Yavetz ("The Personality of Augustus: Reflections on Syme's Roman Revolution," 21–41).

37. Kostof, "Emperor and Duce," 302.

38. For example, the minister of education, G. Bottai, suggested parallels in his work, *L'Italia di Augusto e l'Italia di oggi* (*Accademie e Biblioteche d'Italia*, vol. 11, Rome, 1937), 207–22. For more forceful comparisons between Augustus and Mussolini, see E. Balbo's *Protagonisti dell'Impero di Roma, Augusto e Mussolini* (Rome, 1941), originally written in 1937. Also see L. Curtius, "Mussolini a la Roma antica," *Nuova Antologia* 12 (1934): 487–500. For a recent survey of the use of the Augustan legacy by the Italian Fascists, see M. Cagnetta, "Il mito di Augusto e la 'rivoluzione' fascista," *Quad Stor* 3 (1976): 139–81.

39. Silverio, "Mostra Augustea," 78.

40. For an excellent discussion of Hitler's visit to Rome and his relationship with Mussolini, see A. Scobie, *Hitler's State Architecture: The Impact of Classical Antiquity* (University Park, Pa., 1990), esp. chap. 1, "Mussolini, Hitler and Classical Antiquity," 9–36.

41. For a photograph of Hitler and Mussolini admiring a panel from the North frieze of the Ara Pacis, see Scobie, *Hitler's State Architecture*, fig. 6, originally published in the Italian journal *L'Urbe* in May 1938.

42. J. Charbonneaux, *L'art au siècle d'Auguste* (Paris, 1948). Since he provided neither references nor a bibliography in his study of Augustan art, it is not clear whether Charbonneaux was influenced by Syme.

43. "Mais cette tentative de concilier des institutions libres avec le pouvoir d'un seul, tentative fatalement vouée à l'échec, démontre ce qu'il y avait d'artificiel dans la restauration augustéenne. Le siècle d'Auguste porte la marque de cet artifice." Ibid., 12.

44. The use of art and architecture for increasing one's own *dignitas* and *auctoritas* did not begin with Augustus. For discussions of the long tradition of the use of visual propaganda in the competitive struggles between aristocratic families in Rome during the Republic, see P. Zanker, *The Power of Images in the Age of Augustus*, trans. A. Shapiro (Ann Arbor, 1988), 5–32; A. Ziolkowski, "Mummius' Temple of Hercules Victor and the Round Temple on the Tiber," *Phoenix* 42 (1988): 309–33. For a survey of this issue in relation to the Campus Martius, see recently J. Patterson, "The City of Rome: From Republic to Empire," *JRS* 82 (1992): 186–215, esp. 194–200.

45. Charbonneaux, *L'art*, 65.

46. "En définitive, l'oeuvre artistique de siècle d'Auguste compte moins par sa valeur propre que par les idées qu'elle a mises en mouvement." Ibid., 108.

47. Ibid., 9.

48. Ibid., 71.

49. "Le double cortège figuré sur les murs Nord et Sud rappelle un précédent illustre—la frise des Panathénées—et il n'est pas douteux que l'auteur de la composition romaine l'avait en mémoire quand il dessinait cette suite de personnages. Ici comme au Parthénon, tout un peuple apporte son hommage à la divinité. Mais si l'idée et l'intention sont les mêmes, la Rome d'Auguste se compare à l'Athènes de Périclès sans l'imiter: elle a voulu contempler dans le miroir de marbre le reflet fidèle de son propre visage." Ibid., 69.

50. "Quel est l'auteur du décor sculptural de l'Ara Pacis? Nous ne le savons pas. Mais tout conduit à penser que c'était un Grec: l'intelligence avec laquelle il est entré dans la pensée du prince, la qualité du dessin, la variété des attitudes et du drapé, enfin la tenue du relief solidement ancré dans la tradition hellénique. On peut même préciser qu'il s'agit d'un artiste néo-attique, attaché à la tradition classique du Ve siècle." Ibid., 74.

51. Ibid., 72.

52. Charbonneaux in fact focused his scholarship on the study of Greek art. In 1936, he had published *La sculpture greque au Musée du Louvre*. A mere two years after his book on Augustan art, Charbonneaux published *La sculpture greque* (Paris, 1950). His negative evaluation of Augustan imagery must be understood within the context of his specialization in Greek sculptural form and stylistic development.

53. J. J. Winckelmann, *Geschichte der Kunst des Alterthums* (Dresden, 1764).

54. Toynbee was preoccupied with establishing Greek sculptural dynasties based primarily on literary and epigraphical evidence. Thus she states, "there is no evidence in literary records or from artists' signatures of a 'national' school of Roman or Italian sculptors in the West." Toynbee, "Some Notes," 55.

55. Toynbee, *Hadrianic School*, xiii.

56. For example, in reference to funerary portrait sculpture, she remarked that "The cruder, although by no means always the least attractive, from some points of view, of these portraits, may sometimes have been made by craftsmen of local origin, or by the less skilled western pupils in the Greek ateliers" (Toynbee, "Some Notes," 55).

57. Toynbee, *Hadrianic School*, xviii.

58. Toynbee, "Ara Pacis Reconsidered," 81.

59. Ibid., 89–90. However, after debunking a theory concerning the Pasitelean school, Toynbee remarked that "Studies, such as those on the altar, of the draped human form, male or female, in Roman ceremonial costume, belong to the story of Roman honorific portraits and must have been evolved *de novo* by sculptors in the capital. We cannot detect in them traces of any particular local Greek tradition" (90).

60. L. Budde, *Ara Pacis Augustae* (Hannover, 1957), 14: "Es gab vor der Ara Pacis keine italische Tradition in der Marmorarbeit, und der Abstand von der bodenstandigen republikanischen Kunst . . . war zu groß, um von daher diese klassische Höhe der Leistung begreifbar zu machen."

61. E. Simon, *Ara Pacis Augustae: Monumenta Artis Antiquae*, vol. 1 (Tübingen, 1967), 8.

62. R. Bianchi-Bandinelli, *Rome: The Center of Power, 500 B.C. to A.D. 200* (London, 1970), 192.

63. Bonanno, *Roman Relief Portraiture*, 24.

64. E. Borbein, "Dia Ara Pacis Augustae. Geschichtliche Wirklichkeit und Programm," *JdI* 90 (1975): 252: "Der große Fries, dem wir uns etwas ausführlicher zuwenden, ist trotz seiner römischen Thematik und obwohl ein Person der Zeitgeschichte im Zentrum der Darstellung steht, mit der griechischen Kunst in einem viel spezielleren Sinne zu verbinden: Er zitiert nicht irgendwelche griechischen Formen, sondern ein einzelnes Monument, den Fries des Parthenon auf der Akropolis in Athen."

65. Ibid., 246–48.

66. D. E. E. Kleiner, "The Great Friezes of the Ara Pacis Augustae: Greek Sources, Roman Derivatives and Augustan Social Policy," *MEFRA* 90 (1978): 753–85.

67. I hesitate to summarize any of Kaschnitz's views on structure and spatial representation in Roman art since they are invariably complex and are not easily extracted from the context of his whole work. They are best appreciated by reading Kaschnitz's own eloquent, though admittedly opaque, phrasing. Two useful reviews of Kaschnitz's contributions to the history of ancient art have been published by O. Brendel, *Prolegomena*, 108–21, and M. Bieber, "A Monument for Guido Kaschnitz von Weinberg," *AJA* 71 (1967): 362–86. The majority of his works have been collected by his German students and published in a three-volume set, *Ausgewählte Schriften*, which appeared in 1965 six years after his death. Unfortunately, the numerous studies of Kaschnitz, written in often dense German, have never been translated into accessible English. As a result, in English-speaking countries, the influence of his groundbreaking theories on structure and surfaces has been limited, remaining relatively unavailable to all but the more persevering of students.

68. *Romische Kunst II. Zwischen Republik und Kaiserreich*, ed. H. von Heintze (Rowohlt, 1961), 81: "Dieser Haltung gegenüber zeigen die reliefs der Ara Pacis eine ganz neue Einstellung. Betrachten wir einen beliebigen Teil des Prozessionsfrieses, dann bemerken wir sofort, daß der tektonische Charakter der Struktur, der in der griechischen Kunst immer aufs peinlichste gewahrt wurde, hier verlorengegangen ist. Mit einem Male ist der Reliefgrund in die Darstellung selbst einbezogen. Die Figuren tauchen aus ihm auf und ragen wieder in ihn hinein, wie wir es auf griechischen Reliefs nirgends beobachten konnten." Also note, "When one compares the reliefs on the Ara Pacis with the Parthenon frieze, then one cannot misunderstand the new relationship between space and figure that at that time was brought to the forefront in Augustan sculpture. The individual figures in Greek relief stand out clearly and are isolated from the relief ground so that their spatial relationship is defined solely through the measurable distance from one figure to another. On the other hand, in the representations on the Ara Pacis, the abstract, purely quantitative relationship comes to dominate. An enveloping aura, which definitely derives from the qualitative medium, fluently connects the figures" (Vergleicht man die Reliefs der Ara Pacis mit dem Parthenonfries, dann wird man das neue Verhältnis von Raum und Körper, das im augustischen Bildwerk bereits deutlich an den Tag tritt, nicht verkennen können. Während beim griechischen Relief sich die einzelnen Körper klar vom Grund abheben und isolieren, so daß ihr räumliches Verhältnis ausschließlich durch die meßbaren Abstände dieser Körper voneinander bestimmt wird, tritt bei den Bildern der Ara Pacis an die Stelle der abstrakten, rein quantitativen Beziehungen etwas Fließendes, Einhüllendes und auf diese Weise Körperverbindendes, etwas, dem man unbedingt die Eigenschaften eines qualitativen Mediums zuschreiben muß, wenn es auch zu weit gehen würde, diese Qualität als Luftraum zu bezeichnen). *Ausgewählte Schriften III. Mittelmeerische Kunst*, ed. P. H. von Blankenhagen and H. von Heintze (Berlin, 1965), 467–68.

69. *Romische Kunst II*, 83–84.

70. M. Pallottino, *Etruscan Painting* (Geneva, 1952), 128.

71. B. M. Felletti-Maj, *La tradizione Italica nell'arte Romana* (Rome, 1977), 91–93, 273–74. For the publication of the tomb and its paintings, see M. Cristofano, *La tomba "del Tifone." Cultura e società Tarquinia in età*

tardoetrusca (*MemLinc*, ser. 8, vol. 14.4, Rome, 1969), 209–56; and *Le pitture della tomba del Tifone* (*Monumenti della pittura antica scoperti in Italia, I. Tarquinia*, vol. 5, Rome, 1971).

72. G. Koeppel, "The Role of Pictorial Models in the Creation of the Historical Relief during the Age of Augustus," in *The Age of Augustus*, ed. R. Winkes (Providence, R.I., 1985), 95.

73. Ibid., 97 and n. 20. More recently, a further comparison between the Ara processions and the processional painting from the Tomba del Convegno at Tarquinia has been noted by P. J. Holliday in "Processional Imagery in Late Etruscan Funerary Art," *AJA* 94 (1990): 82, n. 45.

74. G. Koeppel, "The Grand Pictorial Tradition of Roman Historical Representation during the Early Empire," *ANRW* 2.12.1 (1982): 524–25.

75. Koeppel, "Role of Pictorial Models," 97 and fig. 6.

76. See Chapter 5.

77. Holliday, "Processional Imagery," 83, 92–93.

78. For example, in the recently published textbook used by many survey courses of Roman art, N. Ramage and A. Ramage stated: "Artistically, the Parthenon frieze provided the model for the notion of altering the positions and the directions of figures marching in a procession. Even more important, the whole idea of a procession of Athenians, walking in a major civic and religious event, is here copied in the Augustan procession. This was a conscious effort on the part of Augustus and his artists to relate his rule and his dynasty to the greatness of Athens in the fifth century B.C." *Roman Art: Romulus to Constantine* (Englewood Cliffs, N.J., 1991), 94.

79. See especially the essays in Raaflaub and Toher, *Between Republic and Empire*.

80. Brendel, *Prolegomena*, 77–78.

CHAPTER 2

1. *Somnium* 9. For a discussion of the rhetoric of this passage, see Toynbee, "Some Notes," 49–50. Translation from Burford, 13.

2. For an extensive collection of literary references to Greek sculptors, see most recently Stewart, 237–310.

3. See Stewart, 334, for bibliography.

4. M. Roaf, *Sculptures and Sculptors at Persepolis* (*Iran*, vol. 21, London, 1983), esp. chap. 9, "Sculptors' Marks and the Division of Labor," 90–96. The precise nature of the marks on the Persepolitan reliefs remains controversial. Near Eastern scholars are in disagreement regarding whether the marks should be understood as identifiers for individual sculptors or sculptural workshops. For a discussion of the problems with Roaf's cluster analysis method, see M. Root's review in *AJA* 90 (1986): 113–14.

5. C. E. Armi, *Masons and Sculptors in Romanesque Burgundy: The New Aesthetic of Cluny*, vol. 3 (University Park, Pa., 1983). See also N. Stratford, "Romanesque Sculpture in Burgundy: Reflections on Its Geography, on Patronage, on the Status of Sculpture and on the Working Methods of Sculptors," in *Artistes, artisans et production artistique au moyen-âge*, vol. 3, ed. X. Barral i Altet (Paris, 1990), 235–53; I. Forsyth, "The Monumental Arts of the Romanesque Period: Recent Research," in *The Cloisters: Studies in Honor of the Fiftieth Anniversary*, ed. E. Parker (New York, 1992), 3–25; D. Grivot and G. Zarnecki, *Gislebertus, Sculptor of Autun* (London, 1961).

6. The one noteworthy exception is the Trajanic *extispicium* relief in the Louvre that bears the Latin signature of *M. Ulpius Orestes*. Toynbee, after pointing out this exception, remarks that "indeed we should hardly look for signatures on architectural sculptures of an essentially official, public, and monumental character," but offers no explanation as to why we should expect that artists did not sign official Roman historical reliefs. Toynbee, "Some Notes," 58. For the lack of signatures on funerary portraits carved in the last two centuries B.C., however, Toynbee curiously suggests that "these portraits may sometimes have been made by craftsmen of local origin, or by the less skilled western pupils in the Greek *ateliers*, whose names would not have added extra lustre to their works" (55). For a discussion of the meaning of the term "'historical' relief," see G. Koeppel, "The Grand Pictorial Tradition of Roman Historical Representations," *ANRW* 2.12.1 (1982): 512–13.

7. For analyses of the physical evidence, see Chapters 3, 4, and 5.

8. For example: "Of the actual sculptors who created our portraits we know very little. Some portraits show technical similarities that suggest a common source, but in making such rapprochements I have preferred to use the word 'workshops,' as being a rather indefinite term and so appropriate to the present state of our knowledge." E. B. Harrison, *The Athenian Agora*, vol. 1, *Portrait Sculpture* (Princeton, 1953), 6.

9. For a discussion of the terminological problems associated with the label "workshop," see V. Goodlett, "Rhodian Sculptural Workshops," *AJA* 95 (1991): 669–81, esp. 669–72 and n. 1.

10. Burford, 80–81. For a discussion of an actual shop excavated at Aphrodisias, see P. Rockwell, "Unfinished Statuary Associated with a Sculptor's Studio," in *Aphrodisias Papers*, vol. 2, ed. R. R. R. Smith and K. Erim (Ann Arbor, 1991), 127–43.

11. Due to the absence of textual and epigraphical testimony for the personnel and organization of sculptural workshops in Rome, any definition, including that proposed in this study, must remain flexible. There is no fixed model for the operating conditions of Augustan sculptural workshops. Only through the study of the monuments themselves and, to a somewhat lesser de-

gree, through comparative evaluation of studies of other workshop units can we arrive at a clearer understanding of how the Augustan sculptural workshop operated at a practical level.

12. Ashmole, 159. For a discussion of the role of the designer of the Ara processions, see Chapter 4.

13. Roaf, *Sculptures and Sculptors*, 27.

14. Goodlett supposes up to fifteen, but she is referring to bronze casting, not stone carving. Casting pieces in bronze may have required more personnel. See Goodlett, "Rhodian Sculptural Workshops," 678. While the number of craftsmen in collaboration appears to vary from project to project, there is no evidence to suggest whether the growth of any particular workshop was a concern for the ancients. We know that in fifteenth-century Germany statutes were drawn up for sculptors' guilds which specifically addressed the issue of workshop size. These regulations limited the number of apprentices a master artist could take on within a given time period and illustrate how craft guilds were themselves mindful of competition and fearful of monopoly. Such regulations for size may have existed for ancient sculptural workshops. For the German guilds, see M. Baxandall, *The Limewood Sculptors of Renaissance Germany* (New Haven, 1980), 116.

15. Pausanias 5.10.2–10. See also Ashmole, 23.

16. Ashmole 118; Burford, 250.

17. P. Rockwell, "Preliminary Study of the Carving Techniques on the Column of Trajan," *StMisc* 26 (1985): 101–5.

18. Rockwell, "Unfinished Statuary," 141.

19. *Protagoras* 328A; *Republic* 421. K. Arafat and C. Morgan, "Pots and Potters in Athens and Corinth: A Review," *OJA* 8, no. 3 (1989): 311–46, esp. n. 328.

20. Goodlett, "Rhodian Sculptural Workshops," 676–78.

21. On the inheritance of artistic skill, Lucian remarked how his modeling of wax in school led his father to believe he had a natural gift for sculpting (*Somnium* 2). Similarly, Pliny states that "the son of Praxiteles, Cephisodotus, inherited also his skill" (*NH* 36.24).

22. For a discussion of the relevance of Greek sculptors' patronymics, see most recently the summary in Goodlett, "Rhodian Sculptural Workshops," 671–72.

23. Lucian, *Somnium* 2; Toynbee, "Some Notes," 56.

24. Craftsmen in Rome often went into business with fellow former slaves and as a rule were required to maintain social and legal ties with their former owners who upon manumission had become their patrons. Frequently it was the patron who actually owned the workshop and profited from its activities.

25. S. Joshel, *Work, Identity and Legal Status at Rome: A Study of the Occupational Inscriptions* (London, 1992), 92–144.

26. Ibid., 113–22.

27. *Republic* 421, 467A.

28. G. Mendel, *Catalogue des sculptures greques, romaines et byzantines*, vol. 1 (Constantinople, 1912), no. 13 [775], 78–80. Mendel recorded the measurements of the damaged fragment as 2.65 meters long with a maximum height of .34 meter and described the marble as white with black veins. He identified the piece as a sarcophagus fragment and dated it to the second century A.D.

29. For a discussion of the process of polishing with abrasives, see P. Rockwell, *The Art of Stoneworking* (Cambridge, 1993), 48–49.

30. R. Ling, *Roman Painting* (Cambridge, 1991), 217. Diocletian's Price Edicts demonstrate the higher value of figure painting over other types of decorative painting. For the edict, see K. Erim and J. Reynolds, "The Copy of Diocletian's Edict on Maximum Prices from Aphrodisias in Caria," *JRS* 60 (1970): 120–41; T. Frank, *An Economic Survey of Ancient Rome*, vol. 5 (Baltimore, 1940), 305–421. For a discussion of painters' workshops and the organization of labor, see J. Clarke, *The Houses of Roman Italy, 100 B.C.–A.D. 250: Ritual, Space and Decoration* (Berkeley, 1991), 57–63.

31. For a discussion of the existence and importance of specialization in Roman sculpture, see Chapter 4.

32. On the importance of observation in the learning process, note for example, from an anonymous account written in Rome c. A.D. 70, that "Chares [of Lindos] did not learn from Lysippus how to make, by Lysippus showing him a head by Myron, arms by Praxiteles, a torso by Polycleitus, but observed the master making all right in front of him." Auctor, *ad Herrenium* 4.6.9, in Stewart, 299.

33. For a sculptor's perspective on the active learning process, see P. Rockwell, "Some Reflections on Tools and Faking," in *Marble: Art Historical and Scientific Perspectives on Ancient Sculpture*, ed. M. True and J. Podany (Malibu, Calif., 1991), 207–21.

34. "It is easy to take over iconographic formulas, conventions and procedures concerning the superficial rendering of form. But for an artist it is difficult, if not impossible, to renounce his deeper artistic heritage and to step out of his tradition into another, to change the syntax, the structure and the conception of the whole—all those basic categories conditioned by his environment and the collective 'mental set' of a society." C. Nylander, *Ionians in Pasargadae* (Uppsala, 1970), 17. For some fascinating comments from a sculptor concerning the strength of one's own training and the difficulty of abandoning it to adopt another, see Rockwell, "Some Reflections," esp. 221.

35. R. H. Randall Jr., "The Erechtheum Workers," *AJA* 57 (1953): 199–210.

36. A. Burford, *Greek Temple Builders at Epidauros* (Liverpool, 1969), 58.

37. R. D. Weinberger, "St. Maurice and St. André-le-

Bas at Vienne: Dynamics of Artistic Exchange in Two Romanesque Workshops," *Gesta* 23, no. 2 (1984): 75–86.

38. F. Terpak, "The Role of the Saint-Eutrope Workshop in the Romanesque Campaign of Saint-Caprais in Agen," *Gesta* 25, no. 2 (1986): 185–96.

39. Goodlett, "Rhodian Sculptural Workshops," 673–79.

40. L. Scipio brought artists from Asia to Rome after the triumph over Antiochos at the Battle of Magnesia in 189 B.C. (Livy 39.22.9–10) while M. Fulvius Nobilior brought a willing group of artists from Greece to Rome following his capture of Ambracia in 189 B.C. (Livy 39.22.1–2). For further discussions of adult Greek artists emigrating to Rome, see Toynbee, "Some Notes"; Stewart, 96–99; Pollitt, 150–63.

41. Evander had been in the service of Roman clientele before the restoration commission of Augustus in 30/29 B.C. Prior to the second triumvirate, Evander had been a freedman of Aemilius Avianus and had supplied Cicero with decorative statuary from Athens (Cicero, *Epistulae ad Familiares* 7.23). It was during an official visit to Greece in 39 that Antony brought Evander into his service and dispatched him to Alexandria (Porphyrius on Horace, *Satires* 1.3.90).

42. For the activities of a group of freedmen sculptors and architects during the late Republic and early Empire, see E. Rawson, "Architecture and Sculpture: The Activities of the Cossutii," *PBSR* 43 (1975): 36–47, esp. 39–41. This article is reprinted in E. Rawson, *Roman Culture and Society: Collected Papers* (Oxford, 1991), 189–203.

43. For a detailed discussion of the role of the patron, see the subsequent section, "The Patron and the Design."

44. M. Root, review of *Sculptures and Sculptors at Persepolis* by M. Roaf, *AJA* 90 (1986): 113–14.

45. As one relatively mild expression of this attitude, Burford wrote, "The competent, or, to put it another way, the mediocre craftsman was able to maintain the tradition in which he had been trained. *It was left for the great craftsman* [my italics] to transform traditional concepts, not only by reinterpreting familiar styles, but also by experimenting with new materials and techniques" (114).

46. Variations in style seen not as the product of genius but rather as the result of small divergences from the archetype over generations have been the basis of much anthropological discussion of cultural or stylistic drift. See, for instance, R. C. Dunnel, "Style and Function: A Fundamental Dichotomy," *American Antiquity* 43 (1978): 192–202; C. E. Cleland, "From Sacred to Profane: Style Drift in the Decoration of Jesuit Finger Rings," *American Antiquity* 37 (1972): 202–10. Note also, in reference to the development of Neolithic Greek pottery: "This random process of drift, or exploitation

of a range of variation in the execution of an idea, must be considered in conjunction with the potter's active selection of elements. The consistency of selection is guided by continuity of learning between generations or contemporary groups." T. Cullen, "A Measure of Interaction among Neolithic Communities: Design Elements of Greek Urfirnis Ware" (Ph.D. diss., University of Indiana, 1985), 59–60.

47. Arafat and Morgan, "Pots and Potters," 319–20.

48. Goodlett, "Rhodian Sculptural Workshops," 673–78.

49. Roaf, *Sculptures and Sculptors*, 27.

50. *CIL* VI 4032. For additional information on *columbaria*, see the bibliography provided in S. B. Platner, *A Topographical Dictionary of Ancient Rome* (London, 1929), and more recently M. Anderson and L. Nista, *Roman Portraits in Context: Imperial and Private Likenesses from the Museo Nazionale Romano* (Rome, 1989).

51. Stewart, 56–59.

52. For the evidence for Pergamon, see Stewart, 301–3 and references; for Halikarnassos, see Ashmole, 153–59; for the Persian and Near Eastern evidence, see Nylander, *Ionians in Pasargadae*; C. Zaccagnini, "Patterns of Mobility among Ancient Near Eastern Craftsmen," *JNES* 42 (1983): 245–64; M. C. Root, *King and Kingship in Achaemenid Art: Essays on the Creation of an Iconography of Empire* (Acta Iranica, vol. 9, Leiden, 1979); J. M. Sasson, "Instances of Mobility among Mari Artisans," *BASOR* 190 (1968): 46–54; G. Walsher, "Greichen an Hofe des Grosskönigs," in *Festschrift Hans von Greyerz*, ed. E. Walder (Bern, 1967), 189–202; G. Goossens, "Artistes et artisans étrangers en Perse sous les Achéménides," *NouvClio* 1 (1949): 32–44.

53. D. Viviers, *Recherches sur les ateliers de sculpteurs et la Cité d'Athènes à l'époque archaïque: Endoios, Philergos, Aristokles* (Brussels, 1992).

54. Toynbee, "Some Notes," 58.

55. F. Kleiner, "Artists in the Roman World: An Itinerant Workshop in Augustan Gaul," *MEFRA* 89 (1977): 661–96, esp. 662, 686.

56. Pliny, *NH* 35.157; Plutarch, *Life of Poplicola* 13.

57. Goodlett, "Rhodian Sculptural Workshops," 673.

58. Stewart, 62–63.

59. Ashmole, 18.

60. Burford, 155.

61. Ibid., 156.

62. For a discussion of the problems associated with stone provenance and workshop identification, see J. G. Pedley, *Greek Sculpture of the Archaic Period: The Island Workshops* (Mainz, 1976), 16–17.

63. F. Rakob and W. D. Heilmeyer, *Der Rundtempel am Tiber in Rom* (Mainz, 1973). Also see M. Pfanner, "Über das Herstellen von Porträts," *JdI* 104 (1989): 163–64; D. Strong and J. Ward-Perkins, "The Round

Temple in the Forum Boarium," *PBSR* 28 (1960): 7–30. Many of the Pentelic Corinthian capitals later were replaced by versions carved from Carrara marble during the early first century A.D. For a discussion of the Tiberian phase of the circular temple, see Rakob and Heilmeyer, *Der Rundtempel*, 19–23; A. Ziolkowski, "Mummius' Temple of Hercules Victor and the Round Temple on the Tiber," *Phoenix* 42 (1988): 314–15.

64. L. Lazzarini, M. Mariottini, M. Pecoraro, and P. Pensabene, "Determination of the Provenance of Marbles Used in Some Ancient Monuments in Rome," in *Classical Marble*, 403.

65. J. Ward-Perkins, "Tripolitania and the Marble Trade," *JRS* 41 (1951): 89–104, esp. 107; L. Lazzarini et al., "Determination," 403.

66. M. Fischer, "Marble Imports and Local Stone in the Architectural Decoration of Roman Palestine: Marble Trade, Techniques and Artistic Taste," in *Classical Marble*, 161–70, esp. 162–63.

67. M. Waelkens, P. De Paepe, and L. Moens, "Quarries and the Marble Trade in Antiquity," in *Classical Marble*, 18.

68. S. Casson, "An Unfinished Colossal Statue at Naxos," *BSA* 37 (1936–37): 21–25.

69. E. Dolci, "Marmora Lunensia: Quarrying Technology and Archaeological Use," in *Classical Marble*, 79–83.

70. M. Waelkens, "From a Phrygian Quarry: The Provenance of the Statues of the Dacian Prisoners in Trajan's Forum at Rome," *AJA* 89 (1985): 641–53.

71. N. Asgari, "The Stages of Workmanship of the Corinthian Capital in Proconnesus and Its Export Form," in *Classical Marble*, 117; J. Ward-Perkins, "The Marble Trade and Its Organization: Evidence from Nicomedia," *MAAR* 36 (1980): 328–29.

72. H. J. Etienne, *The Chisel in Greek Sculpture* (Leiden, 1968), 19: "When natural stone, and also marble, is newly quarried, the stone is always softer." References in twelfth-century textual accounts suggest that architectural elements such as bases and capitals were prepared at the quarry site since certain types of stone are more easily carved when first quarried. See M. Aubert, "La construction au moyen âge," *BMon* 119 (1961): 32. The Exeter fabric rolls also give evidence that some of the carving of architectural details such as bosses and capitals was done in a studio at some location away from the cathedral, possibly near the quarry known as Hamdon, modern Ham Hill in Somerset. J. Givens, "The Fabric Accounts of Exeter Cathedral As a Record of Medieval Sculptural Practice," *Gesta* 30 (1991): 112–18.

73. *Passio SS. quattuor coronatorum auctore Porphyrio*, 766, 2, and 771, 11, in J. C. Fant, *Cavum antrum Phrygiae: The Organization and Operations of the Imperial Marble Quarries in Phrygia* (*BAR* International Series, vol. 482, Oxford, 1989), 117.

74. From personal discussions with Peter Rockwell in Rome, 1990–91. See also P. Rockwell, "Stone-Carving Tools: A Stone-Carver's View," *JRA* 3 (1990): 351–57; "Sensitivity on the part of the carver is the key to stone-carving tools and their uses. The experienced carver will be responsive to the stone: different stones carve differently, and two blocks of the same kind of stone carve differently" (351).

75. N. Dean, "Geochemistry and Archaeological Geology of the Carrara Marble, Carrara, Italy," in *Classical Marble*, 315.

76. Roaf, *Sculptures and Sculptors*, 90.

77. Burford, 106.

78. J. C. Fant, "Four Unfinished Sarcophagus Lids at Docimium and the Roman Imperial Quarry System in Phrygia," *AJA* 89 (1985): 655–62.

79. Givens, "The Fabric Accounts," 115.

80. Armi, *Masons and Sculptors*, 14.

81. Note in D. Strong and A. Claridge, "Marble Sculpture," in *Roman Crafts*, ed. D. Strong and D. Brown (London, 1976), 195–207: "There was no sharp distinction in Roman times between the artist and the craftsman. The word *marmorarius*, therefore, covers not only the sculptor but also the mason and stone-worker" (195). See also the *Enciclopedia dell'Arte Antica, Classica e Orientale* (Rome, 1961), 870–75, for a comprehensive discussion of the use of the term *marmorarius*.

82. It is interesting to note that Pliny never refers to any of the Greek sculptors as *marmorarii* in his discussion of the history of sculptors in the *Natural History*. Rather Pliny refers to these sculptors by the more generic terms associated with artists or artistic activity (*insignes, artifices*). Most probably, the noteworthy Greek sculptors of the past were held in different esteem that the relief carvers of imperial Rome and as such were not referred to by the same designation. Furthermore, the Romans may not have considered any sculptor who produced primarily nonarchitectural, freestanding pieces as the same kind of craftsman as the relief carver.

83. *CIL* XI 1356, 1322, 1320, 1319.

84. *CIL* X 7039.

85. Burford, 127.

86. Considering the occupations of some of its members, one wonders whether there were measures to prevent certain conflicts of interest in the Epidauran contracting system.

87. Such complex contracting procedures likewise have been suggested for the design and construction of many Romanesque cathedrals and churches. See J. James, "Multiple Contracting in the Saint-Denis Chevet," *Gesta* 32 (1993): 40–58.

88. *Moralia* 489E; also S. Martin, *The Roman Jurists and the Organization of Private Building in the Late Republic and Early Empire* (*CollLatomus*, vol. 204, Brussels, 1989), 30.

89. J. Bundgaard, "The Building Contract from Lebadeia," *ClMed* 8 (1946): 27.

90. Ibid., 33.

91. A building contract from Puteoli dated c. 100 B.C. specifies the use of certain materials, such as wood. See A. Degrassi, *Inscriptiones Latinae Liberae Rei Publicae* (Florence, 1957–63), 518; T. Wiegand, "Die puteolanische Bauinschrift," *Jahr. f. Klass. Philol.*, suppl., 20 (1894): 660–778; Martin, *Roman Jurists*, 39–40.

92. S. Nodelman, "How to Read a Roman Portrait," *Art in America* 63 (January–February 1975): 26–33; Ling, *Roman Painting*, 212–20.

93. M. Garrison, "Seals and the Elite at Persepolis: Some Observations on Early Achaemenid Persian Art," *Ars Orientalis* 21 (1991): 17.

94. Roaf, *Sculptures and Sculptors*, 96.

95. See the discussion in M. C. Root, "Circles of Artistic Programming: Strategies for Studying Creative Process at Persepolis," in *Investigating Artistic Environments in the Ancient Near East*, ed. A. Gunter (Washington, D.C., 1990), 115–39.

96. R. Gem, "The Bishop's Chapel at Hereford: The Roles of Patron and Craftsmen," in *Art and Patronage in the English Romanesque*, ed. S. Macready and F. H. Thompson (London, 1986), 88–93.

97. James, "Multiple Contracting," 52–55.

98. Burford, 103.

99. Ibid., 91.

100. Bundgaard, "Building Contract," 43.

101. Most recently see Stewart, 61. Ashmole, however, supposed that Perikles decided the subject matter for the continuous Ionic frieze (117).

102. Ashmole, 12.

103. P. Zanker, *The Power of Images in the Age of Augustus*, trans. A. Shapiro (Ann Arbor, 1988), 98.

104. R. Talbert, *The Senate of Imperial Rome* (Princeton, 1984), 285–89.

105. *Aqued.* 100–108.

106. Talbert, *Senate*, 373.

107. *CIL* VI 31541, 31702; *AE* (1947): 154, (1951): 182a; Talbert, *Senate*, 373.

108. *AE* (1972): 174; W. Eck, "Die Familie der Volusii Saturnini in neuen Inschriften aus Lucus Feroniae," *Hermes* 100 (1972): 461–84; Suetonius, *Claud.* 9; Talbert, *Senate*, 365.

109. *Ann.* 2.83.

110. W. Trillmach, "Der Germanicus-Bogen in Rom und das Monument für Germanicus und Drusus in Leptis Magna. Archäologisches zur Tabula Siarensis (I 9-21)," in *Estudios sobra la Tabula Siarensis*, ed. J. González and J. Arce (Madrid, 1988), 51–60; D. Potter, "The Tabula Siarensis, Tiberius, the Senate, and the Eastern Boundary of the Roman Empire," *ZPE* 69 (1987): 269–76; W. D. Lebek, "Die drei Ehrenbogen für Germanicus," *ZPE* 67 (1987): 129–48; J. González, "Tabula Siarensis, Fortunales Siarenses et Municipia Civium Romanorum," *ZPE* 55 (1984): 55–100; F. Castagnoli, "L'Arco di Germanico *in circo Flaminio*," *ArchCl* 36 (1984): 329–32.

111. Unfortunately, there has never been a comprehensive survey or even a collection of all the surviving official decrees and *senatus consulta* for public monuments which might help to determine the specific conditions of official state patronage. Perhaps an interdisciplinary study of this material might further clarify the involvement of the state as patron in the creation of one of the most distinct forms of Roman art, the official historical relief.

CHAPTER 3

1. For a recent review and bibliography on the discovery and subsequent history of the Ara Pacis, see S. Settis, "Die Ara Pacis," in *Kaiser Augustus und die verlorene Republik* (Berlin, 1988), 400–426. It remains uncertain how long the altar complex was visible before being buried under the level of the Campus Martius. It may have been burned and destroyed during the Norman invasion of Rome at the end of the eleventh century. Italian restorers have suggested that traces of this burning survive on several areas of the relief decoration and are especially noticeable on the floral frieze on the eastern side of the *saeptum*. See La Rocca, *APA*; M. L. Cafiero and the Comune di Roma Assessorato alla Cultura, *Ara Pacis Augustae* (Rome, 1989).

2. The palace subsequently became the property of the Peretti, nephews of Sixtus V, in the mid-seventeenth century. Later, in the mid-nineteenth century, it passed into the hands of the Ottoboni, dukes of Fiano. Consequently, the building is often referred to both as the "former Palazzo Peretti" and the Palazzo Fiano; see Settis, "Die Ara Pacis," 402–3.

3. "I quali pezzi dall'un canto havevano figure de trionfi che dal tempo sono un poco disfatte e dall'altro havevano certi festoni." The correspondence between Ricci and his Florentine patrons was published as an appendix by E. Petersen, "L'Ara Pacis Augustae," *RM* 9 (1894): 224–28; see also La Rocca, *APA*, 63–65; Settis, "Die Ara Pacis," 402–3. For the series of letters, see Petersen, ibid., 224–25.

4. Unfortunately for modern restorers and scholars, a substantial section of valuable marble between the two sculpted sides was removed, possibly to be reused in an unrelated, anonymous project. For this reason, there are no saw markings on the slabs themselves, which could otherwise serve as evidence for matching the figural slabs with their festooned slabs.

5. While the processional reliefs remained in Rome, the better preserved "Tellus" panel was sent immediately to Florence as evidence of the high quality of the

sculptural cache Ricci had purchased for Cosimo di Medici. For Ricci's correspondence concerning the Tellus panel, see Petersen, "L'Ara Pacis Augustae," 225.

6. There is now a cast of Panel 1 from the North frieze adorning the wall of an exedra in the Belvedere cortile at the Vatican Museum. The original panel was acquired from the Vatican and placed into the modern reconstruction of the altar that stands today.

7. Panel 4 from the North frieze remains to this day in the Musée de Louvre in the Salle de Mécène (Inv. 1088). The relief on the present reconstruction of the Augustan altar is a cast of the original in Paris.

8. A. Pasqui, "Scavi dell'Ara Pacis Augustae," *NSc, Atti della R. Accademia dei Lincei* 27 (1903): 549–74.

9. For the extraordinary photograph showing Panel s4 lying in situ beneath the Palazzo Fiano, see F. Studniczka, "Zur Ara Pacis," *AbhLeip* 27 (1909): 901–42, pl. II, no. 2.

10. For the sake of brevity in the text, the five panels from the South frieze will now be referred to as "Panel" followed by the letter s, denoting South frieze, followed by the appropriate Roman numeral. Since the front or western side of the South procession is extremely fragmentary, the panel numbers commence with III. Thus, the panels of the South frieze are s3, s4, s5, s6, and s7. The panels from the North frieze will be referred to as "Panel N" plus their panel number. They are N1, N2, N3, and N4. The numbering of the panels in both processions commences at the western end of the *saeptum* walls. In the modern reconstruction, the original western end now faces southward.

11. For a comprehensive discussion of the campaigns of 1937–38, see the lavish tome, *Ara Pacis Augustae*, a monument in and of itself, published in 1948 by the director of the excavations, G. Moretti. Also see by Moretti a smaller pamphlet, *Ara Pacis Augustae*, Ministero della Pubblica Istruzione, Itinerari Nr. 67 (Rome, 1959); "La ripresa dello scavo dell'Ara Pacis Augustae," *NSc*, ser. 6, 13 (1937): 37–44; and "Lo scavo e la ricostruzione dell'Ara Pacis Augustae," *Capitolium* 13 (1938): 479–90; and also G. Lugli, "In attesa delloo scavo dell'Ara Pacis Augustae," *Capitolium* 11 (1935): 365–83.

12. R. de Angelis Bertolotti, "Materiali dell'Ara Pacis presso il Museo Nazionale Romano," *RM* 92 (1985): 221–36. During my research year in Rome, these fragments were unavailable for my inspection, although several excellent photographs of certain pieces do exist. For references to these illustrations, see Angelis Bertolotti, 234–35. From the photographs it appears the carving of these fragments is consistent with the techniques preserved on the sections unearthed during excavations conducted in the early twentieth century.

13. D. Conlin, "The Large Processional Friezes on the Ara Pacis Augustae: Early Augustan Sculptural Styles and Workshop Traditions" (Ph.D. diss., Universi-

ty of Michigan, 1993), 25–27. I am indebted to G. Ponti in Rome for first suggesting to me the possibility that the heads on the South frieze were recarved in the fourth century.

14. Bonanno, *Roman Relief Portraiture*, 32–33. For a discussion of the Hadrianic activity in the Campus Martius, see M. T. Boatwright, *Hadrian and the City of Rome* (Princeton, 1987), 33–73.

15. N. Hannestad, *Tradition in Late Antique Sculpture: Conservation, Modernization, Production* (Acta Jutlandica, vol. 69, no. 2, Aarhus, 1994), 20–54. Professor N. Hannestad and I independently arrived at the conclusion that the Ara processions were recut by late antique restorers and we have enjoyed much lively debate on the subject. I am indebted to him for sharing his opinions and listening to my views concerning Augustan marble carving and the late antique restoration. However, I do not believe that the Augustan figures were recarved to the extent to which Hannestad has argued.

16. The rasped surfaces also were observed by both La Rocca (*APA*, 65) and Bonanno (*Roman Relief Portraiture*, 25). For Petersen's paint adhesion theory, see *APA*, 15. Based on chemical analyses of the marble, however, Petersen's hypothesis was questioned by La Rocca (*APA*, 65).

17. Hannestad, *Tradition*, 33–34. While I find Professor Hannestad's theory of ancient weathering damage to the reliefs both interesting and provocative, I have yet to be convinced of the extent of such damage on the Ara processions, especially, as he suggests, in the area between the tops of the heads of the figures and the background surface. That there has been erosion of the marble surface seems clear, but such damage occurs at many different locations on the marble slabs. Water damage to the stone may also have taken place after the reliefs were buried under the Campus Martius, an area of Rome continually subjected to flooding and rising groundwater levels. For a discussion of the waterlogged soil surrounding the remains of the altar during the excavations in the 1930s, see Moretti, "Lo scavo e la ricostruzione," 479–90.

18. The certainty of a late antique restoration of the Hadrianic roundels is attested by the radical and obvious recarving of the original heads in order to transform them into Tetrarchic portrait heads. Such complete portrait alteration is not apparent for the heads of the figures in the South frieze. For a discussion of the possible portrait recarving of figure N36 in Panel N4, see Hannestad, *Tradition*, 48–58.

19. Ibid., figs. 37, 38, and 39.

20. Due to the lack of rasping on any other areas of the background surfaces of both the North and South friezes, as well as the complicated and unclear postancient history of Panel N4, it must remain uncertain as

to whether these isolated rasp marks were due to ancient or a modern carving.

21. Rome, Museo Nazionale Romano, Inv. 4307 (Kockel, 117, pl. 29c–e).

22. Rome, Museo Nazionale Romano, Inv. 106515 (Kockel, 122–23, pl. 35b).

23. Rome, Museo Nazionale Romano, Inv. 4293 (Kockel, 146–47, pl. 58c–d).

24. Rome, Museo Capitolino, Magazzino Sculture, Inv. 1533/1535 (Kockel, 147–48, pl. 60a–d).

25. Rome, Museo Nazionale Romano, Chiostro di Michelangelo, Ala III, Inv. 196632 (Kockel, 114–15, pls. 26c–d, 27a–b).

26. Rome, Musei Capitolini, Palazzo dei Conservatori, Braccio Nuovo, Inv. 2897 (Kockel, 109, pls. 21b, 22a–c).

27. Rome, Musei Capitolini, Palazzo dei Conservatori, Braccio Nuovo, Inv. 2142 (Kockel, 94–95, pls. 10a, 12a–b, 14a–b).

28. Gazda, "Style and Technique," 69–78. "The skillful workmanship and subtleties of design indicate the he [the patron] commissioned a highly able mason, one who was clearly not trained in the Greek manner but was able to assimilate some of its carving mannerisms and turn them to his own artistic purposes. The Hellenization of the Via Statilia relief must, in the final analysis, be seen as a superficial adaptation of Greek figure types and technical tricks which, because of the sculptor's exceptional ability, succeeded in refining the vernacular art form while sacrificing none of its forceful expressive character" (77–78).

29. Ibid., 69.

30. Adam, 76–77. For further discussion, see Chapter 4.

31. See Chapter 4 at n. 273.

32. Hannestad, *Tradition*, 24–25. This tool had been identified by P. Rockwell as a "strumento simile ad un raschietto dentato" in La Rocca, *APA*, 64. For a discussion of the scraper, see P. Rockwell, *The Art of Stoneworking* (Cambridge, 1993), 48.

33. However, it appears that a rasp was applied over the scraper at certain areas.

34. Hannestad, *Tradition*, 20–54.

35. For a discussion of this piece, see V. von Graeve, *Der Alexandersarkophag und seine Werkstatt* (*IstForsch*, vol. 28, Berlin, 1970).

36. Rome, Palazzo dei Conservatori, Museo Nuovo, Inv. 2897 (Kockel, 109, pls. 21b, 22a).

37. Rome, Museo Nazionale Romano, Inv. 4307 (Kockel, 117, pl. 29c–e).

38. Rome, Museo e Galleria Borghese, Inv. 188 (Kockel, 152, pl. 66a, c).

39. Rome, Musei Vaticani, Museo Chiaramonti, Galleria Lapidaria XV, Inv. 9398 (Kockel, 125–26, pls. 37e, 38b, e).

40. For example, note the eye rendering on the nenfro portrait head of Arnth Paipnas dated before 300 B.C. in the Museo Nazionale in Tarquinia (O. Brendel, *Etruscan Art* [New York, 1978], fig. 307).

41. The iris with pupil incision of Augustus's eyes appears to have been an isolated phenomenon on the western half of the South frieze. Of course, this half of the procession is more fragmentary and many figures are missing. Yet, the eyes of the male figure positioned in front of Augustus in the procession who looks back toward the emperor (S15) have neither incised irises or pupils. The figure to the emperor's left (S17), who follows him in the frieze and glances back toward the eastern half of the crowd, bears only incised irises. There appears to be no pattern to the incising of irises or pupils in this area of the frieze.

42. According to the methods of hand identification first established by the Italian art historian Morelli, this repetition of a small detail might indicate a deliberate or subconscious habit of one particular carver, perhaps revealing the hand of a specific artist. However, we have only two instances of this two-figure pattern preserved on the friezes. Such a limited occurrence makes it difficult, in my opinion, to apply the Morellian methods and isolate, with any certainty, the preferences of a particular sculptor.

43. For an imperial portrait reworked during the Constantinian period, see Hannestad, *Tradition*, 93, fig. 59.

44. Ibid., fig. 47. Hannestad's argument that this figure and possibly the entire Augustan arch was recarved during some late antique restoration is, in my opinion, not entirely convincing. I am particularly troubled by his suggestion that "sloppy workmanship," anatomically incorrect body proportions, and flat, linear drapery treatment are not typical of Augustan relief carving. Hannestad appears to follow the assumption that we should expect higher quality from carvers working on official commissions in Augustan Rome. Yet, until we examine further the carving methods and details of final form characteristic for Augustan relief pieces, I believe that we cannot be sure of what to expect from Augustan sculptors. There has yet to be sufficient systematic analyses of Augustan carving methods to justify any quality assessment of the pieces, including the spandrel Victory.

45. The tear ducts of most of the figures on the Flavian Cancelleria reliefs (both foreground and background figures) have been drilled in a manner similar to the Ara processions. Although there has been some controversy concerning post-Flavian recarvings of the Cancelleria friezes, there is no evidence on the stone that any of the background figures have been reworked. I believe the drill work at the tear ducts is Flavian. For discussions of the recarvings, see A.-M. McCann, "A Re-dating of the

Reliefs from the Palazzo della Cancelleria," *RM* 79 (1972): 249–76; M. Bergmann, "Zum Fries B der flavischen Cancelleriareliefs," *MarbWPr* (1981): 19–31.

46. Rome, Museo Nazionale Romano, Inv. 196633 (Kockel, 138–39, pl. 49f).

47. Rome, Museo Nazionale Romano, Inv. 80715 (Kockel, 209–10, pls. 123b–c, 124).

48. Further study of relief carving techniques practiced by sculptors from the Flavian to Antonine periods is critical for establishing a date for many of the atypical tool marks on the Ara processions. It is my opinion that Bonanno's theory for a Hadrianic restoration of the Ara processions during the reorganization of the Campus Martius in the second century A.D. deserves reevaluation. Note also the comment in Hannestad: "Most likely some restoration work [of the Ara Pacis] was carried out during the reign of Hadrian, as suggested by Bonanno, who, however, dates the obvious reworking much too early" (*Tradition*, 53, n. 47). However, Hannestad did not comment upon nor describe the effects of this Hadrianic restoration.

49. For example, for the ridge type, note the eyebrow rendering on the Via Statilia relief (Kockel, pl. 14a–b), on the females on the six-figure funerary relief (Rome, Museo Nuovo, Inv. 2231; Kockel, pl. 33a–b), on the women in the Furii relief displayed at the Vatican (Kockel, pls. 44a–c, 45a–c), and on all three figures in the Louvre funerary relief, Inv. 3493 (Kockel, pl. 50a–d). For the scored ridge type, refer to the eyebrow carving on the head of an elderly male in New York (Metropolitan Museum of Art, Inv. 17.230.133; Kockel, pl. 20b), the male heads on a four-figure funerary relief (Museo Nazionale Romano, Inv. 196632; Kockel, pl. 26c–d), the male heads on a six-figure funerary relief (Museo Nuovo, Inv. 2231; Kockel, pl. 32a, c–d), and the male heads on the Furii relief in the Vatican (Kockel, pl. 46a–b). The scored ridge type was not, however, limited to male heads. Note the scored ridge eyebrows of the female portrait on a marble relief that once stood on the Via Appia (Kockel, pl. 53c–d).

50. See the eyebrow rendering on the rightmost male from a three-figure funerary relief (Museo Capitolino, Inv. 185; Kockel, pl. 34c), a fragmentary male head in the Braccio Nuovo (Palazzo dei Conservatori, Inv. 2687; Kockel, pl. 65d), and a fragmentary male head from Ostia (Magazzino, Inv. 1300; Kockel, pl. 29a–b).

51. As opposed to Hannestad: "It may seem shocking to some that a monument such as the Ara Pacis has been reworked so heavily that the processional friezes can hardly any longer be termed Augustan" (*Tradition*, 5).

52. Settis, "Die Ara Pacis," 403.

53. E. Q. Visconti and G. A. Guattani, *Il Museo Pio Clementino*, vol. 5 (Rome, 1820), pl. 35.

54. Ibid., 191: "Tutte le teste più rilevate sono risarcimento; come ancora le mani d'alcune figure."

55. It is difficult to determine whether the original sections (necks, arms, legs) to which the Renaissance restorations were attached were recarved for the fitting. These areas are in fact much less worn than the damaged drapery surfaces. If the original necks, arms, and so on had been carved to accommodate the attachments, the present positions and gestures of the restored sections may not adequately represent the Augustan composition.

56. F. Carradori, *Istruzione elementare per gli studiosi della scultura* (Florence, 1802), esp. 27–30; see also La Rocca, *APA*, 66–68.

57. F. Von Duhn, "Sopra alcuni bassirilievi che ornavano un monumento pubblico Romano dell'Epoca di Augusto," *AICA* 53 (1881): 330–32.

58. For a complete bibliography on drawings of the Ara Pacis, see Koeppel, 156–57. The mid-eighteenth-century sketches of Panels s6 and s5 and n3 by the American artist Benjamin West are rough and provide little useful information (see R. S. Kramer, *Drawings by Benjamin West and His Son Raphael Lamar West* [New York, 1975], 4–5, pl. 2).

59. Concerning the Dal Pozzo-Albani drawings, Toynbee stated: "The several artists who produced the drawings in this group sketched, rather than mechanically copied, their models; but in no case did they 'restore,' or add details to, the monuments which they recorded" ("Ara Pacis Reconsidered," 94–95). However, unless we are to assume that there was an unrecorded restoration after 1600 which was subsequently not mentioned and removed by Carradori, the Dal Pozzo illustrators added details that were not on the reliefs themselves. For instance, a comparison between the drawings of Panel n2 in the Codex (fig. 55) and the Albani collection (fig. 59a) shows that three figures were given heads in the latter sketch. The same situation occurs in the drawings of Panel n3. The heads of these figures on the present monument are the work of Carradori. Bartoli's artistic license is more obvious. In print 14 (fig. 61), Bartoli imaginatively connected Panel s7 with a section from Panel n2. Therefore, by comparing the drawings with each other and with the reliefs themselves, the Codex sketches appear the least embellished and the most accurate record of the condition of the panels prior to Carradori's reworking of them.

60. One must assume that Panel n1 was in a similar state of preservation before the Renaissance restoration, since the Renaissance carvers restored the same types of additions as Carradori (heads, feet, hands, etc.). The reason for the extensive damage on the North frieze is unclear. The fact that the heads consistently appear to have been separated from the body may argue for deliberate mutilation as opposed to accidental breakage. The question remains however as to why the South frieze heads were not likewise removed. It is a curious situa-

tion that requires further investigation, although the exact causes of the damage may never be fully known.

61. Von Duhn, "Sopra Alcuni," 330.

62. Ibid.: ". . . si per l'ingiurie de i Tempi come ancora per la esposizione in cui erano, dà essere mal'trattati dà i Colpi di sassi . . ."

63. Personal conversation with P. Rockwell at the Ara Pacis, Rome, 1991.

64. Carradori, *Istruzione elementare*, 29; La Rocca, *APA*, 68, n. 19.

65. E. Michon, "Les bas-reliefs historiques," *MonPiot* 17 (1910): 157–263.

66. F. Von Duhn, *MonInst* 11 (1881): pls. 34–35, 1.

67. Moretti, *Ara Pacis Augustae*, 122–23, fig. 108. For an interesting discussion and illustration of this remains of this head, see Hannestad, *Tradition*, 48–52, fig. 31.

68. Michon, "Les bas-reliefs," 167, n. 8.

69. P. Refice and M. Pignatti Morano, "Ara Pacis: Le fasi della ricomposizione nei documenti dell'Archivo Centrale dello Stato," *Roma. Archeologia nel Centro* 2 (1985): 404–20.

70. For specific compositional problems due to the Fascist-period reconstruction, see D. Conlin, "The Reconstruction of Antonia Minor on the Ara Pacis," *JRA* 5 (1992): 209–15, and G. Koeppel, "The Third Man: Restoration Problems on the North Frieze of the Ara Pacis," *JRA* 5 (1992): 214–16.

CHAPTER 4

1. See Chapter 2 at n. 6.

2. The survival of took marks on many ancient Roman monuments has often been attributed to the protective properties of a rose-brown pigment (*scialbatura*) that many believe was applied to the surface by ancient craftsmen to protect the stone. Recently, the hypothesis that *scialbatura* was a man-made substance has been challenged. Chemical analyses suggest instead that *scialbatura* is a naturally occurring patina produced by the activities of certain organisms that no longer exist in cities with substantial air pollution. This new study explains why *scialbatura* is not found on monuments erected after the nineteenth century. See M. del Monte and C. Sabbioni, "A Study of the Patina Called 'Scialbatura' on Imperial Roman Monuments," *Studies on Conservation* 32 (1987): 114–21.

3. For example, see the separate discussions of style and technique in Pfanner, *Titusbogen*, 55–58; A.-M. Leander Touati, *The Great Trajanic Frieze: The Study of a Monument and of the Mechanisms of Message Transmission in Roman Art* (SkrRom, ser. 4, vol. 45, Stockholm, 1987), 83–91.

4. See Chapter 2.

5. P. Rockwell, *The Art of Stoneworking* (Cambridge, 1993), 80.

6. For a discussion of the post-Augustan tool marks on the Ara processions, see Chapter 3.

7. See Chapter 5 for detailed analyses of technique and figural styles on related late first-century B.C. reliefs.

8. For a discussion of this issue, see P. Rockwell, "Some Reflections on Tools and Faking," in *Marble: Art Historical and Scientific Perspectives on Ancient Sculpture*, ed. M. True and J. Podany (Malibu, Calif., 1991), 207–8.

9. Much of the work of early scholars of Greek sculptural practices, namely Blümel and Casson, has been summarized in Adam.

10. Ibid., 49. In her description of the carving of the Illissos stele NM 869, she states: "Thus by the time the sculptor had finished this stage of his work the figures were well and truly lifted out from the background" (121). This approach to carving relief figures is essential to understanding the differences between the conceptualization of sculpted figures in the minds of the Greek carver versus that in the minds of sculptors working in the Italian tradition. The sculptural techniques on classical pieces reveal that from the outset the Greek artist visualized a figure as three-dimensional and as having an internal structure, even when the relief height was extremely low, as on the Parthenon frieze.

11. Recently Rockwell has discussed this same phenomenon of "heading straight for the background": "the reference plane used by the [Greek] carver was changed during the process so that the original reference plane of the front was discarded at the end of stage three in favor of the newly carved background plane" (*Art of Stoneworking*, 108). Note also drawing 38 illustrating the various stages of Egyptian, Greek, and Roman carving (ibid., 110).

12. See the chapter on the drill in Adam, 40–73, especially her description of drill work on the drapery of the pediment figures on the Parthenon and the Hephaisteion.

13. Ibid., 39.

14. Ibid., 76–77. Examples of unsmoothed figural surfaces from the early Hellenistic period are the rasped drapery surfaces on the Sarcophagus of the Mourning Women from the Royal Necropolis of Sidon now displayed in the Istanbul Archaeological Museum. However, while the drapery of the women has been left rasped, the flesh surfaces (particularly those around the area of the face) have been smoothed.

15. Ibid. For example, "beautifully smoothed" (75) and "rubbed to an exquisite finish" (76) are typical of the attitude toward "finished" surface textures.

16. For example, traces of rasping occur on the back plane of the funerary stele of Mnesarete from Attica dated c. 380 B.C., now on display in the Glyptotek in Munich. The anatomical and drapery surfaces of the two female figures in this relief were smoothed. The

practice of rasping surfaces continued in Greece into the Julio-Claudian period. On the two portrait statues of Gaius and Lucius Caesar from the Julian Basilica in Corinth, both drapery and flesh surfaces were left rasped. For a discussion of the tooling of these pieces, see C. de Grazia, "Excavations of the American School of Classical Studies at Corinth: The Roman Portrait Sculpture" (Ph.D. diss., Columbia University, 1973), 96–103. De Grazia tentatively identified both statues as carved from Pentelic marble.

17. Istanbul Archaeological Museum. See G. Mendel, *Catalogue des sculptures grecques, romaines et byzantines*, vol. 1 (Constantinople, 1912), 574.

18. For illustrations, see R. R. R. Smith, *Hellenistic Sculpture* (London, 1991), pl. 203; B. S. Ridgway, *Hellenistic Sculpture*, vol. 1 (Madison, Wis., 1990), pls. 89–94.

19. On the Zoilos frieze, there survives some faint fine tooth chiseling on certain areas of the back plane, while on the Gaius Caesar fragment, traces of a narrow tooth claw chisel appear between the feet of some of the soldier figures. For the Zoilos frieze, see R. R. R. Smith, *Aphrodisias I: The Monument of C. Julius Zoilos* (Mainz am Rhein, 1993); K. Erim, "The Zoilos Frieze," *Madrider Beiträge* 6 (1979): 35–40. H. Yilmaz has argued that certain stylistic connections between the Zoilos frieze and the reliefs on the Ara Pacis ("Der Zoilosfries aus Aphrodisias: Typologie, Stil und Eigenart des Frieses und sein Verhältnis zur Ara Pacis," Diss., Marburg, 1987). I find the comparisons between the style of the Ara figures and those on the Zoilos frieze unconvincing, especially at the level of details. In addition, following my own inspection of the Zoilos frieze and personal consultations in Rome with Peter Rockwell (who is extremely familiar with both Roman and Aphrodisian carving styles), I have concluded that the technical execution of the Zoilos frieze is completely different from the carving of the Ara processions.

20. For illustrations of the fragment from the Cenotaph of Gaius Caesar, see M.-H. Gates, "Archaeology in Turkey," *AJA* 98 (1994): 264–65, fig. 10; J. Borchhardt, *Die Steine von Zêmuri* (Vienna, 1993), cover photograph. On the architecture and ornament of the cenotaph of Gaius Caesar, see J. Ganzert, "Das Kenotaph von Limyra. Rekonstruktionsüberlegungen, ein Werkstattbericht," *Architectura* 10 (1980): 15–32; and *Das Kenotaph für Gaius Caesar in Limyra. Architektur und Bauornamentik* (*IstForsch*, vol. 35, Tübingen, 1984).

21. As Brendel pointed out in *Prolegomena to the Study of Roman Art* (New Haven, 1979), 4–10, a crucial problem in the discourse on Roman art is terminology. The label "Roman" is particularly problematic since the word can be used to describe ethnic, geographical, or temporal conditions. In a study of the identity of artistic personalities and traditions, the term "Roman" is es-

pecially misleading. If we use the term Roman, do we mean only those descendants of the native inhabitants of Latium or are we instead referring to all residents of the culturally and ethnically diverse city of Rome? Furthermore, while any artistic tradition may have its *origins* within a distinct, ethnically homogeneous population, carvers of other nationalities subsequently could just as easily be trained within that specific apprenticeship system. For example, a Greek-born youth brought into a workshop that taught its apprentices non-Greek methods for sculpting might be considered ethnically Greek but his *artistic identity* would be non-Greek. In this study, I am not concerned with the ethnic, national, or cultural identities of the artists, but rather with their artistic training. Therefore, I will avoid the vague term "Roman" when discussing sculptural traditions and individual carvers. Instead, I have chosen to refer to the native approach to shaping stone as well as the sculptors who practiced such methods on the Italian peninsula as it appears in the area of Latium as "Italian." Due to the substantial influence of Etruscan aesthetic and technical preferences, this tradition also may be referred to as "Etrusco-Italian." These terms, "Italian" and "Etrusco-Italian," are not meant to suggest that all carvers working within this tradition were native Etruscans or Latins. There no doubt were many carvers of different nationalities and/or cultures (including Greek) who practiced the Italian method of sculpting stone.

22. In the present study of the Ara Pacis, the term "Roman" will be applied to reliefs, especially to funerary reliefs, which were carved in the city of Rome. Thus, the label "Roman" is geographic and is not meant to be indicative of the cultural or ethnic identity of the artists who carved the reliefs or of the patrons who commissioned the pieces.

23. Gazda, "Style and Technique," 29–37.

24. See P. Rockwell, *Lavorare la pietra* (Rome, 1989), 209–10. Rockwell, in fact, notes the uniqueness of the approach taken by ancient Italian relief carvers as compared with sculptors from earlier periods. He recognizes as the earliest example of this technique at its most developed stage on the Arch of Titus in the Roman Forum (210).

25. Rockwell, *Art of Stoneworking*, 109.

26. "The stages of movement into the stone are progressively the stages of the process for the Roman carver. He knows he is finished by the fact that he has no more detail to add deeper into the stone. The Roman process is purer excavation of the stone that the others." Ibid., 110–11.

27. G. Kaschnitz von Weinberg, *Ausgewählte Schriften III. Mittelmeerische Kunst*, ed. P. H. von Blankenhagen and H. von Heintze (Berlin, 1965), 453–61, 466–75. "Beim Augustus wird die schon bestehende und mit römischem Sinngehalt erfüllte griechische

Struktur als Ganzes übernommen und italisiert. In diesem Umwandlungsprozeß, der nur die Oberfläche und ihr Verhältnis zum Raum angeht, die innere Tektonik aber konserviert und gleichsam in einen fossilen Zustand überführt, wird diese von jeder lebendigen Entwicklung abgeschnittene Tektonik als bloße Gestalt zum Träger einer neuen, ihr im Grunde fremden Formentwicklung. Diese ist in echt italischer Weise nur an der Ausbildung von Grenzwerten interessiert. Sie vermag nicht und beabsichtigt auch nicht, eine kernhafte Struktur des Körperlichen auszubilden" (456).

28. Gazda, "Style and Technique," 100.

29. It is interesting to note that in *Etruscan Art* (New York, 1978), O. Brendel discussed a similar interest in boundaries as characteristic of what he defined as "an Italian school of free design." In a comparison of a stag incised on an Etruscan impasto jug dated to the early seventh century B.C. with animal figures found on Greek Orientalizing vases, Brendel noted the following: "The [Etruscan] stag is drawn in mere outline. Its contour encloses nothing—neither an abstract contrapuntal structure nor a natural one of bones and sinew. If it were real, this creature would look like a blown-up rubber animal," and "The approach is synthetic rather than analytic. Here, as with Etruscan Geometric figures, we find the shapes defined by delineation, from without" (51). One might imagine that if the persons represented on many republican funerary reliefs were to come to life, they would also appear somewhat balloon-like, delineated from without.

30. Rockwell, *Art of Stone Working*, 17.

31. Ibid., 21.

32. Ibid., 199.

33. M. Bonamici, "Il marmo lunense in epoca preromana," in *Il Marmo nella Civiltà Romana*, ed. E. Dolci (Carrara, 1989), 84–113, with an excellent bibliography. In this study, Bonamici argues that marble from the Carrara quarries was used by Etruscan carvers continuously from the second half of the sixth century B.C. to the beginning of the second century B.C. Objects sculpted from Italian marble include a few figural statues and many cippi and bases for cippi. Although Bonamici's assemblage of known pieces carved from Italian marble from central Etruria is impressive, nevertheless, in relation to the numbers of nonmarble statuary from the Etruscan period, the quantity of marble pieces is small. For a discussion of the neutron activation analyses of Etruscan cippi that determined that the selected pieces were Carrara marble, see C. Arias, E. Mello, and M. Oddone, "Studio della provenienza di alcuni cippi etruschi in marmo bianco di Volterra e Pisa," *ArchCl* 43 (1991): 818–27.

34. See Chapter 2 at n. 61.

35. Gazda, "Style and Technique," 25. In reference to the frequent appearance of claw chisel marks on the background surface of most republican funerary reliefs, Gazda remarks: "He evidently did not feel compelled to smooth the surface of the ground, as did many of his Greek colleagues; rather he preferred to leave the surface rough, probably not entirely out of laziness but also because he must have been satisfied with the effect of the claw finish" (39).

36. Due to at least one undocumented Renaissance restoration as well as the effects of weathering and possibly deliberate mutilation of the stone, Panel N1 also appears to have few original Augustan tool marks well preserved. However, like the panels restored by Carradori, a few traces of tooling survive on the marble slab that compare well with carving techniques practiced by urban sculptors in Rome during the late first century B.C. These marks will be discussed in conjunction with those on the sections restored in the late eighteenth century.

37. For a detailed discussion of the techniques and details of form preserved on selected late republican figural reliefs, see Chapter 5.

38. I do not believe that the less visible or "hidden" original marks on the restored sections represent unfinished work on the part of the Augustan carvers because marks from the same tools and tool use occur on prominent areas of the panels not restored by Carradori.

39. In his discussion of the Roman sculptural process, Rockwell describes the phenomenon of the uneven back plane in Roman relief sculpture: "The background is not in fact a plane of its own. It is only the space that remains between the details. The depth of the background varies because it is based only on being further into the stone than the details nearest it." *Art of Stoneworking*, 109.

40. Adam, 86.

41. Rome, Museo Nazionale Romano, Inv. 196632 (Kockel, 114–15, pls. 26c–d, 27a–b, 28a).

42. Rome, Museo Nazionale Romano, Inv. 196633 (Kockel, 138–39, pls. 2a, 48b, 49d–f).

43. Rome, Musei Vaticani, Museo Gregoriano Profano, Inv. 10491 (Kockel, pls. 51b, 52a).

44. Copenhagen, Ny Carlsberg Glyptotek, Cat. 591 IN 762. (Kockel, 151–52, pls. 64a–d, 65a–b).

45. Rome, installed into a wall at Via Po Ia (Kockel, pls. 56a, 57a–d).

46. Additional examples of republican funerary reliefs with significant contour chiseling include the marble relief of the Clodii in Paris, dated to the second quarter of first century B.C., Paris, Musée du Louvre, Ma 3493 Inv. MND 594 (Kockel, pls. 48c, 50a–d), and the marble relief of the Sorilii dated to the mid-Augustan period, Rome, Museo Nazionale di Villa Giulia (Kockel, pls. 80d, 81a, 84a–b).

47. Rome, Museo Nazionale Romano, Inv. 126107 (Kockel, 85–86, pl. 4a, c–d). There are numerous exam-

ples of this phenomenon, such as the travertine relief of L. Septumius, Rome, Museo Nazionale Romano, Inv. 125655 (Kockel, pls. 17a, 18a–c; note especially the oblique angle photo in Kleiner, fig. 39d), and the Rupilius relief, Rome, Museo Capitolino, Inv. 1908 (Kockel, pl. 13a–b; Kleiner, figs. 47a–c).

48. Rome, Museo Nazionale Romano, Inv. 196632.

49. Rome, Musei Vaticani, Museo Chiaramonti, Galleria Lapidaria XV 80, Inv. 9398 (Kockel 125–26, pls. 37e, 38a–e).

50. Rome, Museo Nazionale Romano, Inv. 80728 (Kockel, 176–77, pls. 90a, 92a, c–d; Kleiner, cat. 60).

51. Copenhagen, Ny Carlsberg Glyptotek, Cat. 591 IN 762. (Kockel 151–52, pls. 64a, d, 65a–b).

52. The smoothing of the back plane cannot be due entirely to Carradori's restoration since it also occurs on the panels unearthed in the twentieth century. Nevertheless, on the seven restored panels, it remains extremely difficult to distinguish between areas of original smoothing and those that may have been smoothed by Carradori.

53. For example, note the combination of point and claw chisel marks on the background surface of the Via Statilia relief (Kockel, pls. 12a–b, 14a–b). By the middle of the first century B.C., the claw chisel was the preferred tool for creating the surface texture on the back plane. Most republican funerary reliefs have a claw-chiseled relief ground. Particularly well-preserved claw-chiseled background surfaces include those on the Rupilius relief, Rome, Museo Capitolino, Inv. 1908 (Kockel, pl. 13a–b), the Gavii relief, Rome, S. Giovanni in Laterano (Kockel, pls. 21c, 23a–d), and the Servilii relief, Rome, Musei Vaticani, Museo Gregoriano Profano, Inv. 10491 (Kockel, pls. 51b, 52a–c).

54. There are of course exceptions, such as the Petronius relief, dated mid to late Augustan, Rome, Museo Nazionale Romano, Inv. 78145 (Kockel, pl. 91c–d).

55. Note this use of the claw chisel on the Vettii relief from the Via Po in Rome (Kockel, pls. 56a, 57a–d).

56. There are funerary reliefs with chiseled background surfaces that date roughly contemporaneously with the Ara processions. Note for example the chiseling of the interior surface of the tondos on a four-figure funerary relief, Rome, Museo Nuovo, Inv. 2306 (Kockel, pls. 78a–c, 79a–b) and the chiseled back plane on the Licinii relief, London, British Museum, Inv. 1954.12–14.1 (Kockel, pls. 101a, 102a–b).

57. The difference in surface treatment on the processions may be one of the clearest instances of the influence of Greek technique upon local sculpting practices. It is interesting and important to note, however, that influence upon technique (as opposed to style selection) occurs first in what might be referred to as an area of lesser importance—the background plane. This may indicate that while patrons and designers were

more receptive to "foreign" compositional schemes and figural styles, the artisans within the workshop tended to be less immediately affected by external influences and were less likely to abandon quickly a traditional method of carving. It may also indicate that, on this particular commission, carvers trained in Greek methods of stone sculpting were responsible for the secondary sections of the reliefs.

58. Original hair does not survive on Panel N1 since entire heads were replaced. Carradori, on the other hand, often left the fragmentary remains of necks and hair locks on the back of the neck and simply added the missing portions of the rest of the head. The breaks between Carradori's additions and original carving on Panels N2, N3, S5, S6, and S7 can be seen clearly from a close distance. What remains uncertain is the extent to which Carradori repaired these fragmentary areas in order to achieve a successful join for his new additions. It is quite probable that some amount of marble had to be removed along the break.

59. Rome, Palazzo dei Conservatori, Museo Nuovo, Giardino, Inv. 3323. For further illustration and discussion, see Kockel, 99–100, pls. 11d, 15a–c.

60. Rome, Museo Nazionale Romano, Chiostro di Michelangelo, Ala III, Inv. 196632. For further illustration and discussion, see Kockel, 114–15, pls. 26c–d, 27a–b, 28a. Additional examples illustrating this hair carving tendency include the hair on the togate male on the Via Statilia relief, c. 50 B.C., Rome, Pal. dei Conservatori, Braccio Nuovo, Inv. 2124 (Kockel, pl. 12b), the hair of the youth identified as C. Cavius Spu.f. Rufus on the Gavii relief, c. 40 B.C., Rome, S. Giovanni in Laterano, Chiostro (Kockel, pls. 21c, 23b), the locks on a male head from a relief in Florence, c. 40 B.C., Palazzo Medici Riccardi (Kockel, pl. 24c), and the hair on the male figures in the Furii relief, c. 30s B.C., Rome, Musei Vaticani, Museo Gregoriano Profano, Inv. 10464 (Kockel, pls. 44a–c, 46a–b).

61. Compare, for example, the hairstyle on the two full-length togate males from a funerary relief in Rome, Museo Nazionale Romano, Giardino dei Cinquecento, Inv. 109034 (Kockel, 95–96, pls. 10b, 11a–b) to the softer version on an older male figure from a four-figure funerary relief, Rome, Villa Wolkonsky (Kockel 100, pl. 16d). Both reliefs are dated by Kockel to c. 50 B.C. No doubt the republican trend toward a more full-locked, "youthful" receding hairline style was influenced further by the increased interest in classicized, ageless portrait heads for Augustus and other members of the imperial household.

62. For example, notice the longer, thinner chiseled locks near the temples of the male figure from the Via Statilia relief (Kockel, pl. 12b) and another republican male portrait bust from a relief in Florence (Kockel, pl. 24c). Both heads date at least twenty years prior to the senatorial decree for the Ara Pacis.

63. After extensive comparative analysis with earlier and contemporary figural reliefs carved in Rome, I am convinced that the few traces of drill holes in the hair of some of the figures on the right half of the South frieze are not original Augustan carving.

64. The substantial surface damage to the hair and the veil above the forehead on s32 (Livia) makes it extremely difficult to conclude whether she wore the *nodus* coiffure (fig. 122). The relative intact state of the strands to either side of the now damaged oval area of stone and the sharp break along the left contour of the damaged area suggest that the original marble was in much higher relief and has since broken off. This might support the existence of a rising *nodus* curl. However, on the other hand, the remains of the lower contour of this oval area show two distinct curves that rise up to a point directly above the center of the forehead. The traces of these contours suggest two higher relief strands falling from a central part. To my knowledge, the standard design of the *nodus* curl in relief sculpture was characterized by either a straight or a slightly curved bottom edge—for example, the *nodus* on the rightmost female from a funerary relief from Rome in the Museo Nuovo of the Palazzo dei Conservatori, Inv. 2231 (straight; Kockel, pl. 33b) or the *nodus* style on a female portrait from a fragmentary relief in Ostia Museo, Inv. 460 (curved; Kockel, pl. 33d). Occasionally the bottom contour of the *nodus* curl might come to a V-shaped point, as illustrated by the *nodus* worn by the woman in the Popillius relief (Malibu, J. P. Getty Museum, Inv. 71.AA.260; Kockel, pl. 25b) or that of a woman from a fragmentary relief in Copenhagen (Ny Carlsberg Glyptotek, Inv. 809a; Kockel, pl. 35a). The contours preserved on the Ara Pacis head might suggest that s32 wore her hair in a "central part" manner similar to figure s36.

65. A similar arrangement of two spiraling locks falling down along the neck occurs on the female figure on the marble funerary relief of Anteros and Myrsine dated by Kockel to the mid or late Augustan period (Rome, Museo Nazionale Romano, Inv. 80714). See Kockel, pl. 102d.

66. Rose, 456–59.

67. For the Blaesius relief (Rome, Palazzo dei Conservatori, Museo Nuovo, Sala VI, 3, Inv. 2279), see Kockel, 87, pls. 5b, 6b. In a comparison of the carving of the hair worn by Blaesia with the rendering of hair of an Etruscan female head on a sarcophagus in the Villa Guilia Museum, Gazda notes that: "in both instances either a point or a flat chisel turned on edge was used to separate the major locks. In neither is further indication of individual strands of hair visible" ("Style and Technique," 33). For the relief of Stagia Ammia and P. Vaterius (Rome, Museo Nazionale Romano, Giardino dei Cinquecento, Inv. 39475), see Kockel, 91–92, pl. 6c.

68. For the relief from the so-called Sepolcro del Frontispizio (Rome, Museo Nazionale Romano, Chiostro di Michelangelo, Ala III, Inv. 196632), see Kockel, 114–15, pl. 27a–b. For the Furii relief (Rome, Musei Vaticani, Museo Gregorio Profano, Inv. 10464), see Kockel, 133–34, pl. 45a–c.

69. The third Roman child in the South procession is figure s42, usually said to be Domitius, son of L. Domitius Ahenobarbus. No original hair carving survives on this figure. The entire head of s42 is a Carradori restoration.

70. For detailed photographs of these heads, see Kockel, pl. 17d–e. For a discussion of the recent redating of this piece, see Kockel, 103.

71. Ibid., pl. 38d.

72. Rose, 455–59.

73. On this point, it is worthwhile to compare the hair carving of n35 with that on the boy C. Vettius on the marble Vettii relief, dated by Kockel to the late 20s B.C. Like the barbarian child on the North frieze, young Vettius has curving locks which also end in circular curls. Yet, unlike the foreign child on the Ara Pacis, Vettius was depicted wearing the toga and *bulla* as proud badges of his Roman citizenship. Interestingly, the carver of the Vettius relief did not highlight the center of these curls with drill holes. The chisel alone has been used to create these stylized forms. For detailed photographs of this relief, see Kockel, pl. 57.

74. Gazda, "Style and Technique." Note particularly her discussion of the rendering of the hands on a two-figure relief in the Museo Nuovo (Inv. 2282), where Gazda describes the disproportion of the length of the thumbs and fingers, the odd placing of the finger joints, and the tendency to elongate the fingers and then curl them upward at the tips, leaving a pinched depression for the fingernail (35). She compares this rendering common for many republican funerary reliefs to the hand design found on numerous Etruscan sculptures and specifically points out the similarities to the raised right hand of the bronze "Arringatore" statue.

75. Kockel, pl. 5b.

76. Ibid., pl. 6c.

77. Ibid., pl. 10c.

78. Ibid., pl. 44a–c.

79. Ibid., pl. 10a.

80. Ibid., pl. 68b. See also the design of the completely draped hand on the Ampudius relief, London, British Museum, Inv. 1920–20.1 (ibid., pl. 70b).

81. The date for the burying of the Augustan altar and its sculptural decoration is not certain. Possibly it was a gradual process that began following the razing of the Campus Martius by Norman invaders in the eleventh century. See Chapter 3 for a discussion of the postancient history of the structure.

82. Much of the drapery, especially the frontmost

hanging folds, on the panels restored by Carradori are late eighteenth-century additions. It should be remembered that the volume and plasticity of the drapery folds on Panels s5, s6, s7, n2, and n3 are in large measure the result of Carradori's restoration.

83. Adam, 39.

84. Rome, Musei Capitolini, Braccio Nuovo Inv. 2142. Further illustrations in Kockel, pls. 12b, 14a.

85. Rome, Museo Nazionale Romano Inv. 196632 (Kockel, pls. 26c–d, 27a–b).

86. Some of the better-preserved examples include the drapery treatment on the Gavii relief, Rome, S. Giovanni in Laterano (Kockel, pls. 21c, 23a–d), a six-figure marble relief in Rome in the Museo Nuovo, Palazzo dei Conservatori, Inv. 2231 (Kockel, pls. 32a–d, 33a–b), and especially the Furii relief in Rome in the Musei Vaticani, Museo Gregorio Profano, Inv. 10464 (Kockel, pl. 44a–c). All three of the pieces were carved prior to the consecration of the Ara Pacis in 13 B.C.

87. Several fragments of drapery folds, at present installed at the far left end of the reconstructed South frieze, show a more sophisticated use of the drill and more plastic, volumetric folds. While by no means conclusive, this technical disparity may suggest that these fragments do not belong alongside Panel s3 or even within the South frieze. For compositional problems with the modern placement of some of these fragments, see Koeppel, 117.

88. For a discussion of the technique and the decorative use of the drill in the drapery on the Via Statilia relief, see Gazda, "Style and Technique," 75–77. "In carving the Via Statilia drapery, for the most part the sculptor used his drill *after* shaping the folds, and those folds were often rather flat ridges, typical of the Roman vernacular approach. He completely reversed the Greek procedure, applying the tool as an accent in an already established design, merely underscoring selected areas of the pattern with the deeper dark lines the running drill is able to produce so effectively. In the Via Statilia relief, the firm, dark line left by the running drill was used as a 'positive' accent in the design. It was used decoratively, not structurally, to augment the linear surface pattern and consequent legibility of the design" (75–76). See also Gazda, *ANRW*, 867–69.

89. Rome, Palazzo dei Conservatori, Museo Nuovo (Kockel, pls. 7a–d, 8a).

90. For a discussion on the importance of a stone's receptivity to particular tools and the consequential influence upon sculpting traditions, see the earlier section, "Technique and Stone."

91. The same arrangement occurs on the two flamines s23 and s24 on the restored Panel s5.

92. Note, for example, the rendering of the hair on the male figure on the travertine funerary relief of Aelius and Licinia dated c. 50 B.C., Rome, Museo Nazionale Romano, Inv. 125813 (Kockel, pls. 10c, 11b), on the male figures on the marble Furii relief, Rome, Museo Gregoriano Profano, Inv. 10464 (Kockel, pls. 44a–c, 46a–b), and on the two male figures on the marble Maelii relief, North Carolina Museum of Art (Kockel, pl. 82a–c). The closest comparison, however, is undoubtedly with the nonfunerary first-century B.C. marble "Lictor frieze" in the Vatican, discussed in detail in Chapter 5.

93. An important exception is the fragmentary Lictor frieze in the Museo Gregoriano Profano of the Musei Vaticani. For a detailed discussion of the carving of the *fasces* in the Lictor relief, see Chapter 5.

94. For a discussion of the representation of lictors in processions and the Etruscan heritage of such scenes in Roman art, see most recently P. J. Holliday, "Processional Imagery in Late Etruscan Funerary Art," *AJA* 94 (1990): 73–93.

95. Rome, Villa Wolkonsky (Kockel, pls. 42a, 43c).

96. London, British Museum, Inv. 1954.12–14.1 (Kockel, pl. 101a).

97. See Chapter 5.

98. Rome, Museo Nazionale Romano, Inv. 109034 (Kockel, pl. 13a–b). Note especially the chisel strokes that remain along the right cheek of Rupilius in Kockel, pl. 13b.

99. Rome, Museo Capitolino, Inv. 185 (Kockel, pls. 31b, 34a–b). Clear chisel strokes survive on the marble surface at the jaw area of the male figure illustrated in Kockel, pl. 34b.

100. Paris, Musée du Louvre, MA 3493 (Kockel, pls. 48c, 50a–d).

101. Rome, Villa Doria Pamphili, Columbarium minor (Kockel, pl. 72b; Kleiner, fig. 5).

102. Rome, Museo Nazionale Romano, Inv. 80728. For further illustrations, see Kockel, pl. 92a, c–d.

103. Rome, Musei Vaticani, Galleria Lapidaria, 31c (Kockel, pl. 100a–c).

104. It is extremely difficult to determine exactly how early such smoothing began due to the poor preservation of most of the earliest funerary reliefs from Rome. The facial surfaces of many of these pieces are markless. However, this appears to be due more to the effects of weathering than to deliberate smoothing.

105. For a discussion of the importance of republican political, social, and religious traditions to the policies of Augustus, see most recently W. Eder, "Augustus and the Power of Tradition: The Augustan Principate As Binding Link between Republic and Empire," in *Between Republic and Empire: Interpretations of Augustus and His Principate*, ed. K. A. Raaflaub and M. Toher (Berkeley, 1990), 71–122.

106. The one exception occurs on Panel s7 at the figure s44. For the facial type of s44, see my subsequent discussion.

107. Figure s33 is an exception to this pattern. For

his rear three-quarter view, see my subsequent discussion.

108. When Carradori attempted to recreate the awkward view for his own head addition at figure N17, he represented the cheek, jaw, and ear as viewed from more of a proper angle in order to suggest more successfully its recession into the background.

109. See Chapter 3. Despite the relatively extensive reworking and restoration by Carradori, it is possible based on the remaining marble to conclude that the heads were originally generalized, albeit with less smoothed and "cleaned-up" surfaces. It does not appear that the eighteenth-century restorer actually removed any major portions of the original faces or substantially smoothed down damaged surfaces so as to alter significantly the facial features or supposed portrait (except perhaps where Carradori needed a clean surface to attach a new nose).

110. Of these panels, Panel s5 was restored by Carradori, and therefore the smoother surfaces, additions, and some tool marks on this panel are the results of his reworking. There appears to be an area of transition between the heads depicted in the generic manner on the east and those rendered in the more expressive manner on the west. For example, figure s27, who stands in front of Agrippa, bears many of the facial traits of the expressive type. The head of the "Rex Sacrorum" (s26) appears to be a combination of the generic, ovoid head, and surface facial incision. Figure s25, a background male standing in front of the "Rex Sacrorum," appears more generic than expressive. However, the upper face of s25 was completely restored by Carradori. It is possible that as part of the preparation for his additions, Carradori smoothed down a great portion of original facial incision on figure s25.

111. Compact, squarish heads are found on some of the earliest funerary reliefs in Rome, as for example on the reliefs adorning the monument of the Clodii and Clodia Stacte dated to the first quarter of the first century B.C., Rome, Villa Wolkonsky (Kockel, pls. 2b–c, 3a–b), on the Sallustii relief, Rome, Vila Wolkonsky (Kockel, pl. 17b), and on the Servilii relief, Rome, Villa Wilkonsky (Kockel, pl. 43a–c).

112. For instance, see the brow treatment on the following pieces: the marble head of Alexander from Pergamon in the Archaeological Museum at Istanbul (Pollitt, fig. 5; Stewart, fig. 699), the marble portrait of Attalos I from Pergamon in the Staatliche Museum in Berlin (Pollitt, fig. 25; Stewart, figs. 680–82), and the marble head of Helios from Rhodes in the Archaeological Museum at Rhodes (Pollitt, fig. 48). Note especially the design of the foreheads and eye areas on the portrait heads from Delos in the National Archaeological Museum in Athens (Pollitt, figs. 72, 75–77) and on the "Sulla" portrait in Malibu (Stewart, fig. 803).

113. The expressive designs of the faces of the male figures in the western half of the South frieze have many comparisons with republican funerary portrait heads. For specific republican versions of the divided brow format and incised facial lines, see the male figures on the travertine four-figure relief dated to the first half of the first century B.C., Rome, Museo Nazionale Romano, Inv. 126107 (Kockel, pl. 4d), on the travertine Blaesius relief, Rome, Museo Nuovo, Inv. 2279 (Kockel, pl. 6a), on the so-called Eurysaces relief, Rome, Museo Nuovo (Kockel, pls. 7d, 8a), and on a fragmentary full-length two-figure relief, Rome, Museo Nazionale Romano, Inv. 109034 (Kockel, pls. 10b, 11a–b).

114. Selected bibliography on the portraiture of Augustus includes B. Schmaltz, "Zum Augustus-Bildnis Typus Primaporta," *RM* 93 (1986): 211–43; G. Grimm, "Die Porträts der Triumviri C. Octavius, M. Antonius und M. Aemilius Lepidus," *RM* 96 (1989): 347–64; K. Fittschen and P. Zanker, *Katalog der römischen Porträts in den Capitolinischen Museen*, vol. 1, *Kaiser- und Prinzenbildnisse* (Rome, 1985); K. Vierneisel and P. Zanker, eds., *Die Bildnisse des Augustus* (Munich, 1979); P. Zanker, *Studien zu den Augustus-Porträts: I. Der Actiumtypus* (Göttingen, 1978). The head of Augustus on the South frieze compares extremely well with a fragmentary head of Augustus wearing the *corona civica* from a relief found near a fountain south of the Forum at the town of Luni. Like the Ara processions, this relief was carved from marble extracted from the nearby Carrara quarries. Note especially the strong division of the brow into a flatter upper section and a swollen lower section, the deep set eyes and the long, thick curved locks adorning the forehead and temple areas. For a photograph and brief discussion of this relief head, see A. Frova, "La produzione di scultura a Luni," *Quaderni del Centro Studi Lunensi* 10–12 (1985–87): 223–50, fig. 14.

115. Despite the fact that the heads in Panels s3, s4, and s5 display a more accurate understanding of the relationships between flesh and bone than those in Panels s6 and s7, nevertheless there are still basic problems with symmetry and anatomical proportions.

116. Selected bibliography on the subject of republican portraiture, realism, and verism includes B. Schweitzer, *Die Bildniskunst der römischen Republik* (Leipzig, 1948); O. Vessberg, *Studien zur Kunstgeschichte der römischen Republik* (*SkrRom*, vol. 8, Lund, 1941); G. M. A. Richter, "The Origin of Verism in Roman Portraits," *JRS* 45 (1955): 39–46; E. H. Richardson, "The Etruscan Origins of Early Roman Sculpture," *MAAR* 21 (1953): 75–124; J. Breckenridge, "Origins of Roman Republican Portraiture: Relations with the Hellenistic World," *ANRW* 1.4 (1973): 826–54. Also see the bibliography in U. Hiesinger, "Portraiture in the Roman Republic," *ANRW* 1.4 (1973): 820–25.

117. For the portraits of Agrippa, see F. Johansen,

"Ritratti marmorei e bronzei di M. Vipsanio Agrippa," *AnalRom* 6 (1971): 17–48. The fact that a more realistic portrait was chosen for the figure identified as Agrippa and not for the other figures in this area of the procession has led some scholars, who wish to see the reliefs as depicting a specific ceremony in 9 B.C., to argue that this is meant to be a posthumous portrait of the general, who died in 12 B.C. and therefore could not have been physically present. However, there is no substantial evidence from other Roman monuments or sculptures to declare that the realistic style was either used as a symbol of death or used for only posthumous portraits. Therefore, the suggestion offered by some scholars (that this is supposed to represent the "ghost of Agrippa") based on the portrait type is an unsatisfactory argument and a misuse of the stylistic evidence.

118. Since one of the important results of employing the veristic style is the creation of a portrait or portrait-like rendering, this head most likely was meant to represent a specific historical person. However, the identity of figure S44 has never been satisfactorily settled upon. See Torelli, *Typology and Structure*, 48, for the identification as M. Appuleius, and J. Pollini, "Studies in Augustan 'Historical' Reliefs" (Ph.D. diss., University of California at Berkeley, 1978), 116–18, for Sextus Appuleius.

119. In addition to the facial styles of the adult figures, the children represented on the North and South friezes display two distinct types of facial design: a generalized version similar to the adults for Roman children and a Hellenistic cherublike type for the barbarian captives. Here the two styles were likely used to accentuate the differences in appearance between Roman and foreign children.

120. Rome, Museo Nazionale Romano, Inv. 39475 (Kockel, pl. 6c).

121. Rome, Museo Nuovo, Inv. 2142 (Kockel, pl. 7a–d).

122. Rome, Palazzo dei Conservatori, Braccio Nuovo, Inv. 2142 (Kockel, pls. 10a, 11a–b).

123. Rome, Villa Wilkonsky (Kockel, pls. 15d, 16a–d).

124. M. Pallottino, "L'Ara Pacis e i suoi problemi artistici," *BdA* 32 (1938): 162–72. Almost forty years later, A. Bonanno, in a study examining portraits and other heads on relief sculpture from the Republic to the period of Septimius Severus, included a chapter on the Ara Pacis in which he made various observations on both the technique and style of certain heads on the main processional friezes (*Roman Relief Portraiture*, 23–34). It is important to note, however, that Bonanno was primarily concerned with identifying various personages, not with making formal stylistic or technical analyses. He discussed only the relief heads particularly important historically or most interesting to him and did not propose specific designers for areas of the processions.

125. Pallottino, "L'Ara Pacis," 168–72. Like most Roman art historians working in the first half of this century, Pallottino did not distinguish between the actions of a designer (or designers) and those of the stone carvers.

126. Ibid., 170.

127. Ibid., 171.

128. Ibid., 170. The designations used by Pallottino, namely Senate and Populus, were due to the generally accepted identifications for these figural groups in the early part of this century. The designations "Senate" and "Roman People" were first suggested by F. Von Duhn in "Sopra alcuni bassirilievi che ornavano un monumento pubblico Romano dell'Epoca di Augusto," *AICA* 53 (1881): 308.

129. It is important to remember that the complete compositions of the processional friezes remain to this day incompletely understood due to problems of reconstructing the panels and satisfactorily resetting the fragments. See Chapter 3.

130. An example of this approach to identifying designers can be found in F. Magi's study of the Flavian Cancelleria reliefs in the Museo Gregoriano Profano of the Vatican (*I rilievi flavi del Palazzo della Cancelleria* [Rome, 1945]). Magi identifies two designers, A and B, as responsible for the different compositional formats of the *adventus* and *profectio* friezes.

131. The bibliography on the subject of illusionism in Greek, Etruscan, and Roman art is extensive. For example, see the following general studies: Pollitt, 185–209; M. Pallottino, *Etruscan Painting* (Geneva, 1952), 103–28.

132. For a recent discussion of the narrative reading of the monuments of the Campus Martius in the Augustan period and the use of the Via Flaminia as the directional thread through the complex, see D. Favro, "Reading the Augustan City," in *Narrative and Event in Ancient Art*, ed. P. Holliday (Cambridge, 1993), 230–57.

133. See Chapter 2.

134. R. Ling, *Roman Painting* (Cambridge, 1991), 217–20, 234–35.

135. Pfanner, *Titusbogen*, 55–58.

136. P. Rockwell, "Preliminary Study of the Carving Techniques on the Column of Trajan," *StMisc* 26 (1985): 101–5. See also Rockwell, *Art of Stoneworking*, 201.

137. Refer to figs. 3–11 for these panels and figures.

138. Rockwell, "Preliminary Study," 101–5.

139. M. Waelkens, "From a Phrygian Quarry: The Provenance of the Statues of the Dacian Prisoners in Trajan's Forum at Rome," *AJA* 89 (1985): 641–53.

140. Pfanner, "Über das Herstellen von Porträts," *JdI* 104 (1989): 164–66.

141. Rockwell, *Art of Stoneworking*, 178.

142. Unfinished funerary reliefs from Rome dated to the first century B.C. often show that the drapery was carved prior to and separate from the portrait head.

In many cases, this may have been the result of prefabricating most of the funerary relief before the sale, after which the features of the buyer or his deceased family member would be sculpted onto the unfinished head.

143. Similar discrepancies between the positioning of torsos and lower limbs were noticed by M. Pfanner on the Arch of Titus panels. Pfanner proposed that these "mistakes" were due in large part to the lack of detailed preliminary sketches. See Pfanner, *Titusbogen*, 55–58.

144. On the point of temporary specialization, see Rockwell, *Art of Stoneworking*, 182.

CHAPTER 5

1. Musei Vaticani, Museo Gregorio Profano, Inv. 9486–9491. See W. Helbig, *Führer durch die öffentlichen Sammlungen klassischer Altertümer in Rom*, 4th rev. ed., ed. Hermine Speier, vol. 1 (Tübingen, 1963), 1020; A. J. B. Wace, "Fragments of Roman Historical Reliefs in the Lateran and Vatican Museums," *PBSR* 3 (1905): 275–94 (mistakenly dated fragments to the Flavian period); see O. Vessberg, *Studien zur Kunstgeschichte der römischen Republik* (*SkrRom*, vol. 8, Lund, 1941), 190, 267–69. Unfortunately, the findspot of these fragments was never recorded. However, the pieces were probably found in Rome. Because their extremely damaged condition would have made them undesirable for collectors, they probably would not have been moved out of or into the city. Moreover, the technical and stylistic characteristics of the relief compare well with both marble and travertine funerary reliefs dated to the late republican period that were certainly carved and displayed in Rome.

2. The remains of a low-relief, draped torso with the *fasces* suggest that there may be four lictors preserved in the fragments. The problem here is that the modern reconstruction of the frieze is highly dubious. For instance, on the basis of proportional sizing alone, it is clear that the fragment of drapery now placed under the head of an elderly male figure is incorrect, and may therefore constitute the tenth identifiable figure in the Lictor frieze.

3. Both the fragment blocks and the figures themselves are numbered sequentially from the viewers' left to right according to the present reconstruction. Although the identity of the foreground figure (head 2) is highly debatable, nevertheless the remaining broken stone suggests it was a young female figure. The rounded form with drilled holes under the chin of head 1 appears to be the damaged contour of a female hair bun (similar to that worn by figure s36 [Antonia Minor] on the South frieze). Moreover, the broken section to the viewers' left of the jaw of head 3 may contain not only the outline of the upper portion of the ear of head 3 but

possibly the outline of a cylindrical *nodus* on head 2. If the remains are that of a *nodus*, then the relief could be dated on the basis of the hairstyle as no earlier than c. 40 B.C. For one discussion of dating and female hairstyles on republican funerary reliefs, see Kleiner, 127–41.

4. The left edge of fragment 1 is a clean-cut surface prepared by claw chisel strokes for joining to another block. Similar instances of figures spanning two blocks occur on the Ara friezes (e.g., figures of Augustus and Agrippa), although nowhere on the preserved sections of the Ara processions does the face of a figure actually cross over or end abruptly at a join.

5. The ridge type can be found on a few of the faces in Panels s5, s6, and s7, including the figures of Tiberius, Antonia Minor, s33, and s46, although the original sharpness of the ridges very likely has been softened by Carradori's surface reworking. Most of the heads on left portion of the South frieze have the simple, ridge type of eyebrow, including the portrait of Augustus. For a more detailed discussion of the carving of the eye area, see Chapter 3.

6. For examples of this ridge type of eyebrow, see the eyebrows on the female figure on the Via Statilia relief (Kockel, pl. 14a–b; Gazda, *ANRW*, fig. 13; Kleiner, fig. 11), and the elder male figure on the Rabirius relief (Kockel, pl. 49d; Kleiner, fig. 63b).

7. Chapter 4.

8. Differences include the disproportionately large ear, the heavy upper eyelid, the hairline, the overall profile contour, and the virtual lack of an internal skeletal structure for head 5 on the Lictor frieze. Nevertheless, the composition of the two late first-century lictor figures is extraordinarily similar, as is the entire two-figure grouping on fragment 3 as compared with the composition of figures s11 and s12 on the South frieze. The sixth figure on the Lictor frieze, whose head is now lost, was very likely positioned facing left and looking straight at head 5, in the same manner as s12 faces s11.

9. The *fasces* in both the Lictor frieze and the South frieze are likewise similar in design and execution. For a discussion of the carving of the *fasces* on the Ara Pacis, see Chapter 4. The carving of the *fasces* in the Vatican relief, although somewhat less exact and refined, was done with precisely the same simple, efficient chiseling method, which is especially apparent in the carving of the channels that separate the rods.

10. The type of hairstyle and hairline on head 5 as well as the other youths on the Lictor frieze (the hair recedes over the temples while the forehead locks curve downward to form a semicircular contour) was a popular hairstyle for male figures on funerary reliefs in the late Republic. Although the coiffure has been dated as late as 13 B.C. (the *consecratio* of the Ara Pacis), it is generally not found on male youths later than 30 B.C. (Kleiner, 121–27). On the bases of hairstyle as well as de-

tails of anatomical rendering, drapery treatment, and carving techniques, the Lictor frieze can be reasonably dated to c. 40–30 B.C.

11. For examples of two distinct eye forms on one figure in the Ara processions, see Chapter 4. It should be noted that in some instances where the difference between the two eyes is relatively minimal, the asymmetry may be due to compensation for optical distortion caused by the relatively low position of the viewer in relation to the reliefs.

12. Of the male youths in the Lictor frieze, only figure 8 appears not to have the "receding" hairline. However, the exact nature of his hairstyle must remain uncertain since the surface is heavily damaged and the forehead temple area that is better preserved is the temple closest to the back plane, hidden from view, which may not reflect the hairline at the temple area in the more apparent foreground level.

13. Chapter 4.

14. For a discussion of the drapery treatment on the South frieze, see Chapter 4.

15. See the eyebrow area of head 1 (figs. 205, 206), the eyes and neck of head 3 (figs. 206, 207), the cheek, jaw, and neck of head 5 (figs. 210, 211), and the foreground temple area of head 7 (fig. 219).

16. Traces of the early stages of removing larger sections of stone and roughing out the basic contours with the point or punch survive along the edges where the figures merge into the background planes. These marks were never left on the Ara processions, but were often left on late republican funerary reliefs. In addition, there are no traces of either contour chiseling or background smoothing on the Lictor fragments. This may suggest that the Lictor workshop was not yet exploring the effects or advantages of these distinct carving techniques, which we have discovered not only on the Ara reliefs but on many first-century funerary reliefs.

17. Chapter 4.

18. Whether the complete frieze depicted a processional ceremony is difficult to determine, although the figures on block 2 (Inv. 2702) appear to be in motion, which suggests that the composition was not entirely static.

19. The most complete publication of these reliefs is W. Von Sydow, "Die Grabexedra eines römischen Feldherren," *JdI* 89 (1974): 187–216. The remaining two pieces, which will not be discussed in this study but are nonetheless important, are a severely damaged fragment showing drapery folds and the shoulder and forearm of a male figure (Inv. 2703), and an epistyle block with a spiraling tendril design in relief (Inv. 2704), which is very similar to the spiraling floral frieze on the exterior of the Ara Pacis precinct walls. Fragment 2703 was discovered alongside fragment 2449 (three figures), while fragment 2704 was found with block 2702 (two figures).

20. Rome, Pal. dei Conservatori, Braccio Nuovo, Inv. 2449.

21. Rome, Pal. dei Conservatori, Braccio Nuovo, Inv. 2702.

22. Von Sydow, "Die Grabexedra," 188–89.

23. Chapter 4.

24. Von Sydow, "Die Grabexedra," 195–96, 214–16.

25. Chapter 4.

26. See the head of an unidentified man at the Rhode Island School of Design in Providence (J. Breckenridge, "Origins of Roman Republican Portraiture: Relations with the Hellenistic World," *ANRW* 1.4 [1973]: fig. 3) and the marble male portrait in the Ny Carlsberg Glyptotek (Pollitt, fig. 79).

27. Chapter 4.

28. Chapter 4.

29. Chapter 4. The technique of drilling between the fingers was commonly used for sculpting figures on republican funerary reliefs. For examples, see Kleiner, figs. 2, 4, 34, 37, 47. The hand of figure 5 preserves the only surviving trace of the drill on the Via Druso blocks. The lack of drill work in the small section of drapery folds may indicate that the relief predates the Lictor frieze or, instead, may simply be the result of a workshop that has not yet begun to experiment with the foreign carving tool.

30. Chapter 4.

31. Chapter 4.

32. For a comprehensive discussion of the figural and drapery styles and the carving techniques on funerary reliefs dated to the early first century B.C., see Gazda, "Style and Technique."

33. Museo Nazionale Romano, chiostro, ala III, Inv. 80728 (Kleiner, 230). Kockel dates this relief to the mid or late Augustan period (176–77).

34. Chapter 4.

35. Chapter 4. For a description of this style of hair and the use of the variations on the *nodus* in dating funerary reliefs, see Kleiner, 128–41.

36. For a reasonably comprehensive yet succinct summary of the various types of hairstyles and clothing worn by figures on late republican funerary reliefs, see Kleiner, 118–62.

37. The sculptors of freestanding statues and portraits in the round had been using abrasives for smoothing before the practice was introduced to relief carvers. For a discussion of the importance of abrasion in Greek sculpture, see Chapter 4.

38. Chapter 4.

39. Chapter 4.

40. For the identification of this figure, see Rose, 456.

41. Chapter 4.

42. Chapter 4.

43. Chapter 4.

44. For republican examples, see Gazda, "Style and Technique," 47–68, and *ANRW*, 856–68.

45. Kockel, 114–15, pls. 26c–d, 27a–b, 28a.

46. For contour chiseling, see Chapter 4.

47. For a discussion of the rasping of surfaces on republican funerary reliefs, see Chapter 3.

48. For a discussion of detailed analyses in relation to the study of Flavian reliefs, see Pfanner, *Titusbogen*, 58–63.

49. See Gazda, "Style and Technique," 35–36 (Blaesius relief), 75–76 (Via Statilia relief), and *ANRW*, 861.

50. For a discussion of workshop specialization and the carving of the Ara processions, see Chapter 4.

51. B. M. Felletti-Maj, *La tradizione Italica nell'arte Romana* (Rome, 1977), 267–72; T. Hölscher, "Historische Reliefs," in *Kaiser Augustus und die verlorene Republik* (Berlin, 1988), 363–64.

52. For example, on figs. 236 and 237, note the awkward combinations of almost frontal, three-quarter view torsos with profile heads, as on the two attendants standing in front of the musician and the unnatural position of the legs of the rightmost figure in this pairing.

53. For discussions of this terminology and various definitions of the Italic style in Roman art, see Felletti-Maj, *La tradizione Italica*, 19–39; O. Brendel, *Prolegomena to the Study of Roman Art* (New Haven, 1979), 104–50; R. Bianchi Bandinelli, *Rome: The Center of Power, 500 B.C. to A.D. 200* (New York, 1970), 51–71.

54. In fact, the combination of high polish on white, fine-grained marble with small-scale, low-relief heads shown most often in profile view more closely resembles the meticulous work of first-century gem carvers rather than the larger-scale figural reliefs carved during this period.

55. Chapter 4.

56. See especially H. Kähler, "Die Ara Pacis und die augusteische Friedensidee," *JdI* 69 (1954): 67–100; E. Bielefeld, "Bemerkungen zu den kleinen Friesen am Altar der Ara Pacis Augustae," *RM* 73–74 (1966–67): 259–65; Felletti-Maj, *La tradizione Italica*, 272–78; R. de Angelis Bertolotti, "Materiali dell'Ara Pacis presso il Museo Nazionale Romano," *RM* 92 (1985): 230–34.

57. For example, see also Toynbee, "Ara Pacis Reconsidered," 73–74.

58. Felletti-Maj, *La tradizione Italica*.

59. Chapter 3. Almost all of the heads in both of these friezes have been damaged. The localization of the damage seems to indicate that it was due to deliberate vandalism rather than accident. Small dowel holes at the necks of the Vestal figures (figs. 246, 247) indicate that a repair project was at least initiated at some point during the altar's history. Whether this project was an ancient repair or postancient is uncertain, since the period in which the Ara Pacis was sufficiently buried beneath the Campus Martius so as to be undisturbed (its restoration terminus post quem) remains unclear. Whether the rasping ought to be associated with the dowel holes for replacement heads is debatable. A substantial hole that appears to have been drilled for a dowel occurs above the neck of the third figure from the left on the sacrificial frieze. However, neither this figure nor any of the others in this relief have been left with a rasped surface finish. If this dowel hole is contemporary with those on the Vestal side, then it would suggest that the rasping was the result of some other stage of carving.

60. Chapter 3.

61. Similar polishing and channel outlining occur on the well-known Paris census relief of the so-called Altar of Domitius Ahenobarbus. For bibliography on this relief, see Torelli, *Typology and Structure*, 5–25, and H. Kähler, *Seethiasos und Census: Die Reliefs aus dem Palazzo Santa Croce in Rom* (*Monumenta Artis Romanae*, vol. 6, Berlin, 1966). More recently, see A. Kuttner, "Some New Grounds for Narrative: Marcus Antonius's Base (The Ara Domitti Ahenobarbi) and Republican Biographies," in *Narrative and Event in Ancient Art*, ed. P. Holliday (Cambridge, 1993), 198–229.

62. The technical execution (polish with occasional drilled outlining) of the small Ara processions compares extremely well with two other Augustan reliefs—the caryatid plaque from Pozzuoli, now on display in the Naples Museum (Inv. 6715) and a relief depicting Orpheus, Euridice, and Hermes (Inv. 6727), also in the Naples Museum and probably from Campania. The technical similarities may indicate that during the first century B.C. or earlier, South Italian workshops were responsible for introducing Greek carving methods for small reliefs in the Italic figural style.

CONCLUSION

1. Specifically see A. Kuttner, "Some New Grounds for Narrative: Marcus Antonius's Base (The Ara Domitti Ahenobarbi) and Republican Biographies," in *Narrative and Event in Ancient Art*, ed. P. Holliday, (Cambridge, 1993), 198–229. Note in reference to the Paris census reliefs from the so-called Altar of Domitius Ahenobarbus: "Style is used here, therefore, as carrier of meaning, to describe the character of the patron responsible for this image, as well as to imply a grave virtue and probity to his exercise of censorial office" (213). For the associations of the archaizing style used for the terracotta plaques on the Temple of Apollo Palatinus, see B. Kellum, "Sculptural Programs and Propaganda in Augustan Rome," in *The Age of Augustus*, ed. R. Winkes (Providence, R.I., 1986) 169–76, and reprinted in *Roman Art in Context*, ed. E. D'Ambra (Englewood Cliffs, N.J., 1993), 75–83.

2. For a brief summary of the First Style with bib-

liographical references, see R. Ling, *Roman Painting* (Cambridge, 1991), 12–22.

3. Examples of the use of First Style for entranceways or atria include the House of Sallust in Pompeii (late second or early first century B.C.) and the Samnite House in Herculaneum (late second or early first century B.C.).

4. Kellum, "Sculptural Programs," 169.

5. The Augustan form of the Mausoleum is frequently debated. For a recent summary of the scholarship on the Mausoleum, see J. Reeder, "Typology and Ideology in the Mausoleum of Augustus: Tumulus and Tholos," *ClAnt* 11 (1992): 265–307.

6. The connection between the form of the altar proper of the Ara Pacis and the archaic altars at Lavinium is my own observation. It is important to note that there was an increase in building activity, including a possible imperial residence, at Lavinium close to the archaic sanctuary during the Augustan period. However, certainly the Lavinium altars were not the only source of inspiration. For a recent discussion of possible Greek models, especially the altar of Poseidon and Amphitrite at Tenos, see D. Castriota, *The Ara Pacis Augustae and the Imagery of Abundance in Later Greek and Early Roman Imperial Art* (Princeton, 1995), 33–41; fig. 55a–b.

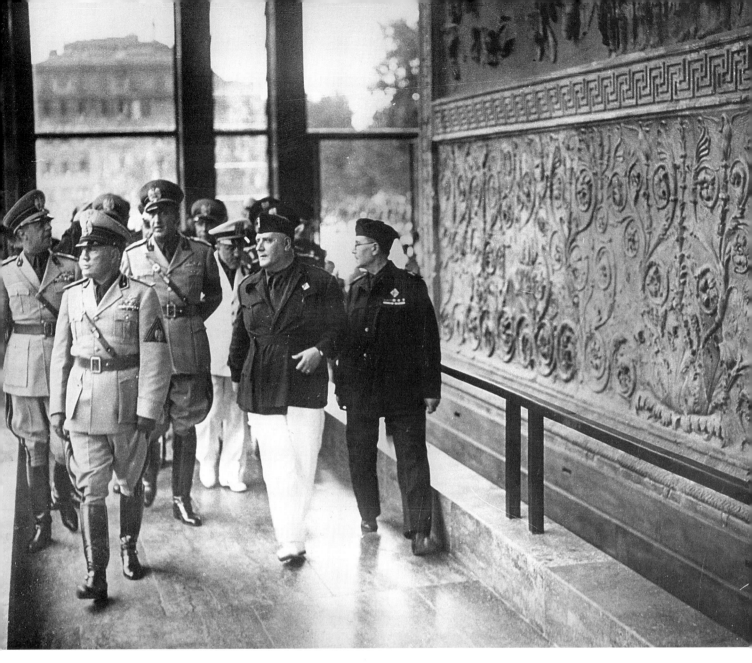

FIGURE 1. Mussolini visiting the reerected Ara Pacis in Rome. INR 76.2385.

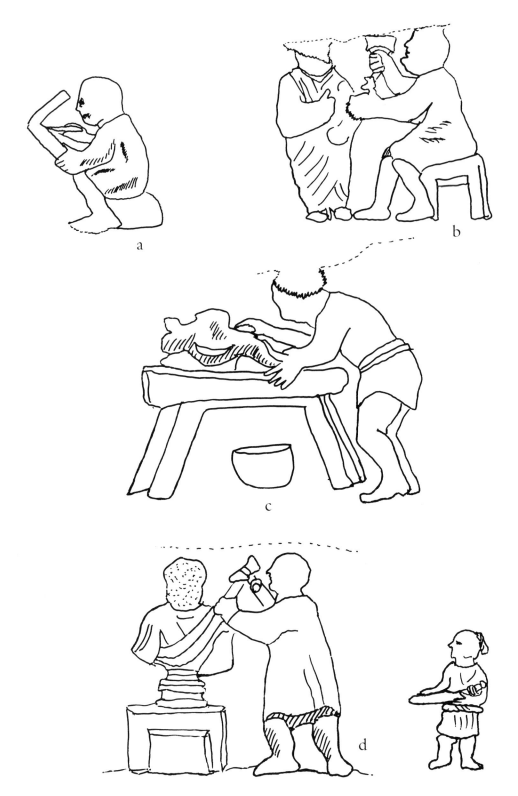

FIGURE 2a–d. Scene of sculptors' workshop. From fragmentary relief from Ephesus. Istanbul Archaeological Museum. Drawing by author after G. Mendel, *Catalogue des sculptures greques, romaines et byzantines*, vol. 1 (Constantinople, 1912), 78.

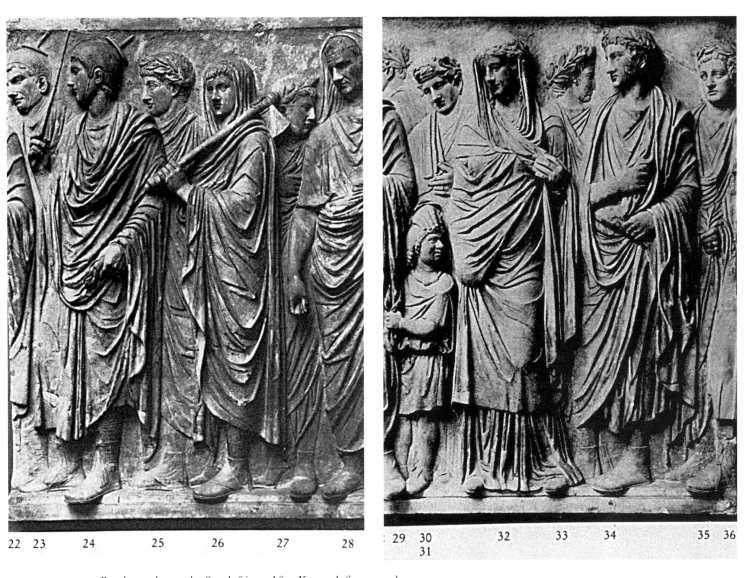

FIGURE 3. Panels 5 and 6 on the South frieze. After Koeppel, figs. 12 and 13.

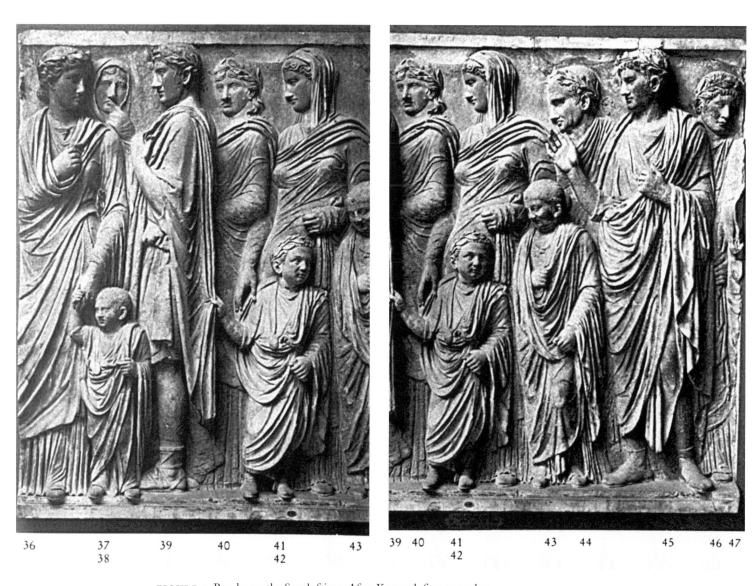

| 36 | | 37 | 39 | 40 | | 41 | | 43 |
| | | 38 | | | | 42 | | |

| 39 | 40 | 41 | | 43 | 44 | | 45 | | 46 | 47 |
| | | 42 | | | | | | | |

FIGURE 4. Panel 7 on the South frieze. After Koeppel, figs. 14 and 15.

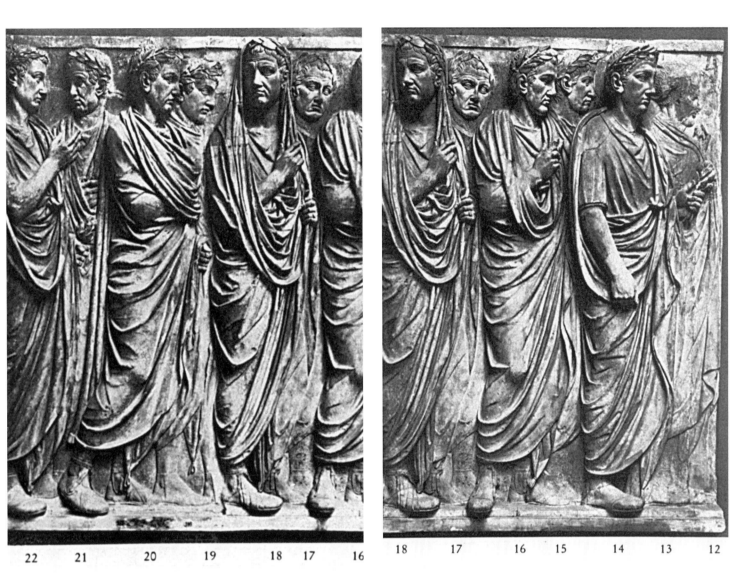

FIGURE 5. Panel 2 on the North frieze. Right side and middle section. After Koeppel, figs. 19 and 20.

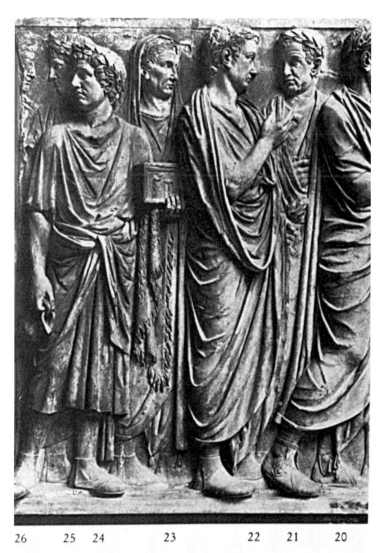

FIGURE 6.
Panel 2 on the
North frieze.
Left side.
After Koeppel,
fig. 21.

26 25 24 23 22 21 20

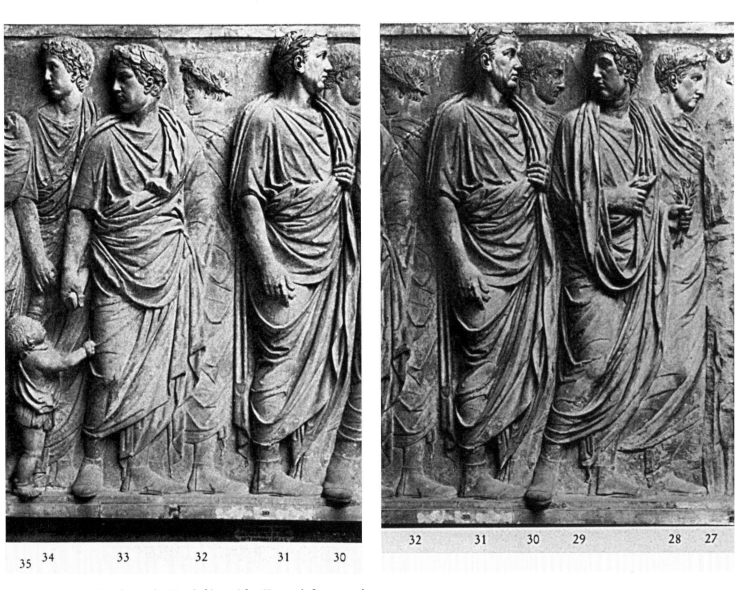

35 34 33 32 31 30

32 31 30 29 28 27

FIGURE 7. Panel 3 on the North frieze. After Koeppel, figs. 22 and 24.

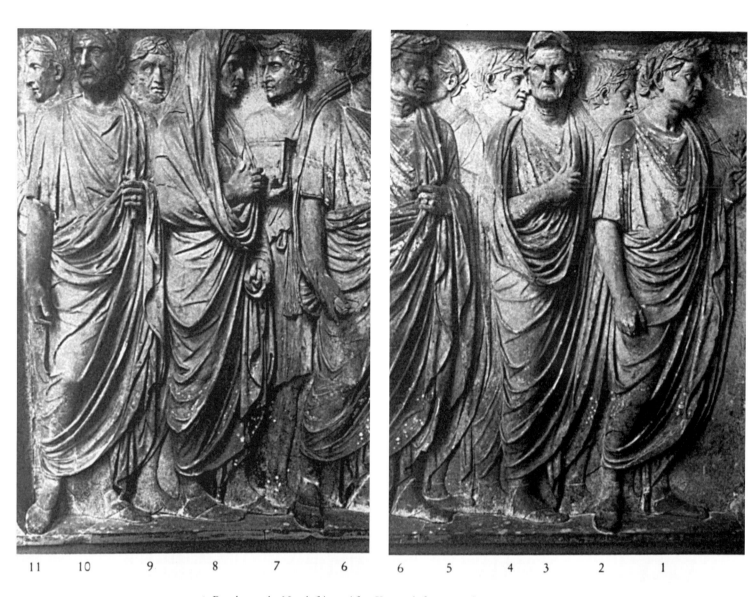

| 11 | 10 | 9 | 8 | 7 | 6 | 6 | 5 | 4 | 3 | 2 | 1 |

FIGURE 8. Panel 1 on the North frieze. After Koeppel, figs. 16 and 18.

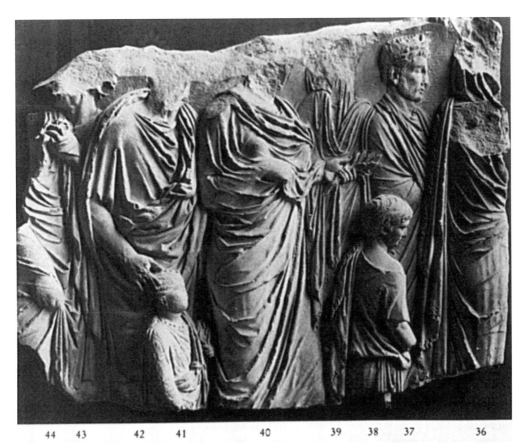

FIGURE 9.
Panel 4
(the Louvre
panel) on the
North frieze.
After Koeppel,
fig. 25.

44 43 42 41 40 39 38 37 36

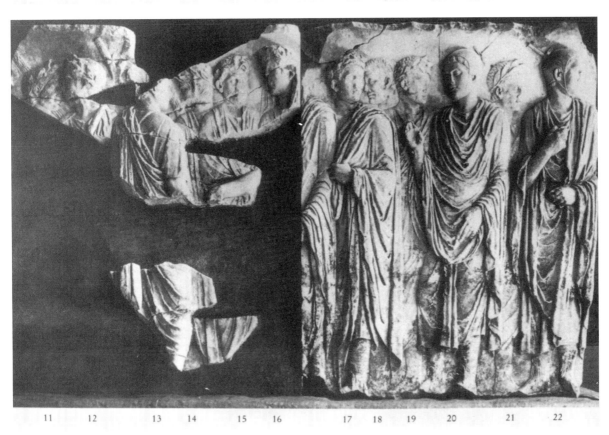

11 12 13 14 15 16 17 18 19 20 21 22

FIGURE 10. Panels 3 and 4 on the South frieze. After Koeppel, fig. 10.

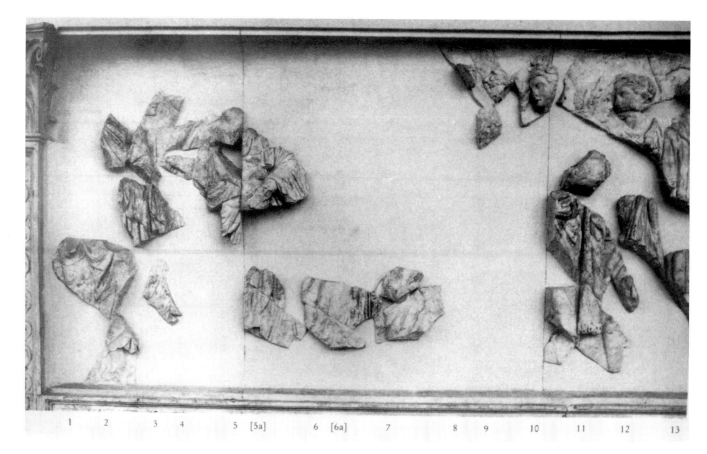

FIGURE 11. Fragments of Panels 1 and 2 and Panel 3 on the South frieze. After Koeppel, fig. 8.

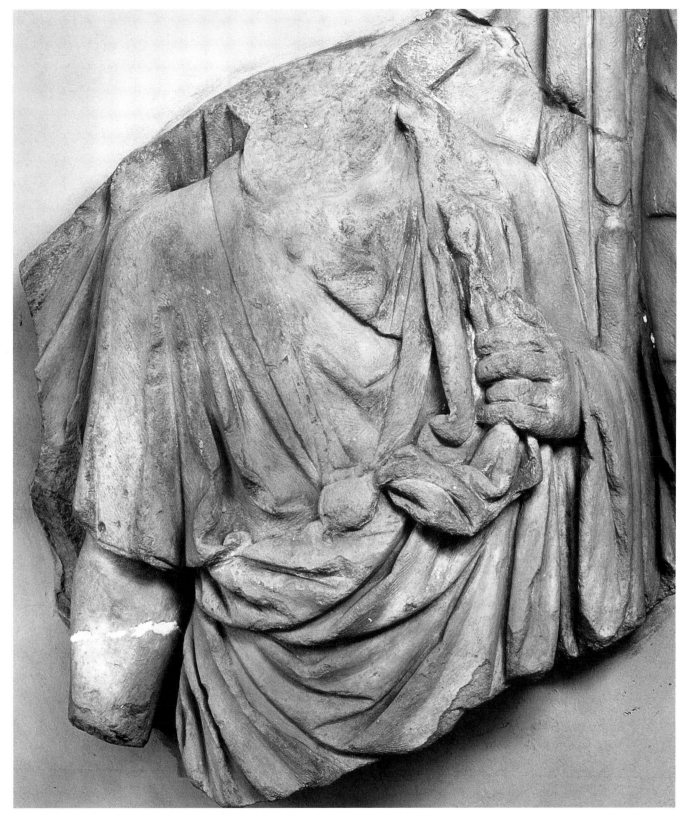

FIGURE 12. Figure N45. Torso of a male youth ("Gaius Caesar"). FB 36/10.

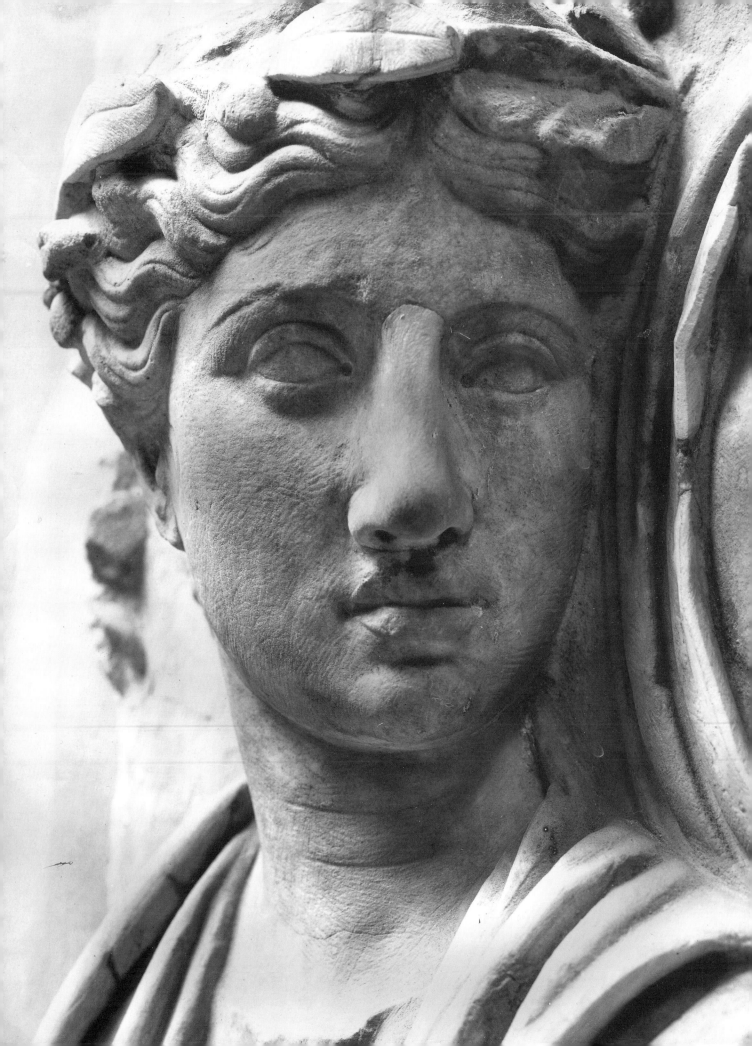

Opposite: FIGURE 13. Figure s36 (Antonia Minor). Rasp marks on face and neck. INR 32.717. *Top:* FIGURE 14. Figure s22 (flamen). Rasp marks on right forearm. *Bottom:* FIGURE 15. Figure s22 (flamen). Rasp marks on right hand.

Top: FIGURE 16. Figure S39 (Drusus). Rasp marks on drapery at left shoulder. *Bottom:* FIGURE 17. Figure N42 (background male). Rasp marks on drapery at torso. *Opposite:* FIGURE 18. Figure S41 (Antonia Maior). Rasp marks on veil. FB 49/5.

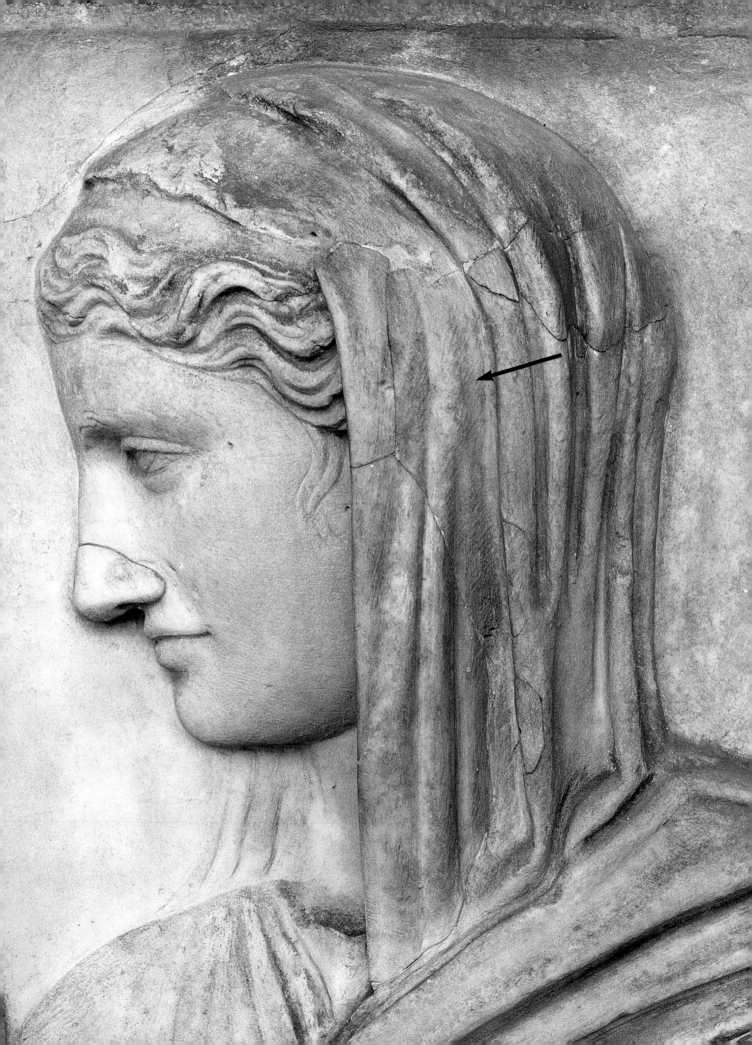

Above: FIGURE 19. Figure S36 (Antonia Minor). Scraper marks on chin.
Opposite: FIGURE 20. Figure S17 (togate male). Scraper marks on left side of face.

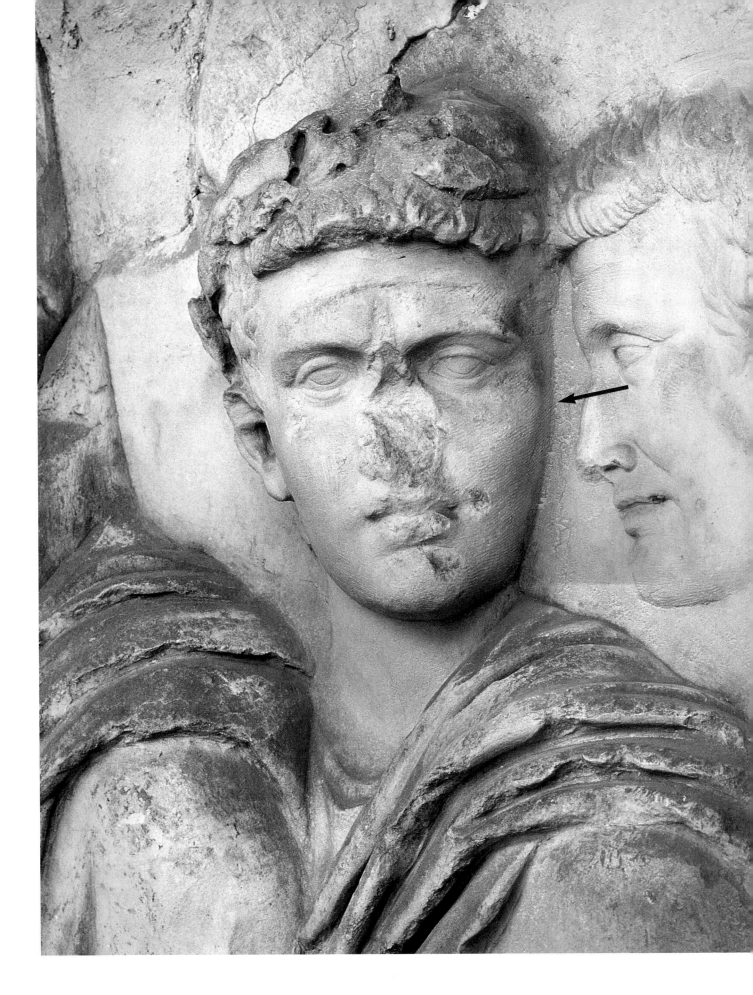

Top: FIGURE 21. Figure S28 (Agrippa). Scraper marks at temple.
Bottom: FIGURE 22. Figure S22 (flamen). Scraper marks on drapery at right shoulder.

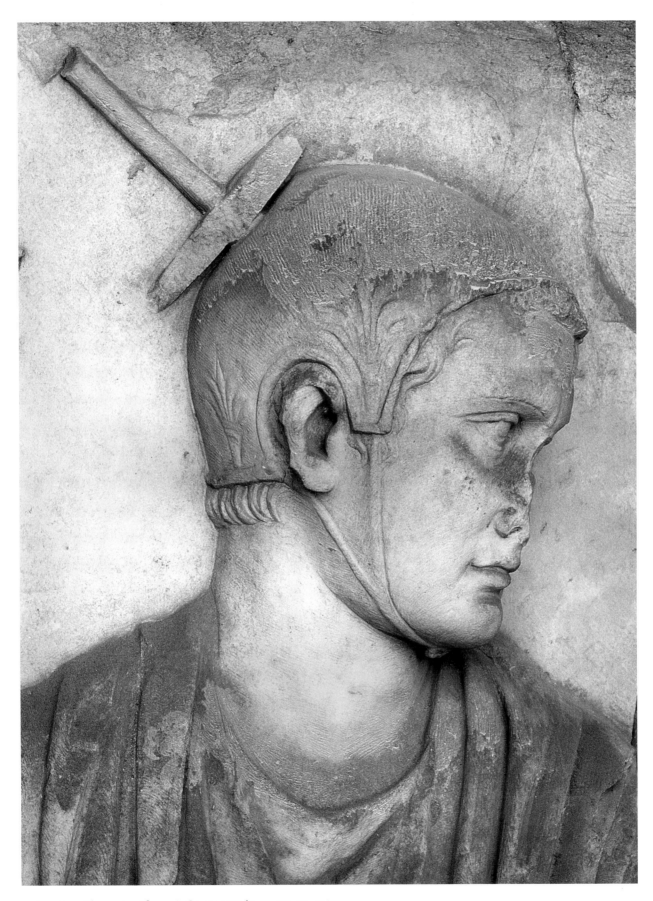

FIGURE 23. Figure S22 (flamen). Scraper marks on cap. FB 42/12.

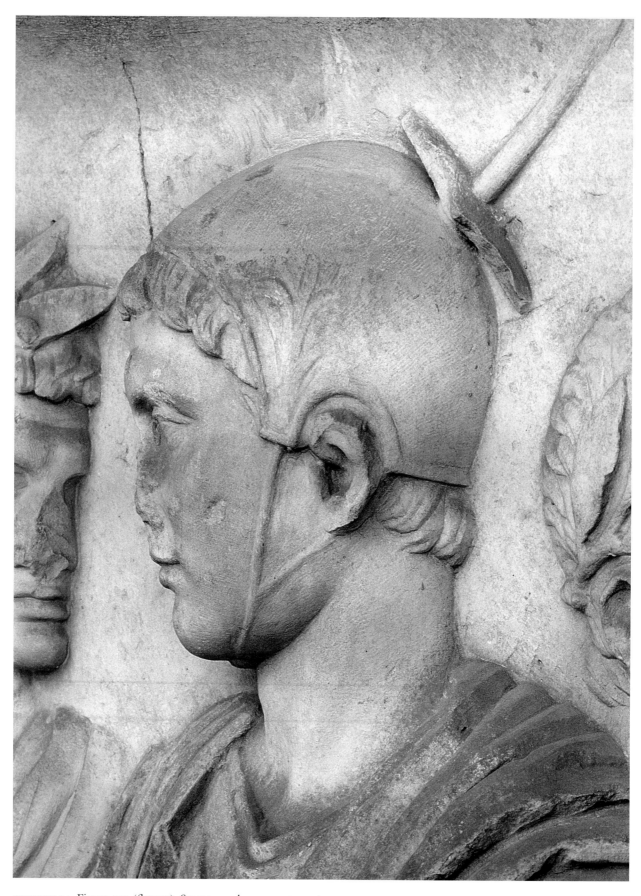

FIGURE 24. Figure S20 (flamen). Scraper marks on cap. FB 42/10.

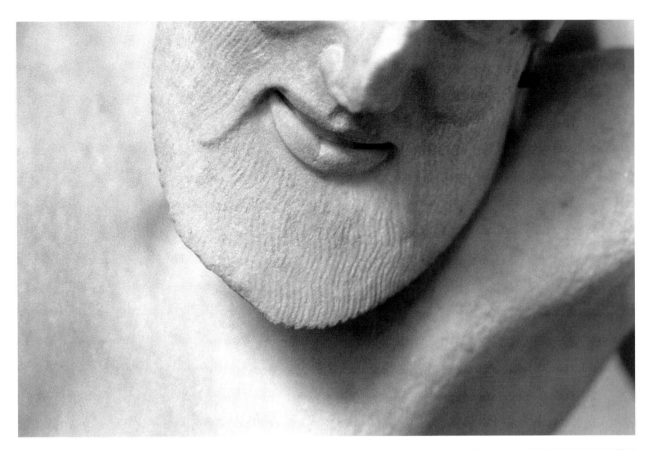

Top: FIGURE 25. Warrior from the pediment of the Temple of Zeus at Olympia. Scraper marks on beard.
Bottom: FIGURE 26. Funerary stele in Munich. Scraper marks on vessel.

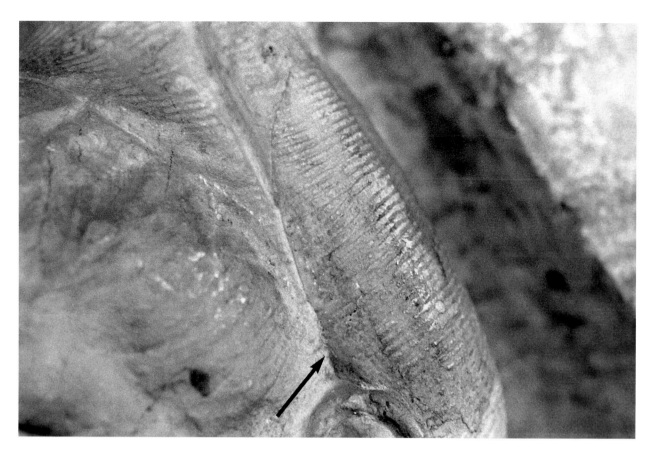

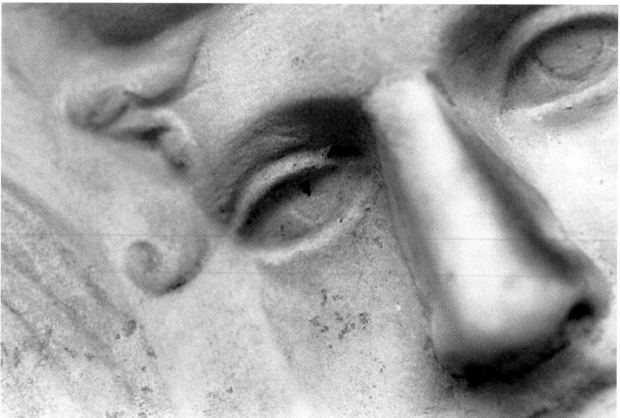

Top: FIGURE 27. Elderly female on the Santecroce funerary relief. Scraper marks on hair.
Bottom: FIGURE 28. Figure s30 ("Barbarian Queen"). Eye area.

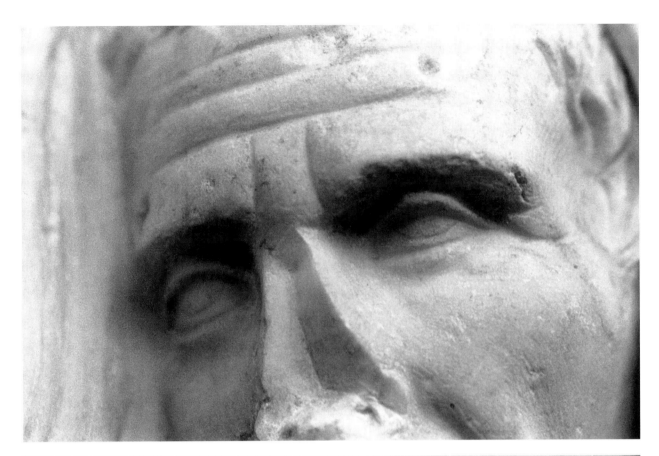

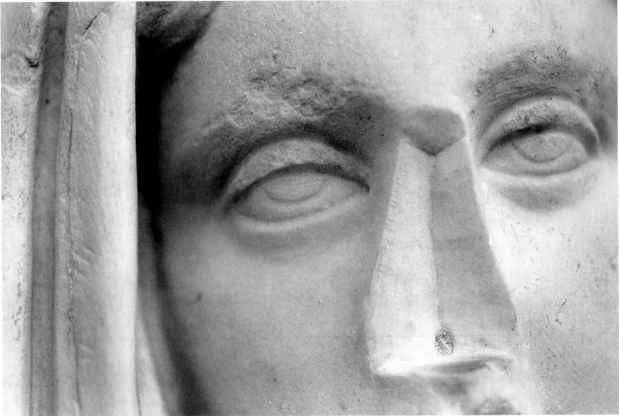

Top: FIGURE 29. Figure S28 (Agrippa). Eye area and nose.
Bottom: FIGURE 30. Figure S32 (Livia). Eye area and nose.

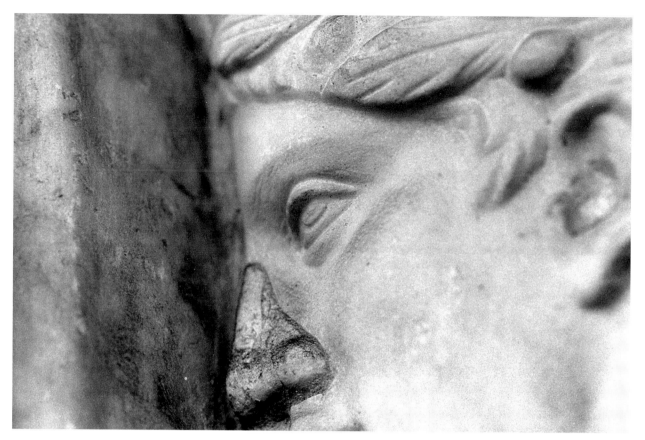

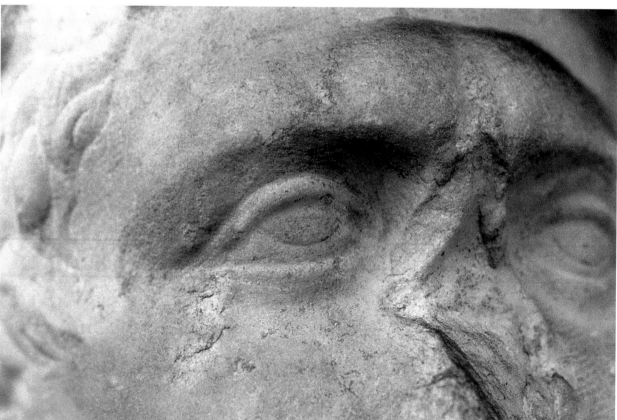

Top: FIGURE 31. Figure S29 (background male). Eye area.
Bottom: FIGURE 32. Figure S17 (togate male). Eye area and lower forehead.

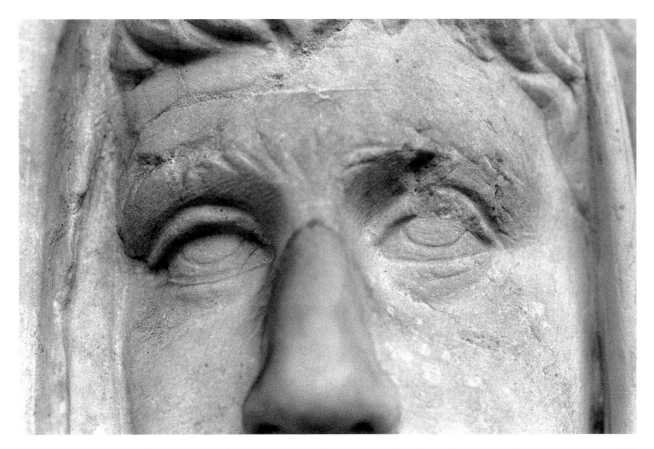

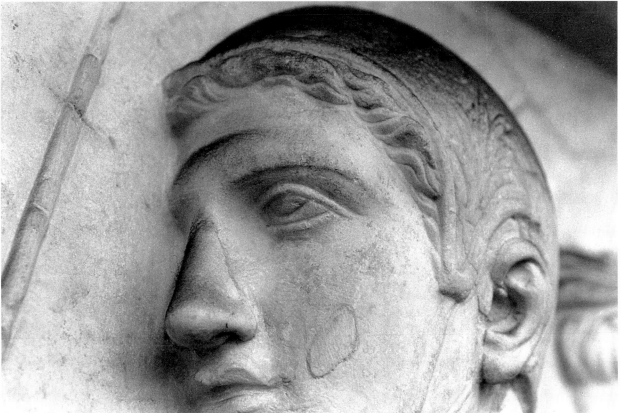

Top: FIGURE 33. Figure s26 ("Rex Sacrorum"). Eye area and forehead.
Bottom: FIGURE 34. Figure s24 (flamen). Upper portion of face.

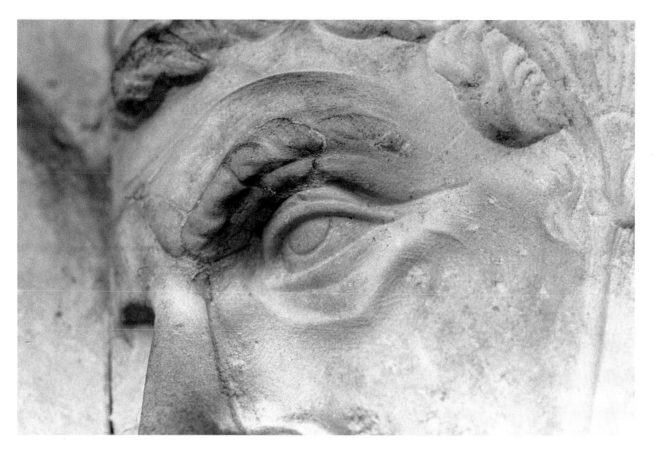

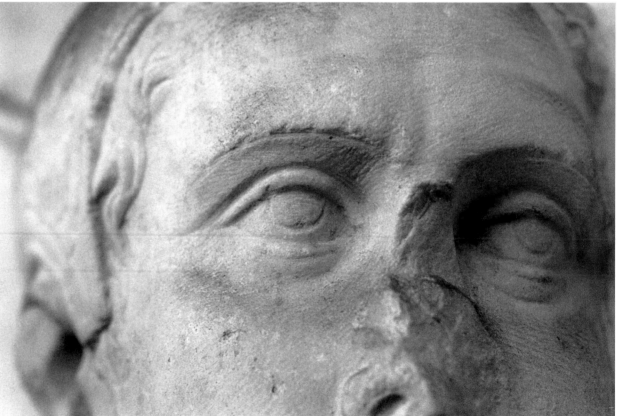

Top: FIGURE 35. Figure S23 (flamen). Eye area.
Bottom: FIGURE 36. Figure S22 (flamen). Eye area and lower forehead.

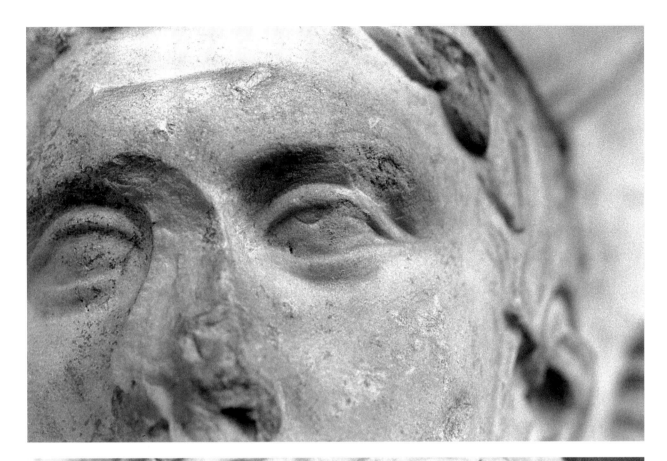

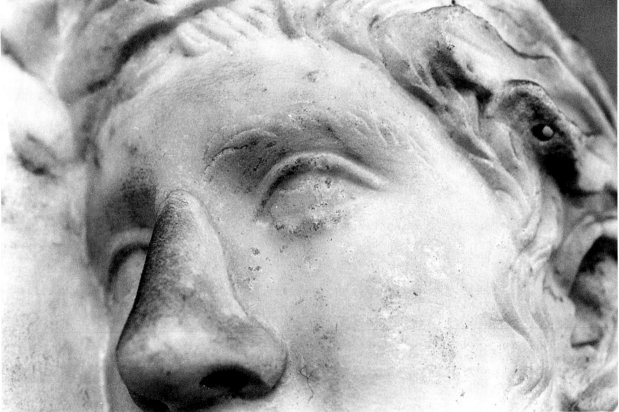

Top: FIGURE 37. Figure S20 (flamen). Eye area and lower forehead.
Bottom: FIGURE 38. Figure S39 (Drusus). Upper portion of face.

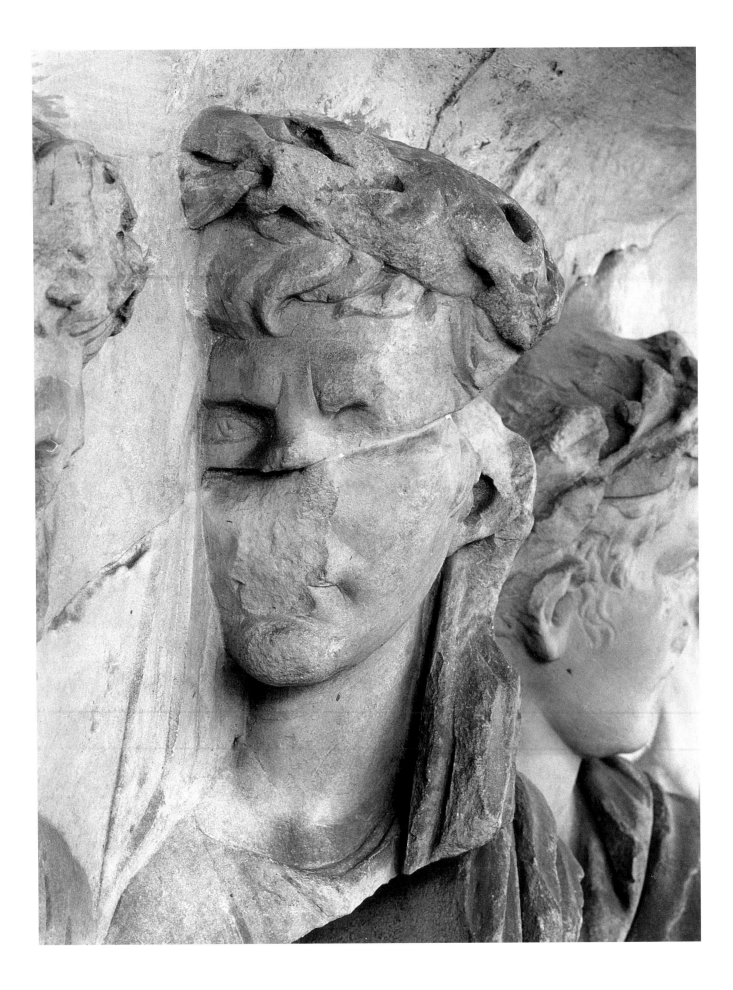

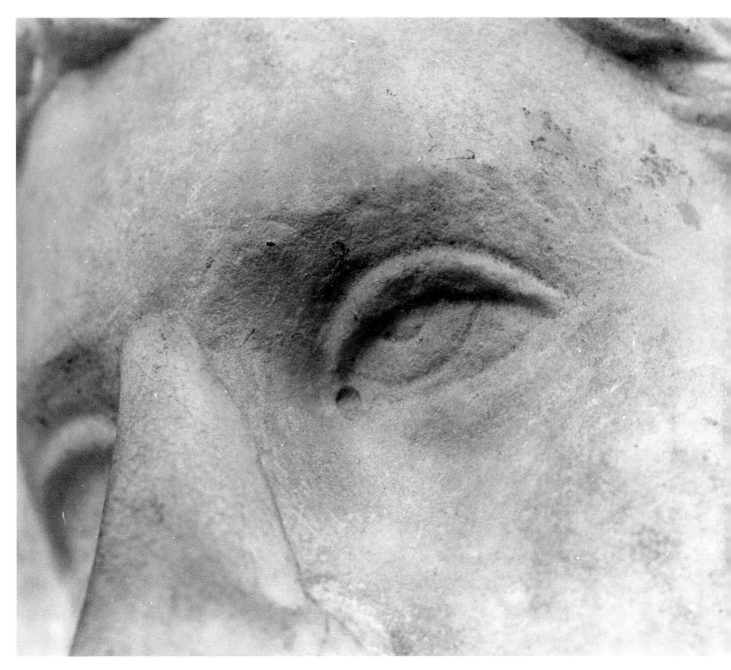

Opposite: FIGURE 39. Figure S16 (Augustus). Face. FB 38/12.
Above: FIGURE 40. Figure S45 (Ahenobarbus). Detail of left eye.

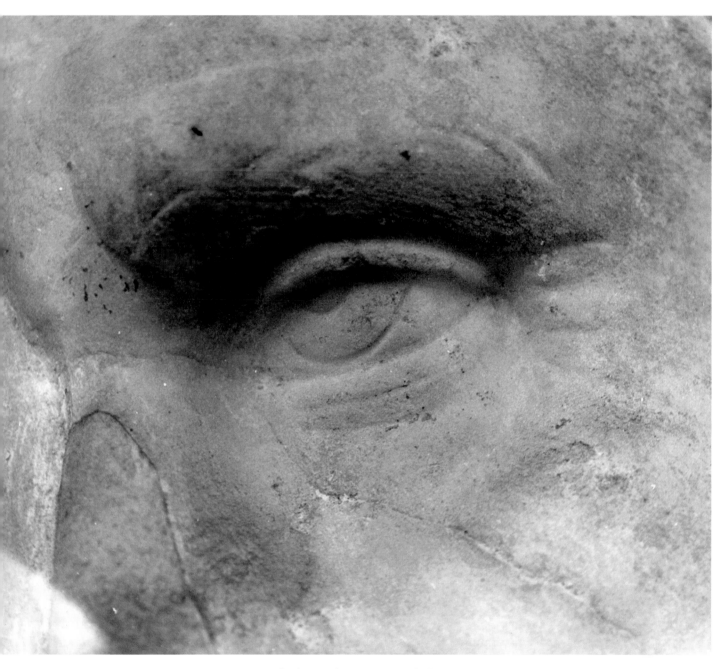

FIGURE 41. Figure s44 (background male). Detail of left eye.

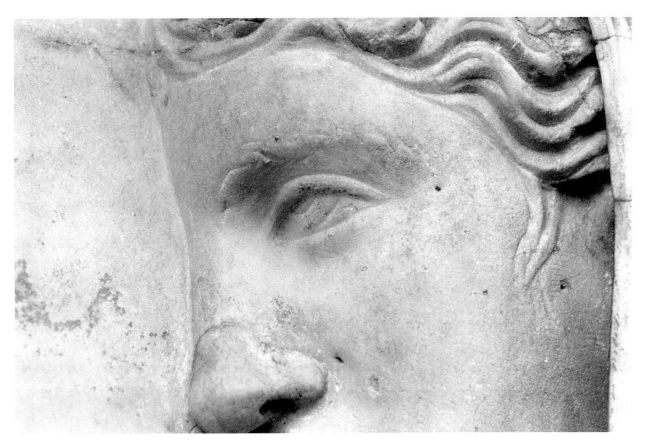

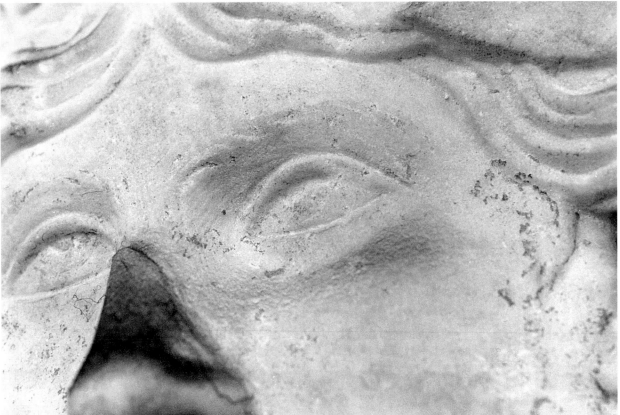

Top: FIGURE 42. Figure S41 (Antonia Maior). Upper portion of face.
Bottom: FIGURE 43. Figure S40 (background female). Eye area.

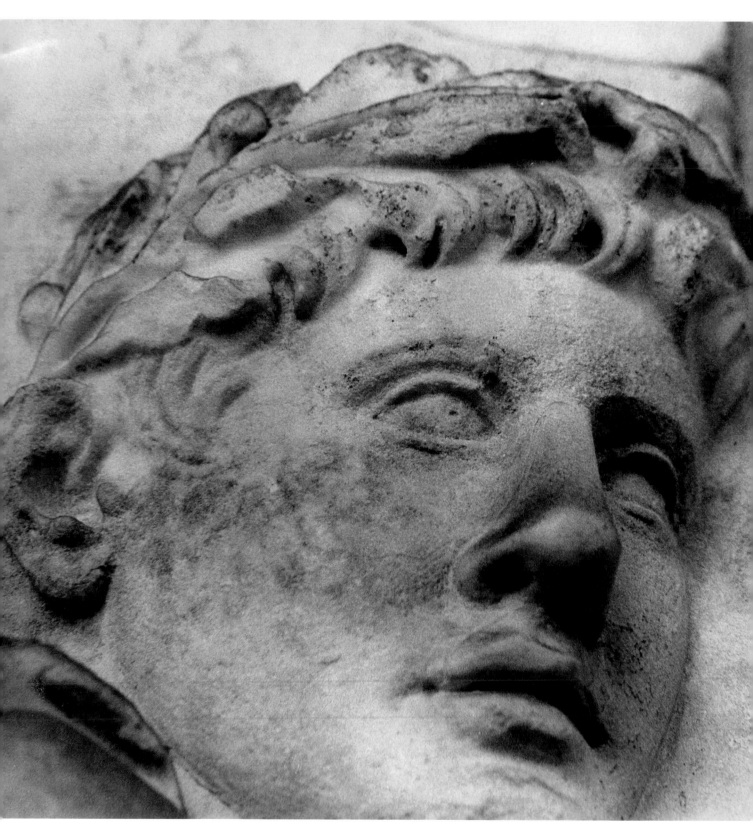

FIGURE 44. Figure S46 (background male?). Face.

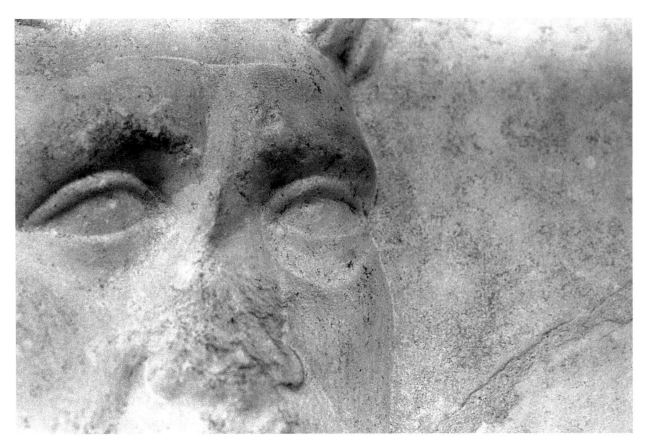

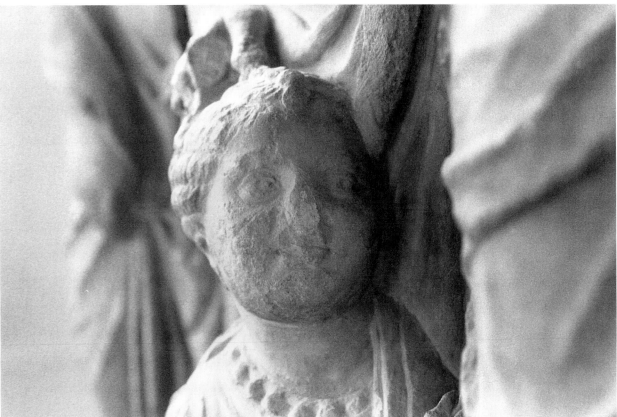

Top: FIGURE 45. Figure s15 (togate male). Eye area and lower forehead.
Bottom: FIGURE 46. Figure n41 (female child). Face.

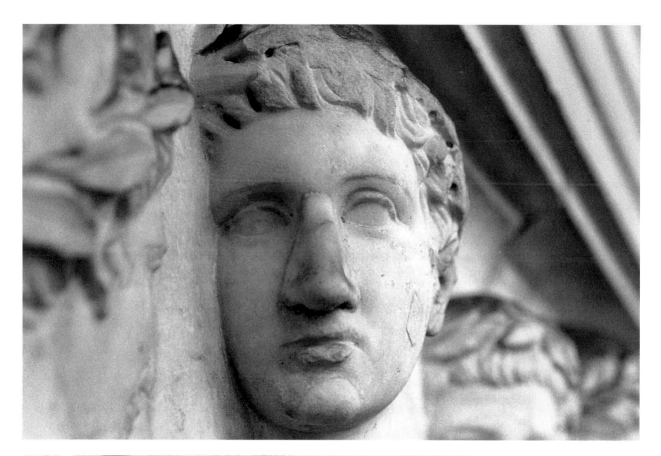

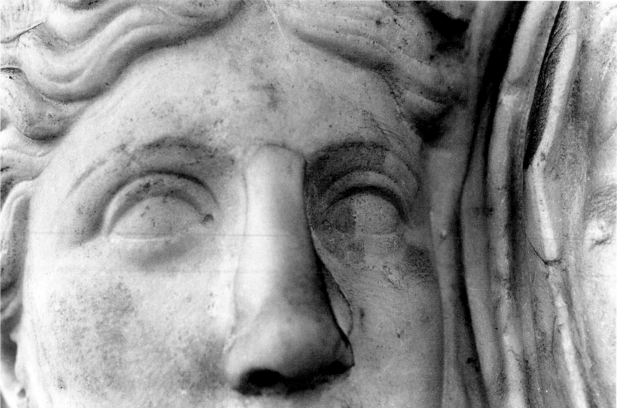

Top: FIGURE 47. Figure s34 ("Tiberius"). Face.
Bottom: FIGURE 48. Figure s36 (Antonia Minor). Eye area.

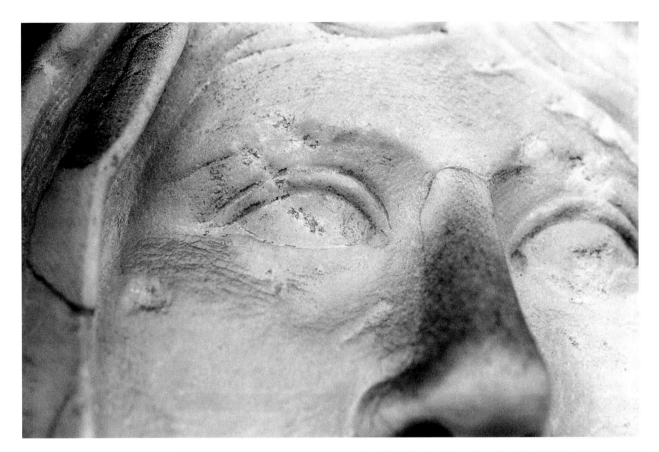

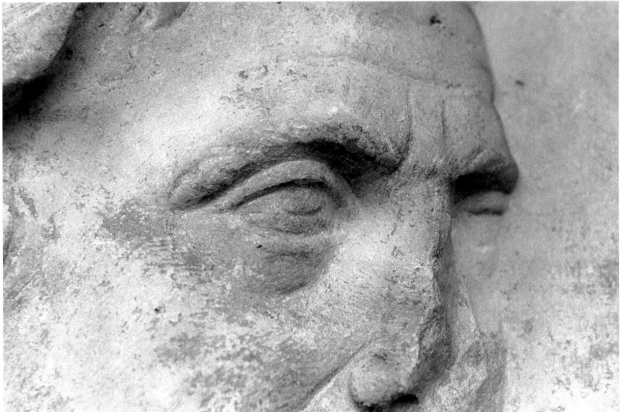

Top: FIGURE 49. Figure S37 (background female). Eye area.
Bottom: FIGURE 50. Figure S21 (background male). Eye area, nose, and lower forehead.

FIGURE 51. Figure N3 (lictor). Damaged surface of drapery at torso.

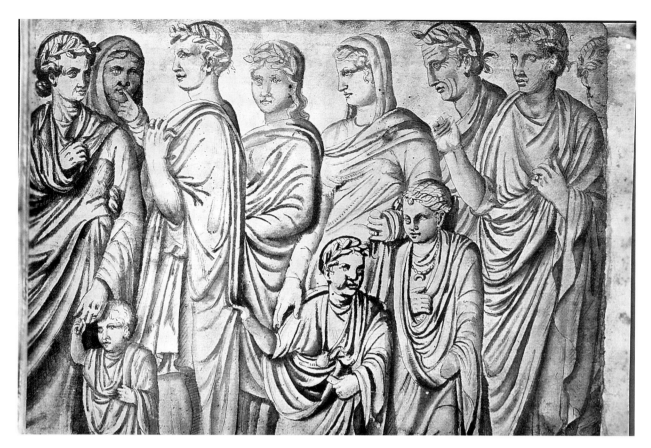

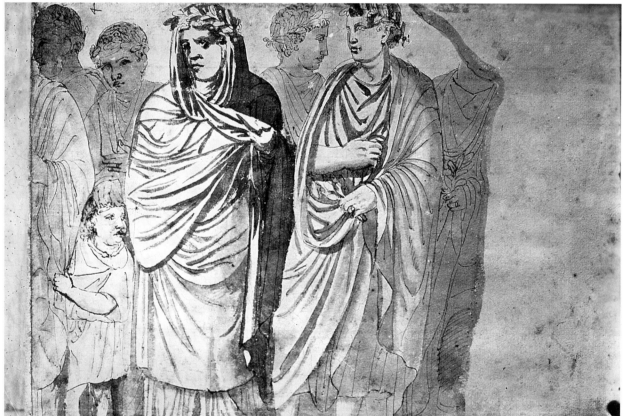

Top: FIGURE 52. Panel s7. Codex Ursanianus drawing. INR 4.
Bottom: FIGURE 53. Panel s6. Codex Ursanianus drawing. INR 4.

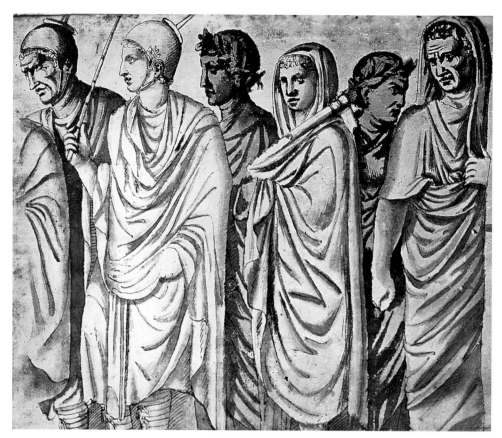

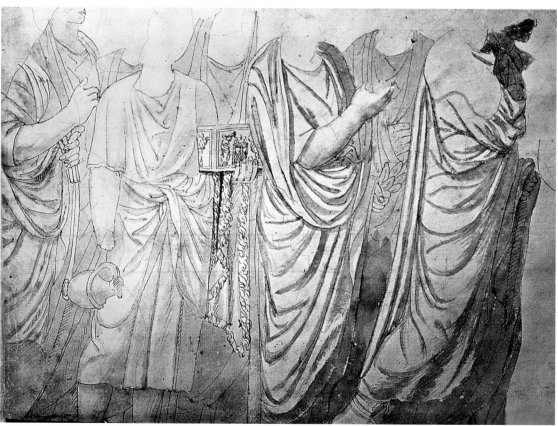

FIGURE 55. Panel N2. Codex Ursanianus drawing. INR 3.

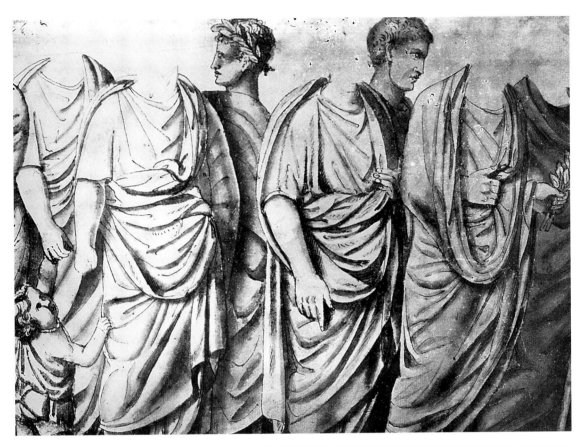

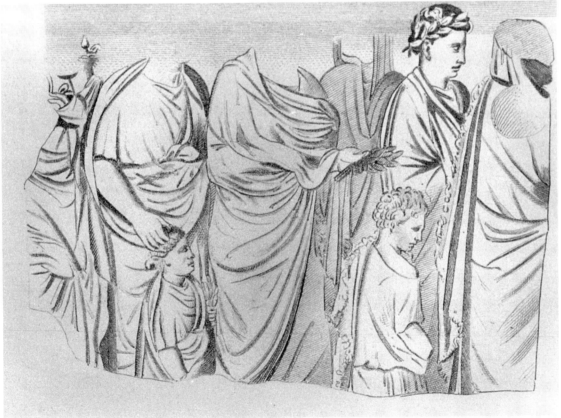

Top: FIGURE 56. Panel N3. Codex Ursanianus drawing. INR 1.
Bottom: FIGURE 57. Panel N4. Codex Ursanianus drawing. After Von Duhn, *MonInst* II (1881): fig. 1a.

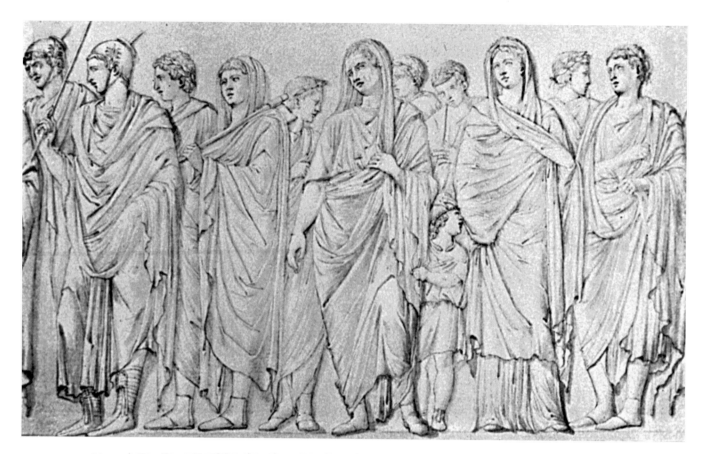

Top:
FIGURE 58a.
Panels s6 and s5.
Dal Pozzo Albani
Collection.
After Toynbee,
"Ara Pacis
Reconsidered,"
fig. 29a.

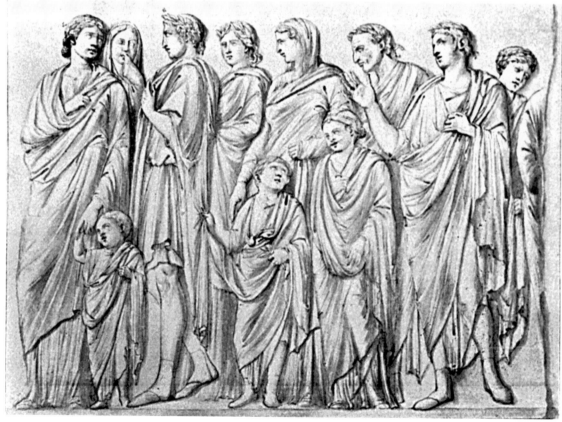

FIGURE 58b. Panel s7. Dal Pozzo Albani Collection. After Toynbee, "Ara Pacis Reconsidered," fig. 29b.

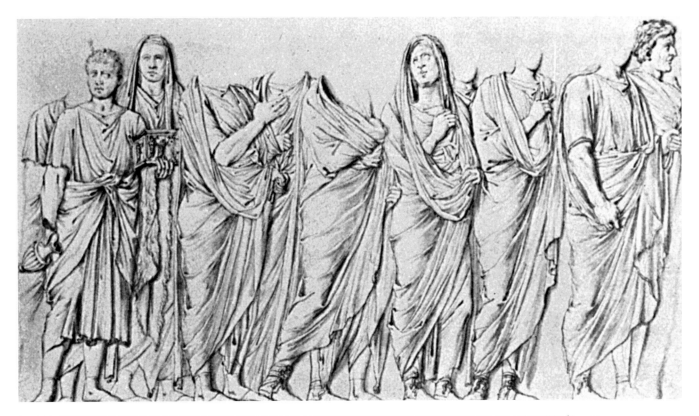

Top:
FIGURE 59a.
Panel N2.
Dal Pozzo Albani
Collection.
After Toynbee,
"Ara Pacis
Reconsidered,"
fig. 30a.

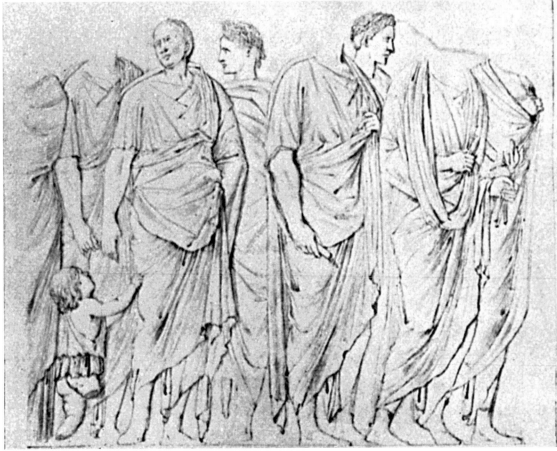

FIGURE 59b. Panel N3. Dal Pozzo Albani Collection. After Toynbee, "Ara Pacis Reconsidered," fig. 30b.

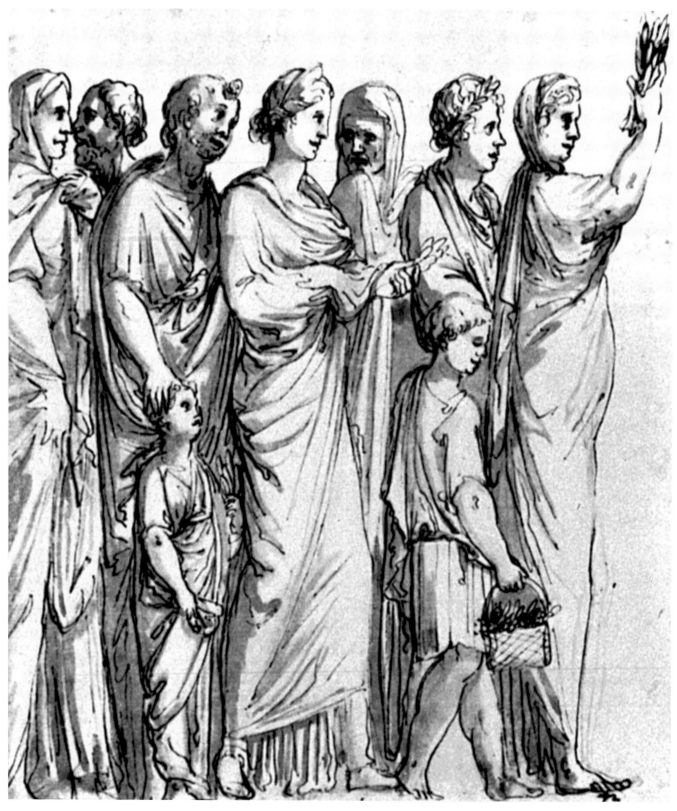

Above: FIGURE 60. Panel N4. Dal Pozzo Albani Collection. After Toynbee, "Ara Pacis Reconsidered," fig. 31a.

Opposite, top: FIGURE 61. Panels S7 and N2 joined together. Bartoli engraving. After *Admiranda Romanarum antiquitatum ac veteris sculpturae vestigia* (Rome, 1693), pl. 14.

Opposite, bottom: FIGURE 62. Panels S5 and S6. Bartoli engraving. After *Admiranda Romanarum antiquitatum ac veteris sculpturae vestigia* (Rome, 1693), pl. 15.

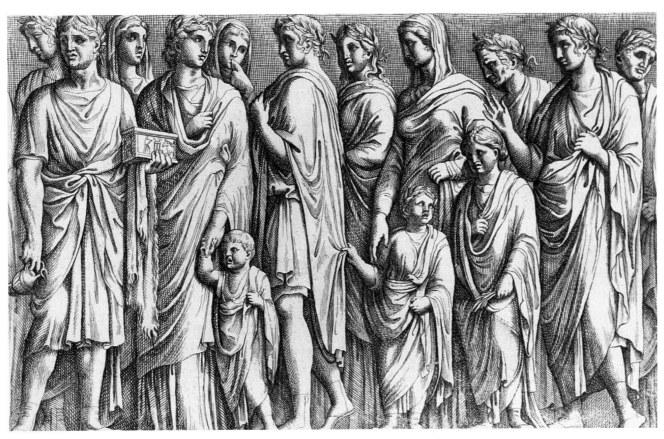

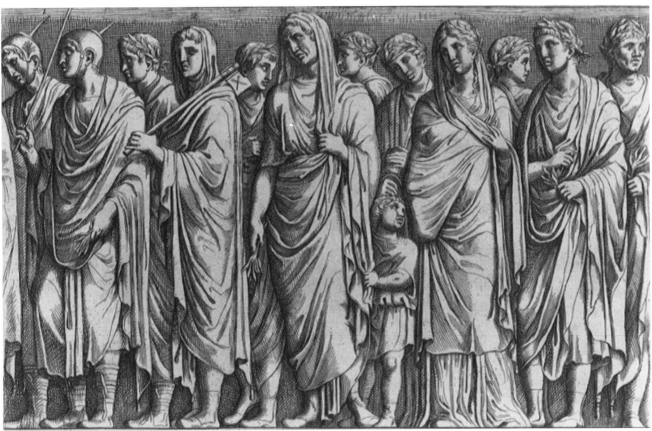

Above: FIGURE 63. Ara panels in storage at the Museo Nazionale Romano, Rome. Panels sawed into pieces. INR 76.2397.

Opposite, top: FIGURE 64. Figure N33 (togate male). Head restored by F. Carradori. Detail of break between original marble and Carradori restoration.

Opposite, bottom: FIGURE 65. Figure S35 (background male). Head restored by F. Carradori. Detail of head.

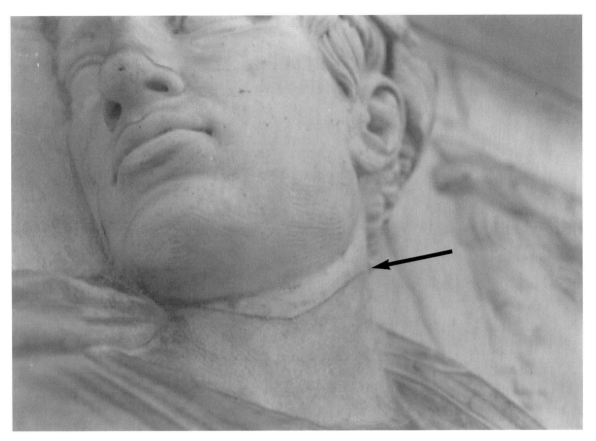

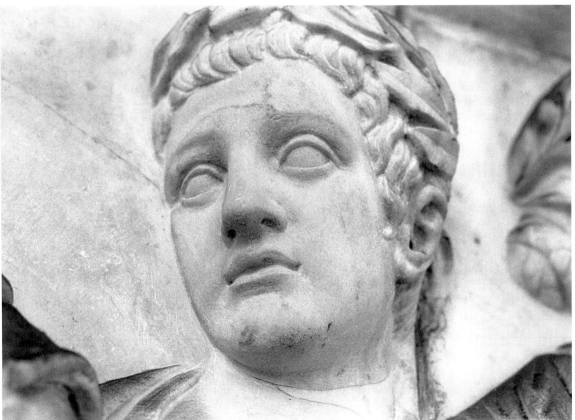

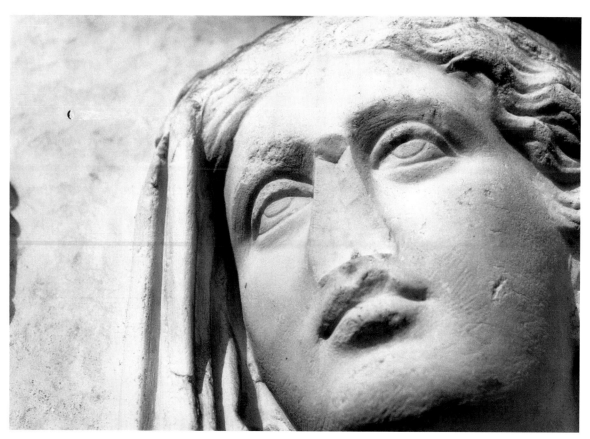

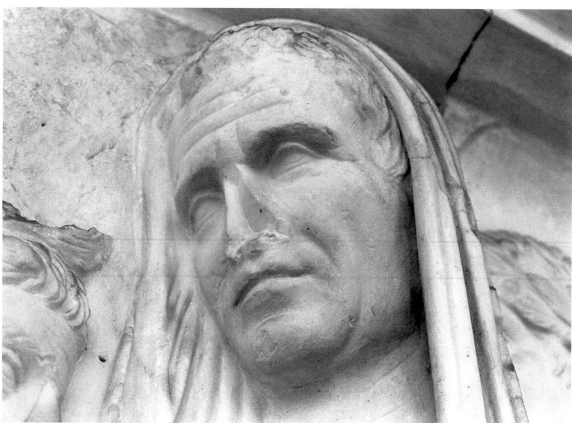

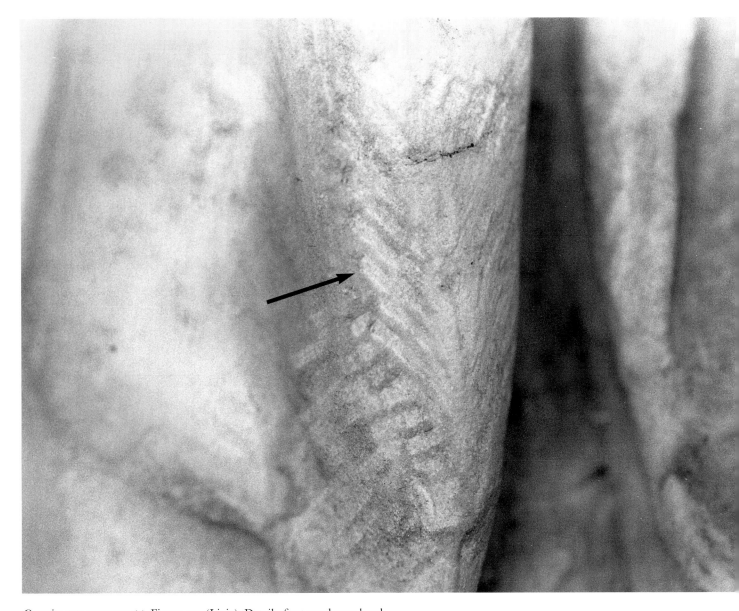

Opposite, top: FIGURE 66. Figure S32 (Livia). Detail of recarved nose break.
Opposite, bottom: FIGURE 67. Figure S28 (Agrippa). Detail of recarved nose break.
Above: FIGURE 68. South frieze. Detail of traces of claw chisel on drapery made by the restorer F. Carradori.

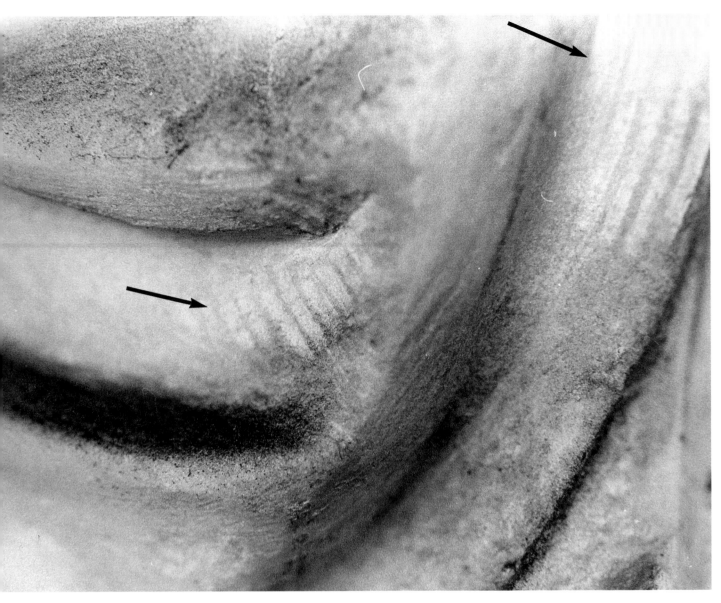

FIGURE 69. South frieze. Detail of traces of claw chisel on drapery made by the restorer F. Carradori.

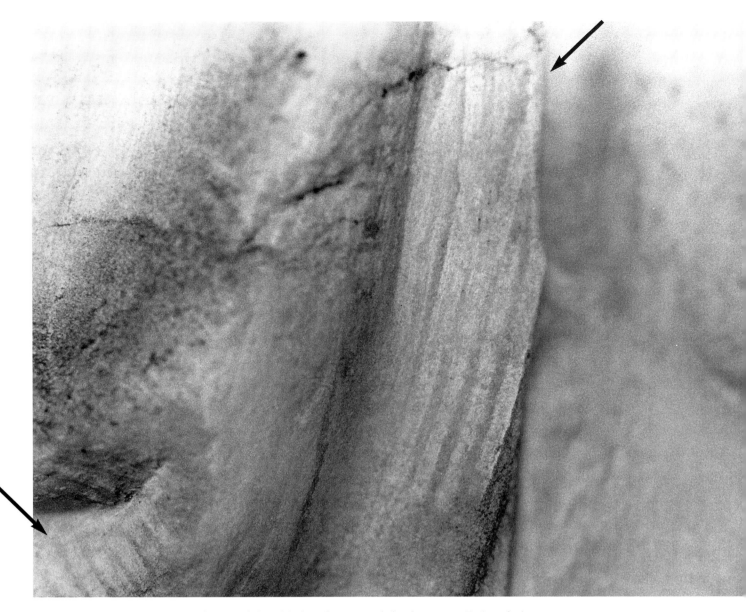

FIGURE 70. South frieze. Detail of traces of claw chisel on drapery made by the restorer F. Carradori.

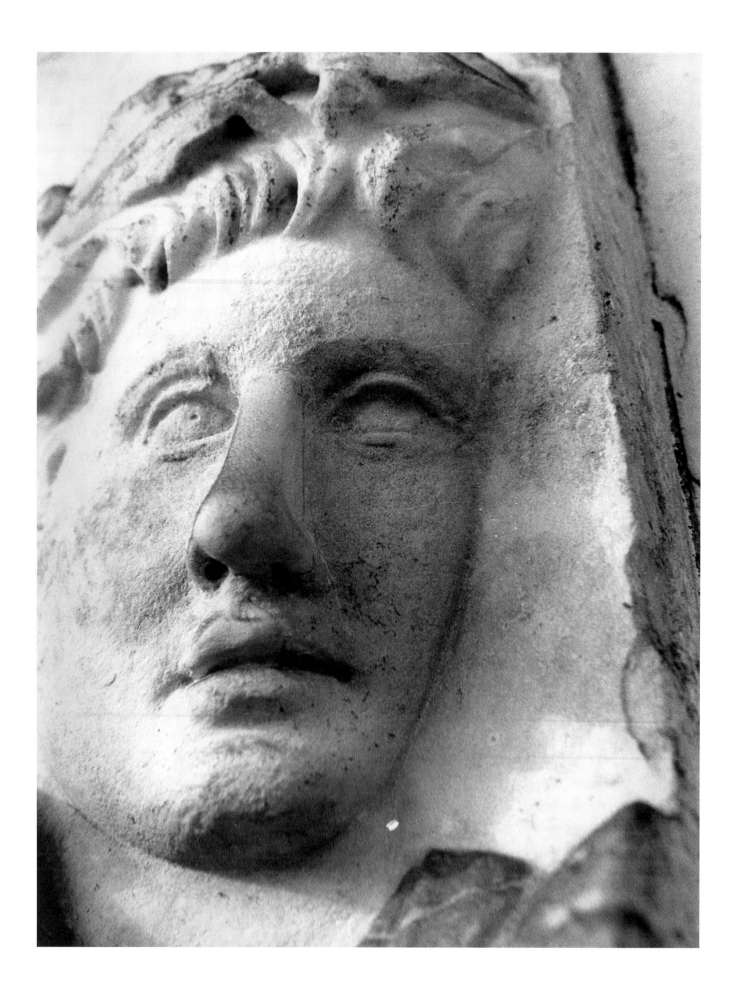

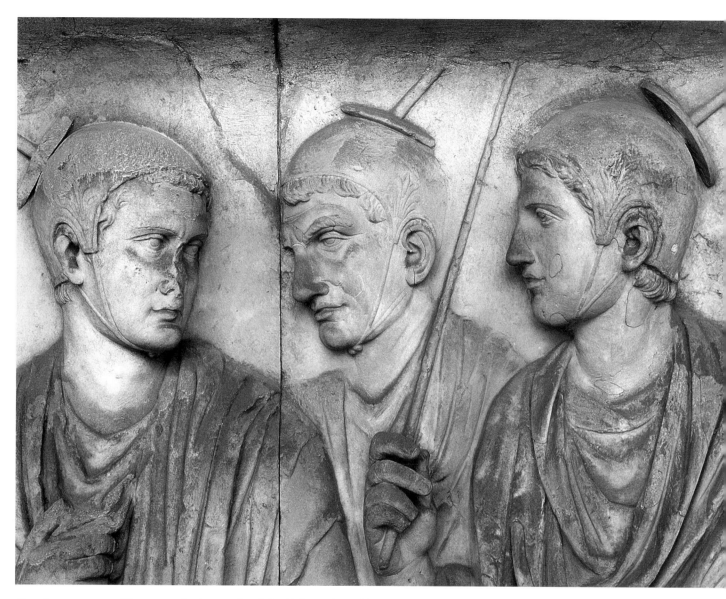

Opposite: FIGURE 71. Figure s46 (background male?). Oblique view of head. Acid washed surface texture.
Above: FIGURE 72. Figures s22, s23, and s24 (flamines). Heads and upper torsos. FB 43/8.

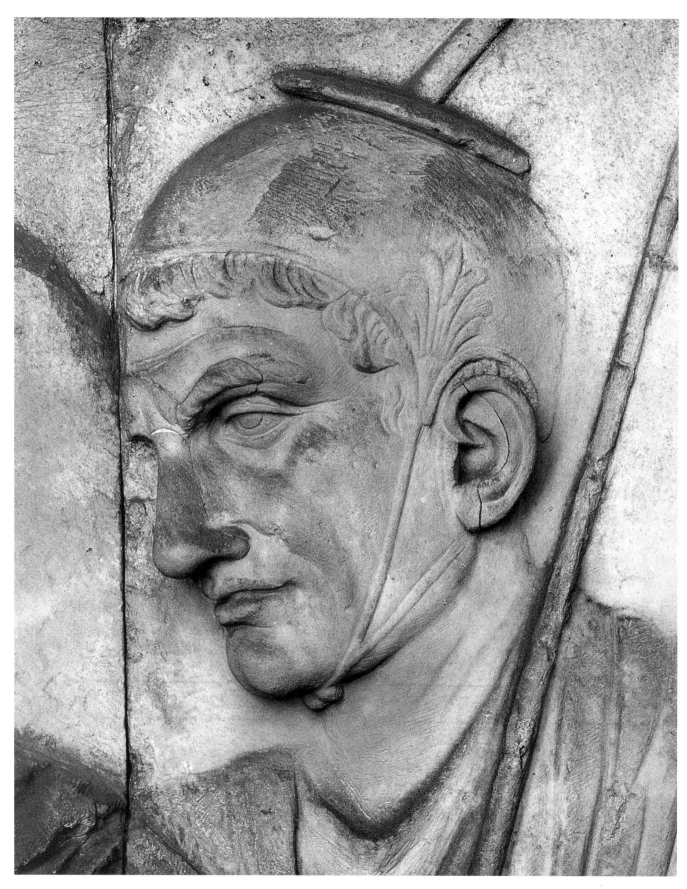

Above: FIGURE 73. Figure s23 (flamen). Head. FB 43/1. *Opposite:* FIGURE 74. Figure s24 (flamen). Head. FB 43/2.

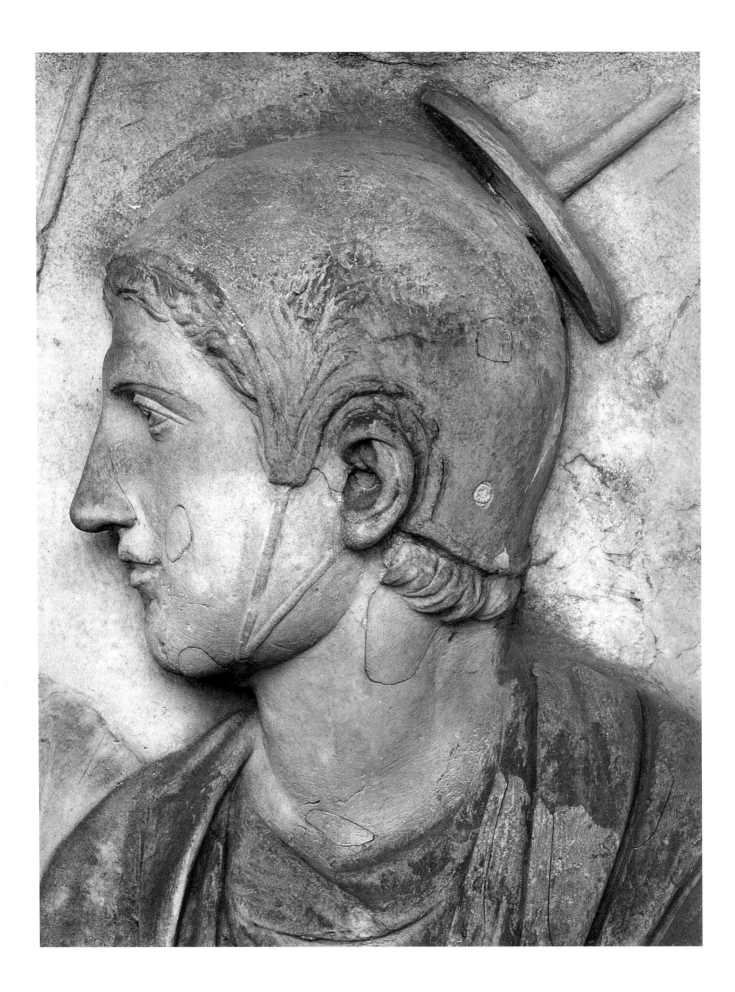

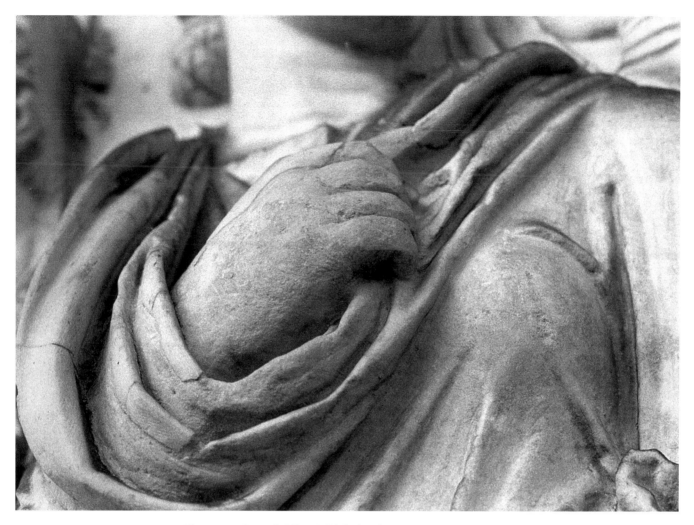

FIGURE 75. Figure S36 (Antonia Minor). Right hand.

FIGURE 76. Figure s45 (Ahenobarbus). Right hand.

Top: FIGURE 77. Figure S28 (Agrippa). Background surface in front of right foot.
Bottom: FIGURE 78. Figure S27 (background male). Background surface around feet.

Top: FIGURE 79. Figure N14 (togate male). Chisel marks at feet.
Bottom: FIGURE 80. Figures N33, N34, and N35. Chisel marks at feet.

Above: FIGURE 81. Figure N31 (togate male). Chisel marks on background at feet.
Opposite: FIGURE 82. Figure S33 (background male). Head. Contour chiseling. FB 49/2.

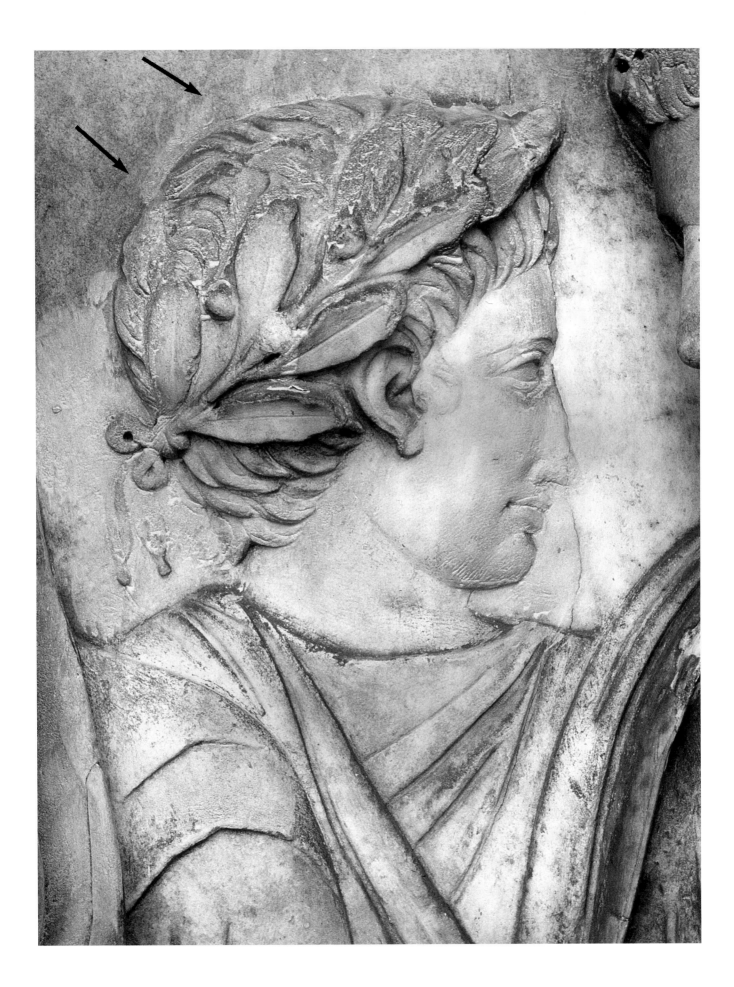

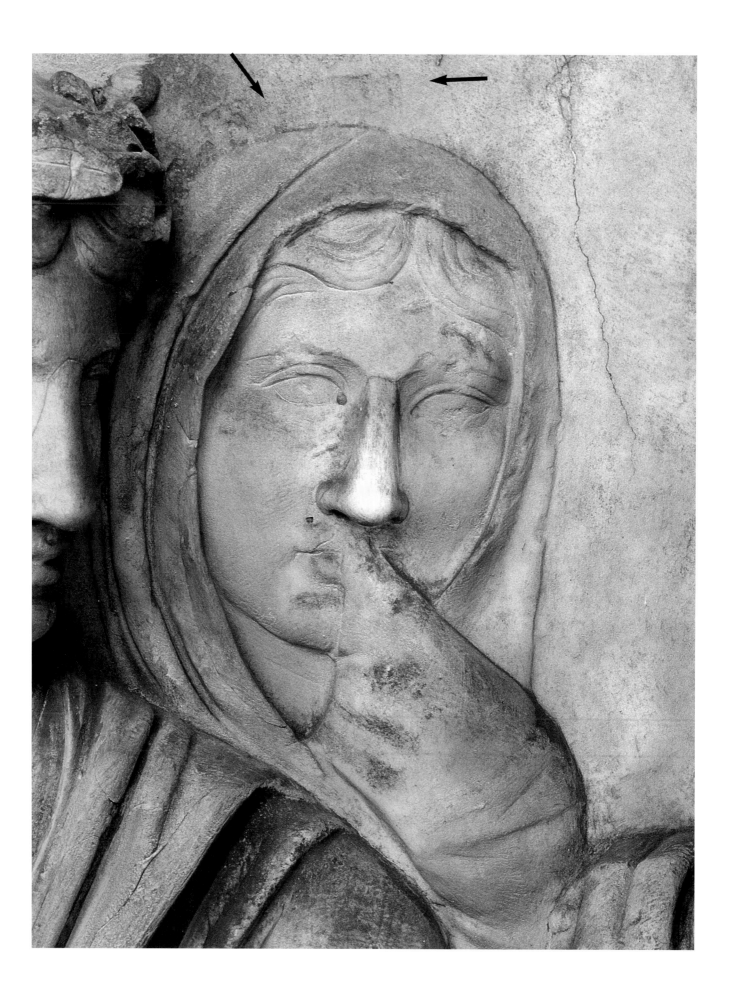

Opposite: FIGURE 83. Figure S37 (background female). Head. FB 48/4.
Above: FIGURE 84. Figures S33 and S32 (Livia). Detail of contour chiseling.

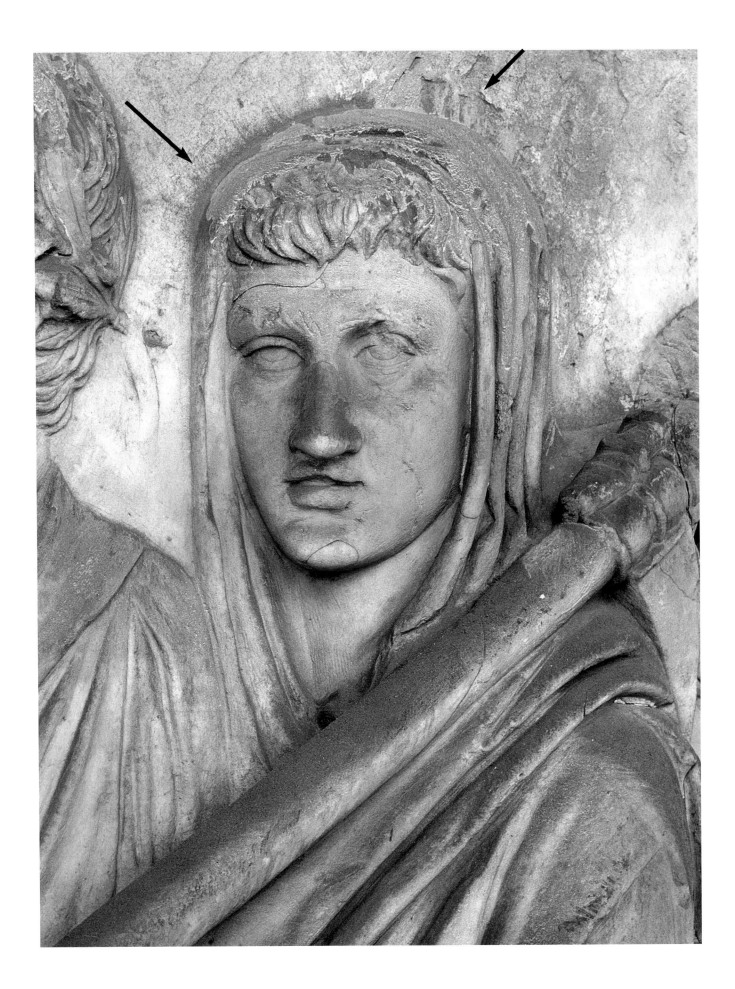

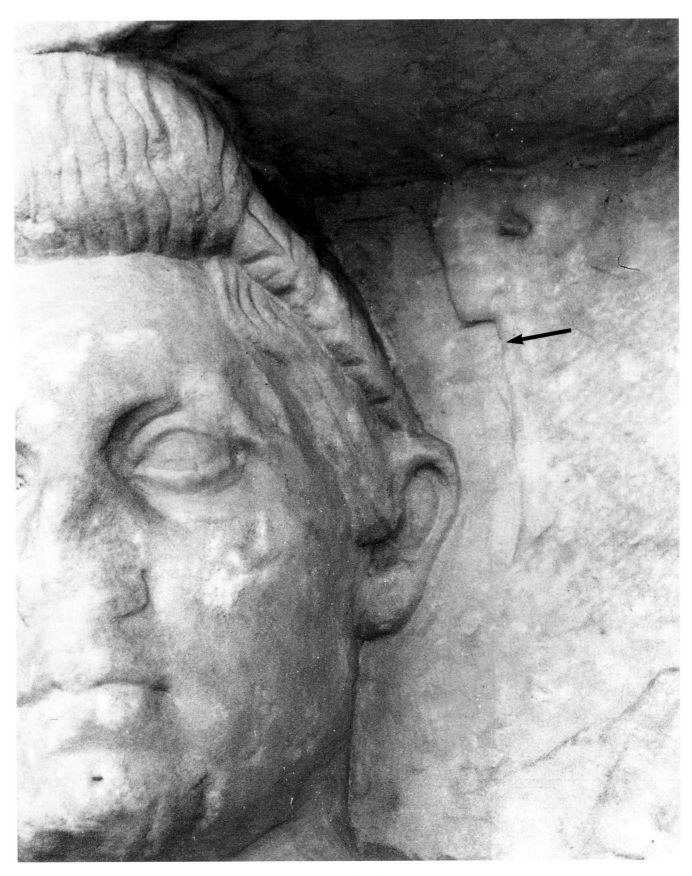

Opposite: FIGURE 85. Figure S26 ("Rex Sacrorum"). Head. Contour chiseling. FB 43/6.
Above: FIGURE 86. Female figure on the Frontispizio relief. Detail of contour chiseling.

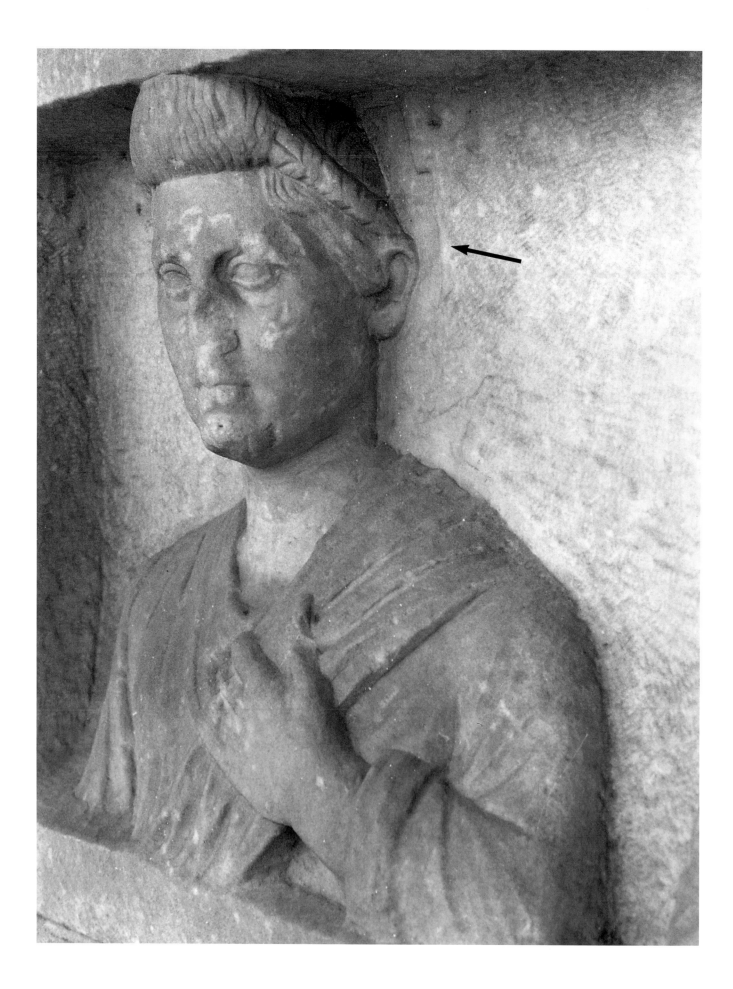

Opposite: FIGURE 87. Female figure on the Frontispizio relief. Detail of contour chiseling.
Above: FIGURE 88. Male figure on the Rabirius relief. Detail of contour chiseling.

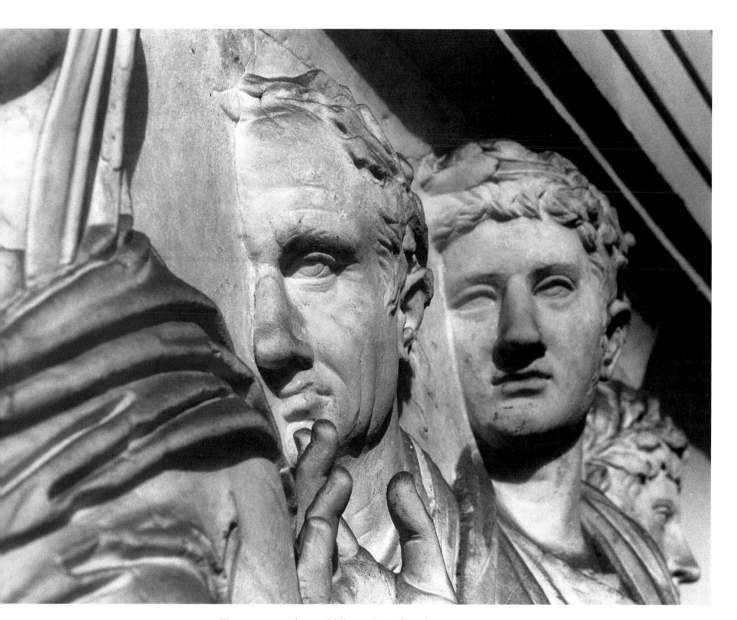

FIGURE 89. Figures S44 and S45. Oblique view of heads.

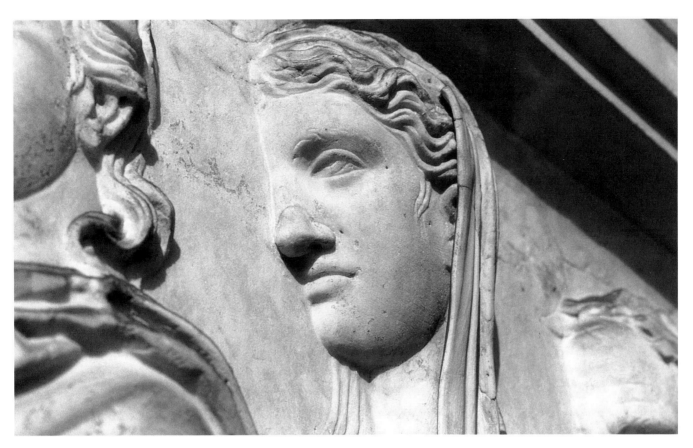

FIGURE 90. Figure S41 (Antonia Maior). Oblique view of head.

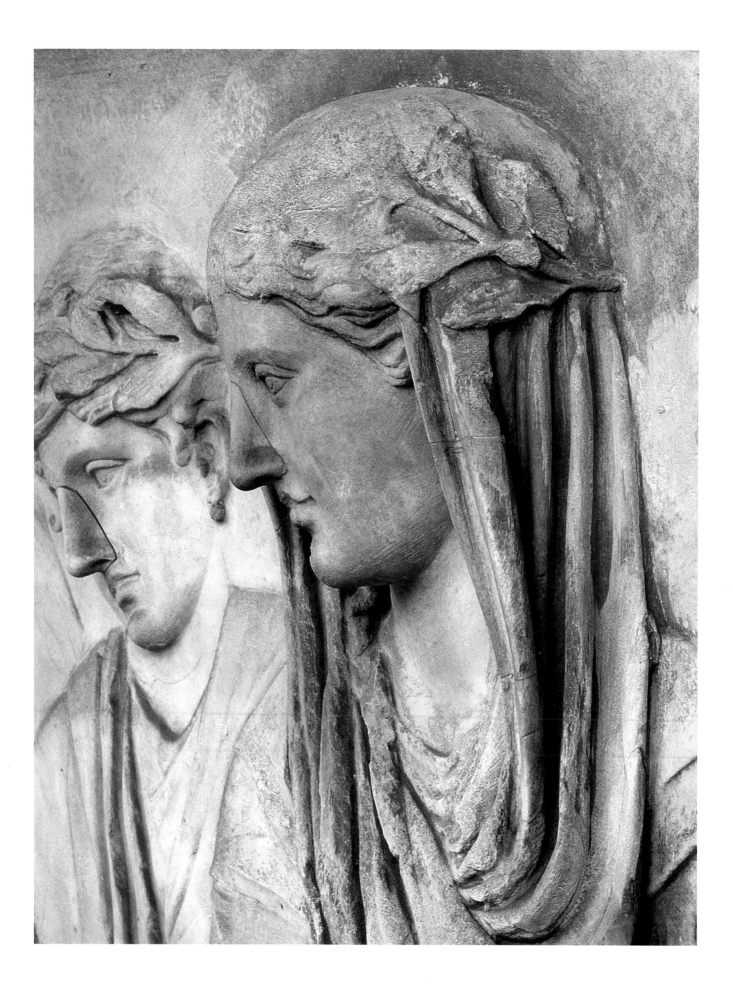

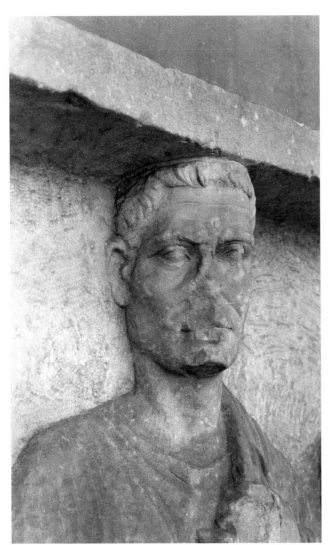

Opposite: FIGURE 91. Figures S32 and S30. Detail of heads. FB 48/12.
Above, left: FIGURE 92. Male figure on the Frontispizio relief.
Above, right: FIGURE 93. Female figure on the Santecroce relief.

FIGURE 94.
Male figure
on the
Mattei relief.
Detail of
head.

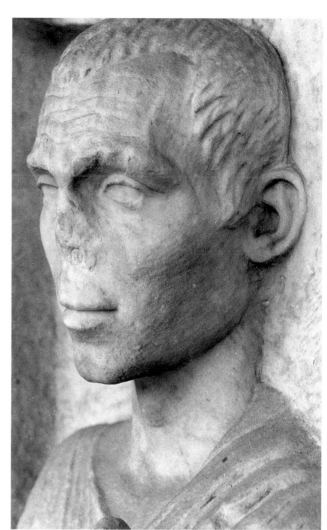

Top: FIGURE 95. Figure s39 (Drusus). Chisel marks on background surface at head.
Bottom: FIGURE 96. Figure n37 (background male). Chisel marks on background surface at head.

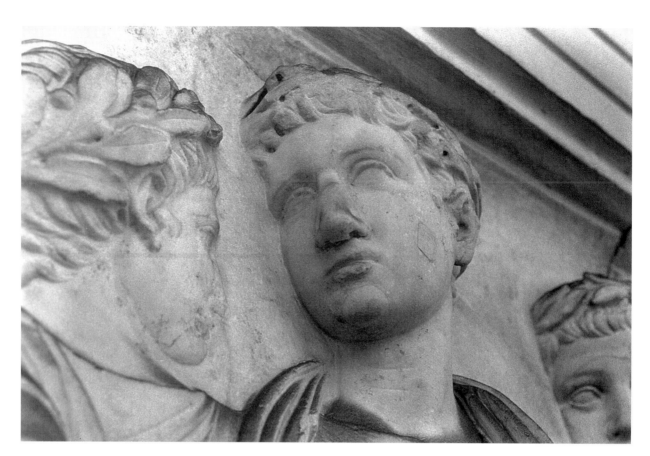

FIGURE 97. Figure S34 ("Tiberius"). Smoothed background surface at head.

FIGURE 98.
Male figure
on the
Frontispizio
relief.
Hair.

FIGURE 99. Male figure on the Frontispizio relief. Hair.

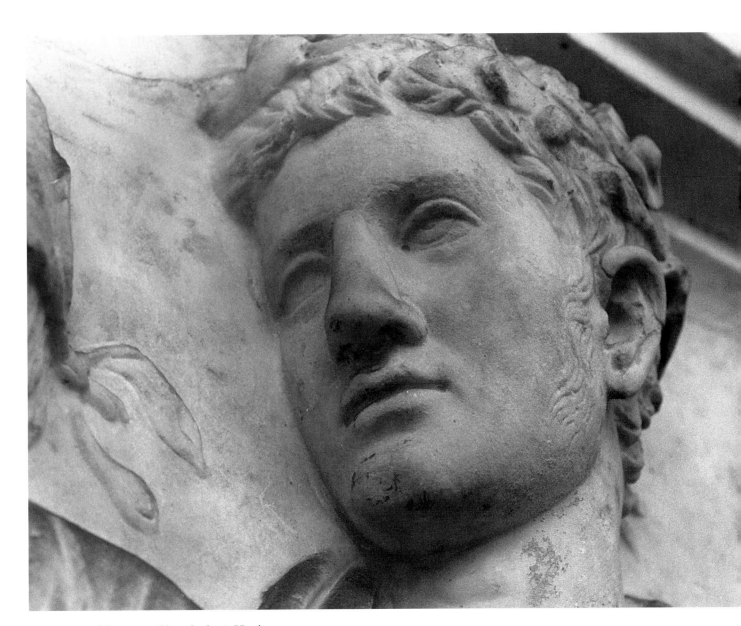

FIGURE 100. Figure S45 (Ahenobarbus). Head.

FIGURE 101. Figure S45 (Ahenobarbus). Hair.

FIGURE 102. Figure S45 (Ahenobarbus). Hair.

Top: FIGURE 103. Figure S24 (flamen). Hair. *Bottom:* FIGURE 104. Figure S24 (flamen). Hair.

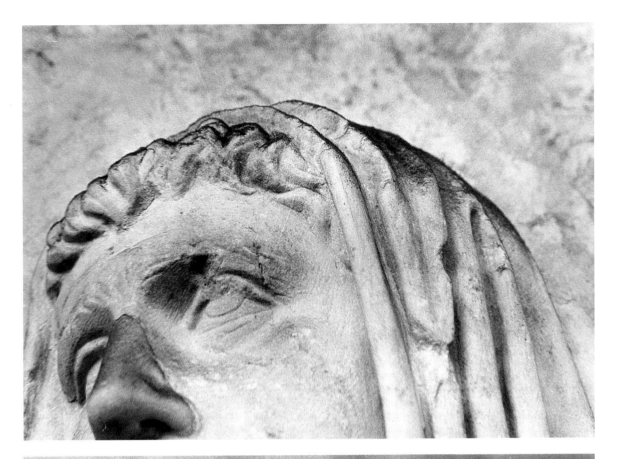

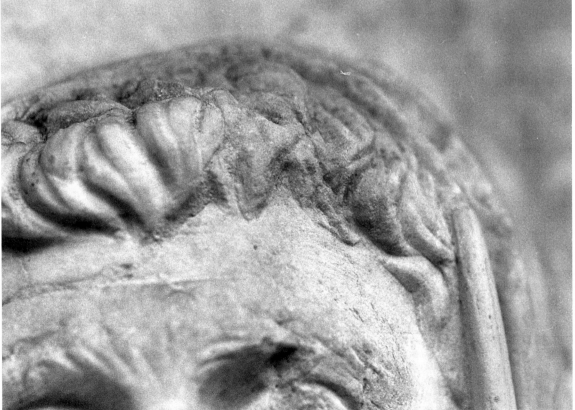

Top: FIGURE 105. Figure s26 ("Rex Sacrorum"). Hair. *Bottom:* FIGURE 106. Figure s26 ("Rex Sacrorum"). Hair.

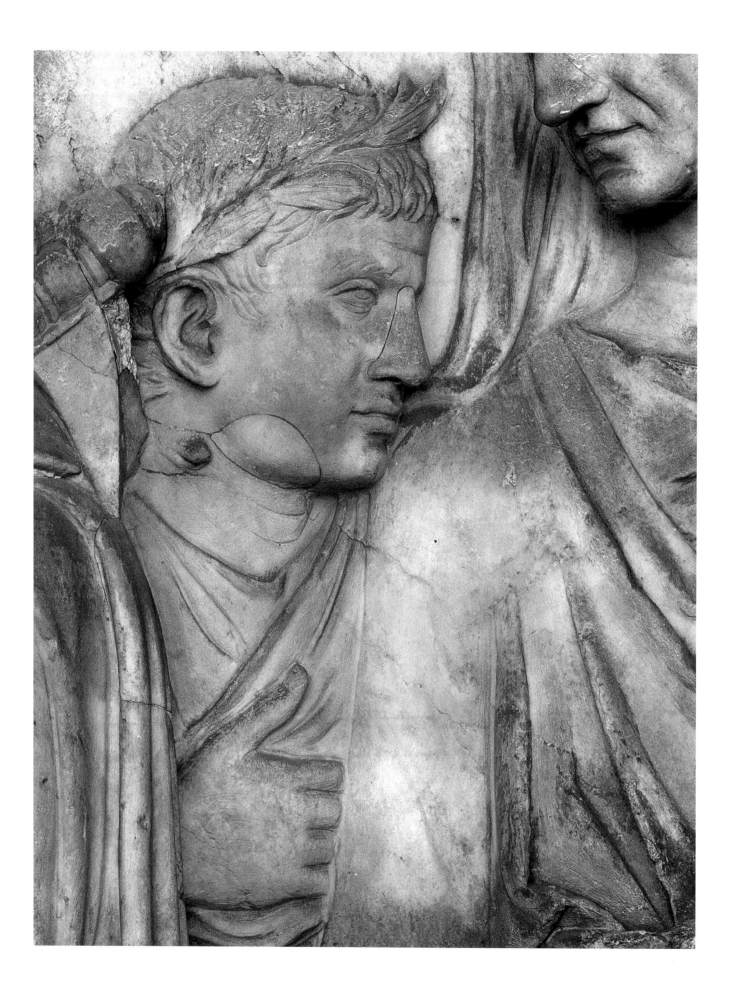

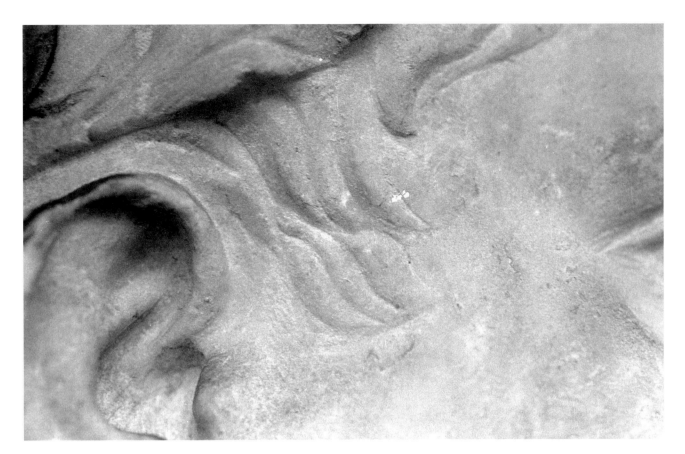

Opposite: FIGURE 107. Figure S27 (background male). Head and torso. FB 43/7.
Top: FIGURE 108. Figure S27 (background male). Hair. *Bottom:* FIGURE 109. Figure S27 (background male). Hair.

Top: FIGURE 110. Figure s33 (background male). Hair. *Bottom:* FIGURE 111. Figure s33 (background male). Hair.

Top: FIGURE 112. Figure N30 (background male). Head. *Bottom:* FIGURE 113. Figure N30 (background male). Hair and face.

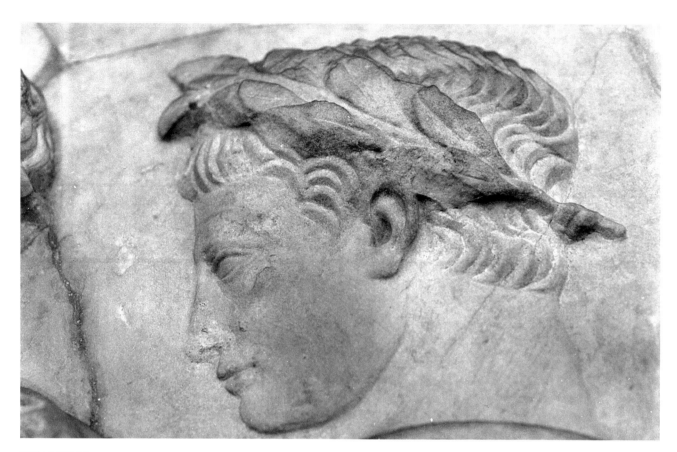

Top: FIGURE 114. Figure N32 (background male). Head.
Bottom: FIGURE 115. Figure N32 (background male). Oblique view of back of head.

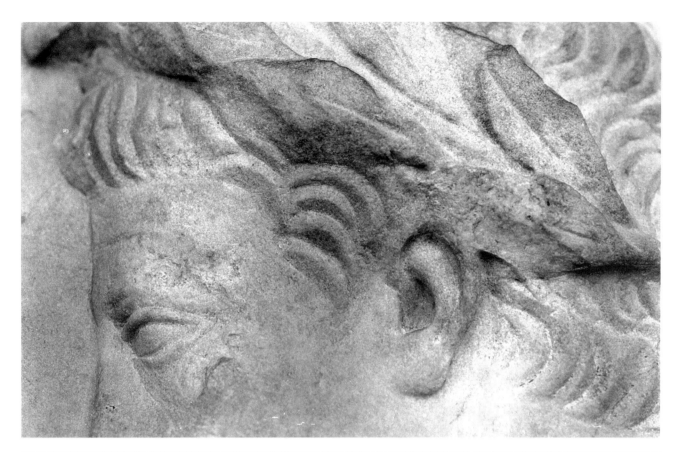

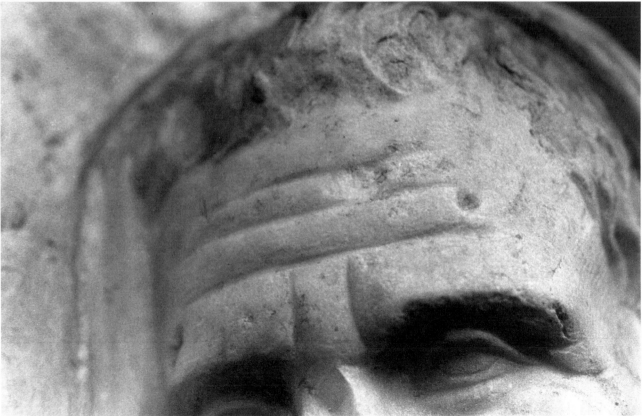

Top: FIGURE 116. Figure N32 (background male). Hair.
Bottom: FIGURE 117. Figure S28 (Agrippa). Hair and forehead.

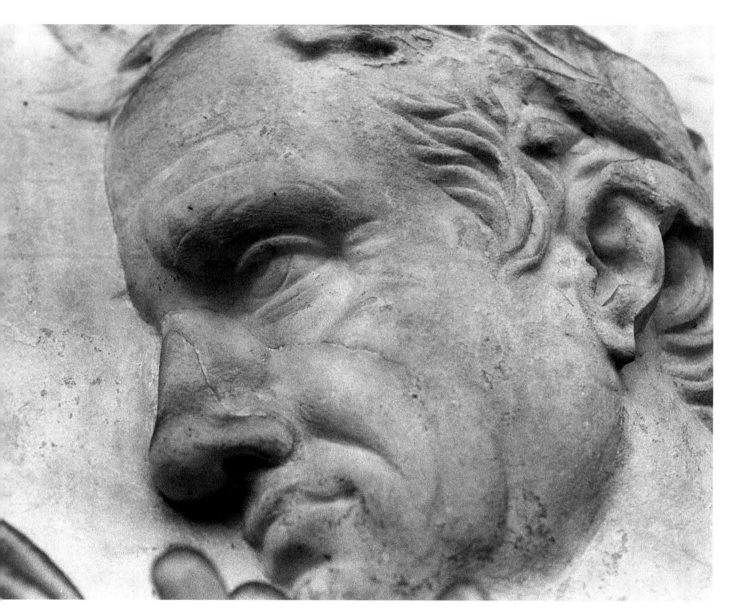

FIGURE 118. Figure s44 (background male). Face.

FIGURE 119. Figure S44 (background male). Hair.

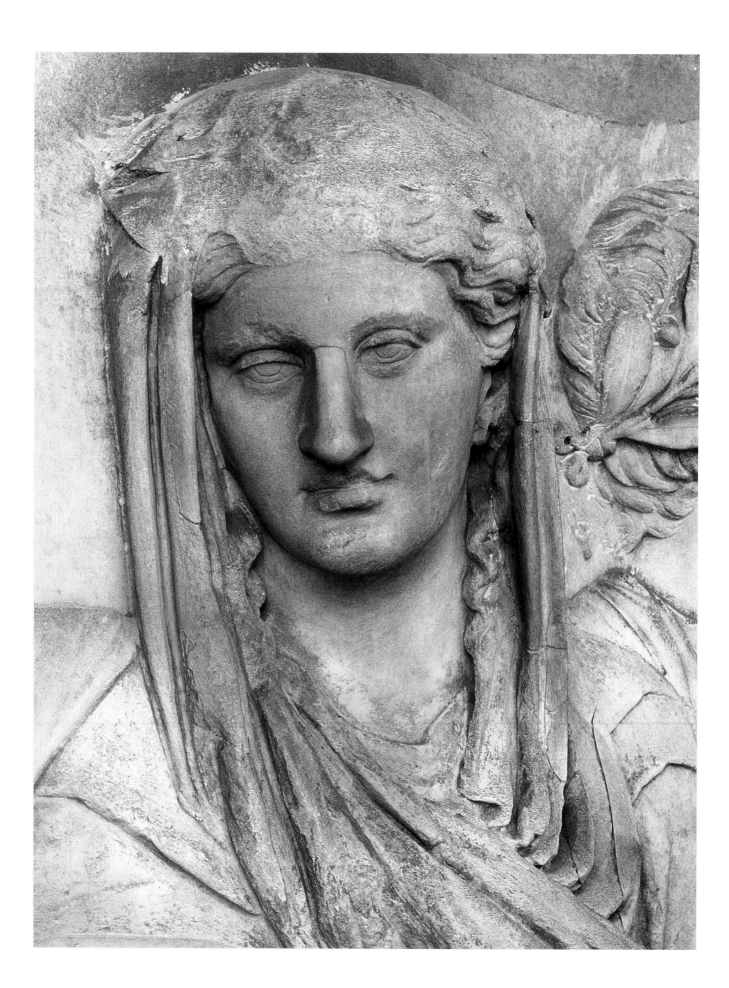

Opposite: FIGURE 120. Figure S32 (Livia). Head. FB 43/12.
Top: FIGURE 121. Figure S32 (Livia). Hair. *Bottom:* FIGURE 122. Figure S32 (Livia). *Nodus?*

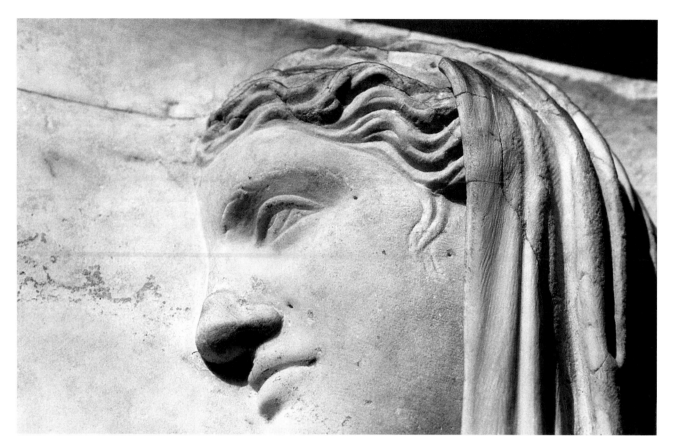

Top: FIGURE 123. Figure s41 (Antonia Maior). Oblique view of head.
Bottom: FIGURE 124. Figure s41 (Antonia Maior). Hair.

Top: FIGURE 125. Figure S37 (background female). Oblique view of head.
Bottom: FIGURE 126. Figure S40 (background female). Hair.

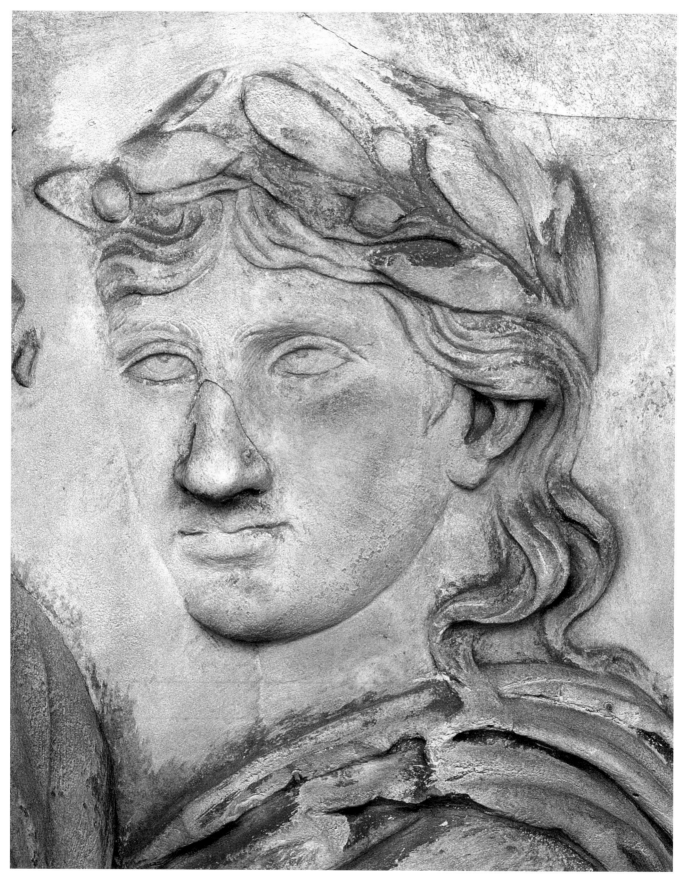

Above: FIGURE 127. Figure s40 (background female). Head. FB 49/3.
Opposite: FIGURE 128. Figure s36 (Antonia Minor). Head. FB 48/6.

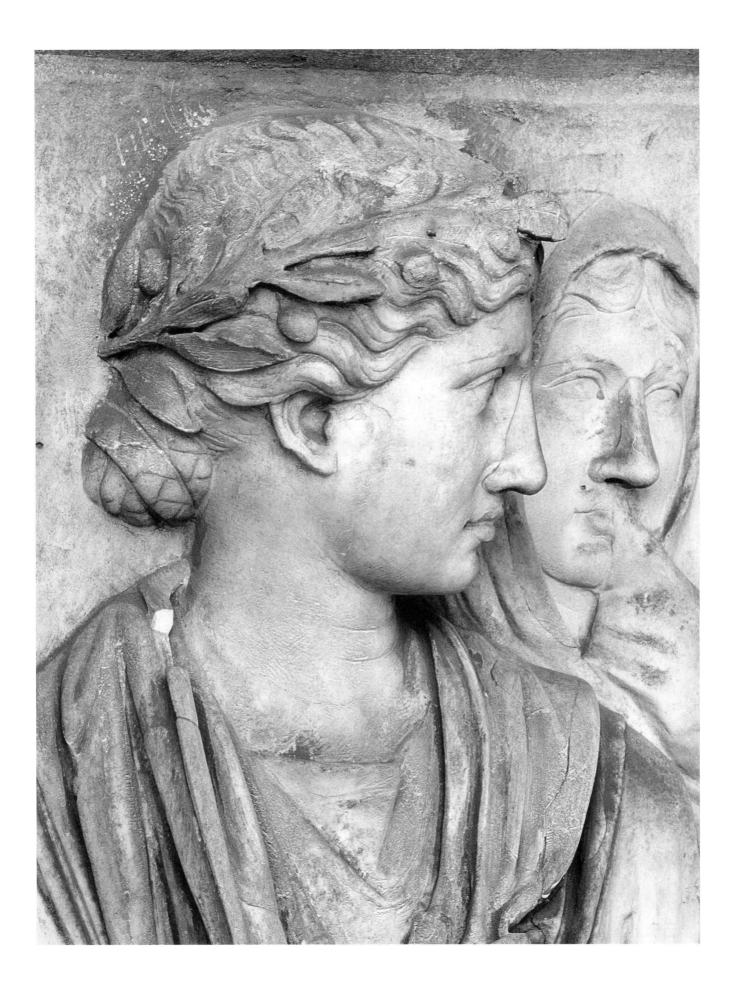

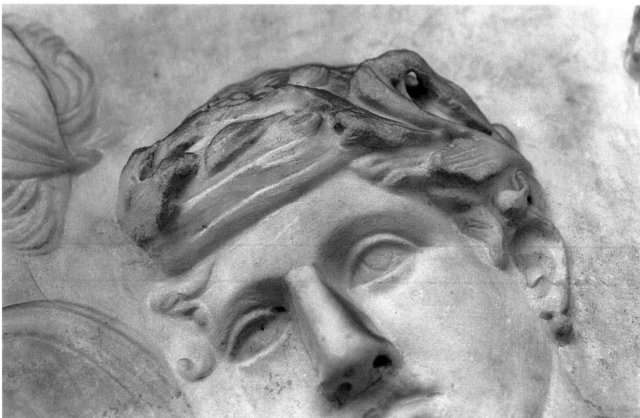

Top: FIGURE 129. Figure s36 (Antonia Minor). Hair.
Bottom: FIGURE 130. Figure s30 ("Barbarian Queen"). Upper portion of head.

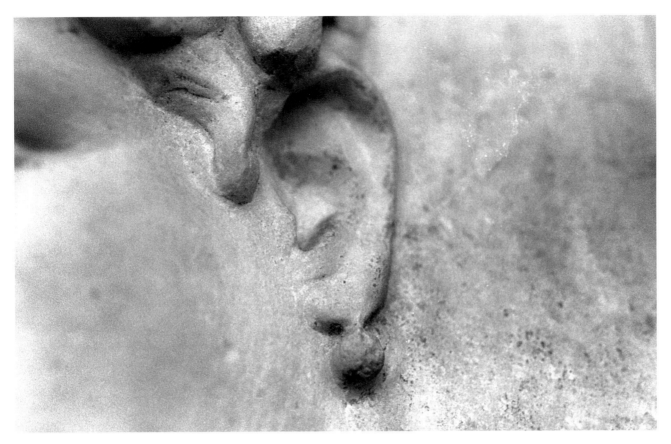

FIGURE 131. Figure S30 ("Barbarian Queen"). Left ear with earring.

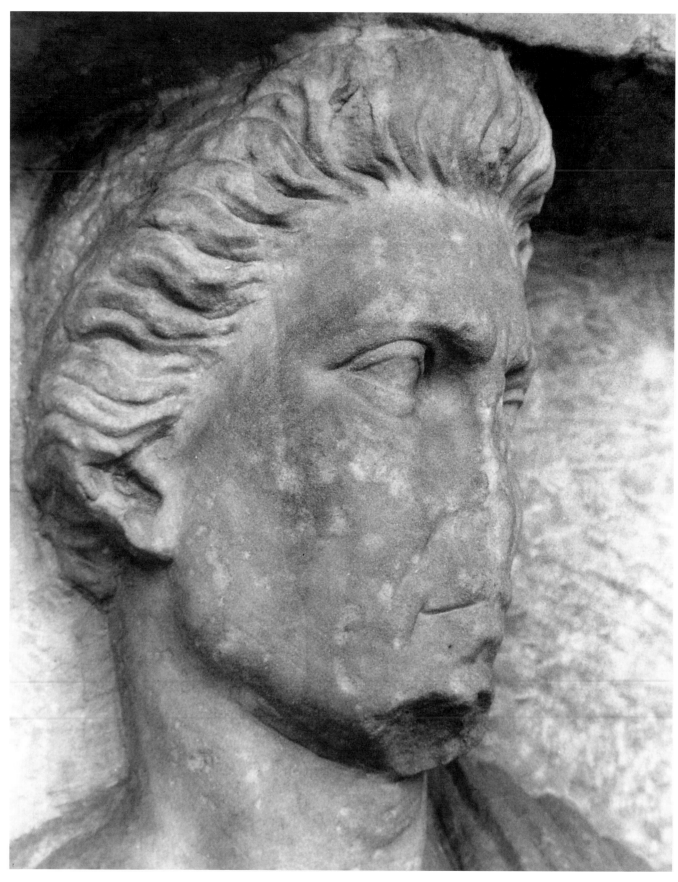

Above: FIGURE 132. Female figure on the Frontispizio relief. Head.
Opposite: FIGURE 133. Figure S43 ("Domitia"). Head and upper torso. FB 49/12.

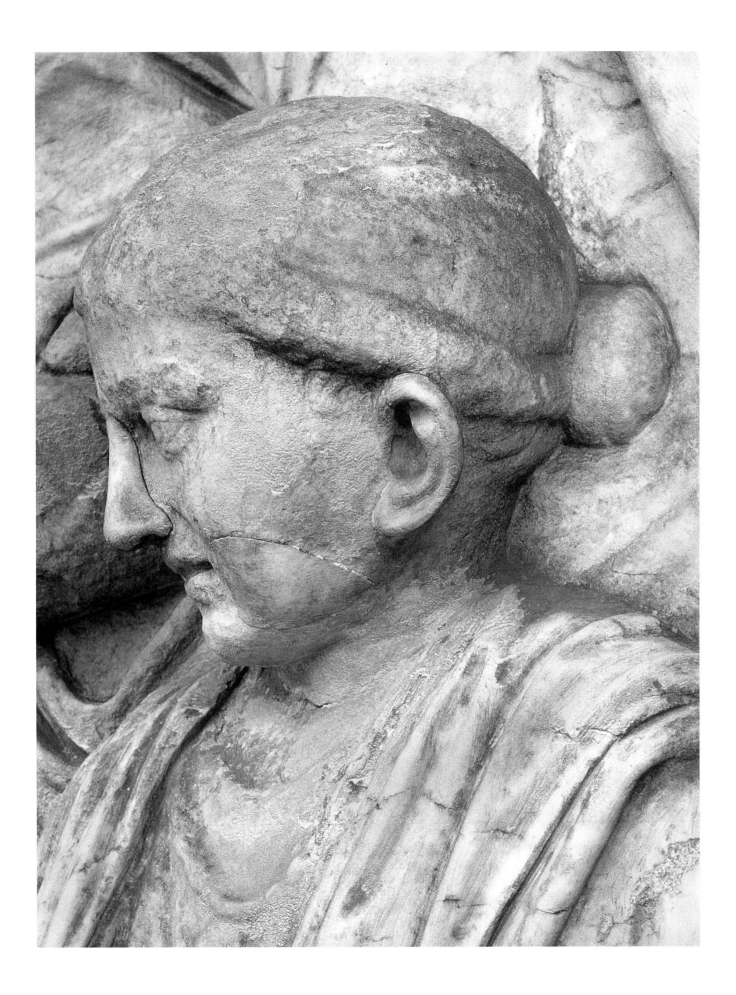

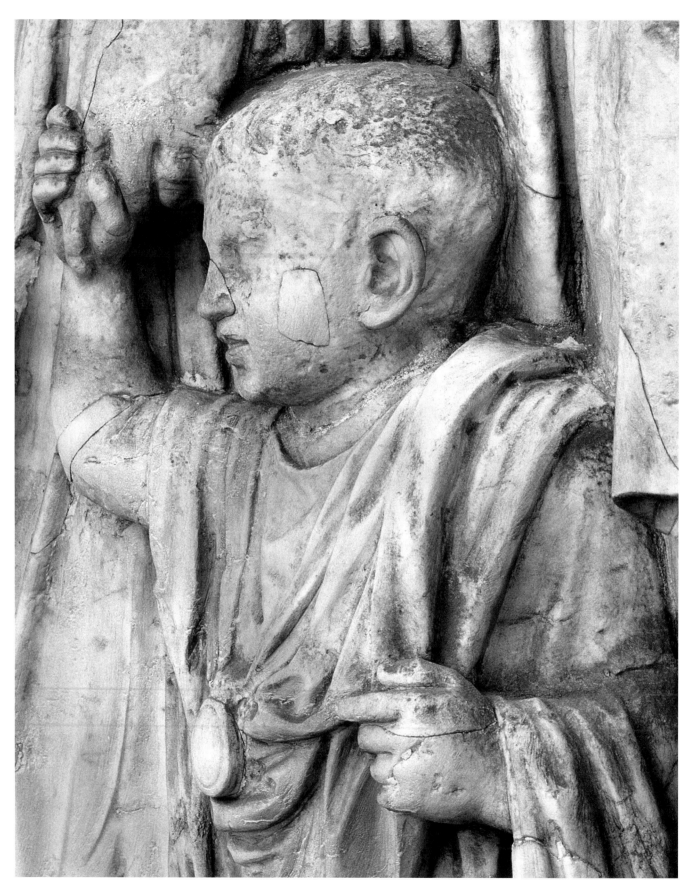

Above: FIGURE 134. Figure S38 (Germanicus). Head and torso. FB 49/8.
Opposite: FIGURE 135. Figure S31 (barbarian child). Head. FB 48/10.

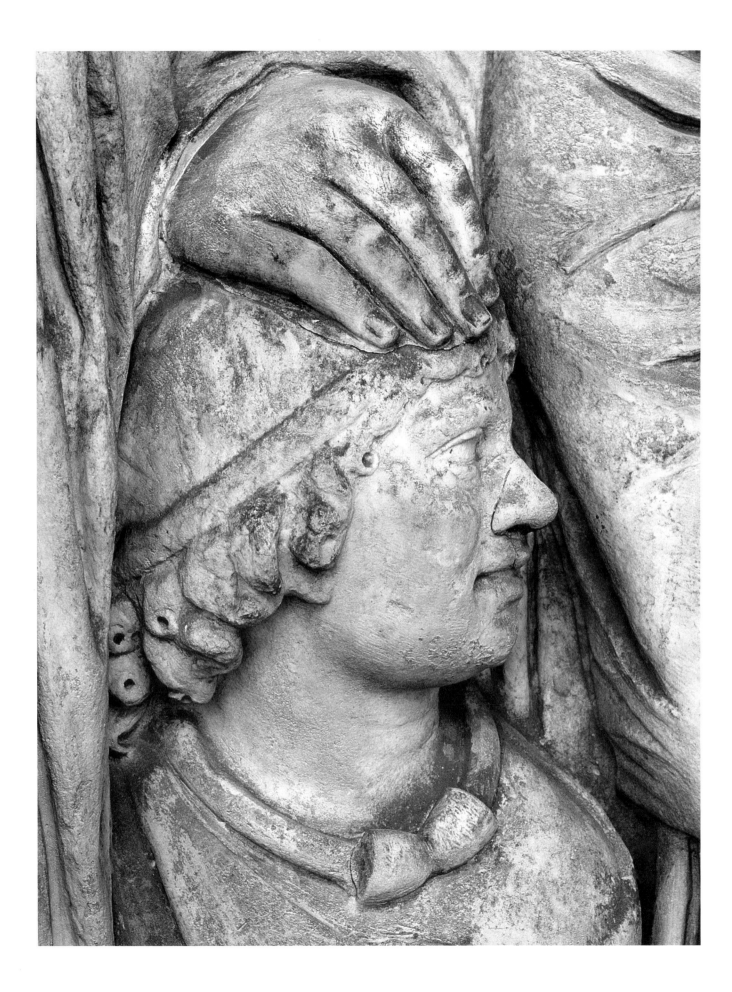

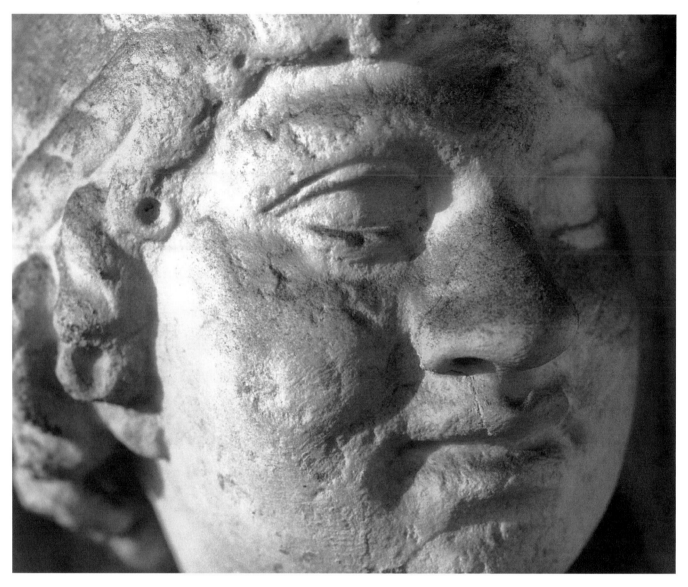

Above: FIGURE 136. Figure s31 (barbarian child). Face.
Opposite: FIGURE 137. Figure N35 (barbarian child). Top of head. FB 33/7.

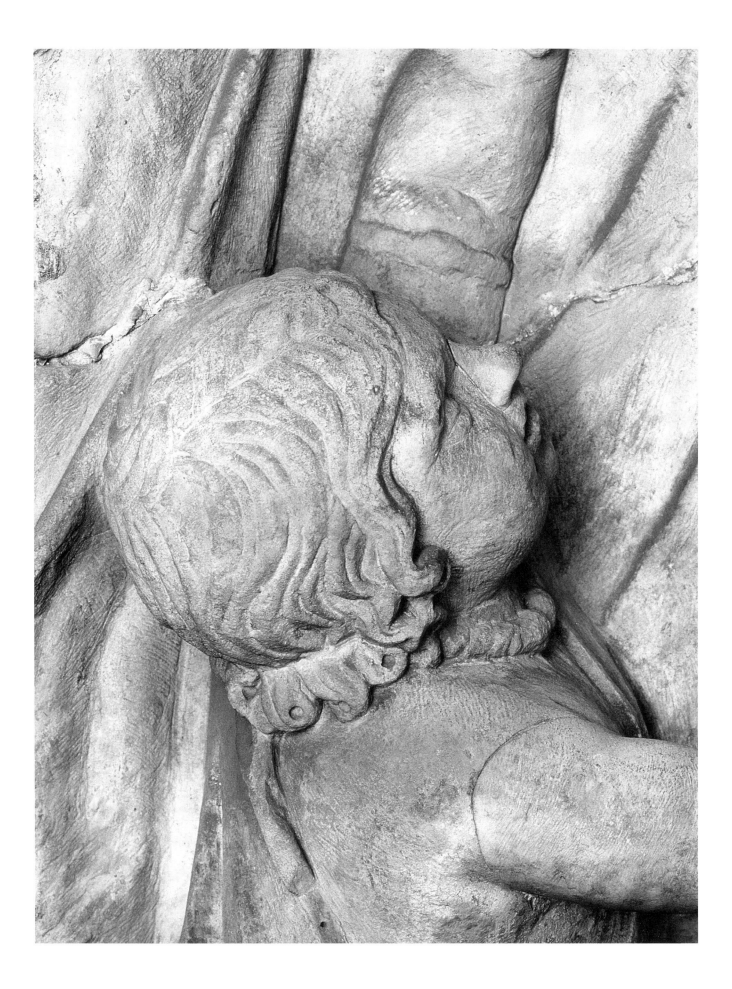

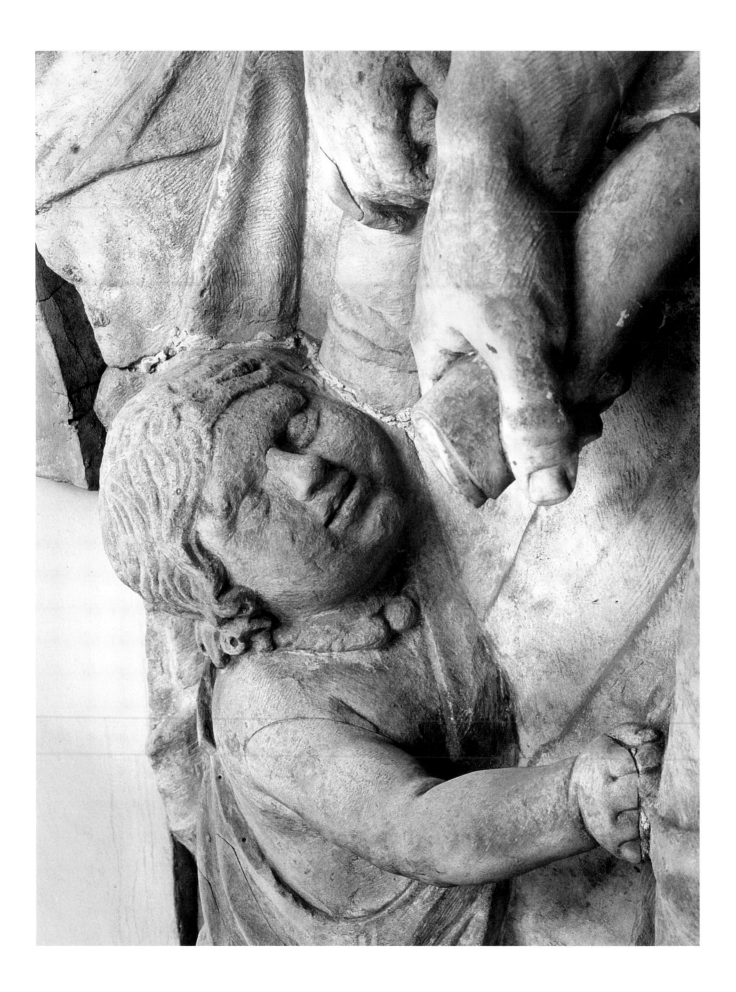

Opposite: FIGURE 138. Figure N35 (barbarian child). Upper torso and head. FB 37/3.
Top: FIGURE 139. Figure S41 (Antonia Maior). Right hand. *Bottom:* FIGURE 140. Figure S20 (flamen). Left hand.

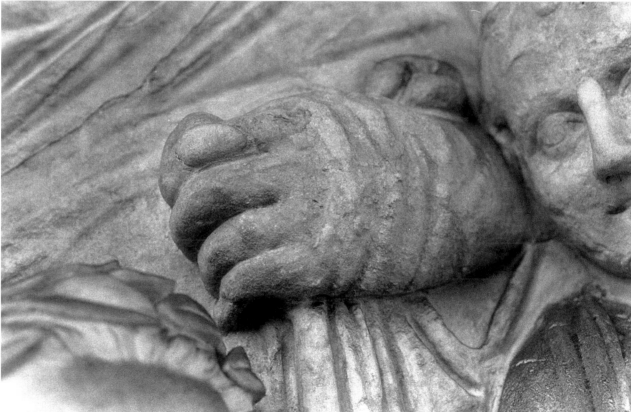

Top: FIGURE 141. Figure S46 (background male?). Left hand.
Bottom: FIGURE 142. Figure S41 (Antonia Maior). Left hand.

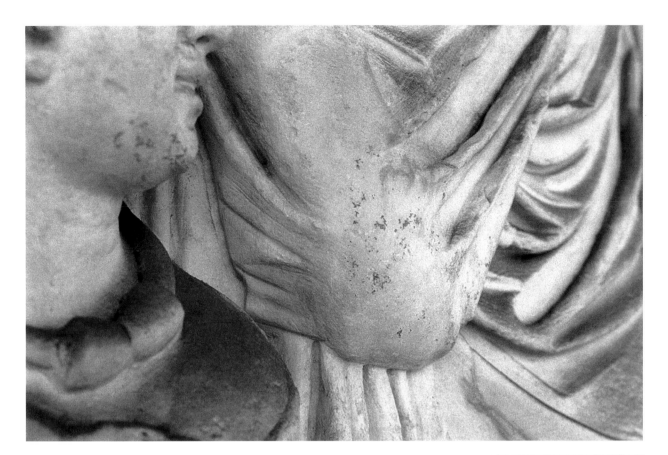

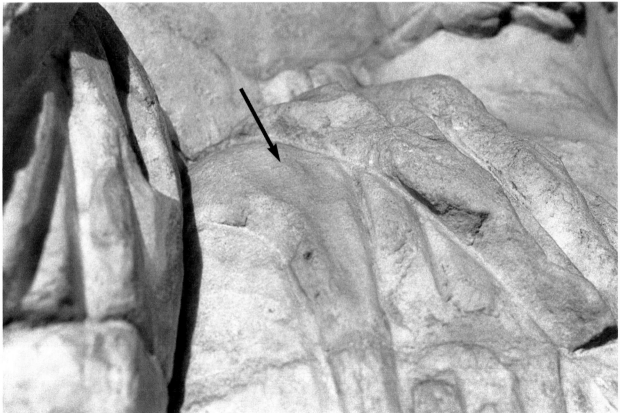

Top: FIGURE 143. Figure S32 (Livia). Right hand.
Bottom: FIGURE 144. Figure S13 (lictor). Chisel marks on drapery at left shoulder.

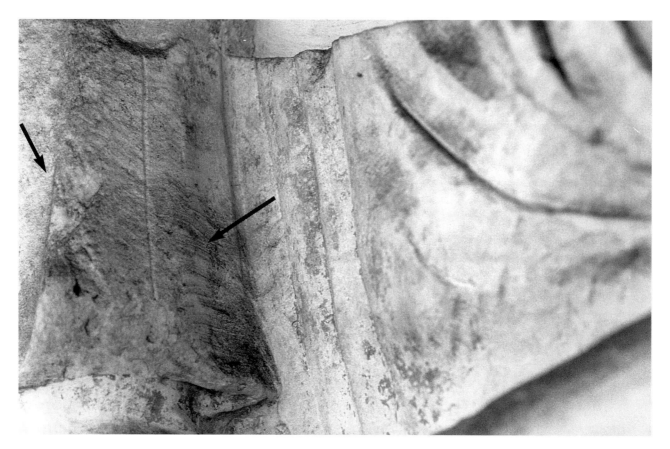

Top: FIGURE 145. Figure S13 (lictor). Chisel marks on drapery at right arm.
Bottom: FIGURE 146. Figure S14 (lictor). Chisel marks on drapery at left shoulder.

Top: FIGURE 147. Figure s12 (lictor). Chisel marks on drapery.
Bottom: FIGURE 148. Figure s15 (togate male). Chisel marks on drapery at upper torso.

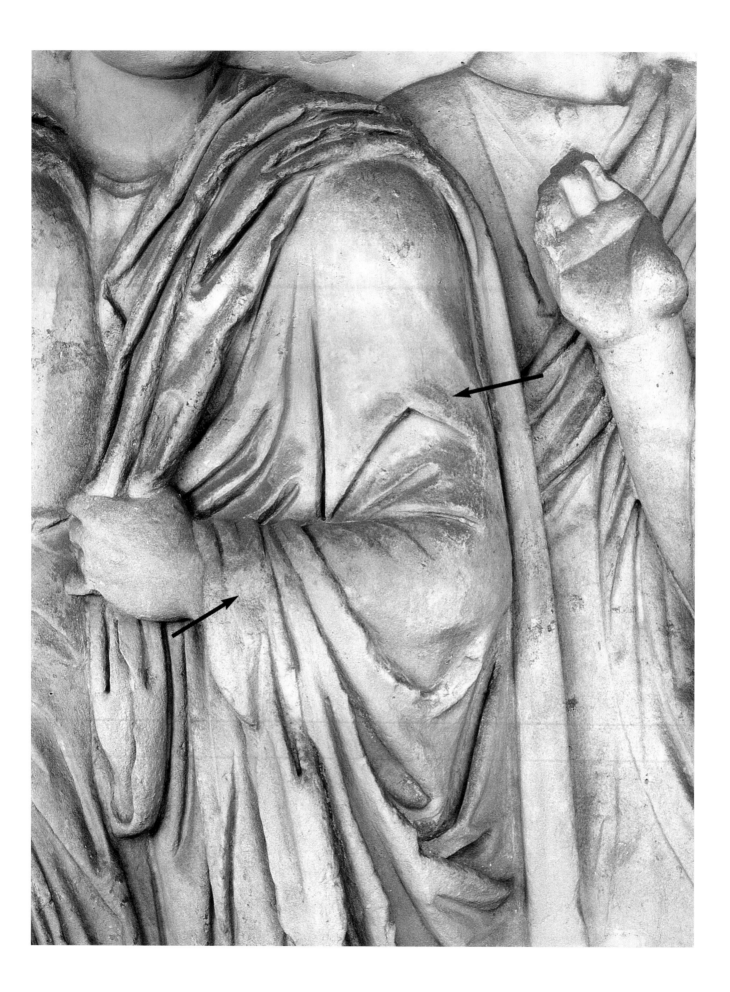

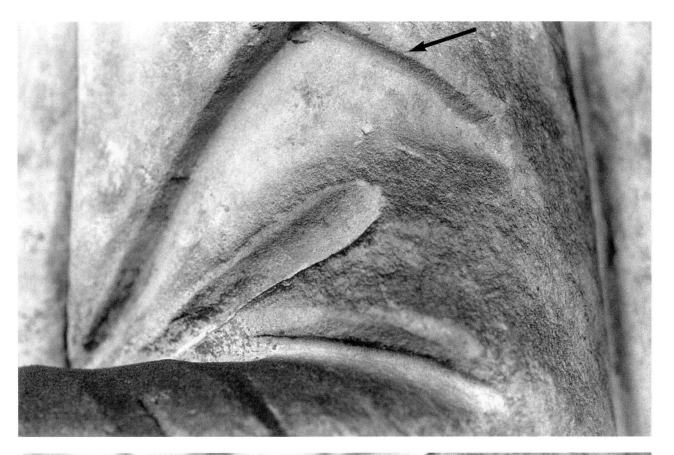

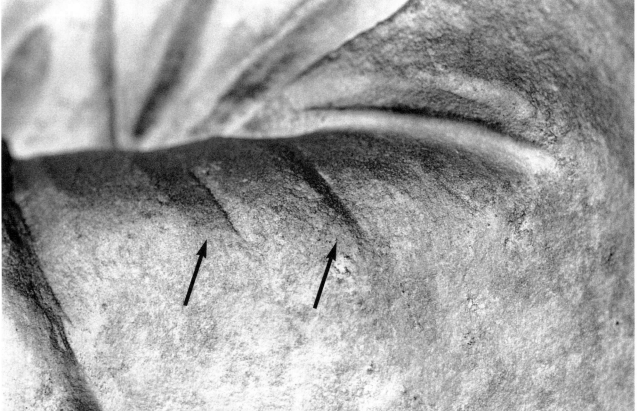

Opposite: FIGURE 149. Figure S17 (togate male). Left arm. FB 39/10. *Top:* FIGURE 150. Figure S17 (togate male). Chisel marks on drapery at upper left arm. *Bottom:* FIGURE 151. Figure S17 (togate male). Chisel marks on drapery at left forearm.

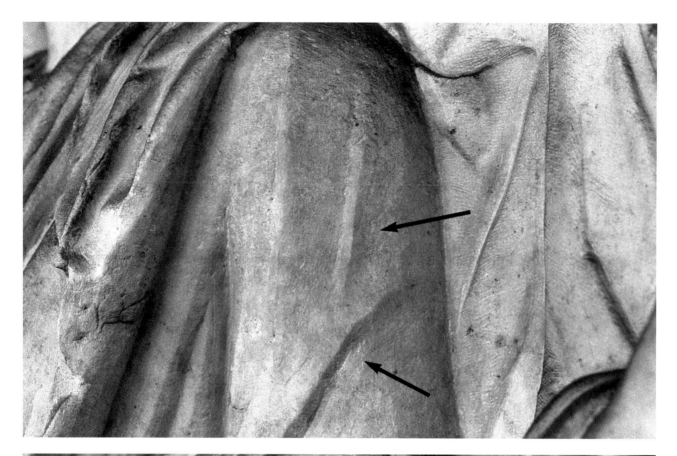

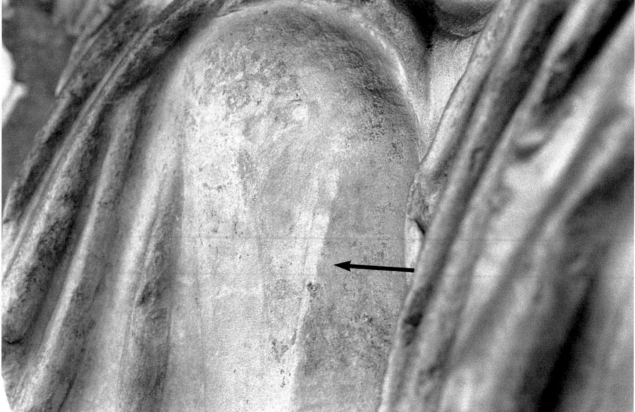

Top: FIGURE 152. Figure S20 (flamen). Chisel marks on drapery at left shoulder.
Bottom: FIGURE 153. Figure S16 (Augustus). Chisel marks on drapery at left shoulder.

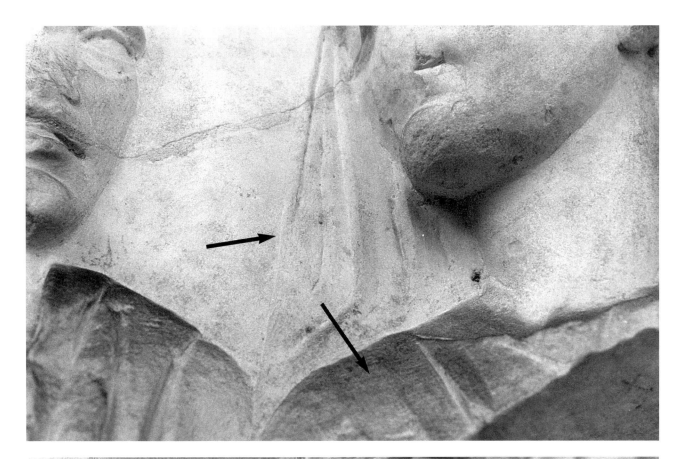

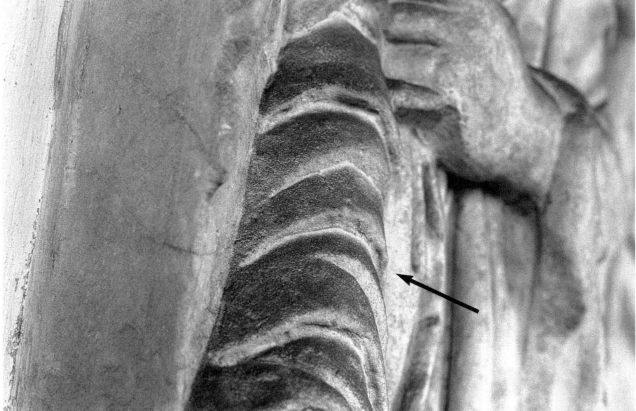

Top: FIGURE 154. Figure s16 (Augustus). Chisel marks on drapery at right shoulder and veil.
Bottom: FIGURE 155. Figure s16 (Augustus). Chisel marks on drapery at left forearm.

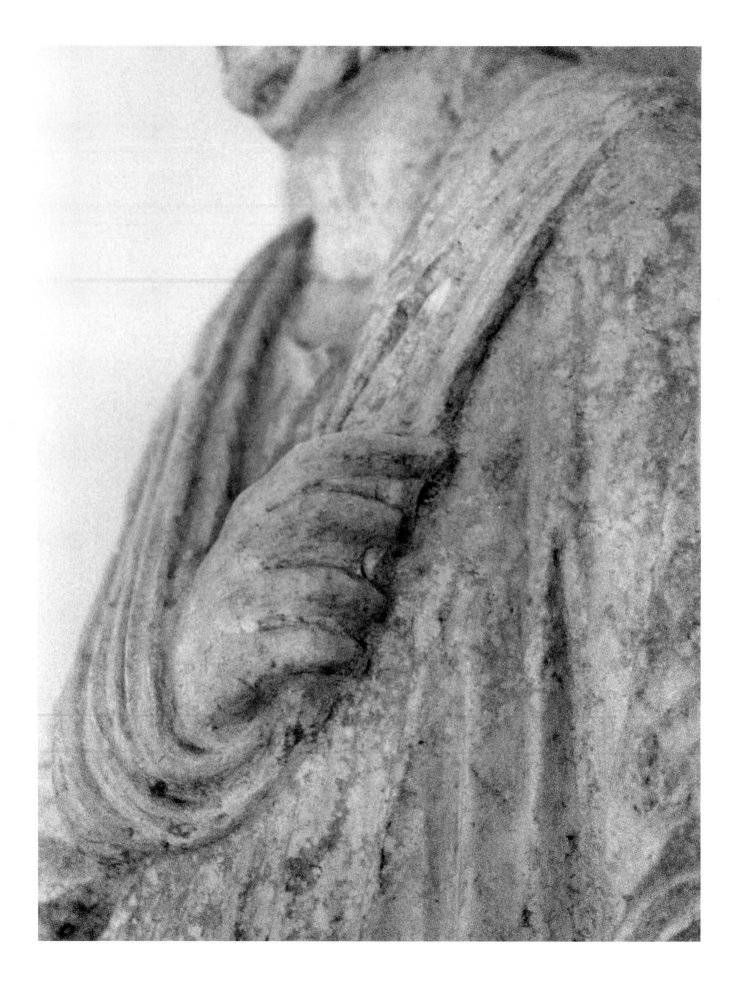

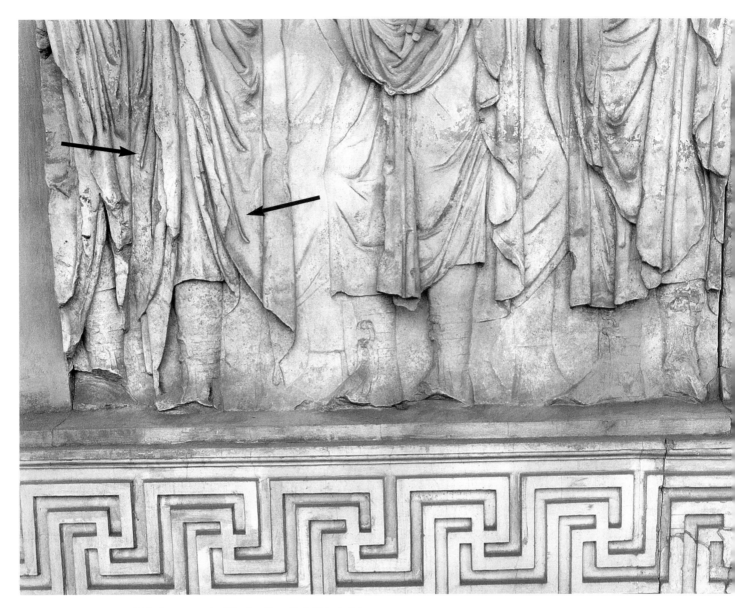

Opposite: FIGURE 156. Male figure on the Via Statilia relief. Chiseled drapery at torso.
Above: FIGURE 157. Panel S4. Figures S16 through S22. Legs and lower drapery. FB 50/10.

Above: FIGURE 158. Figure S17 (togate male). Drilled drapery channels.
Opposite: FIGURE 159. Figure S25 (background male). Drilled drapery channels.

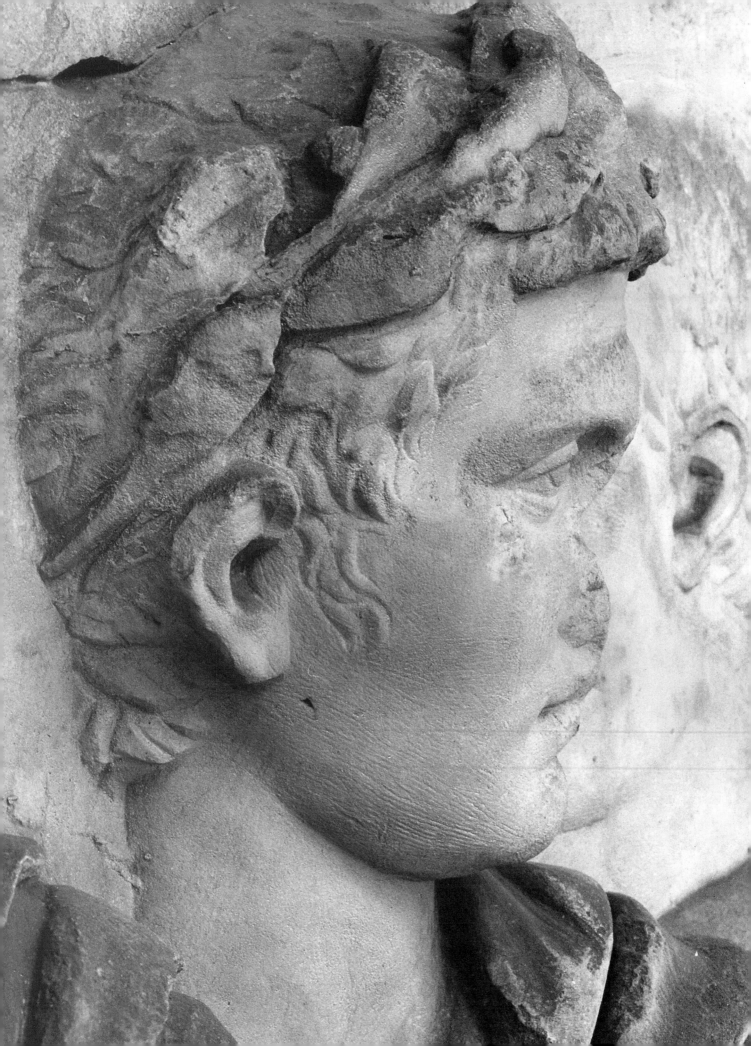

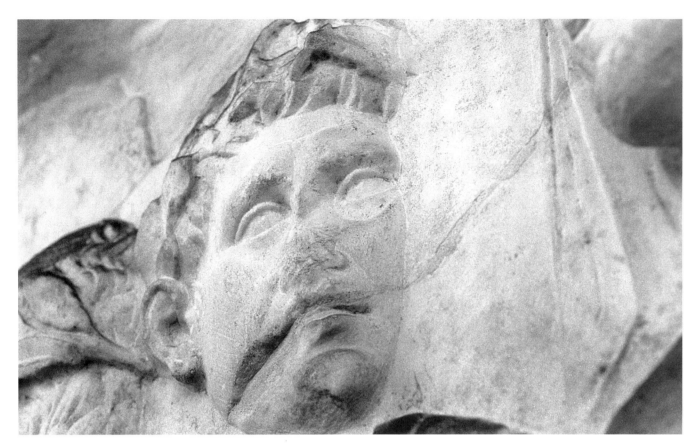

Opposite: FIGURE 160. Figure S17 (togate male). Right side of head. FB 39/2.
Above: FIGURE 161. Figure S15 (togate male). Oblique view of head.

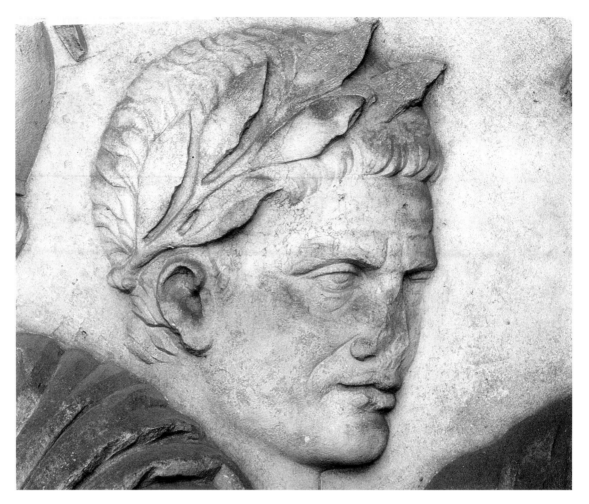

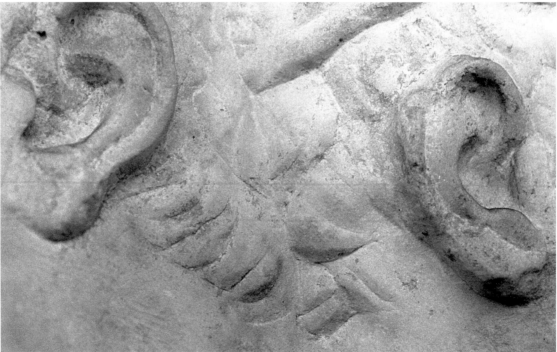

Top: FIGURE 162. Figure s21 (background male). Head. FB 42/11.
Bottom: FIGURE 163. Figures s18 and s19 (background males). Hair.
Opposite: FIGURE 164. Figure s20 (flamen). Head. FB 39/6.

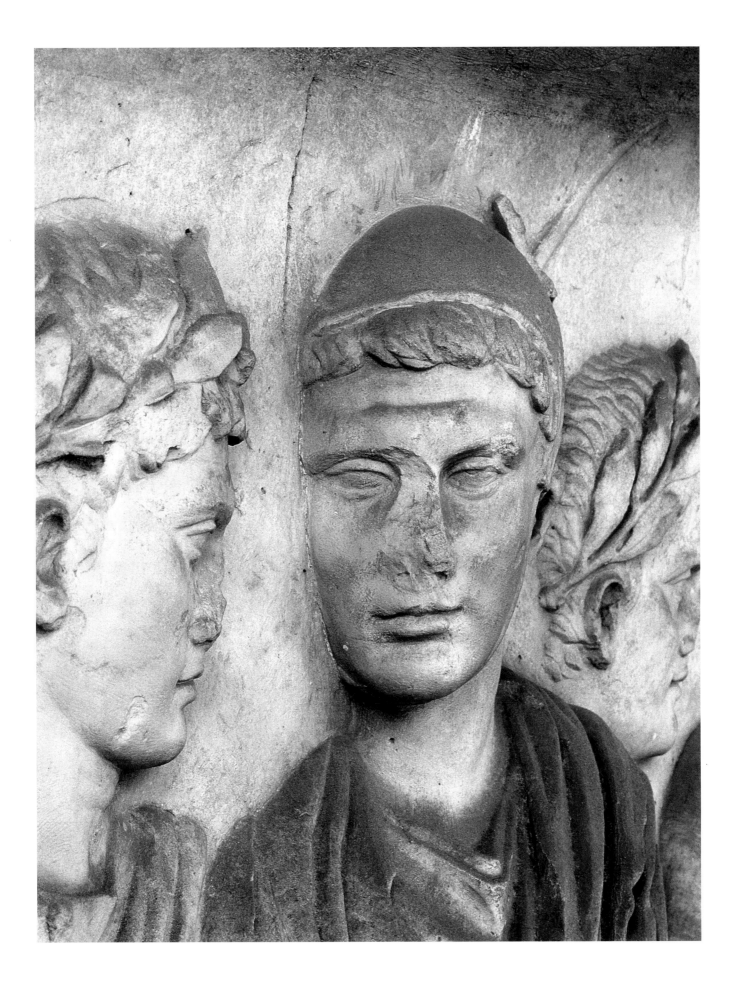

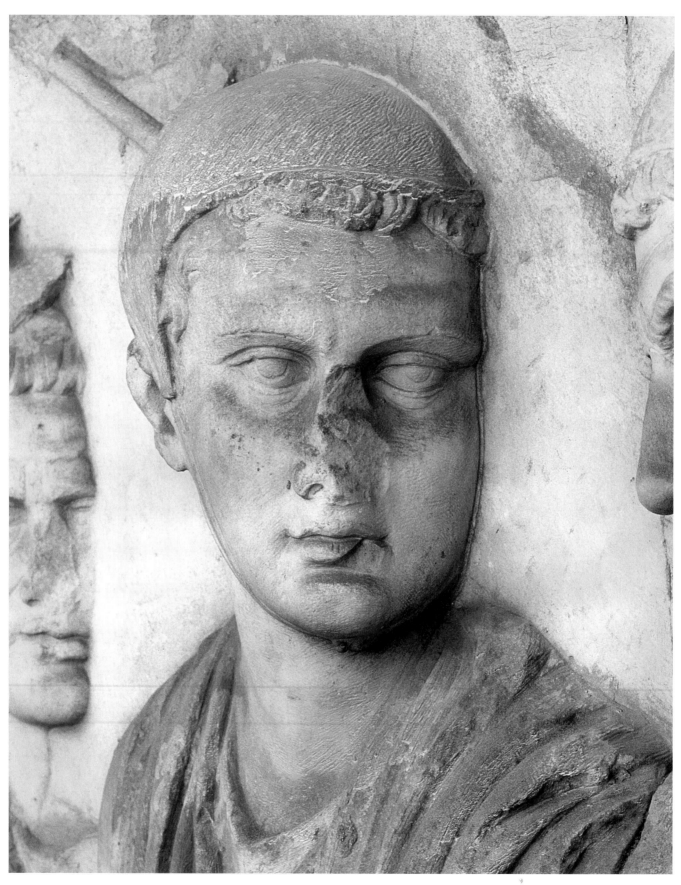

Above: FIGURE 165. Figure S22 (flamen). Head. FB 43/3.
Opposite: FIGURE 166. Figure S16 (Augustus). Oblique view of head.

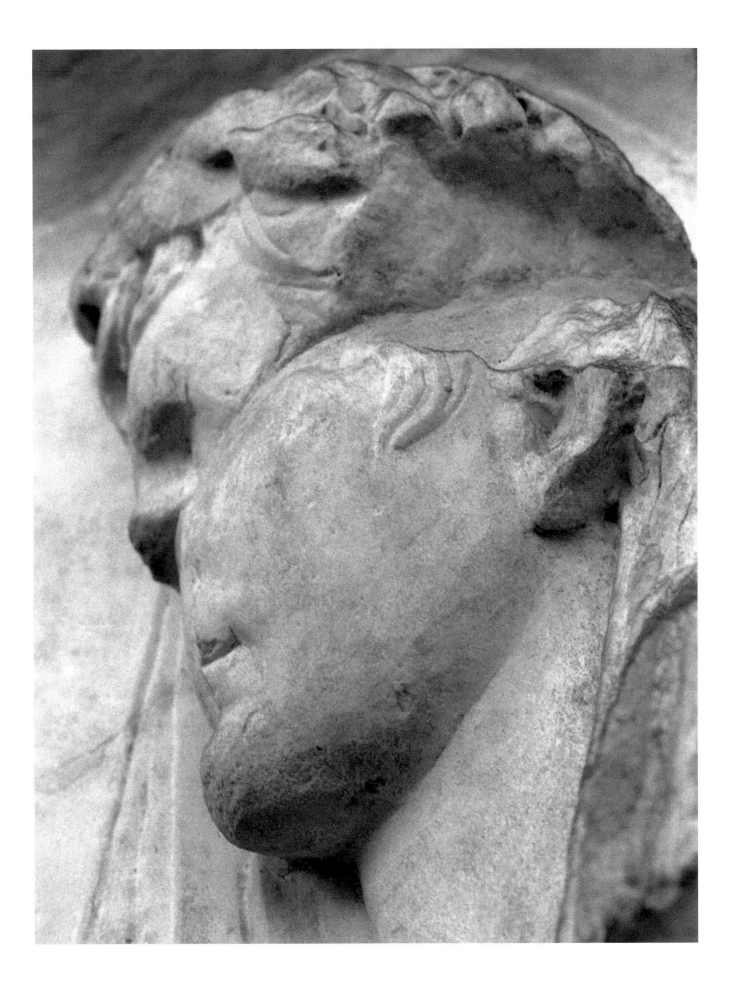

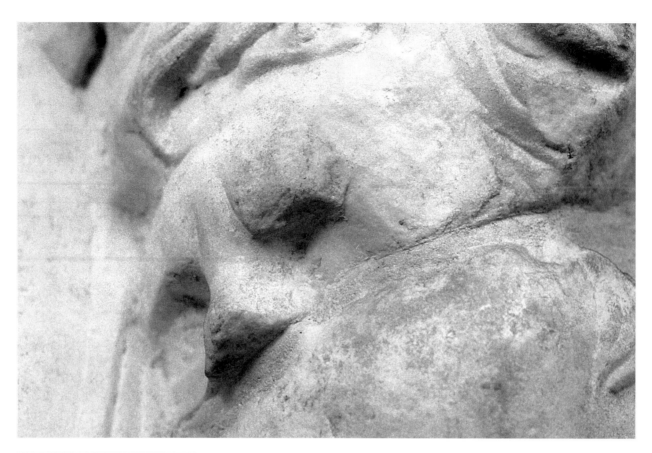

Top: FIGURE 167. Figure s16 (Augustus). Eye area and lower forehead. *Bottom:* FIGURE 168. Figure s14 (lictor). Hair. *Opposite:* FIGURE 169. Figures s11, s12, and s13 (lictors). Heads.

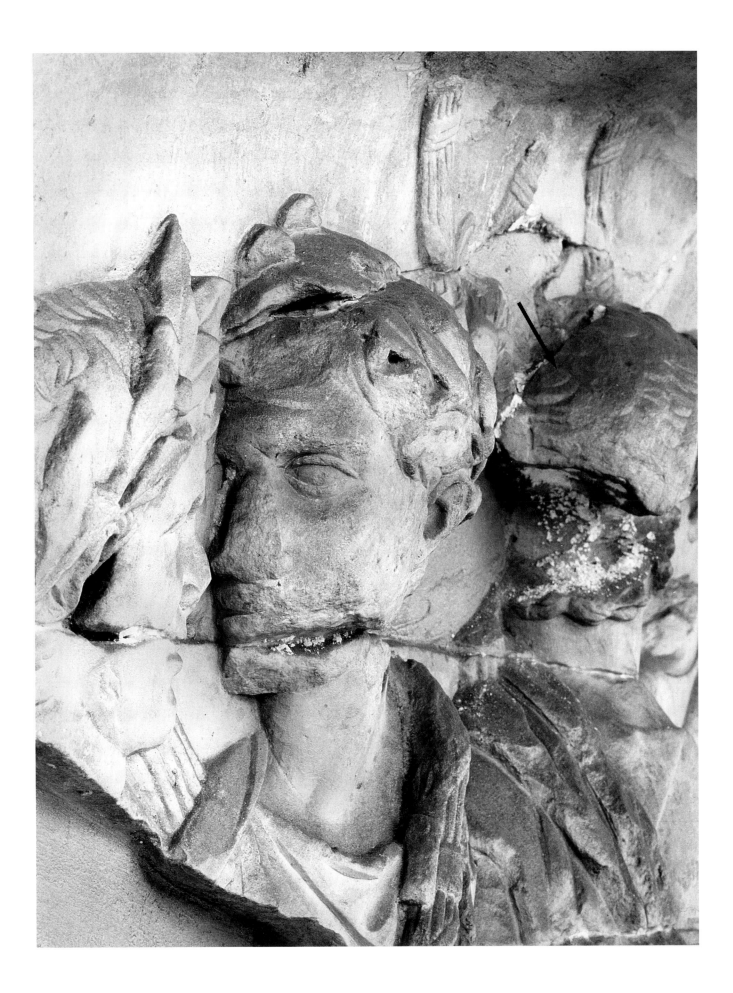

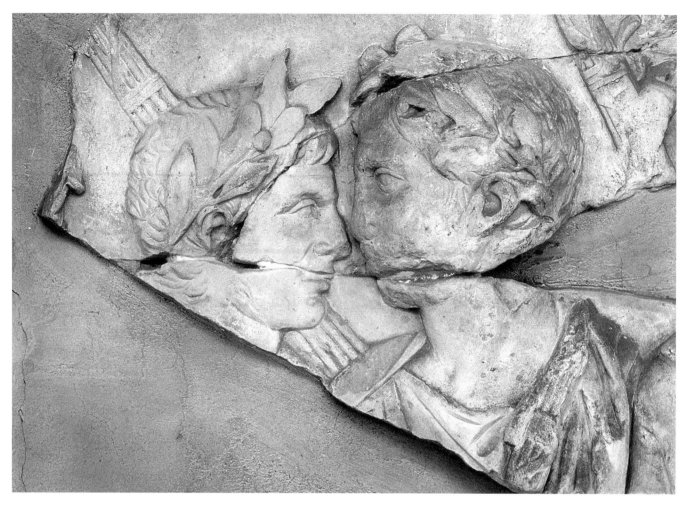

FIGURE 170. Figures s11 and s12 (lictors). Heads. FB 38/6.

Top: FIGURE 171. Figure S12 (lictor). Hair. *Bottom:* FIGURE 172. Figure S11 (lictor). Hair.

FIGURE 173. Figure SII (lictor). Hair.

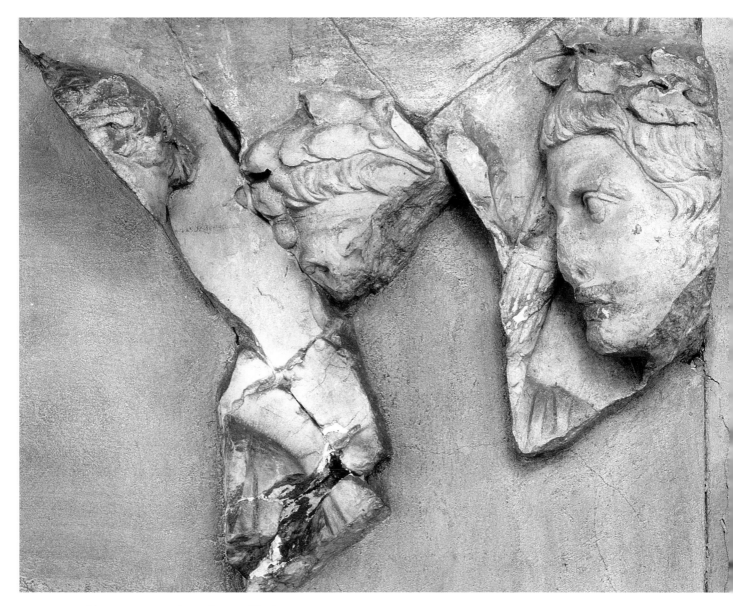

FIGURE 174. Figures s8, s9, and s10 (lictors). Heads. FB 38/5.

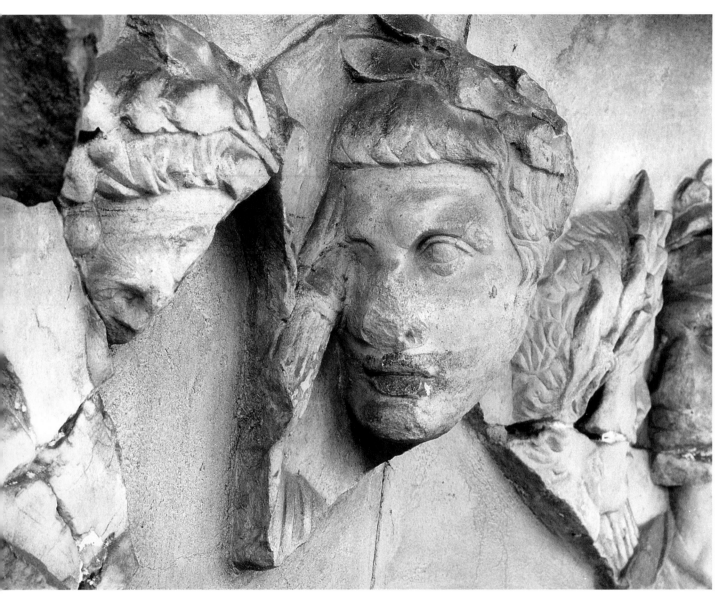

FIGURE 175. Figures S9 and S10 (lictors). Heads. FB 38/2.

FIGURE 176. Figure s9 (lictor). Upper portion of head.

FIGURE 177. Figure s8 and s9 (lictors). Hair.

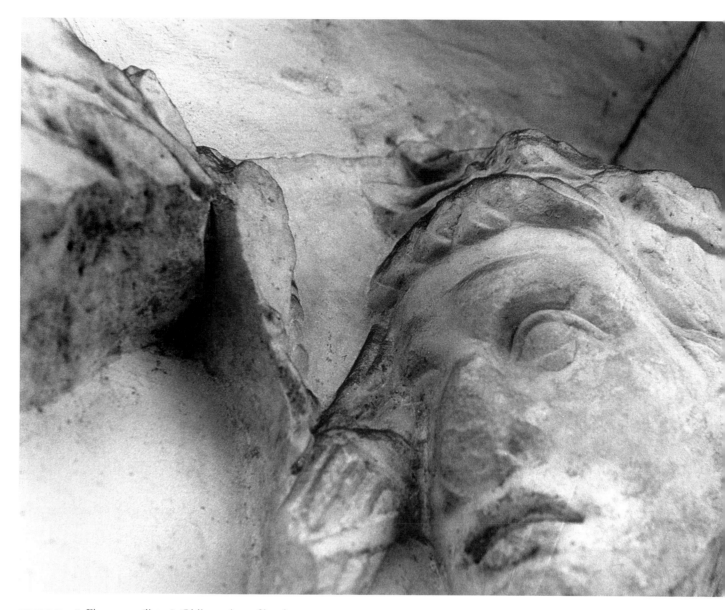

FIGURE 178. Figure S10 (lictor). Oblique view of head.

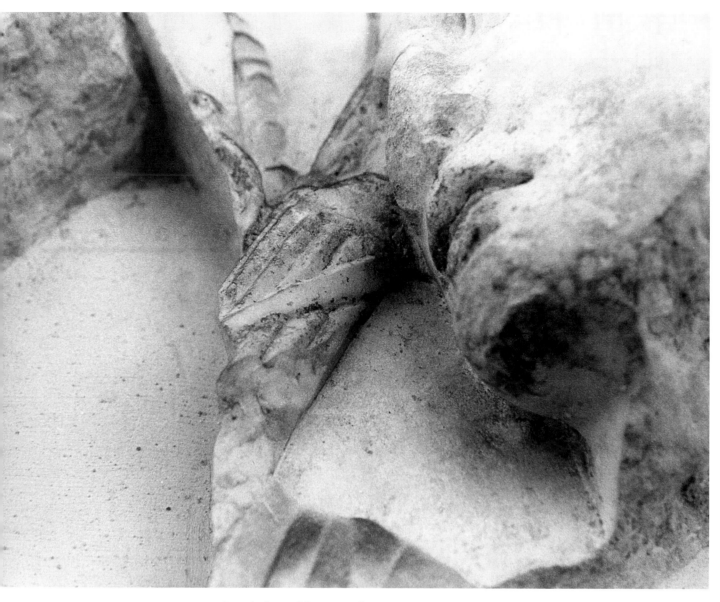

FIGURE 179. *Fasces* in front of figure s10 (lictor).

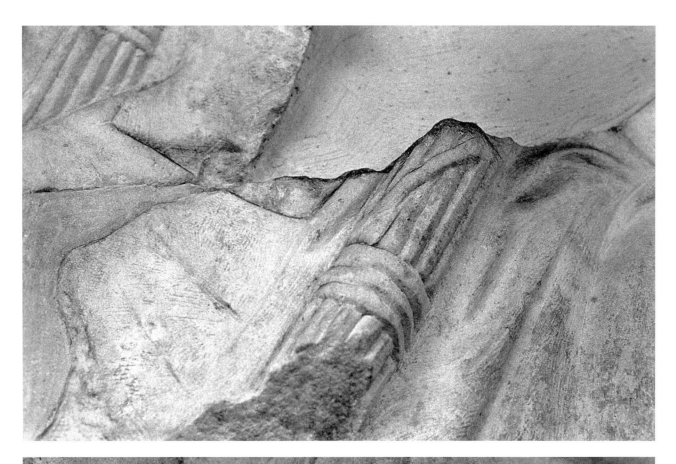

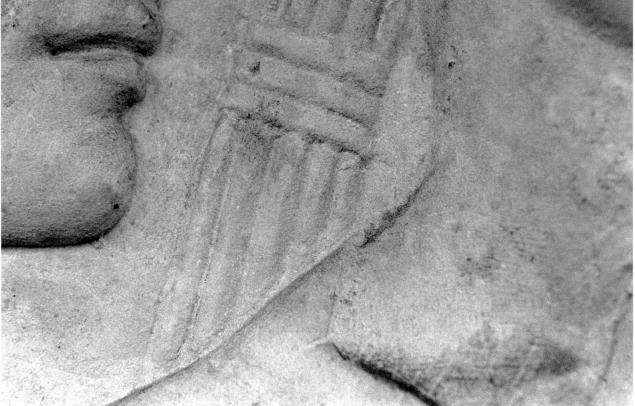

Top: FIGURE 180. *Fasces* held by figure s5 (lictor). *Bottom:* FIGURE 181. *Fasces* between figures s3 and s4 (lictors).

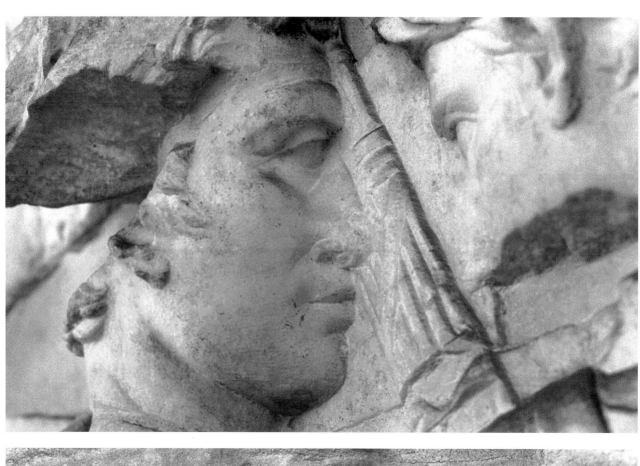

Top: FIGURE 182. *Fasces* held by figure S14 and head of S13 (lictors). *Bottom:* FIGURE 183. *Fasces* held by figure S11 (lictor).

Top: FIGURE 184 *Fasces* held by figure SII (lictor). *Bottom:* FIGURE 185. *Fasces* held by figure NI (lictor).

Above: FIGURE 186. *Fasces* held by figure N3 (lictor).
Opposite: FIGURE 187. Figure S16 (Augustus). Head. Chisel marks on cheek and jaw. FB 39/3.

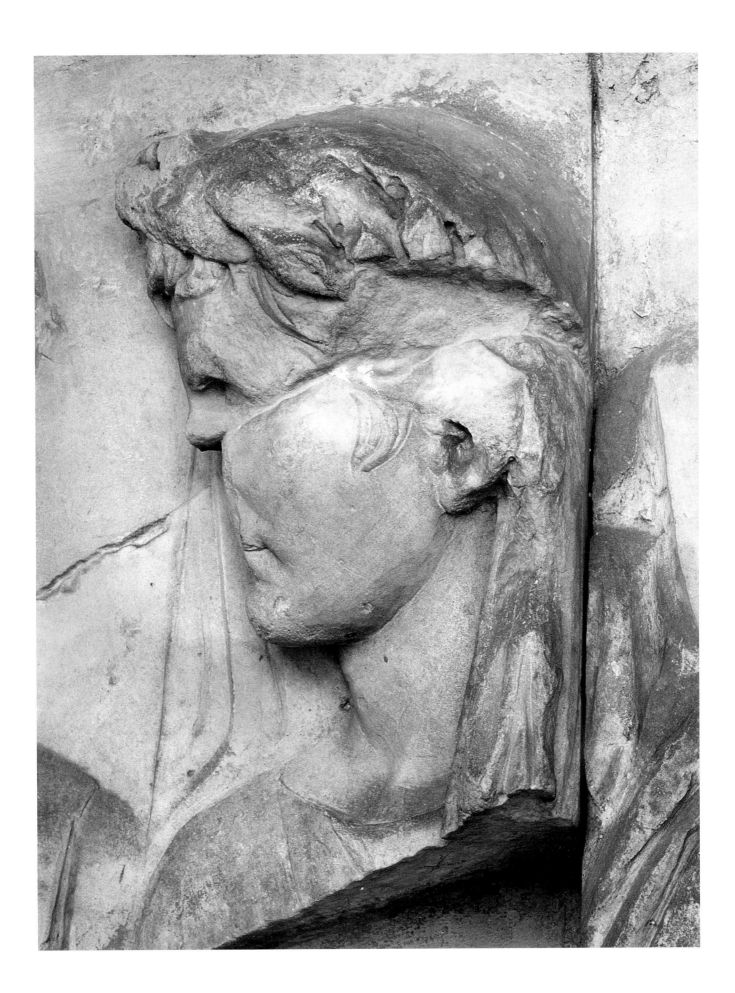

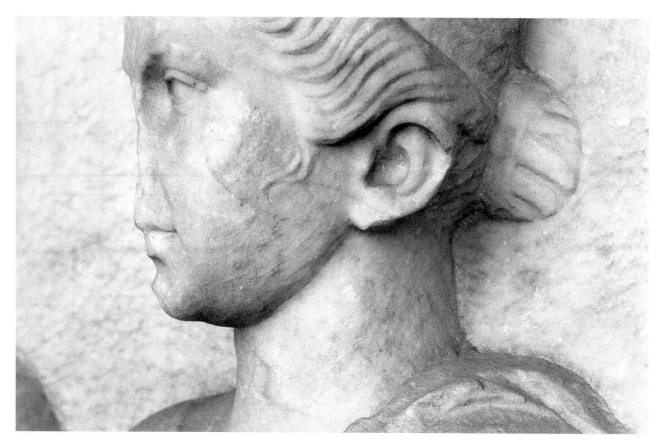

Above: FIGURE 188. Female figure on the Mattei relief. Head and neck.
Opposite: FIGURE 189. Female figure on the Mattei relief. Chisel marks on face and veil.

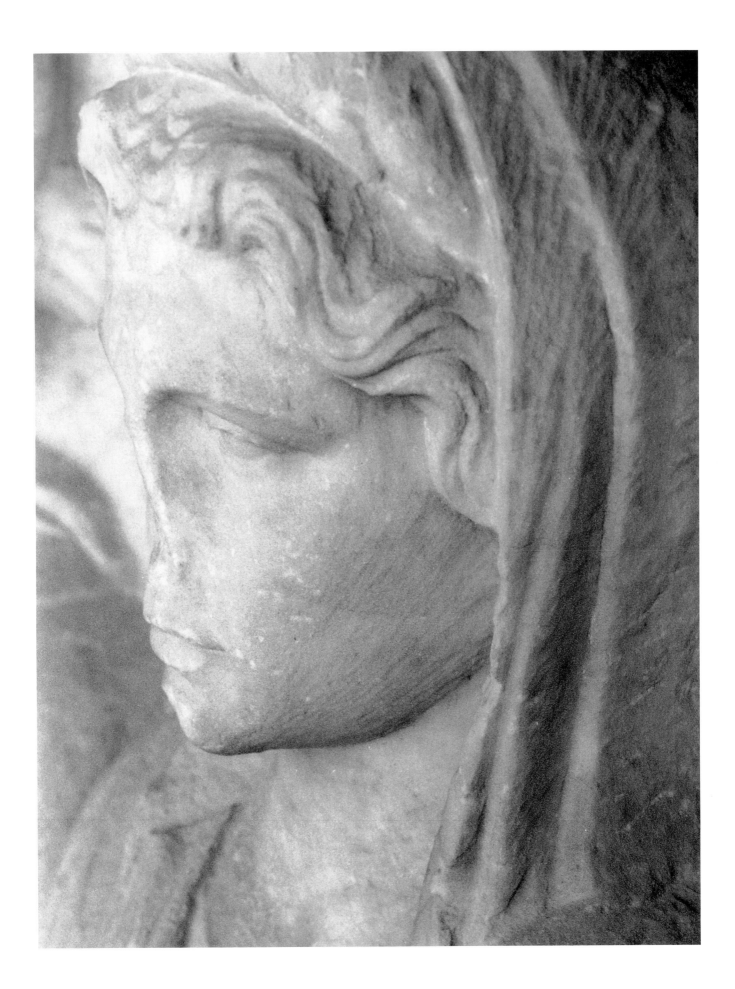

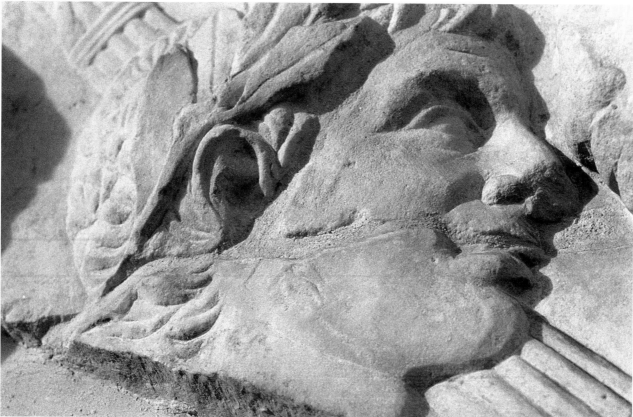

Top: FIGURE 190. Figure s16 (Augustus). Chisel marks on right forearm. *Bottom:* FIGURE 191. Figure s11 (lictor). Head.

FIGURE 192. Figure S12 (lictor). Neck.

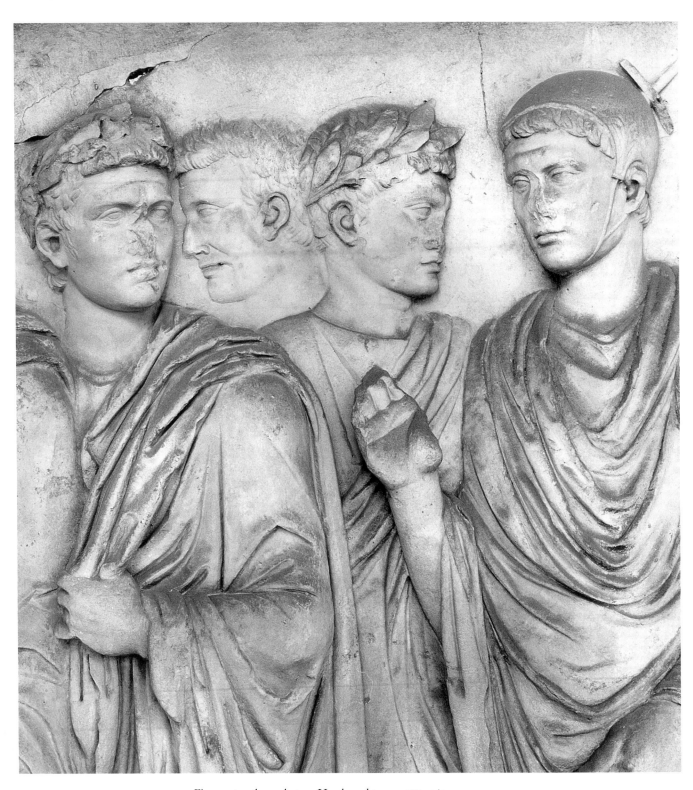

FIGURE 193. Figures s17 through s20. Heads and torsos. FB 39/7.

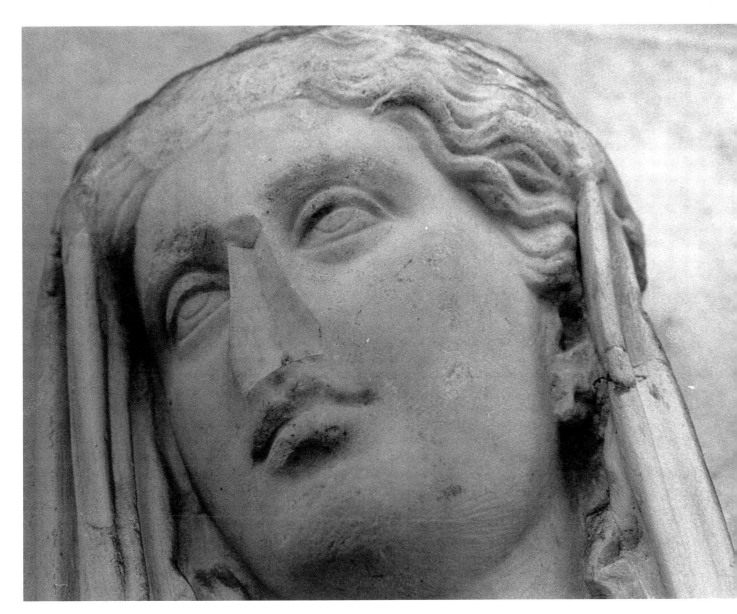

FIGURE 194. Figure S32 (Livia). Oblique view of face.

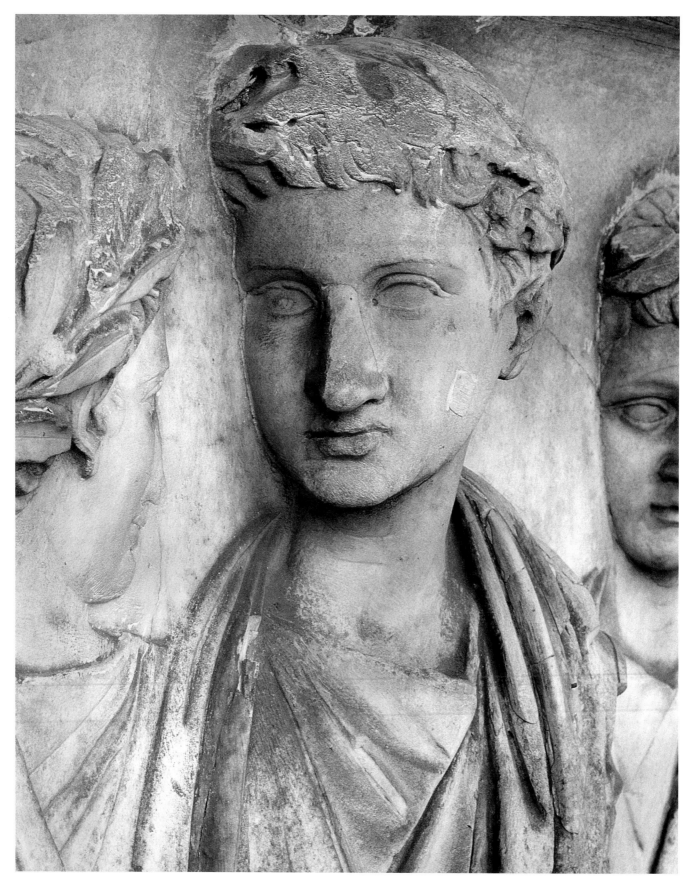

Above: FIGURE 195. Figure s34 ("Tiberius"). Head. FB 48/5.
Opposite: FIGURE 196. Figure s39 (Drusus). Head. FB 48/8.

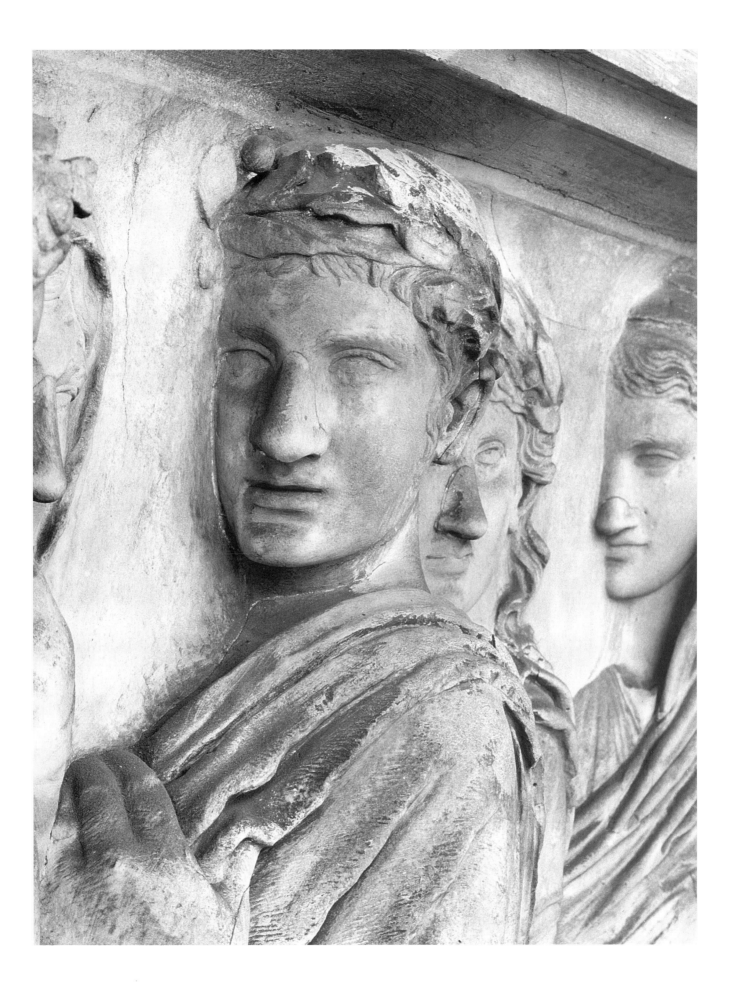

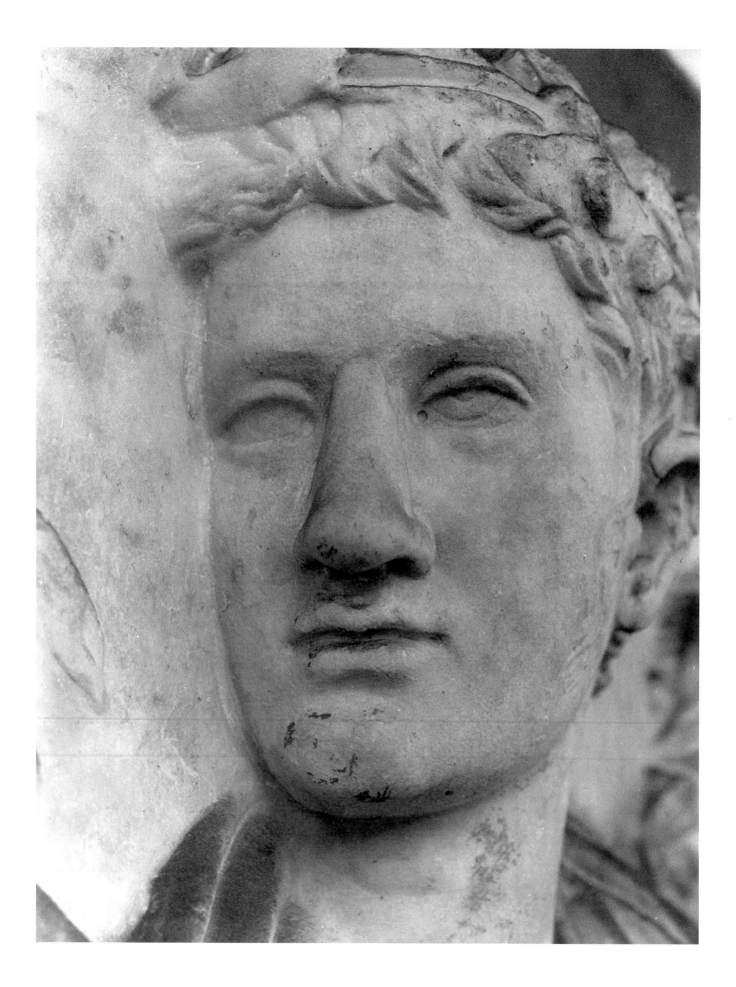

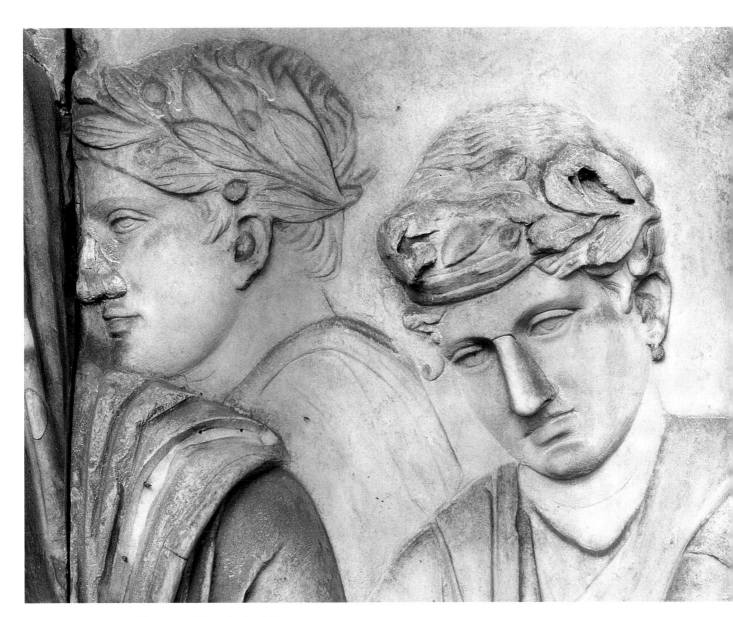

Opposite: FIGURE 197. Figure s45 (Ahenobarbus). Face.
Above: FIGURE 198. Figures s29 and s30. Heads. FB 48/3.

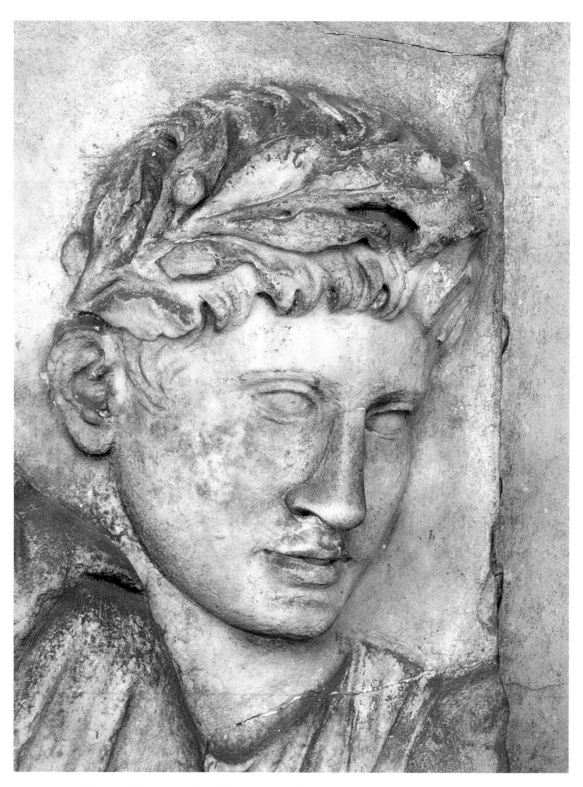

FIGURE 199. Figure s46 (background male?). Head. FB 50/2.

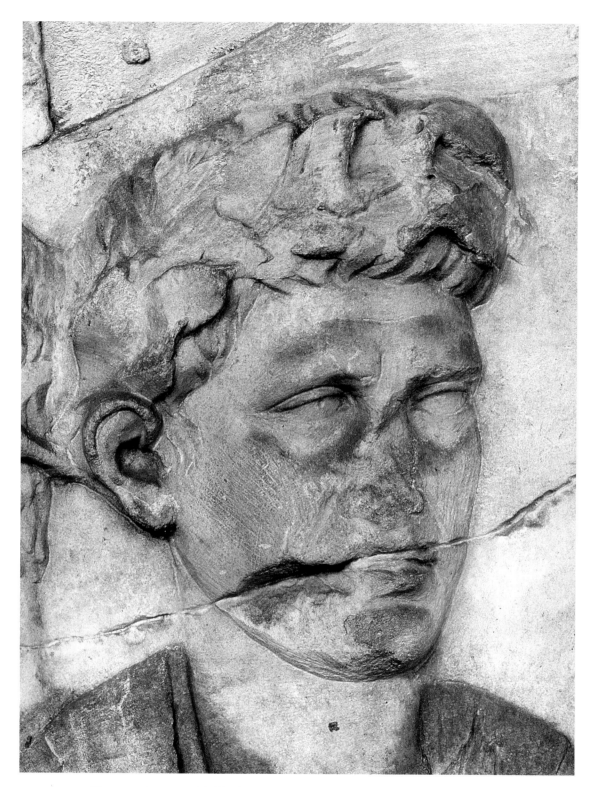

FIGURE 200. Figure S15 (togate male). Head. FB 39/1.

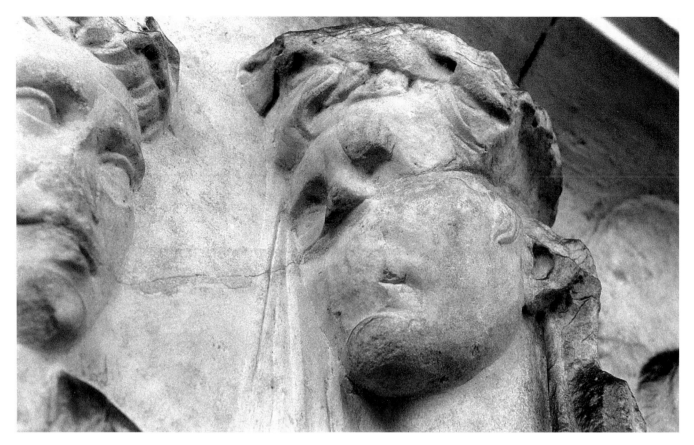

Above: FIGURE 201. Figure s16 (Augustus). Oblique view of face.
Opposite: FIGURE 202. Figure s28 (Agrippa). Face. INR 86.1504.

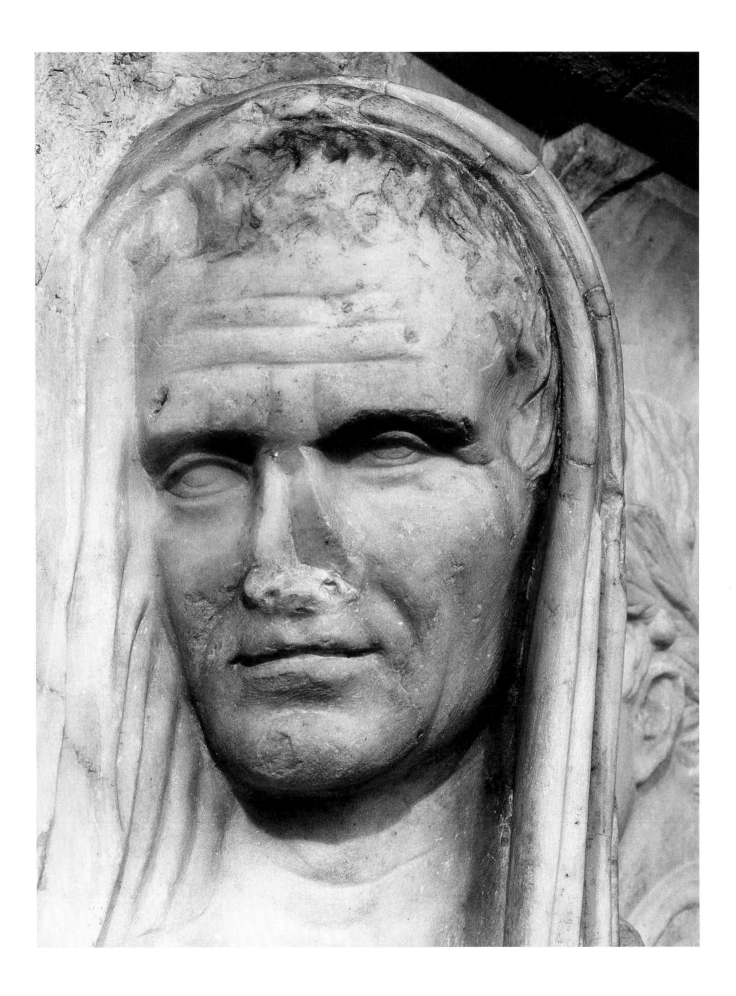

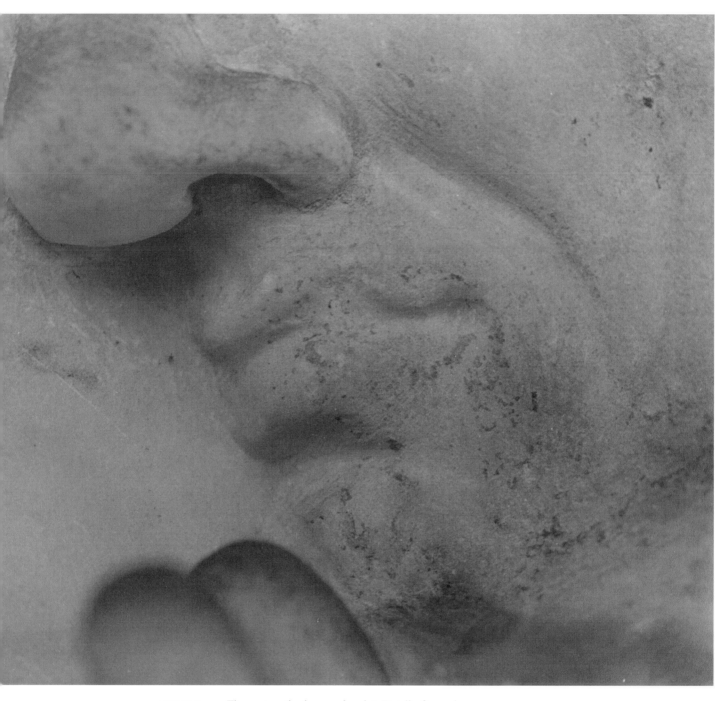

FIGURE 203. Figure s44 (background male). Detail of mouth.

FIGURE 204. Lictor frieze. Fragments in the present reconstruction. Köln 2361/0.

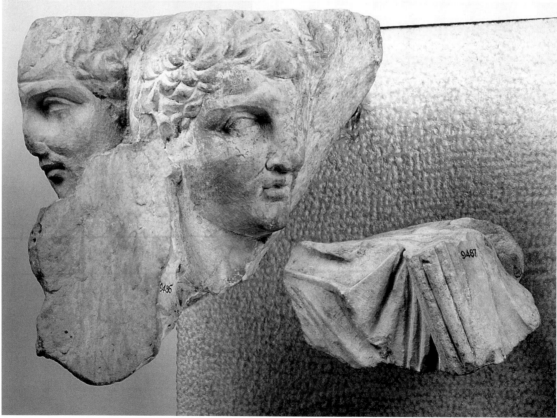

Top: FIGURE 205. Lictor frieze. Heads 1 and 3. Köln 2309/6. *Bottom:* FIGURE 206. Lictor frieze. Heads 1 and 3. Köln 2309/5. *Opposite:* FIGURE 207. Lictor frieze. Head 3. Köln 2377/2.

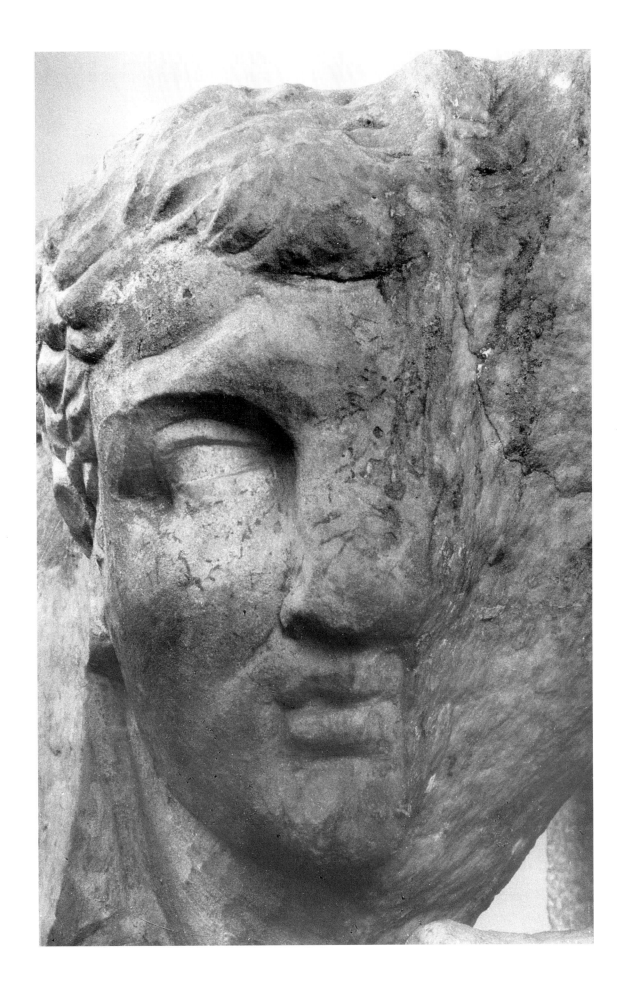

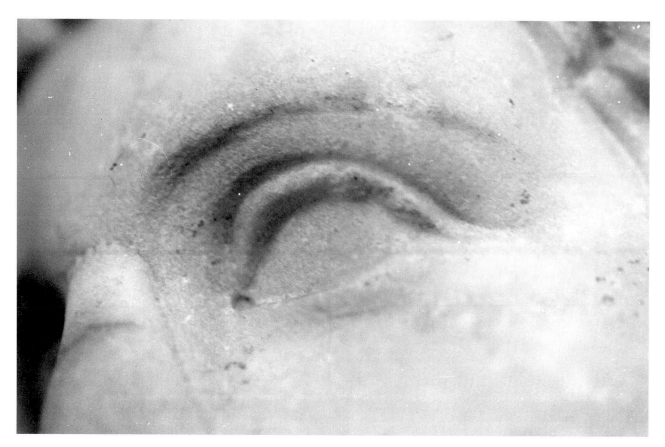

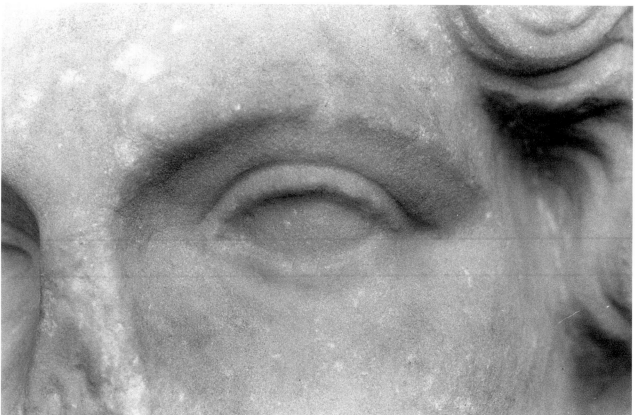

Top: FIGURE 208. Figure s34 ("Tiberius"). Left eye. *Bottom:* FIGURE 209. Veiled female figure on the Mattei relief. Left eye.

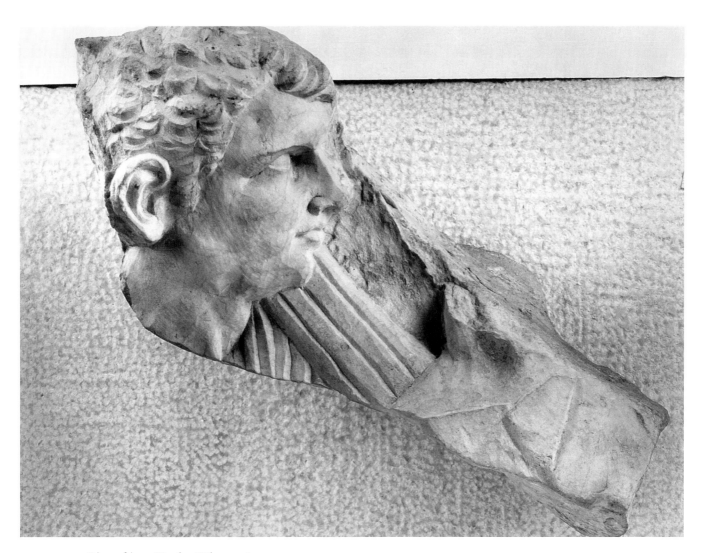

FIGURE 210. Lictor frieze. Head 5. Köln 2309/4.

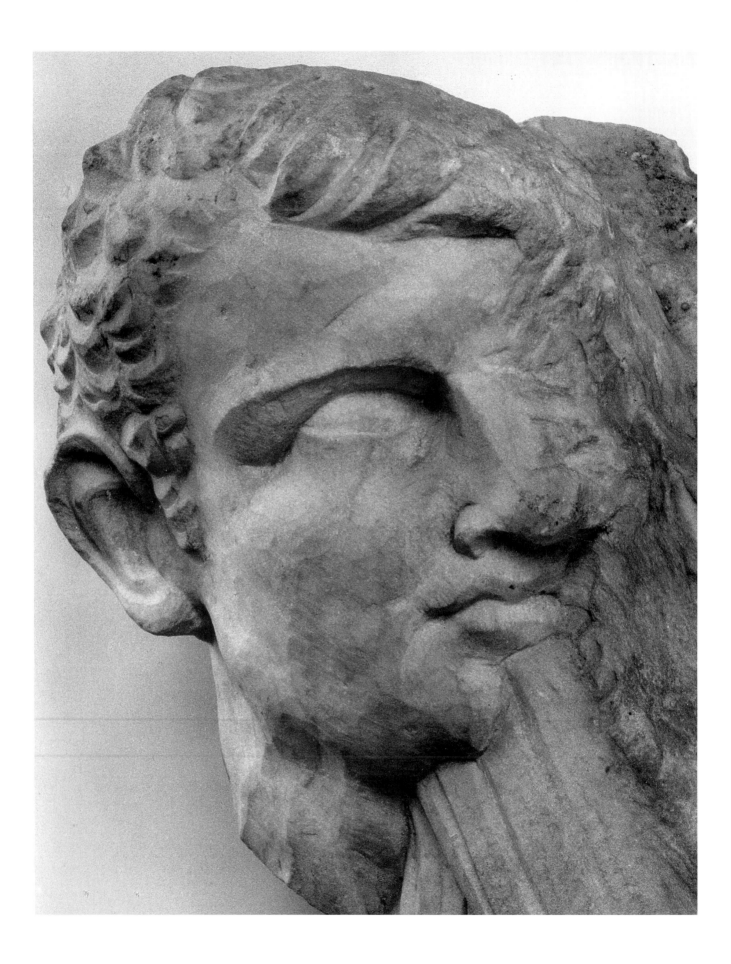

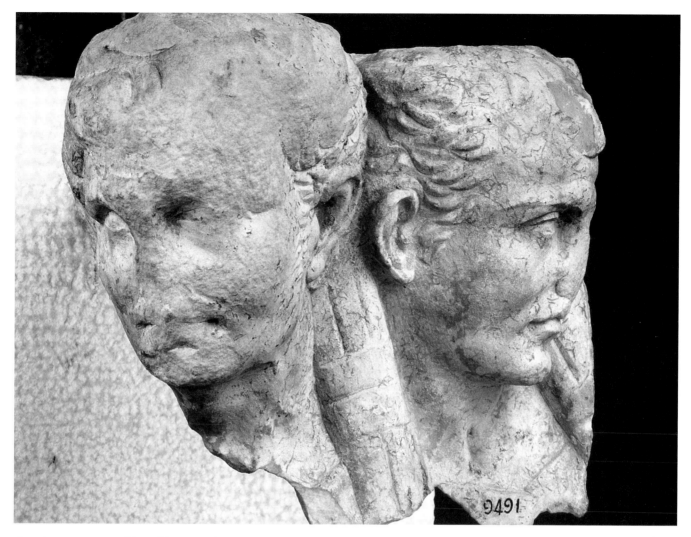

Opposite: FIGURE 211. Lictor frieze. Head 5. Face. Köln 2376/35.
Above: FIGURE 212. Lictor frieze. Heads 8 and 9. Köln 2308/10.

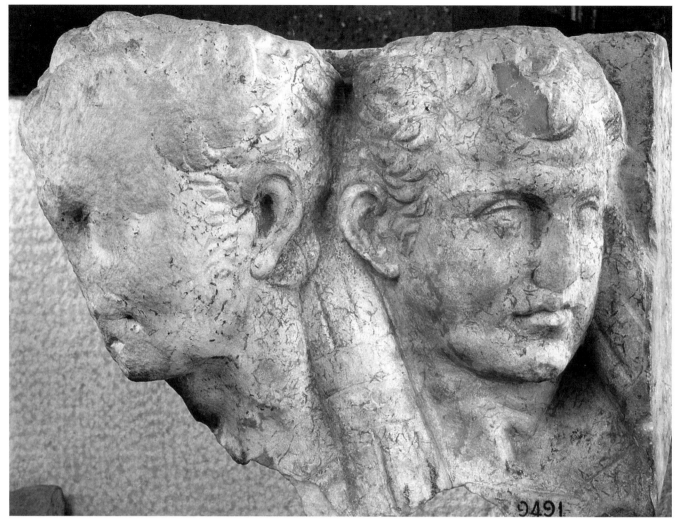

Above: FIGURE 213. Lictor frieze. Heads 8 and 9. Köln 2308/9.
Opposite: FIGURE 214. Lictor frieze. Head 8. Face. Köln 2376/30.

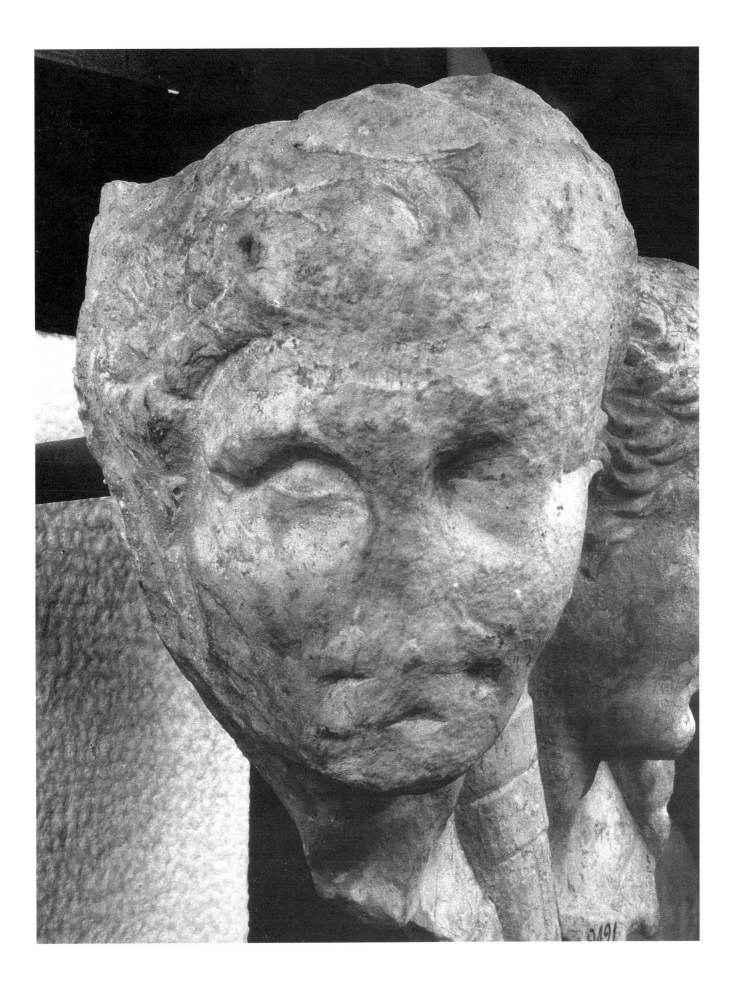

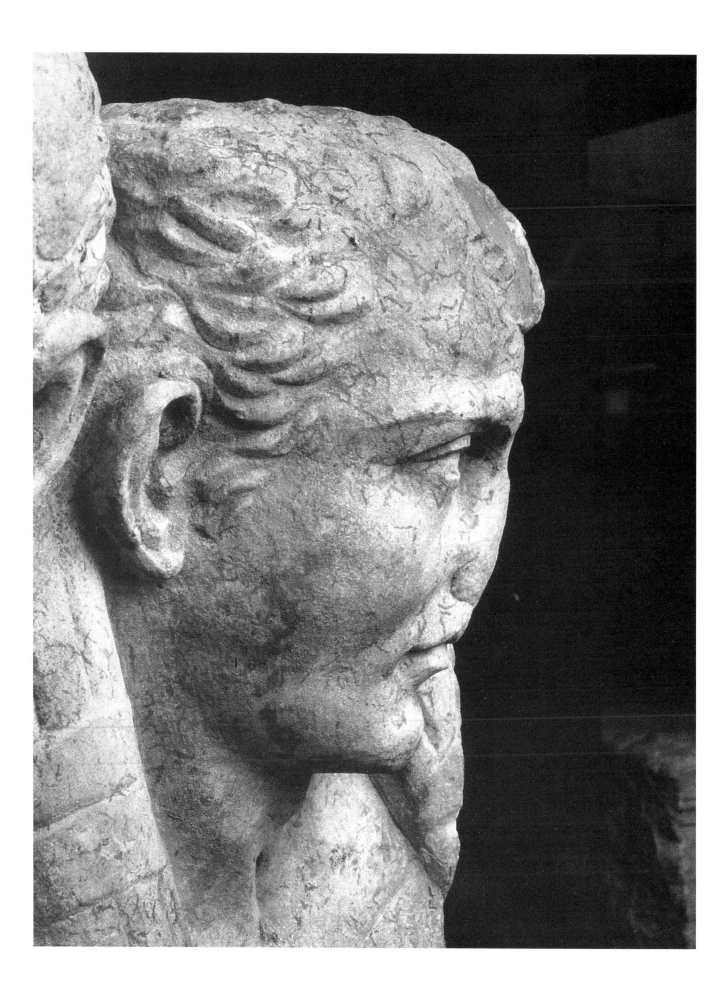

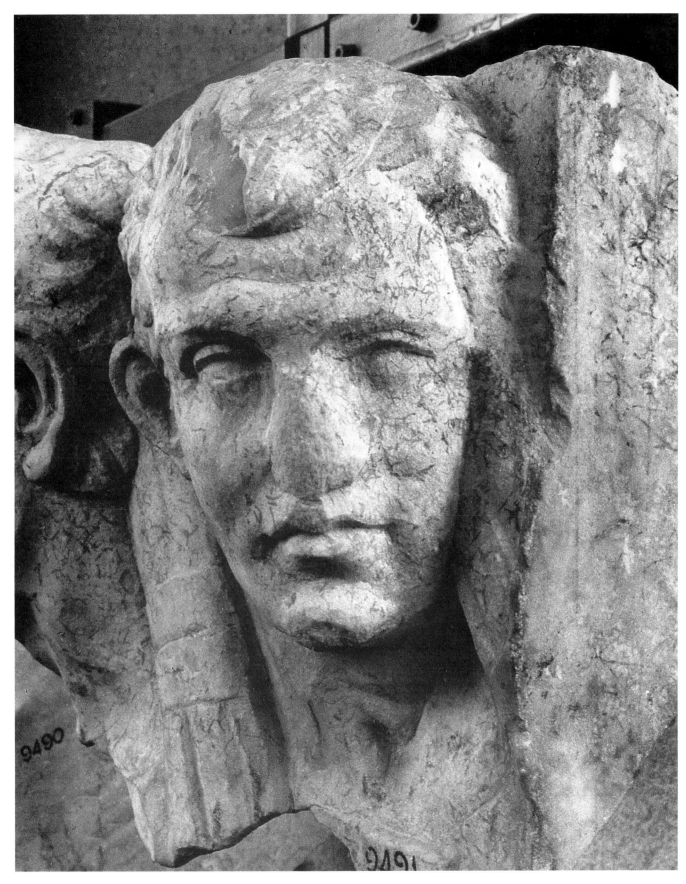

Opposite: FIGURE 215. Lictor frieze. Head 9. Profile view of head. Köln 2376/31.
Above: FIGURE 216. Lictor frieze. Head 9. Face. Köln 2376/29.

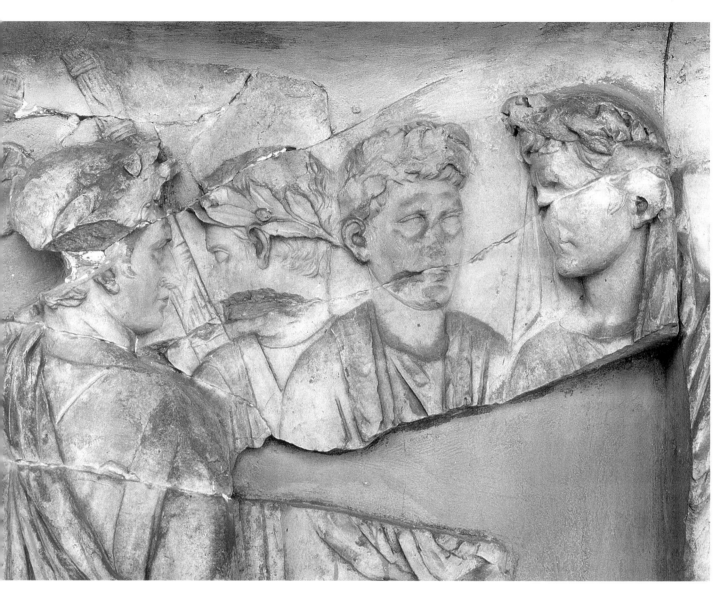

Above: FIGURE 217. Figures s13 through s16. Heads and torsos. FB 38/7.
Opposite: FIGURE 218. Lictor frieze. Head 7. Köln 2376/33.

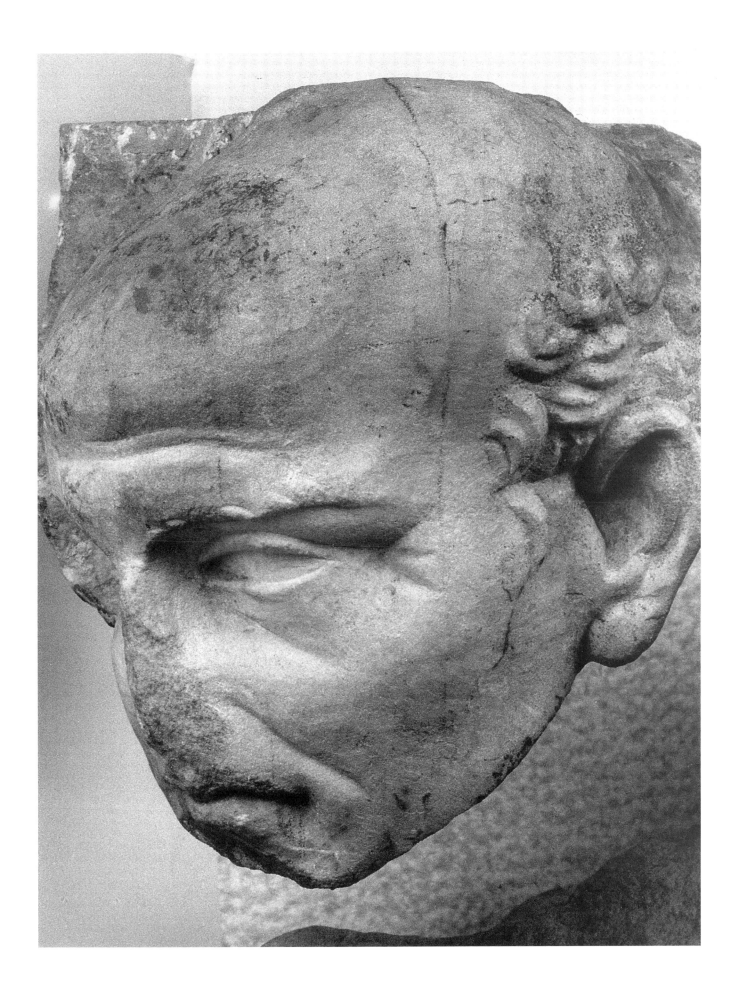

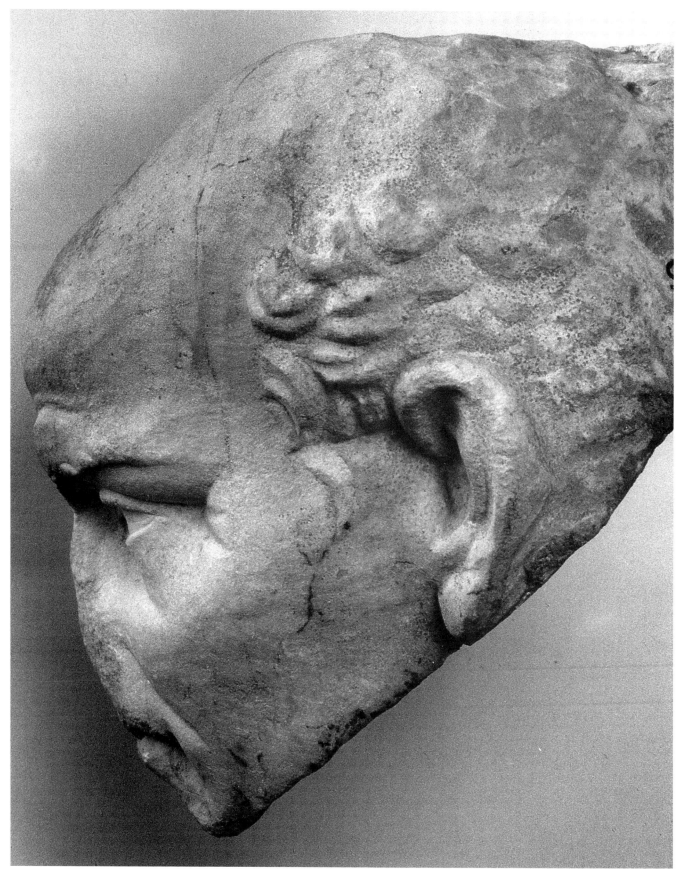

Above: FIGURE 219. Lictor frieze. Head 7. Profile view of head. Köln 2376/32.
Opposite: FIGURE 220. Lictor frieze. Head 7. Face. Köln 2376/34.

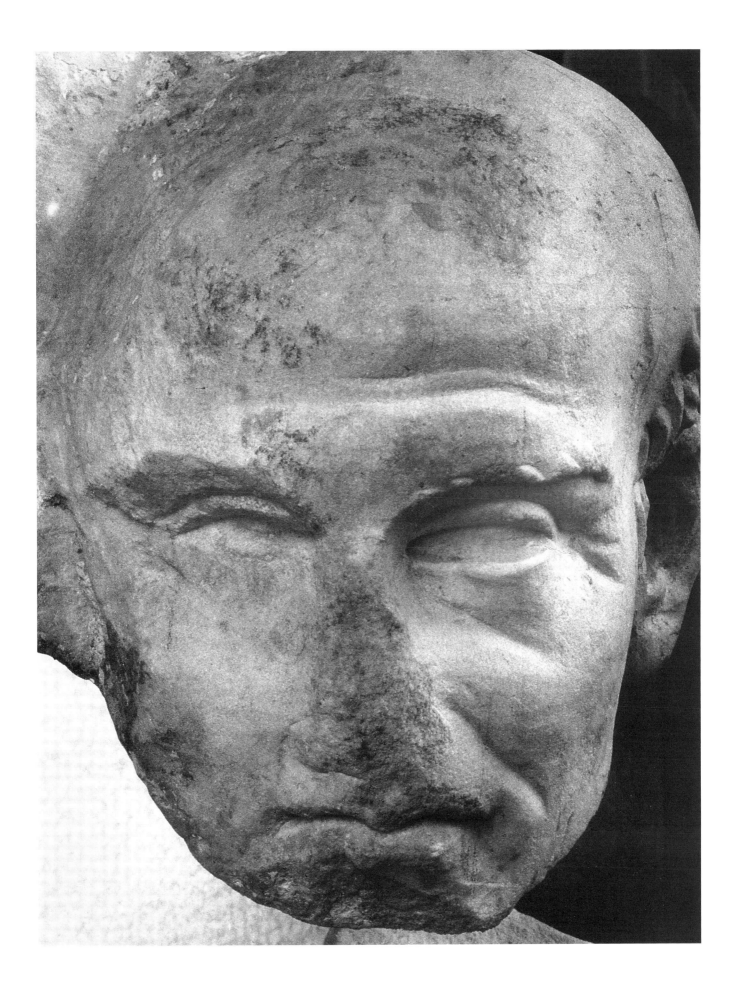

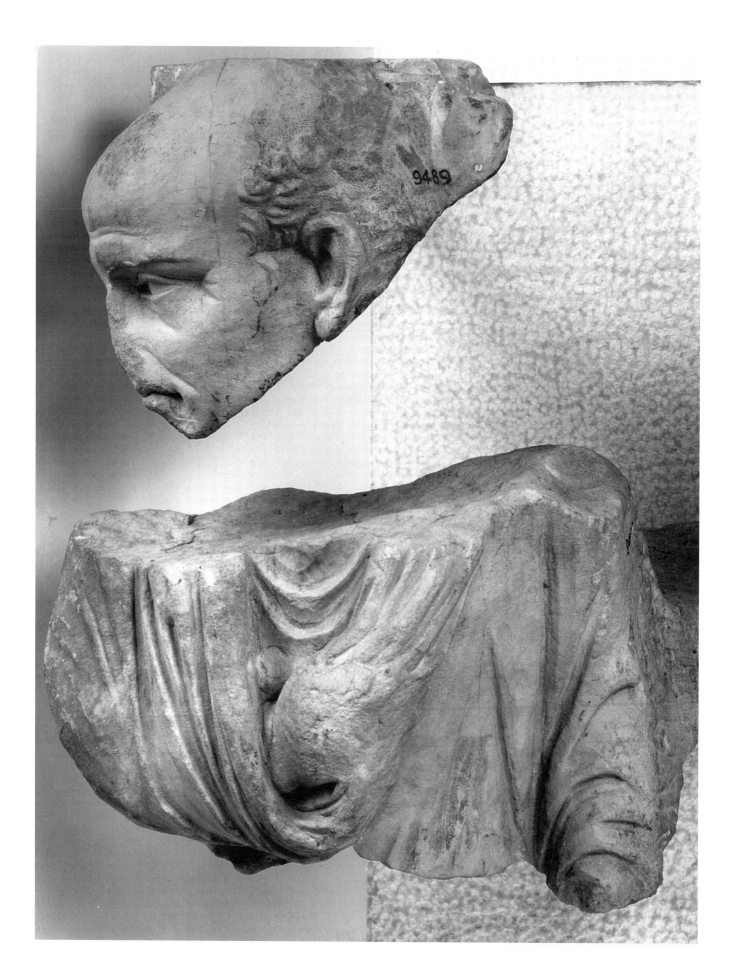

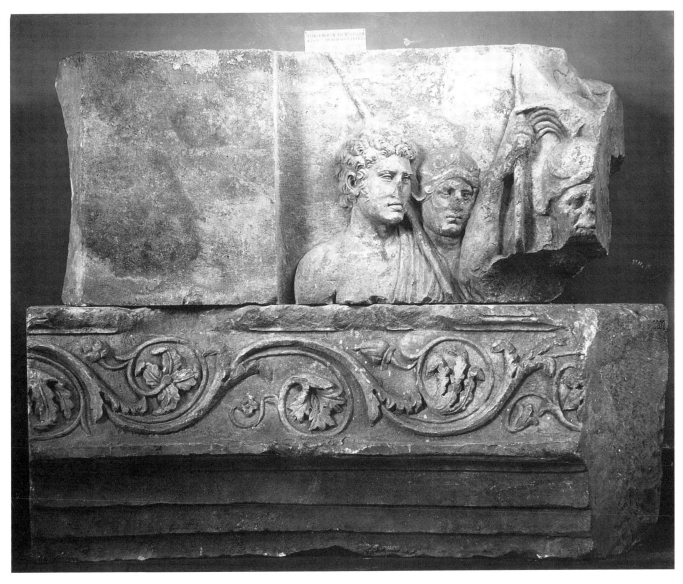

Opposite: FIGURE 221. Lictor frieze. Head 7 and torso fragment as presently reconstructed. Köln 2309/2.
Above: FIGURE 222. Via Druso relief. Block 1. Capitoline archives.

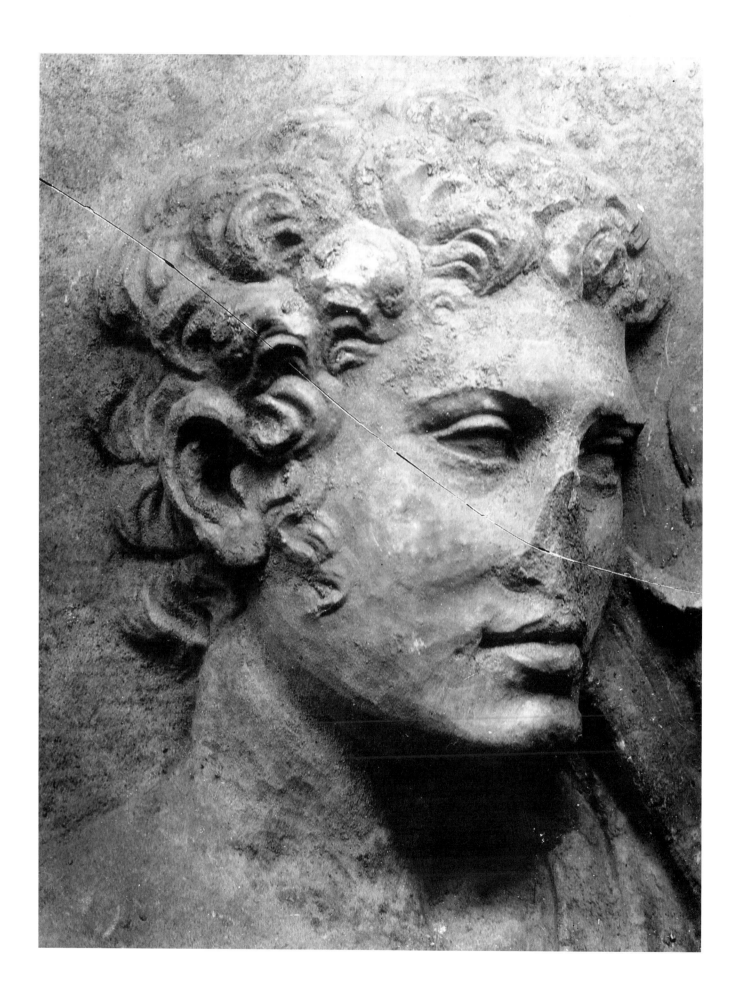

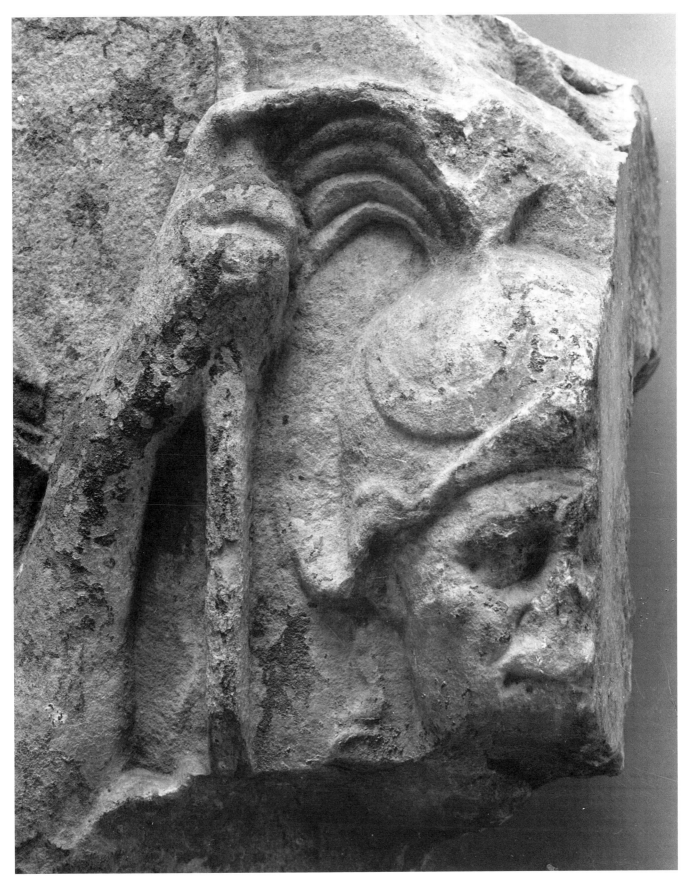

Opposite: FIGURE 223. Via Druso relief. Block 1. Figure 1. Capitoline archives.
Above: FIGURE 224. Via Druso relief. Block 1. Figure 3. Photo Capitoline archives.

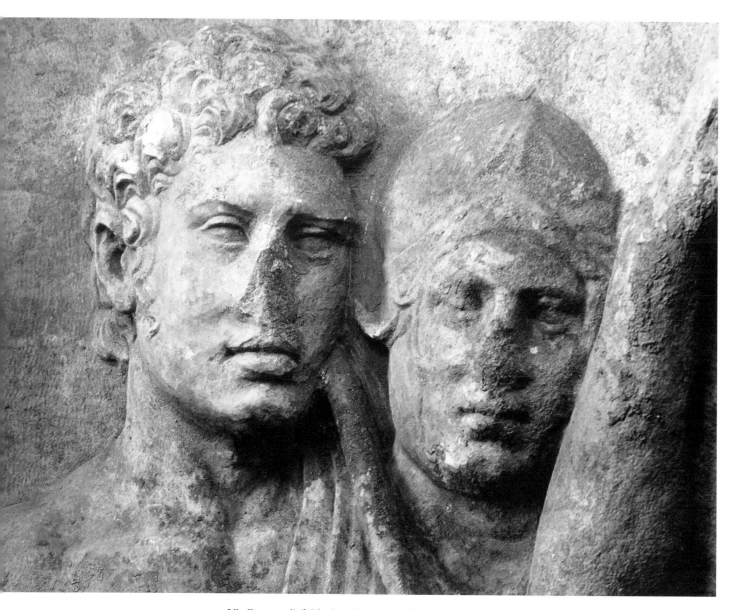

FIGURE 225. Via Druso relief. Block 1. Figures 1 and 2. Capitoline archives.

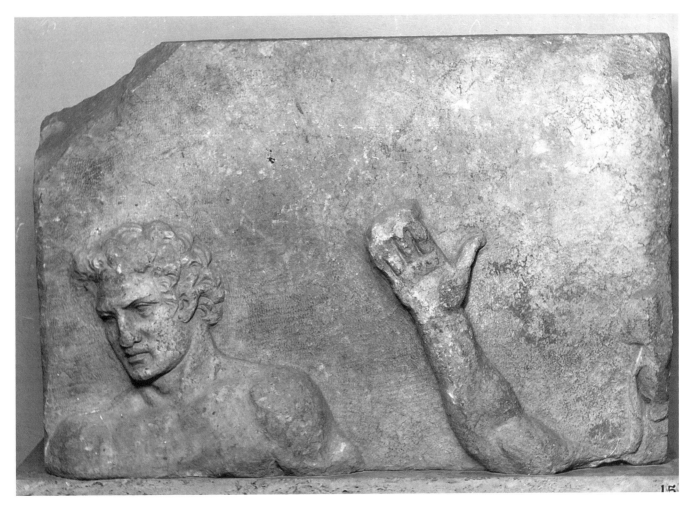

FIGURE 226. Via Druso relief. Block 2. Photo Capitoline archives.

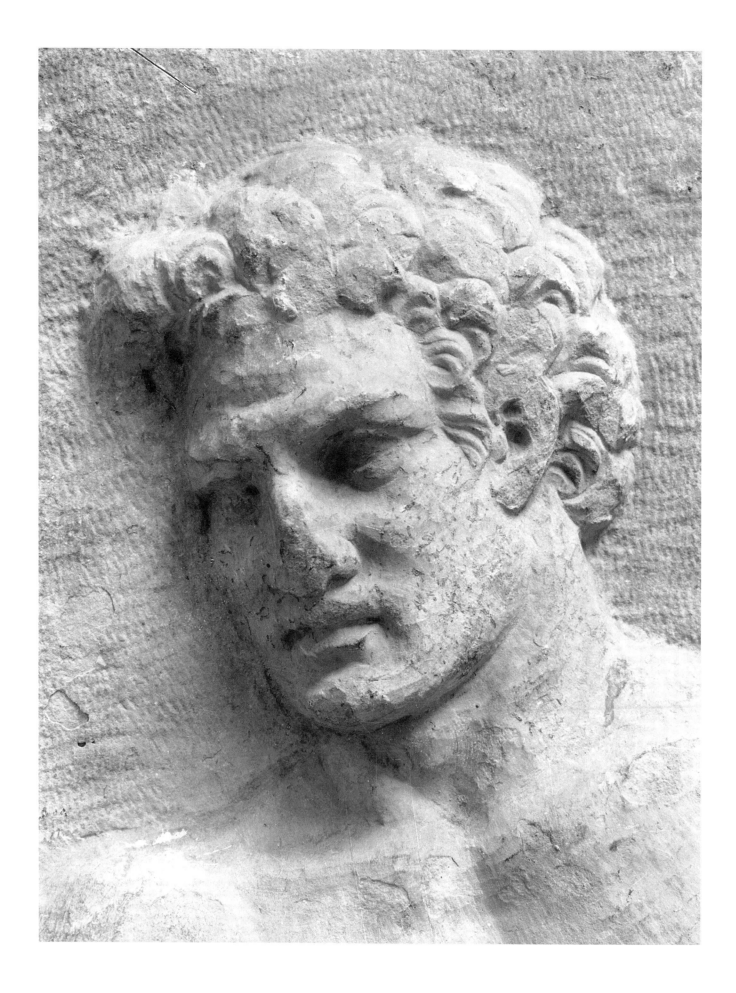

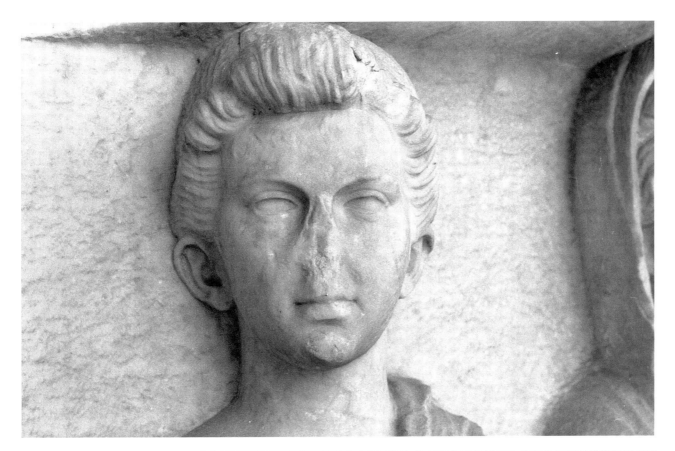

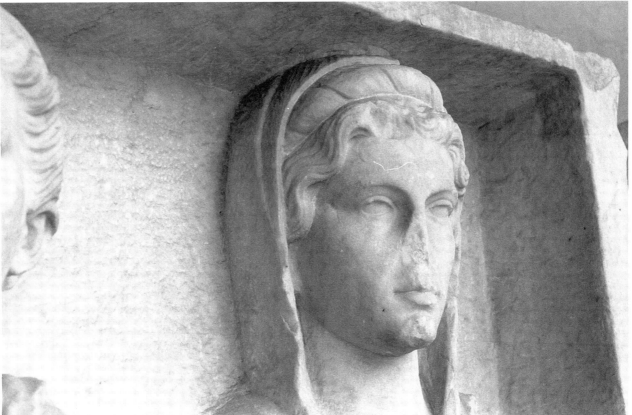

Opposite: FIGURE 227. Via Druso relief. Block 2. Figure 4. Photo Capitoline archives.
Top: FIGURE 228. Female figure on the Mattei relief.
Bottom: FIGURE 229. Veiled female figure on the Mattei relief. Oblique view of head.

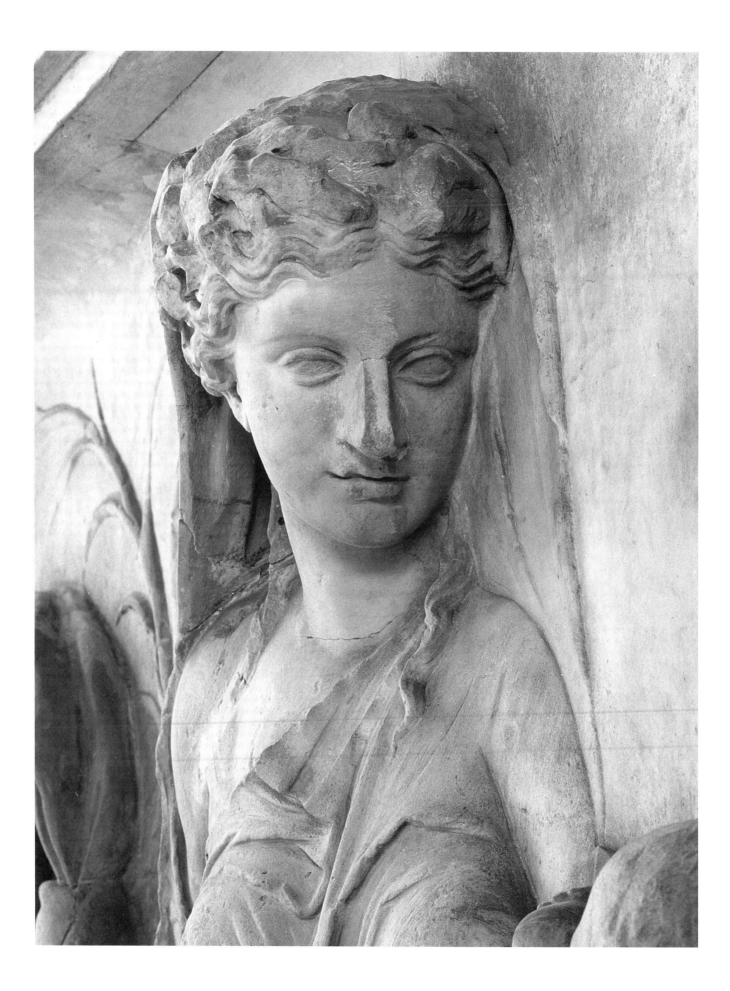

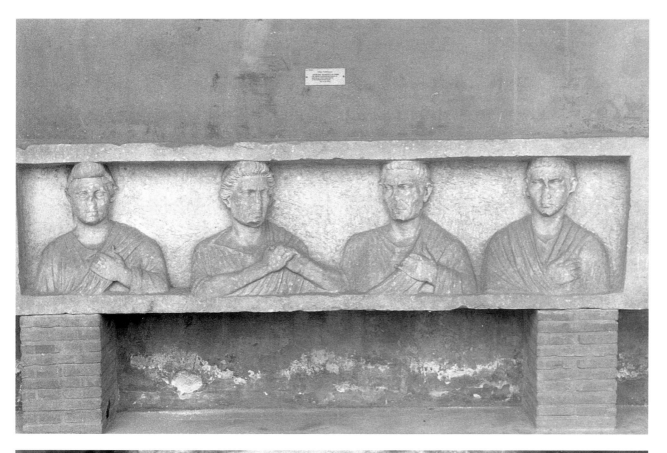

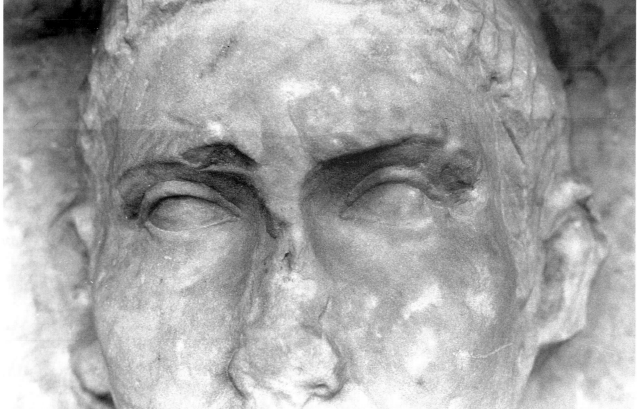

Opposite: FIGURE 230. "Tellus" figure. Ara Pacis. Face. FB 29/11.
Top: FIGURE 231. Four-figure Frontispizio relief. *Bottom:* FIGURE 232. Younger male figure on the Frontispizio relief. Eye area.

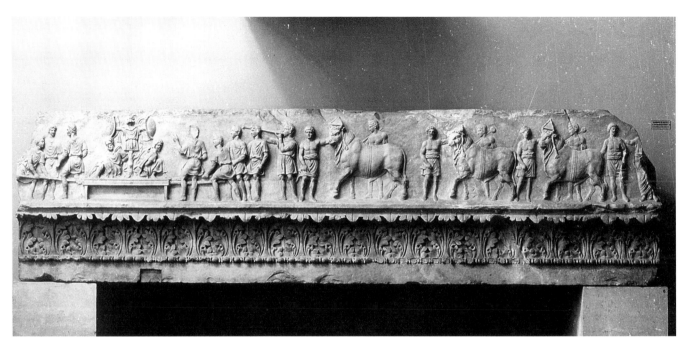

FIGURE 233. Frieze from the Temple of Apollo Sosianus, Rome. Large procession fragment. INR 71.44.

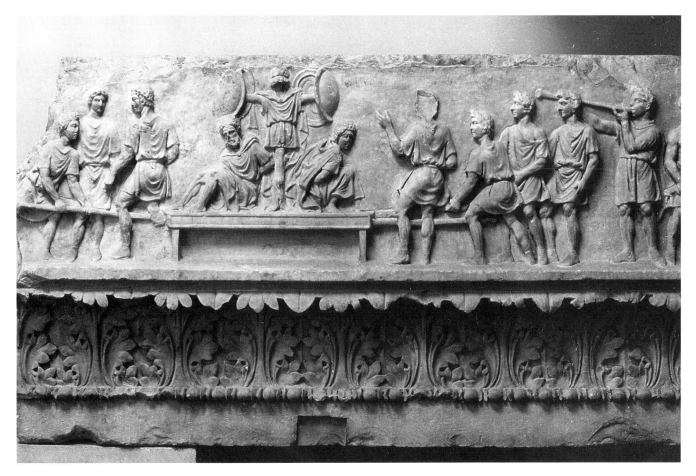

FIGURE 234. Frieze from the Temple of Apollo Sosianus, Rome. Large procession fragment. Left half.
INR 71.45.

Frieze from the Temple of Apollo Sosianus.

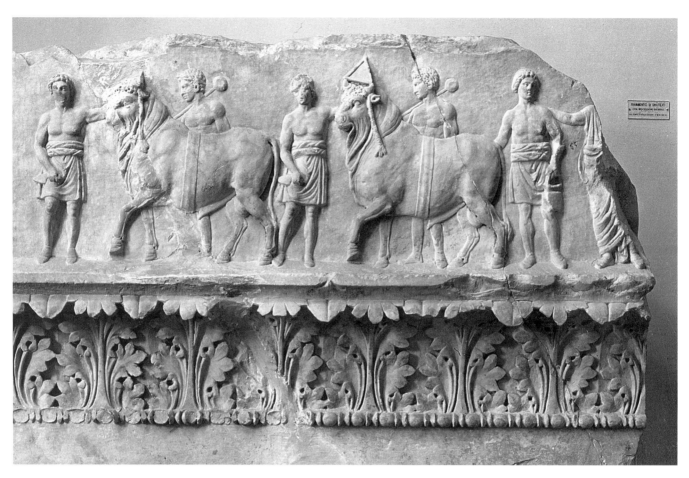

Above: FIGURE 235. Frieze from the Temple of Apollo Sosianus, Rome. Large procession fragment. Right half. INR 71.47.

Opposite: FIGURE 236. Frieze from the Temple of Apollo Sosianus, Rome. Fragment with lictor. INR 60.1254.

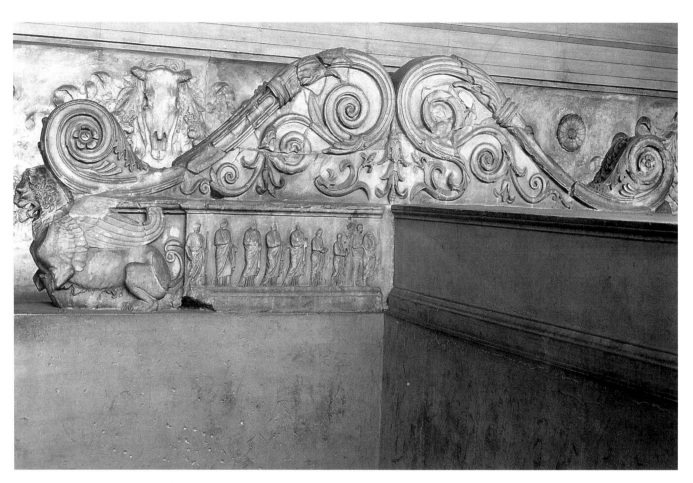

FIGURE 237. Vestal frieze. Interior side of north wing of altar. Ara Pacis. FB 47/2.

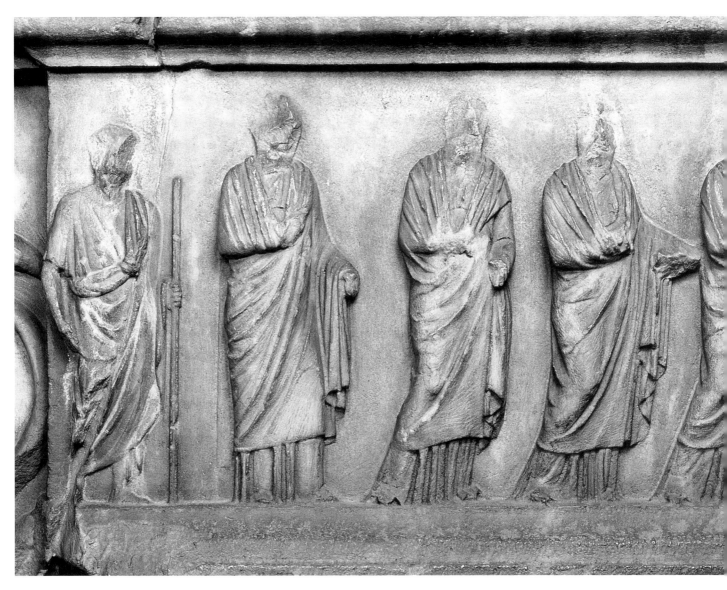

FIGURE 238. Vestal frieze. Interior side of north wing of altar. Ara Pacis. Left side. FB 47/I.

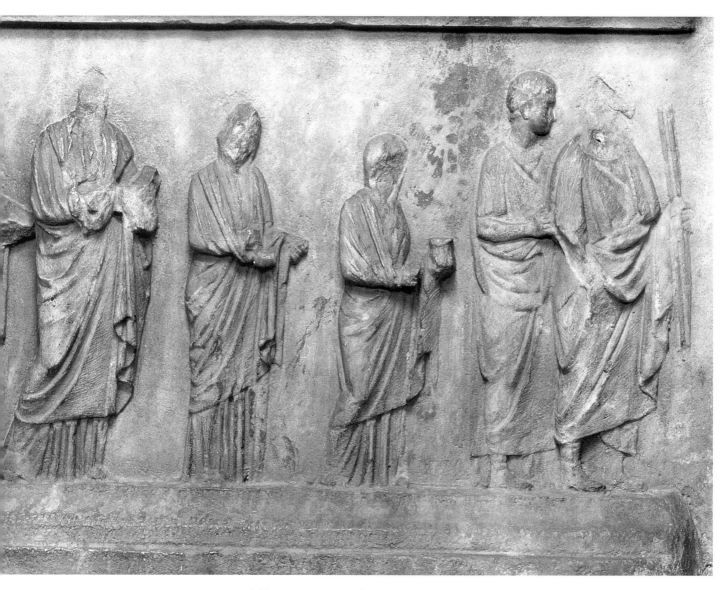

FIGURE 239. Vestal frieze. Interior side of north wing of altar. Ara Pacis. Right side. FB 46/10.

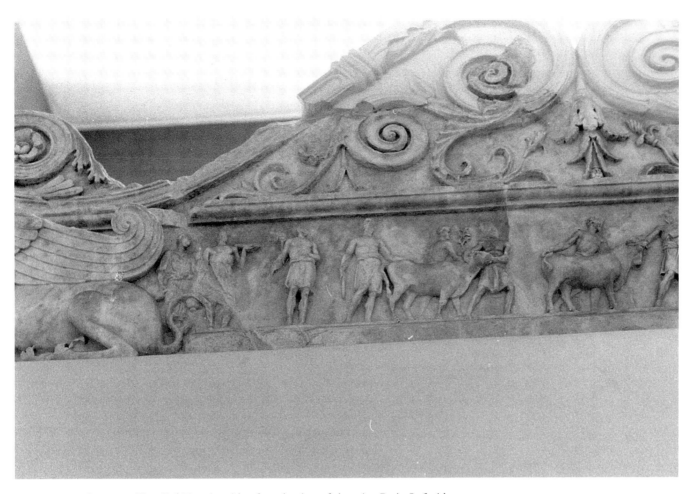

FIGURE 240. Suovetaurilia relief. Exterior side of north wing of altar, Ara Pacis. Left side.

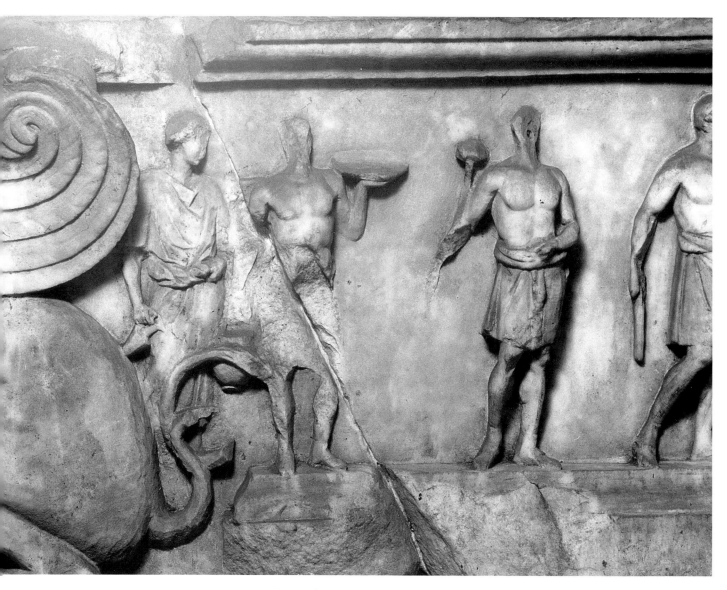

FIGURE 241. Suovetaurilia relief. Exterior side of north wing of altar, Ara Pacis. Figures 1–4. FB 40/2.

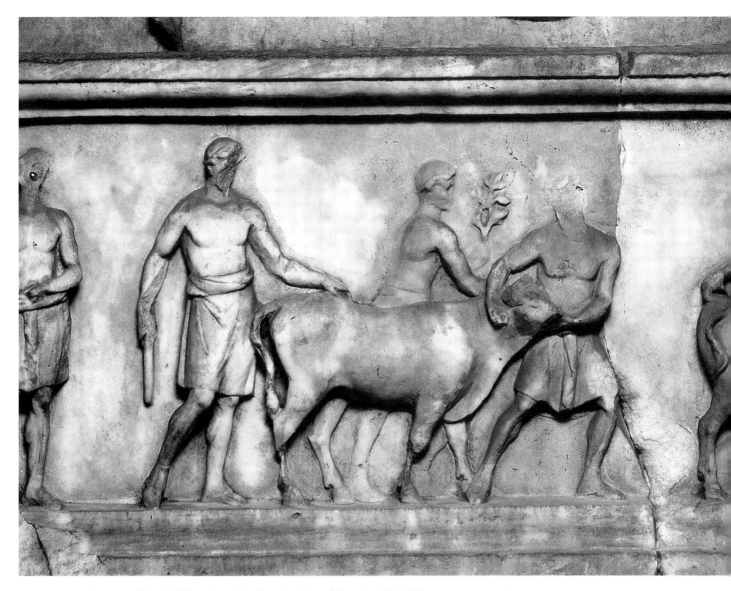

FIGURE 242. Suovetaurilia relief. Exterior side of north wing of altar, Ara Pacis. Figures 4–7. FB 40/3.

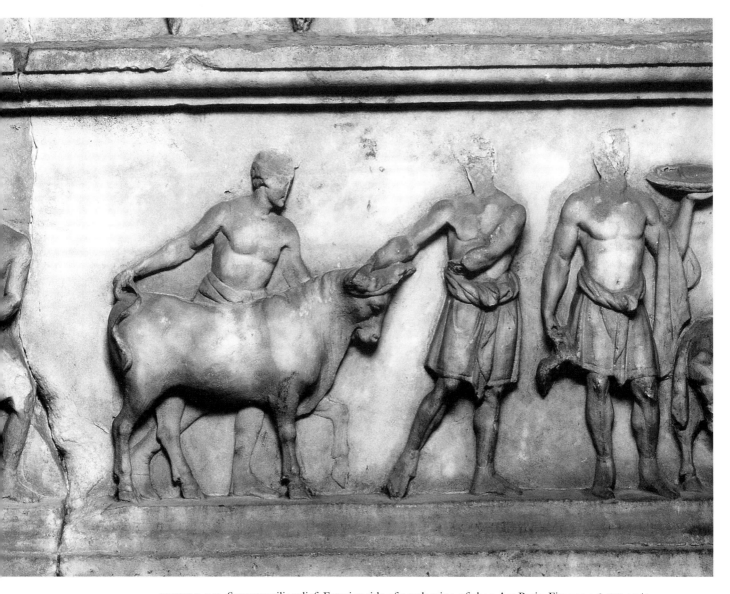

FIGURE 243. Suovetaurilia relief. Exterior side of north wing of altar, Ara Pacis. Figures 5–8. FB 40/4.

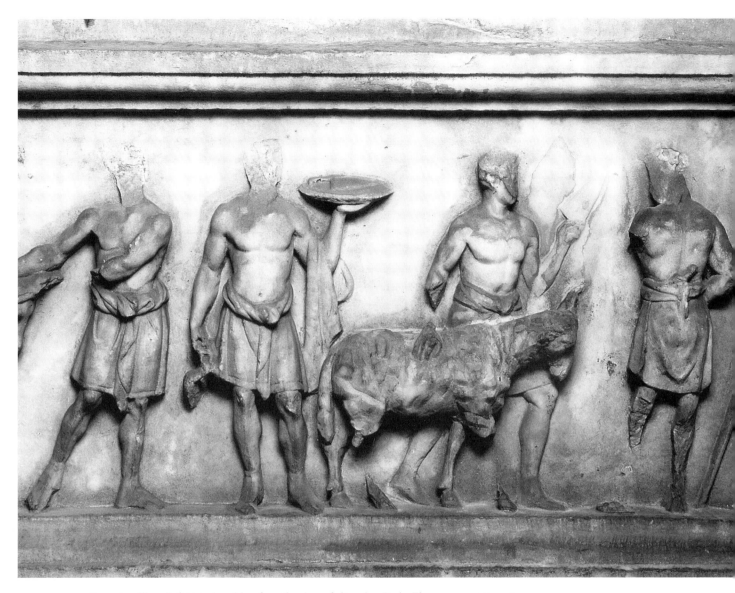

FIGURE 244. Suovetaurilia relief. Exterior side of north wing of altar, Ara Pacis. Figures 7–10. FB 40/5.

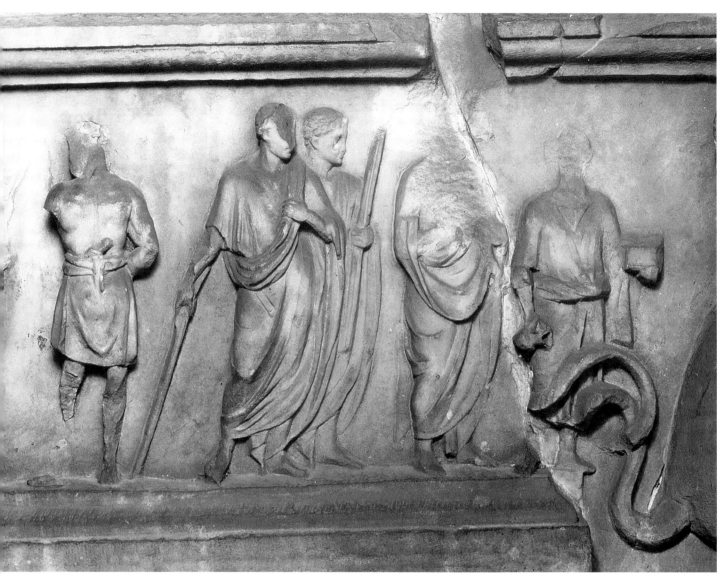

Above: FIGURE 245. Suovetaurilia relief. Exterior side of north wing of altar, Ara Pacis. Figures 10–14. FB 40/8.
Opposite: FIGURE 246. Vestal frieze. Ara Pacis. Oblique view of Vestal.

FIGURE 247. Vestal frieze. Ara Pacis. Dowel hole in neck of Vestal.

BIBLIOGRAPHY

Adam, S. *The Technique of Greek Sculpture in the Archaic and Classical Periods. BSA*, suppl. vol. 3. London, 1966.

Amelung, W. *Die Sculpturen des Vaticanischen Museums*. Vols. 1–2. Berlin, 1903–8.

Anderson, M., and L. Nista. *Roman Portraits in Context: Imperial and Private Likenesses from the Museo Nazionale Romano*. Rome, 1989.

Angelis Bertolotti, R. de. "Materiali dell'Ara Pacis presso il Museo Nazionale Romano." *RM* 92 (1985): 221–84.

Arafat, K., and C. Morgan. "Pots and Potters in Athens and Corinth: A Review." *OJA* 8, no. 3 (1989): 311–46.

Arias, C., E. Mello, and M. Oddone. "Studio della provenienza di alcuni cippi etruschi in marmo bianco di Volterra e Pisa." *ArchCl* 43 (1991): 818–27.

Armi, C. E. *Masons and Sculptors in Romanesque Burgundy: The New Aesthetic of Cluny III*. University Park, Pa., 1983.

Asgari, N. "The Stages of Workmanship of the Corinthian Capital in Proconnesus and Its Export Form." In *Classical Marble: Geochemistry, Technology and Trade*, edited by N. Herz and M. Waelkens, 115–25. NATO ASI series. Dordrecht, 1988.

Ashmole, B. *Architect and Sculptor in Classical Greece*. New York, 1972.

Aubert, M. "La construction au moyen âge." *BMon* 119 (1961): 7–42.

Balbo E. *Protagonisti dell'Impero di Roma, Augusto e Mussolini*. Rome, 1941.

Baxandall, M. *The Limewood Sculptors of Renaissance Germany*. New Haven, 1980.

Berczelly, L. "Ilia and the Divine Twins: A Reconsideration of Two Relief Panels from the Ara Pacis Augustae." *ActaAArtHist* 5 (1985): 89–149.

Bergmann, M. "Zum Fries B der flavischen Cancelleriareliefs." *MarbWPr* (1981): 19–31.

Bianchi Bandinelli, R. *Rome: The Center of Power, 500 B.C. to A.D. 200*. New York, 1970.

Bieber, M. "A Monument for Guido Kaschnitz von Weinberg." *AJA* 71 (1967): 362–86.

Bielefeld, E. "Bemerkungen zu den kleinen Friesen am Altar der Ara Pacis Augustae." *RM* 73–74 (1966–67): 259–65.

Billows, R. "The Religious Procession on the Ara Pacis Augustae: Augustus' Supplicatio in 13 B.C." *JRA* 6 (1993): 80–92.

Boatwright, M. *Hadrian and the City of Rome*. Princeton, 1987.

Bonamici, M. "Il marmo lunense in epoca preromana." In *Il Marmo nella Civiltà Romana*, edited by E. Dolci, 84–113. Carrara, 1989.

Bonanno, A. *Roman Relief Portraiture to Septimius Severus*, 23–34. *BAR* Suppl. Ser. 6. Oxford, 1976.

Booth, A. "Venus on the Ara Pacis." *Latomus* 25 (1966): 873–79.

Borbein, A. "Gerhart Rodenwaldt." *AA* 102 (1987): 697–700.

Borbein, E. "Die Ara Pacis Augustae. Geschichtliche Wirklichkeit und Programm." *JdI* 90 (1975): 242–66.

Borchhardt, J. *Die Steine von Zêmuri*. Vienna, 1993.

Borda, M. *La scuola di Pasiteles*. Bari, 1953.

Börker, C. "Neuattisches und pergamenisches an den Ranken der Ara Pacis." *JdI* 88 (1973): 283–317.

Bottai, G. *L'Italia di Augusto e l'Italia di oggi*, 207–22. *Accademie e Biblioteche d'Italia*, vol. 11. Rome, 1937.

Bowersock, G. W., and T. J. Cornell, eds. *A. D. Momigliano: Studies on Modern Scholarship*. Berkeley, 1994.

Breckenridge, J. "Origins of Roman Republican Portraiture: Relations with the Hellenistic World." *ANRW* 1.4 (1973): 826–54.

Brendel, O. *Etruscan Art*. New York, 1978.

———. *Prolegomena to the Study of Roman Art*. New Haven, 1979.

Broise, H. "Deux nouveaux fragments des Actes des frères arvales de l'année 38 après J.-Chr." *MEFRA* 92 (1980): 215–48.

Bruto, M. L., and C. Vannicola. "Strumenti e tecniche di lavorazione dei marmi antichi." *ArchCl* 42 (1990): 287–324.

Buchner, E. "Horologium Solarium Augusti." *RM* 87 (1980): 355–73.

———. "Solarium Augusti und Ara Pacis." *RM* 83 (1976): 319–65.

———. *Die Sonnenuhr des Augustus*. Mainz, 1982.

Budde, L. *Ara Pacis Augustae*. Hannover, 1957.

Bundgaard, J. "The Building Contract from Lebadeia." *ClMed* 8 (1946): 1–43.

Burford, A. *Craftsmen in Greek and Roman Society*. London, 1972.

———. *Greek Temple Builders at Epidauros*. Liverpool, 1969.

Büsing, H. "Ranke und Figur an der Ara Pacis Augustae." *AA* 2 (1977): 247–57.

Cafiero, M. L., and the Comune di Roma Assessorato alla Cultura. *Ara Pacis Augustae*. Rome, 1989.

Cagnetta, M. "Il mito di Augusto e la 'rivoluzione' fascista." *QuadStor* 3 (1976): 139–81.

Carradori, F. *Istruzione elementare per gli studiosi della scultura*. Florence, 1802.

Casson, S. "An Unfinished Colossal Statue at Naxos." *BSA* 37 (1936–37): 21–25.

Castagnoli, F. "L'Arco di Germanico *in circo Flaminio*." *ArchCl* 36 (1984): 329–32.

Castriota, D. *The Ara Pacis Augustae and the Imagery of Abundance in Later Greek and Early Roman Imperial Art*. Princeton, 1995.

Cecchelli, C. "L'Ara della Pace sul Campidoglio." *Capitolium* 1 (1925): 65–71.

Cederna, A. *Mussolini urbanista: Lo sventramento di Roma negli anni del consenso*. Rome, 1981.

Charbonneaux, J. *L'art au siècle d'Auguste*. Paris, 1948.

——. *La sculpture greque*. Paris, 1950.

——. *La sculpture greque au Musée du Louvre*. Paris, 1936.

Clarke, J. *The Houses of Roman Italy, 100 B.C.–A.D. 250: Ritual, Space and Decoration*. Berkeley, 1991.

Cleland, C. E. "From Sacred to Profane: Style Drift in the Decoration of Jesuit Finger Rings." *American Antiquity* 37 (1972): 202–10.

Colini, A. "Bassorilievo funerario di Via Statilia." *BullComm* 54 (1926): 177–82.

Conlin, D. "The Large Processional Friezes on the Ara Pacis Augustae: Early Augustan Sculptural Styles and Workshop Traditions." Ph.D. diss., University of Michigan, 1993.

——. "The Reconstruction of Antonia Minor on the Ara Pacis." *JRA* 5 (1992): 209–15.

Courband, E. *Le bas-relief romain à représentations historiques*, 61–114. BEFAR, vol. 81. Paris, 1899.

Cristofano, M. *Le pitture della tomba del Tifone. Monumenti della pittura antica scoperti in Italia, I. Tarquinia*, vol. 5. Rome, 1971.

——. *La tomba "del Tifone." Cultura e società Tarquinia in età tardoetrusca*, 209–56. *MemLinc*, ser. 8, vol. 14.4. Rome, 1969.

Cullen, T. "A Measure of Interaction among Neolithic Communities: Design Elements of Greek Urfirnis Ware." Ph.D. diss., University of Indiana, 1985.

Curtius, L. "Mussolini a la Roma antica." *Nuova Antologia* 12 (1934): 487–500.

Dean, N. "Geochemistry and Archaeological Geology of the Carrara Marble, Carrara, Italy." In *Classical Marble: Geochemistry, Technology and Trade*, edited by N. Herz and M. Waelkens, 315–23. NATO ASI series. Dordrecht, 1988.

Degrassi, A. *Fasti Anni Numani et Juliani. Inscriptiones Italiae* XIII.2. Rome, 1963.

——. *Inscriptiones Latinae Liberae Rei Publicae*. Florence, 1957–63.

Dolci, E. "Marmora Lunensia: Quarrying Technology and Archaeological Use." In *Classical Marble: Geochemistry, Technology and Trade*, edited by N. Herz and M. Waelkens, 77–84. NATO ASI series. Dordrecht, 1988.

Dunnel, R. C. "Style and Function: A Fundamental Dichotomy." *American Antiquity* 43 (1978): 192–202.

Eck, W. "Die Familie der Volusii Saturnini in neuen Inschriften aus Lucus Feroniae." *Hermes* 100 (1972): 461–84.

Enciclopedia dell'Arte Antica, Classica e Orientale. Rome, 1961.

Erim, K. "The Zoilos Frieze." *Madrider Beiträge* 6 (1979): 35–40.

Erim, K., and J. Reynolds. "The Copy of Diocletian's Edict on Maximum Prices from Aphrodisias in Caria." *JRS* 60 (1970): 120–41.

Etienne, H. J. *The Chisel in Greek Sculpture*. Leiden, 1968.

Fabbrini, L. "Il ritratto giovanile di Tiberio a la iconografia di Druso Maggiore." *BdA* 49 (1964): 304–26.

Fant, J. C. *Cavum antrum Phrygiae: The Organization and Operations of the Imperial Marble Quarries in Phrygia*. BAR International Series, vol. 482. Oxford, 1989.

——. "Four Unfinished Sarcophagus Lids at Docimium and the Roman Imperial Quarry System in Phrygia." *AJA* 89 (1985): 655–62.

Favro, D. "Reading the Augustan City." In *Narrative and Event in Ancient Art*, edited by P. Holliday, 230–57. Cambridge, 1993.

Felletti-Maj, B. M. *Museo Nazionale Romano, I Ritratti*. Rome, 1953.

——. *La tradizione Italica nell'arte Romana*. Rome, 1977.

Fischer, M. "Marble Imports and Local Stone in the Architectural Decoration of Roman Palestine: Marble Trade, Techniques and Artistic Taste." In *Classical Marble: Geochemistry, Technology and Trade*, edited by N. Herz and M. Waelkens, 161–70. NATO ASI series. Dordrecht, 1988.

Fittschen, K., and P. Zanker. *Katalog der römischen Porträts in den Capitolinischen Museen*. Vol. 1, *Kaiser- und Prinzenbildnisse*. Rome, 1985.

Forsyth, I. "The Monumental Arts of the Romanesque Period: Recent Research." In *The Cloisters: Studies in Honor of the Fiftieth Anniversary*, edited by E. Parker, 3–25. New York, 1992.

Frova, A. "La produzione di scultura a Luni." *Quaderni del Centro Studi Lunensi* 10–12 (1985–87): 223–50.

Fullerton, M. "The Domus Augusti in Imperial Iconography of 13–12 B.C." *AJA* 89 (1985): 473–83.

Galinsky, K. *Augustan Culture: An Interpretive Introduction*. Princeton, 1996.

——. "Venus in a Relief on the Ara Pacis Augustae." *AJA* 70 (1976): 223–43.

——. "Venus, Polysemy, and the Ara Pacis Augustae." *AJA* 96 (1992): 457–75.

Ganzert, J. *Das Kenotaph für Gaius Caesar in Limyra. Architektur und Bauornamentik*. IstForsch, vol. 35. Tubingen, 1984.

——. "Das Kenotaph von Limyra. Rekonstruktionsüberlegungen, ein Werkstattbericht." *Architectura* 10 (1980): 15–32.

Gardner, P. *New Chapters in Greek Art*. Oxford, 1926.

Garrison, M. "Seals and the Elite at Persepolis: Some Observations on Early Achaemenid Persian Art." *Ars Orientalis* 21 (1991): 1–29.

Gates, M.-H. "Archaeology in Turkey." *AJA* 98 (1994): 264–65.

Gazda, E. K. "Etruscan Influence in the Funerary Reliefs of Late Republican Rome: A Study of Roman Vernacular Portraiture." *ANRW* 1.4 (1982): 855–70.

——. "Style and Technique in the Funerary Reliefs of Late Republican Rome." Ph.D. diss., Harvard University, 1971.

——, ed. *Roman Art in the Private Sphere*. Ann Arbor, 1991.

Gem, R. "The Bishop's Chapel at Hereford: The Roles of Patron and Craftsmen." In *Art and Patronage in the English Romanesque*, edited by S. Macready and F. H. Thompson, 87–96. London, 1986.

Gigliogli, G. "Il sepolcreto imperiale." *Capitolium* 6 (1930): 532–67.

Givens, J. "The Fabric Accounts of Exeter Cathedral As a Record of Medieval Sculptural Practice." *Gesta* 30 (1991): 112–18.

González, J. "Tabula Siarensis, Fortunales Siarenses et Municipia Civium Romanorum." *ZPE* 55 (1984): 55–100.

Goodlett, V. "Rhodian Sculptural Workshops." *AJA* 95 (1991): 669–81.

Goossens, G. "Artistes et artisans étrangers en Perse sous les Achéménides." *NouvClio* 1 (1949): 32–44.

Grazia, C. de. "Excavations of the American School of Classical Studies at Corinth: The Roman Portrait Sculpture." Ph.D. diss., Columbia University, 1973.

Grimm, G. "Die Porträts der Triumviri C. Octavius, M. Antonius und M. Aemilius Lepidus." *RM* 96 (1989): 347–64.

Grivot, D., and G. Zarnecki. *Gislebertus, Sculptor of Autun*. London, 1961.

Grummond, N. de. "Pax Augusta and the Horae on the Ara Pacis Augustae." *AJA* 94 (1990): 663–77.

Gunter, A., ed. *Investigating Artistic Environments in the Ancient Near East*. Washington, D.C., 1990.

Halfmann, H. *Itinera Principium: Geschichte und Typologie der Kaiserreisen im römischen Reich*. Stuttgart, 1986.

Hannestad, N. *Roman Art and Imperial Policy*. Aarhus, 1986.

——. *Tradition in Late Antique Sculpture: Conservation, Modernization, Production*. Acta Jutlandica, vol. 69, no. 2. Aarhus, 1994.

Harrison, E. B. *The Athenian Agora*. Vol. 1, *Portrait Sculpture*. Princeton, 1953.

Helbig, W. *Führer durch die öffentlichen Sammlungen klassischer Altertümer in Rom*. Vols. 1–3. 4th rev. edition, edited by Hermine Speier. Tübingen, 1963–72.

Herz, N., and M. Waelkens, eds. *Classical Marble: Geochemistry, Technology and Trade*. NATO ASI series. Dordrecht, 1988.

Hiesinger, U. "Portraiture in the Roman Republic." *ANRW* 1.4 (1973): 820–25.

Holliday, P. J., ed. *Narrative and Event in Ancient Art*. Cambridge, 1993.

——. "Processional Imagery in Late Etruscan Funerary Art." *AJA* 94 (1990): 73–93.

Holloway, R. R. "Who's Who on the Ara Pacis." *Alessandria e il mondo Ellenistico-Romano. Studi et Materiali. Ist. Arch. Univ. Palermo* 6 (1984): 625–28.

Hölscher, T. "Die Geschichtsauffassung in der römischen Repräsentationskunst." *JdI* 95 (1980): 265–321.

——. "Historische Reliefs." In *Kaiser Augustus und die verlorene Republik*, 363–64. Berlin, 1988.

Hönn, K. *Augustus im Wandel zweier Jahrtausende*. Leipzig, 1938.

Horace: The Complete Odes and Epodes with the Centennial Hymn. Trans. W. G. Shepherd. New York, 1983.

Johansen, F. "Ritratti marmorei e bronzei di M. Vipsanio Agrippa." *AnalRom* 6 (1971): 17–48.

Joshel, S. *Work, Identity and Legal Status at Rome: A Study of the Occupational Inscriptions*. London, 1992.

Kähler, H. "Die Ara Pacis und die augusteische Friedensideee." *JdI* 69 (1954): 67–100.

——. *Seethiasos und Census: Die Reliefs aus dem Palazzo Santa Croce in Rom*. Monumenta Artis Romanae, vol. 6. Berlin, 1966.

Kaiser Augustus und die verlorene Republik.
Antikenmuseum Berlin. Staatliche Museen
Preussischer Kulturbesitz. Berlin, 1988.

Kaschnitz von Weinberg, G. *Ausgewählte Schriften II.
Römische Bildnisse.* Edited by G. Kleiner and
H. von Heintze. Berlin, 1965.

——. *Ausgewählte Schriften III. Mittelmeerische Kunst.*
Edited by P. H. von Blankenhagen and H. von
Heintze. Berlin, 1965.

——. *Romische Kunst II. Zwischen Republik und
Kaiserreich.* Edited by H. von Heintze. Rowohlt,
1961.

Kellum, B. "Sculptural Programs and Propaganda
in Augustan Rome." In *The Age of Augustus,*
edited by R. Winkes, 169–76. Providence, R.I.,
1986.

Kleiner, D. E. E. "The Great Friezes of the Ara Pacis
Augustae: Greek Sources, Roman Derivatives
and Augustan Social Policy." *MEFRA* 90 (1978):
753–85.

——. *Roman Group Portraiture: The Funerary Reliefs
of the Late Republic and Early Empire.* New York,
1977.

Kleiner, F. "Artists in the Roman World: An Itinerant
Workshop in Augustan Gaul." *MEFRA* 89
(1977): 661–96.

Kockel, V. *Porträtreliefs Stadtrömischer Grabbauten.*
Mainz, 1993.

Koeppel, G. "The Grand Pictorial Tradition of Roman
Historical Representations." *ANRW* 2.12.1
(1982): 507–35.

——. "Die historischen Reliefs der römischen
Kaiserzeit V: Ara Pacis Augustae, Teil 1." *BJb* 187
(1987): 101–57.

——. "Die historischen Reliefs der römischen
Kaiserzeit V: Ara Pacis Augustae, Teil 2." *BJb* 188
(1988): 97–106.

——. "The Role of Pictorial Models in the
Creation of the Historical Relief during the
Age of Augustus." In *The Age of Augustus,*
edited by R. Winkes, 89–106. Providence, R.I.,
1985.

——. "The Third Man: Restoration Problems on the
North Frieze of the Ara Pacis." *JRA* 5 (1992):
214–16.

Kostof, S. "The Emperor and the Duce: The Planning
of the Piazzale Augusto Imperatore in Rome."
In *Art and Architecture in the Service of Politics,*
edited by H. Millon and L. Nochlin, 270–325.
Cambridge, Mass., 1978.

Kramer, R. S. *Drawings by Benjamin West and His Son
Raphael Lamar West.* New York, 1975.

Kraus, T. *Die Ranken der Ara Pacis. Ein Beitrag
zur Entwicklungsgeschichte der augusteischen
Ornamentik.* Berlin, 1953.

Kuttner, A. *Dynasty and Empire in the Age of Augustus:
The Case of the Boscoreale Cups.* Berkeley, 1995.

——. "Some New Grounds for Narrative: Marcus
Antonius's Base (The Ara Domitti Ahenobarbi)
and Republican Biographies." In *Narrative and
Event in Ancient Art,* edited by P. Holliday,
198–229. Cambridge, 1993.

La Rocca, E. *Ara Pacis Augustae: In occasione del
restauro del fronte orientale.* Rome, 1983.

Lazzarini, L., M. Mariottini, M. Pecoraro, and
P. Pensabene. "Determination of the Provenance
of Marbles Used in Some Ancient Monuments
in Rome." In *Classical Marble: Geochemistry,
Technology and Trade,* edited by N. Herz and
M. Waelkens, 399–409. NATO ASI series, 1988.

Lebek, W. D. "Die drei Ehrenbogen für Germanicus."
ZPE 67 (1987): 129–48.

Ling, R. *Roman Painting.* Cambridge, 1991.

Lugli, G. "In attesa dello scavo dell'Ara Pacis
Augustae." *Capitolium* 11 (1935): 365–83.

McCann, A.-M. "A Re-dating of the Reliefs from the
Palazzo della Cancelleria." *RM* 79 (1972):
249–76.

Magi, F. *I rilievi flavi del Palazzo della Cancelleria.*
Rome, 1945.

Marconi, P. "L'Arte dell'età di Augusto." *Emporium* 513
(1937): 477–90.

Martin, S. *The Roman Jurists and the Organization of
Private Building in the Late Republic and Early
Empire.* CollLatomus, vol. 204. Brussels, 1989.

Mendel, G. *Catalogue des sculptures greques, romaines et
byzantines.* Vol. 1. Constantinople, 1912.

Michon, E. "Les bas-reliefs historiques." *MonPiot* 17
(1910): 157–263.

Millon, H., and L. Nochlin, eds. *Art and Architecture
in the Service of Politics.* Cambridge, Mass., 1978.

Monte, M. del, and C. Sabbioni. "A Study of the
Patina Called 'Scialbatura' on Imperial Roman
Monuments." *Studies on Conservation* 32 (1987):
114–21.

Moretti, G. *Ara Pacis Augustae.* Rome, 1948.

——. *Ara Pacis Augustae.* Ministero della Pubblica
Istruzione. Itinerari Nr. 67 Rome, 1959.

——. "La ripresa dello scavo dell'Ara Pacis Augustae."
NSc, ser. 6, 13 (1937): 37–44.

——. "Lo scavo e la ricostruzione dell'Ara Pacis
Augustae." *Capitolium* 13 (1938): 479–90.

Mustelli, D. "L'Arte Augustea." In *Augustus. Studi in
occasione del bimillenario Augusteo,* edited by the
Accademia nazionale dei Lincei, 307–38. Rome,
1938.

Neutsch, B. "Zur Meisterfrage der Cancelleria-Reliefs."
JdI 63–64 (1948–49): 100–110.

Nodelman, S. "How to Read a Roman Portrait." *Art in
America* 63 (January–February 1975): 26–33.

Nylander, C. *The Ionians in Pasargadae*. Uppsala, 1970.

L'Orange, H. P. "Ara Pacis Augustae. La zona floreale." *ActInstRomNorv* 1 (1962): 7–16.

———. "Zum frührömischen Frauenporträt." *RM* 44 (1929): 169–79.

Pallottino, M. "L'Ara Pacis e i suoi problemi artistici." *BdA* 32 (1938): 162–72.

———. *Etruscan Painting*. Geneva, 1952.

Paris, R., ed. *Dono Hartwig: Originale Ricongiunti e Copie tra Roma e Ann Arbor*. Rome, 1994.

Pasqui, A. "Per lo studio dell'Ara Pacis Augustae. Le origine e il concetto architettonico del monumento." *StRom* 1 (1913): 283–304.

———. "Scavi dell'Ara Pacis Augustae." *NSc. Atti della R. Accademia dei Lincei* 27 (1903): 549–74.

Patterson, J. "The City of Rome: From Republic to Empire." *JRS* 82 (1992): 186–215.

Pedley, J. G. *Greek Sculpture of the Archaic Period: The Island Workshops*. Mainz, 1976.

Petersen, E. "L'Ara Pacis Augustae." *RM* 9 (1894): 177–228.

———. *Ara Pacis Augustae. Sonderschr. OAI*, vol. 2. Vienna, 1902.

———. "Ara Pacis Augustae." *JOAI* 9 (1906): 309–13.

———. "Il fregio dell'Ara Pacis." *RM* 10 (1895): 138–45.

Pfanner, M. *Der Titusbogen*. Mainz, 1983.

———. "Über das Herstellen von Porträts." *JdI* 104 (1989): 157–257.

Picard, Ch. "L'Exposition du bimillénaire de la naissance d'Auguste." *RA* 9 (1938): 335–37.

Platner, S. B. *A Topographical Dictionary of Ancient Rome*. London, 1929.

Pollini, J. "Ahenobarbi, Apulei and Some Others on the Ara Pacis." *AJA* 90 (1986): 453–60.

———. "Studies in Augustan 'Historical' Reliefs." Ph.D. diss., University of California at Berkeley, 1978.

Pollitt, J. J. *Art in the Hellenistic Age*. Cambridge, 1986.

———. *The Art of Rome: Sources and Documents*. Reissue. Cambridge, 1983.

Potter, D. "The Tabula Siarensis, Tiberius, the Senate, and the Eastern Boundary of the Roman Empire." *ZPE* 69 (1987): 269–76.

Raaflaub, K. A., and M. Toher, eds. *Between Republic and Empire: Interpretations of Augustus and His Principate*. Berkeley, 1990.

Rakob, F., and W. D. Heilmeyer. *Der Rundtempel am Tiber in Rom*. Mainz, 1973.

Ramage, N., and A. Ramage. *Roman Art: Romulus to Constantine*. Englewood Cliffs, N.J., 1991.

Randall, R. H., Jr. "The Erechtheum Workers." *AJA* 57 (1953): 199–210.

Rawson, E. "Architecture and Sculpture: The Activities of the Cossutii." *PBSR* 43 (1975): 36–47.

———. *Roman Culture and Society: Collected Papers*. Oxford, 1991.

Reeder, J. "Typology and Ideology in the Mausoleum of Augustus: Tumulus and Tholos." *ClAnt* 11 (1992): 265–307.

Refice, P., and M. Pignatti Morano. "Ara Pacis: Le fasi della ricomposizione nei documenti dell'Archivo Centrale dello Stato." *Roma. Archeologia nel Centro* 2 (1985): 404–20.

Res Gestae Divi Augusti. Trans. P. Brunt and J. M. Moore. Oxford, 1967.

Richardson, E. H. "The Etruscan Origins of Early Roman Sculpture." *MAAR* 21 (1953): 75–124.

Richter, G. M. A. *Ancient Italy*. Ann Arbor, 1955.

———. "The Origin of Verism in Roman Portraits." *JRS* 45 (1955): 39–46.

Ridgway, B. S. *Hellenistic Sculpture*. Vol. 1. Madison, Wis., 1990.

Riegl, A. *Die spätrömische Kunstindustrie*. Vienna, 1901.

———. *Stilfragen*. Berlin, 1893.

Roaf, M. *Sculptures and Sculptors at Persepolis. Iran* vol. 21. London, 1983.

Rockwell, P. *The Art of Stoneworking*. Cambridge, 1993.

———. "Finish and Unfinish in the Carving of the Sebasteion." *JRA*, supp. ser., 1 (1990): 101–18.

———. *Lavorare la Pietra*. Rome, 1989.

———. "Preliminary Study of the Carving Techniques on the Column of Trajan." *StMisc* 26 (1985): 101–11.

———. "Some Reflections on Tools and Faking." In *Marble: Art Historical and Scientific Perspectives on Ancient Sculpture*, edited by M. True and J. Podany, 207–21. Malibu, Calif., 1991.

———. "Stone-Carving Tools: A Stone-Carver's View." *JRA* 3 (1990): 351–57.

———. "Unfinished Statuary Associated with a Sculptor's Studio." In *Aphrodisias Papers*, vol. 2, edited by R. R. R. Smith and K. Erim, 127–43. Ann Arbor, 1991.

Root, M. C. "Circles of Artistic Programming: Strategies for Studying Creative Process at Persepolis." In *Investigating Artistic Environments in the Ancient Near East*, edited by A. Gunter, 115–39. Washington, D.C., 1990.

———. *King and Kingship in Achaemenid Art: Essays on the Creation of an Iconography of Empire. Acta Iranica*, vol. 9. Leiden, 1979.

———. Review of *Sculptures and Sculptors at Persepolis* by M. Roaf. *AJA* 90 (1986): 113–14.

Rose, C. B. "'Princes' and Barbarians on the Ara Pacis." *AJA* 94 (1990): 453–67.

Sasson, J. M. "Instances of Mobility among Mari Artisans." *BASOR* 190 (1968): 46–54.

Sauron, G. "Le message esthétique des rinceaux de l'Ara Pacis Augustae." *RA* 81 (1988): 3–40.

———. "Le message symbolique des rinceaux de l'Ara Pacis Augustae." *CRAI* (January–March 1982): 80–101.

———. "Les modèles funéraires classiques de l'art décoratif néo-attique au Ier siècle avant J.-C." *MEFRA* 91 (1977): 183–236.

Schäfer, M. "Zum Tellusbild auf der Ara Pacis Augustae." *Gymnasium* 66 (1959): 288–301.

Scheid, J. *Romulus et ses frères. Le Collège Arvale, un modèle du culte public dans la Rome des empereurs. BEFAR*, vol. 275. Rome, 1990.

Schmaltz, B. "Zum Augustus-Bildnis Typus Primaporta." *RM* 93 (1986): 211–43.

Schurr, W. *Augustus*. Lübeck, 1934.

Schütz, M. "Zur Sonnenuhr des Augustus auf dem Marsfeld. Eine Auseinandersetzung mit E. Buchners Rekonstruktion und seiner Deutung der Ausgrabungsergebnisse, aus der Sicht eines Physikers." *Gymnasium* 97 (1990): 432–57.

Schweitzer, B. *Die Bildniskunst der römischen Republik*. Leipzig, 1948.

Scobie, A. *Hitler's State Architecture: The Impact of Classical Antiquity*. University Park, Pa., 1990.

Settis, S. "Die Ara Pacis." In *Kaiser Augustus und die verlorene Republik*, 400–426. Berlin, 1988.

Sieveking, J. "Das römische Relief." In *Festschrift Paul Arndt*, 14–35. Munich, 1925.

Silverio, A. M. L. "La Mostra Augustea della Romanità." In *Dalla Mostra al Museo: Dalla Mostra Archeologica del 1911 al Museo della Civiltà Romana*, Marsilio editori, 77–90. Venice, 1983.

Simon, E. *Ara Pacis Augustae: Monumenta Artis Antiquae*. Vol. 1. Tübingen, 1967.

———. *Augustus. Kunst und Leben in Rom um die Zeitenwerde*. Munich, 1986.

Smith, R. R. R. *Aphrodisias*. Vol. 1, *The Monument of C. Julius Zoilos*. Mainz, 1993.

———. *Hellenistic Sculpture*. London, 1991.

Spaeth, B. "The Goddess Ceres in the Ara Pacis Augustae and the Carthage Relief." *AJA* 98 (1994): 65–100.

———. *The Roman Goddess Ceres*. Austin, Tex., 1996.

Stewart, A. *Greek Sculpture: An Exploration*. New Haven, 1990.

Stratford, N. "Romanesque Sculpture in Burgundy: Reflections on Its Geography, on Patronage, on the Status of Sculpture and on the Working Methods of Sculptors." In *Artistes, artisans et production artistique au moyen-âge*, vol. 3, edited by X. Barral i Altet, 235–53. Paris, 1990.

Strong, D., and D. Brown, eds. *Roman Crafts*. London, 1976.

Strong, D., and A. Claridge. "Marble Sculpture." In *Roman Crafts*, edited by D. Strong and D. Brown, 195–207. London, 1976.

Strong, D., and J. Ward-Perkins. "The Round Temple in the Forum Boarium." *PBSR* 28 (1960): 7–30.

Strong, E. "The Augustan Exhibition in Rome and Its Historical Significance." *Nineteenth Century* 124 (1938): 169–77.

———. *Roman Sculpture from Augustus to Constantine*. New York, 1907.

———. "Romanità throughout the Ages." *JRS* 29 (1939): 137–66.

———. "Terra Mater or Italia?" *JRS* 27 (1937): 114–26.

Strzygowski, J. *Orient oder Rom: Beiträge zur Geschichte der spätantiken und frühchristlichen Kunst*. Leipzig, 1901.

Studniczka, F. "Zur Ara Pacis." *AbhLeip* 27 (1909): 901–42.

Syme, R. "Neglected Children on the Ara Pacis." *AJA* 88 (1984): 583–89.

———. *The Roman Revolution*. Oxford, 1939. Reprint. London, 1967.

Talbert, R. *The Senate of Imperial Rome*. Princeton, 1984.

Terpak, F. "The Role of the Saint-Eutrope Workshop in the Romanesque Campaign of Saint-Caprais in Agen." *Gesta* 25, no. 2 (1986): 185–96.

Thompson, H. "The Altar of Pity in the Athenian Agora." *Hesperia* 21 (1952): 79–82.

Torelli, M. "Topografia e Iconologia. Arco di Portogallo, Ara Pacis, Ara Providentiae, Templum Solis." *Ostraka* 1 (1992): 105–31.

———. *Typology and Structure of Roman Historical Reliefs*. Ann Arbor, 1982.

Touati, A.-M. L. *The Great Trajanic Frieze: The Study of a Monument and of the Mechanisms of Message Transmission in Roman Art. SkrRom*, ser. 4, vol. 45. Stockholm, 1987.

Toynbee, J. M. C. "The Ara Pacis Reconsidered and Historical Art in Roman Italy." *ProcBritAc* 39 (1953): 67–95.

———. *The Hadrianic School: A Chapter in the History of Greek Art*. Cambridge, 1934.

———. "Some Notes on Artists in the Roman World. II: Sculptors." *CollLatomus* 9 (1950): 49–65.

Trillmach, W. "Der Germanicus-Bogen in Rom und das Monument für Germanicus und Drusus in Leptis Magna. Archäologisches zur Tabula Siarensis (I 9-21)." In *Estudios sobre la Tabula Siarensis*, edited by J. González and J. Arce, 51–60. Madrid, 1988.

True, M., and J. Podany, eds. *Marble: Art Historical and Scientific Perspectives on Ancient Sculpture*. Malibu, Calif., 1991.

Vessberg, O. *Studien zur Kunstgeschichte der römischen Republik. SkrRom*, vol. 8. Lund, 1941.

Vierneisel, K., and P. Zanker, eds. *Die Bildnesse des Augustus*. Munich, 1979.

Visconti, E. Q., and G. A. Guattani. *Il Museo Pio Clementino*. Vol. 5. Rome, 1820.

Viviers, D. *Recherches sur les ateliers de sculpteurs et la Cité d'Athènes à l'époque archaïque: Endoios, Philergos, Aristokles*. Brussels, 1992.

Von Duhn, F. "Sopra alcuni bassirilievi che ornavano un monumento pubblico Romano dell'Epoca di Augusto." *AICA* 53 (1881): 302–32 with illustrations in *MonInst* 11 (1881): pls. 34–35.

———. "Über einige Basreliefs und ein römisches Bauwerk der ersten Kaiserzeit." *Miscellenea Capitolina* (1879) 11–16.

Von Sydow, W. "Die Grabexedra eines römischen Feldherren." *JdI* 89 (1974): 187–216.

Wace, A. J. B. "Fragments of Roman Historical Reliefs in the Lateran and Vatican Museums." *PBSR* 3 (1905): 275–94.

Waelkens, M. "From a Phrygian Quarry: The Provenance of the Statues of the Dacian Prisoners in Trajan's Forum at Rome." *AJA* 89 (1985): 641–53.

Waelkens M., P. De Paepe, and L. Moens. "Quarries and the Marble Trade in Antiquity." In *Classical Marble: Geochemistry, Technology and Trade*, edited by N. Herz and M. Waelkens, 11–28. NATO ASI series. Dordrecht, 1988.

Walsher, G. "Greichen an Hofe des Grosskönigs." In *Festgabe Hans von Greyerz*, edited by E. Walder, 189–202. Bern, 1967.

Ward-Perkins, J. "The Marble Trade and Its Organization: Evidence from Nicomedia." *MAAR* 36 (1980): 325–38.

———. "Tripolitania and the Marble Trade." *JRS* 41 (1951): 89–104.

Weber, W. *Princeps*. Vol. 1, *Studien zur Geschichte des Augustus*. Stuttgart, 1936.

Weickert, C. "Gladiotoren-Relief der Müncher Glyptotek." *MüJb* 2 (1925): 1–38.

Weinberger, R. D. "St. Maurice and St. André-le-Bas at Vienne: Dynamics of Artistic Exchange in Two Romanesque Workshops." *Gesta* 23, no. 2 (1984): 75–86.

Weinstock, S. "Pax and the Ara Pacis." *JRS* 50 (1960): 44–58.

Welin, E. "Die beiden Festtage der Ara Pacis Augustae." *Dragma Martino P. Nilsson. Acta Inst. Regni Sueciae*, ser. 2, 1 (1939): 500–513.

Wickhoff, F., and W. Ritter von Hartel. *Die Wiener Genesis*. Vienna, 1895.

Wiegand, T. "Die puteolanische Bauinschrift." *Jahr. f. Klass. Philol.*, suppl., 20 (1894): 660–778.

Winckelmann, J. J. *Geschichte der Kunst des Alterthums*. Dresden, 1764.

Winkes, R., ed. *The Age of Augustus: Interdisciplinary Conference Held at Brown University, April 30–May 2, 1982*. Providence, R.I., 1985.

Yilmaz, H. "Der Zoilosfries aus Aphrodisias: Typologie, Stil und Eigenart des Frieses und sein Verhältnis zur Ara Pacis." Diss., Marburg, 1987.

Zaccagnini, C. "Patterns of Mobility among Ancient Near Eastern Craftsmen." *JNES* 42 (1983): 245–64.

Zanker, P. *The Power of Images in the Age of Augustus*. Trans A. Shapiro. Ann Arbor, 1988.

———. *Studien zu den Augustus-Porträts: I. Der Actiumtypus*. Göttingen, 1978.

Ziolkowski, A. "Mummius' Temple of Hercules Victor and the Round Temple on the Tiber." *Phoenix* 42 (1988): 309–33.

INDEX

Aachen, 40

Achaemenid art, 28, 32, 33, 36, 39–40. *See also* Persepolis

Adventus, 3, 107 (n. 3)

Agrippa (Marcus Vipsanius Agrippa) (s28), 49, 51–52, 54, 65, 68–69, 71, 78, 80, 84, 93, 97–98, 127 (n. 117), 129 (n. 4), figs. 21, 29, 67, 77, 117, 202; return from campaigns, 3, 107 (n. 3)

Agrypnus (sculptor of Maecenas), 34

Ahenobarbus (L. Domitius Ahenobarbus) (s45), 51–52, 54, 65, 68, 78, figs. 40, 76, 89, 100–102, 197

Alexandria, 12, 33

Anathyrosis, 94, 100

Anatolia, 60–61

Anglo-Norman art, 29, 40

Antonia Maior (s41), 66, 69, 72, 78, figs. 18, 42, 90, 123–24, 138, 142

Antonia Minor (s36), 49, 51–52, 65, 69–71, 78, 97–98, 129 (nn. 3, 5), figs. 13, 19, 48, 75, 128–29

Antoninus Pius, 55

Antony (Marcus Antonius), 33, 95, 115 (n. 41)

Aphrodisias: Odeion workshop, 30; Zoilos frieze, 60–61, 122 (n. 19)

Ara Pacis Augustae, 33, 42; post-ancient history, 2, 117 (n. 1), 125 (n. 81); *dedicatio*, 3, 97, 101, 108 (n. 7); *constitutio*, 3, 101, 108 (n. 7); spiral/floral frieze, 4, 10, 45, 84, 108 (n. 18); interior garland reliefs, 4, 10, 84; description, 4–8; drawing, 5; plan, 5; identification by Von Duhn, 8, 12; modern re-erection near Tiber River, 9, 13–14, 46; Petersen's reconstruction, 9, 14, 46; excavations, 9, 46, 56, 118 (n. 11); architectural models, 9, 108 (nn. 16, 17); modern cleaning, 11; comparison with classical Greek monuments, 12, 15–16, 18–19, 21–23; comparison with Hellenistic monuments, 12, 15–16, 21, 79; influence from

Etrusco-Italic paintings, 23, 83, 109 (n. 15), 112 (n. 78); evidence for paint, 48, 118 (n. 16); comparisons with republican reliefs, 48–50; comparisons with Etruscan portraiture, 50, 119 (n. 40); references in calendars, 107–8 (n. 5); ancient representations of, 108 (n. 5); relationship to Arval Brethren, 108 (n. 5); measurements, 108 (n. 8). *See also* Restorations

—Altar proper, 4, 106, 132 (n. 6); small processional friezes, 84, 100–102, 131 (nn. 59, 62), figs. 237–47

—Mythological panels, 4, 10, 18, 45, 84, 109 (n. 21); Tellus Panel, 10, 97, 109 (n. 19), 117 (n. 5), fig. 230

—North and South friezes, 23, 45, 118 (n. 12); drawings of, 7; identification of participants, 10, 109 (n. 20), 128 (nn. 124, 128); Pallottino's theory of four sculptors, 16, 81–82; discovery, 45–47; states of preservation, 46, 53–54, 118 (n. 17); male hair rendering, 68–69, 75, 77, 97–98, 124 (n. 61), 125 (n. 63); female hair rendering, 69–70, 75, 77, 97–98, 125 (n. 65); children's hair rendering, 70–72, 125 (nn. 69, 73), figs. 133–38; hands, 72, 96, 125 (nn. 74, 80), 130 (n. 29), figs. 139–43; drapery, 73–75, 77–78, 81–84, 88, 98, 105, 125 (n. 82), 126 (n. 87), 128 (n. 142), figs. 144–59; flesh surfaces, 75–77; facial types, 78–81, 88, 93, 96–99, 127 (nn. 109, 113), 128 (nn. 118, 119, 124); composition; 81–86, 104–5, 128 (n. 129); fragments of Panels s1 and s2, fig. 11; Panel s3, 56, 73–79, 91, 98, fig. 10; Panel s4, 54, 56, 73–77, 79, 81, 98, fig. 10; Panel s5, 46, 53–54, 73, 79, 81–83, fig. 3; Panel s6, 46, 53–54, 73, 78–79, 81–83, fig. 3; Panel s7, 46, 53–54, 73, 78–79, 81–83, fig. 4;

Panel n1, 46, 52, 54, 56, 73, 76, 78, 82, 118 (n. 6), fig. 8; Panel n2, 46, 53–54, 73, 82, figs. 5, 6; Panel n3, 46, 53–54, 73, 82, fig. 7; Panel n4, 46, 48, 54, 56, 64, 67, 82–83, 118 (n. 7), fig. 9. *See also* Restorations

Architects, 38, 40. *See also* Workshops

Artists. *See* Architects; Painters; Potters, Athenian; Sculptors; Stonemasons; Workshops

Artynoi, 38

Asia Minor, 60, 63

Athens, 34–35, 38, 60, 86–87

—Altar of Pity, 9

—Altar of the Twelve Gods, 9, 21

—Erechtheion, 32

—Parthenon, 13, 15, 19, 21, 32, 40, 109 (nn. 4, 9), 110 (n. 27); Panathenaic frieze, 12–13, 15, 19, 21, 30, 110 (n. 17), 112 (n. 68), 113 (n. 78)

Augustan neoclassicism, 1, 15, 58, 79–80; imitation of Athenian classicism, 79–80

Augustus Caesar, 34, 41, 62, 71, 78, 87, 126 (n. 105); absence from Rome, 3; reluctance to receive commendations, 3; return from campaigns, 3; *Res Gestae*, 14, 28, 41, 108 (n. 7); bimillenial celebration of, 14–15; idealization of, 15, 104; as patron of arts, 16, 33, 40–41, 111 (n. 44); criticism of, 17–18, 103; perpetual *tribunicia potestas*, 18; settlement of Octavian, 18; comparison with Perikles, 19; Actium, 33; portrait on South procession, 46, 51–52, 73, 75–77, 79, 81, 84, 93, 119 (n. 41), 127 (n. 114), 129 (nn. 4, 5), figs. 39, 153–55, 166–67, 187, 190, 201, 217; Prima Porta statue, 79; Via Labicana statue, 79

"Barbarian Queen" (s30), 69–70, 98, figs. 28, 91, 130–31, 198

Bartoli engravings, 53, 120 (n. 59), figs. 61–62